MAKING CULTURE
*English-Canadian Institutions
and the Arts before
the Massey Commission*

D1199795

Canadian culture began, according to popular belief, in the late 1950s with the establishment of the Canada Council, and blossomed in the nationalist celebrations of the 1960s. The truth, as Maria Tippett shows in this study, is very different. From the late nineteenth century forward, Canada has enjoyed a complex, wide-ranging, and diverse cultural life. Its musicians, visual artists, dramatists, and writers, professional and amateur, have been active in rural areas and urban centres, supported by philanthropists, consumers, and governments.

Tippett reveals the breadth, depth, and character of cultural activity in English Canada. She also explores the infrastructure that sustained it in the nineteenth century and into the middle of the twentieth: educational institutions, public and private patrons, cultural organizations, and foreign influences.

By focusing on these factors rather than on cultural artefacts, she provides all those involved in cultural studies with a new way of coming to grips with the cultural and the historical process. Her study also paves the way for an understanding of the Massey Commission, the Canada Council, and the flourishing of Canadian culture in the years since the council's establishment.

Making Culture is a richly detailed picture of a vigorous cultural environment and the foundations that enabled it to grow.

MARIA TIPPETT is a historian living in Vancouver. Her earlier books include *Emily Carr: A Biography; From Desolation to Splendour: Changing Perceptions of the British Columbia Landscape*, with Douglas Cole; *Art at the Service of War: Canada, Art, and the Great War*; and *Breaking the Cycle and Other Stories from a Gulf Island*.

MARIA TIPPETT

MAKING CULTURE
English-Canadian
Institutions and the Arts
before the Massey Commission

UNIVERSITY OF TORONTO PRESS
Toronto Buffalo London

© University of Toronto Press 1990
Toronto Buffalo London
Printed in Canada

ISBN 0-8020-2743-1 (cloth)
ISBN 0-8020-6784-0 (paper)

Printed on acid-free paper

Canadian Cataloguing in Publication Data

Tippett, Maria, 1944–
 Making culture : English-Canadian institutions
 and the arts before the Massey Commission

 Includes bibliographical references.
 ISBN 0-8020-2743-1 (bound) ISBN 0-8020-6784-0 (pbk.)

 1. Canada – Civilization – 20th century. 2. Canada –
 Intellectual life – History. 3. Canada – Social life
 and customs – 20th century.* 4. Arts – Canada –
 History – 20th century. I. Title.

 FC95.4.T5 1990 971.06 C90-093476-X
 F1021.2.T5 1990

This book has been published with the help of a grant from the Social
Science Federation of Canada, using funds provided by the Social Sciences
and Humanities Research Council of Canada.

This book is for A.C.L.S.

Contents

viii Contents

Preface

Growing up with artistic inclinations in Victoria, British Columbia, during the 1940s and 1950s, I was exposed to a wide variety of cultural activities. There were after-school ballet classes at Velda Willie's Dance Studio, where a former 'ballerina' from the Royal Ballet – now the wife of a naval officer – guided me through the rudiments of her profession. On Saturday mornings there were art classes at the YWCA, where I further cultivated my passion for horses by learning how to draw them on a grid; in the afternoons I was marched off to private piano lessons until I rebelled and successfully persuaded my parents to let me study the clarinet and saxophone. These instruments were first taught to me by Reg Roy, who led the dance band at the Club Sirocco. After I showed some aptitude, a university-trained music teacher was employed to guide me through the Royal Conservatory of Music examination system and to prepare me for the annual music festival. By my mid-teens I had attained some proficiency in music and dance and had even begun to earn money by playing in the Stardusters dance band on the weekends. But I never considered making a career out of these activities. And when I embarked for Europe at the end of high school, I quickly discovered that I preferred, and was better suited, to be an observer rather than a performer.

My early training no doubt heightened my appreciation for what I saw and heard during my two-and-a-half-year sojourn in western and eastern Europe. It also awakened my curiosity about, and desire to investigate, the early twentieth-century cultures of Germany and the Soviet Union. But above all it eventually led me, as a professional

scholar, to the study of Canada; specifically to an examination of two aspects of the development of its visual arts, theatre, music, and literature. I became concerned, first, with the process by which works of art are created by the artist, received by the 'audience,' interpreted by the critic, and made part of the public domain and the nation's consciousness. Second, I developed an interest in the 'selfconsciously "performative" ' dialogue that exists between the reader, viewer, or listener and the cultural artefact, be it poem, play, musical composition, novel, or painting.[1]

This work deals with the first of these matters: that is, with the dynamic that enables works of art to come into being. Though it begins in 1900, the reader should not assume that Canada possessed no cultural institutions, patrons, and organizations prior to the outset of this century. The years following Confederation witnessed the founding of the Ontario Society of Artists (1872) and the National Gallery of Canada (1880). They also saw the emergence of private patrons such as John Owens, whose fortune established the Owens Art School in Saint John in 1884. Even the years prior to Confederation were not without cultural institutions. Literary journals existed – the *Literary Garland* (1838–51) was one – and theatres – Montreal's Theatre Royal (1825) prominent among them – were also to be found. But it was not until the country's population growth, political unification, economic strength, and technological sophistication were sufficient to produce a wide range of organizations, institutions, and patrons that a foundation able to support a reasonably mature cultural life appeared.

This study is not only confined to a specific time period; it focuses on one cultural group, that composed of English-speaking Canadians who were largely, though not entirely, of British origin. It does not embrace the rich and vibrant cultures of the Inuit and native Indians, nor that of the French Canadians, nor what the ethno-cultural groups making up an ever growing part of the population did, save when these things were brought within the orbit of English Canada's cultural life. How members of these groups organized themselves, what patterns of institutionalization existed among them, and the manner in which patrons approached the task of encouraging them were all different, and consideration of these matters has been left aside for separate study. To have included them here would, indeed, not only have done them a disservice; it would have contributed to the unwieldiness of an already vast and difficult to manage subject.

Given the complex character of the activities that I have chosen to

focus upon, I have organized my chapters around several themes. The first involves looking at the framework of institutions generally, for this framework, like the trusses, buttresses, and spans which supported the medieval cathedral, was indispensable to the maintenance of the activity to which it gave rise. In considering it, moreover, one gets some understanding of the kinds of motives that animated cultural activities – among which maintaining status, upholding tradition, or fostering change were not the least significant. Secondly, I turn to the quite explicit concern with 'education' which lay at the heart of much encouragement of culture, and so give attention to the private music teachers, university radio stations, drama festivals, and academies of art and music, all of which sought to stimulate and refine the talents, intellect, and feeling of amateur, professional, and onlooker alike. Next to be considered are the various forms taken by public patronage as governors general, politicians, and bureaucrats moved to stimulate, encourage, and recognize cultural activity through the creation of agencies such as the National Gallery of Canada, the organization of events such as the historical pageants marking the tercentenary of Quebec or the sixtieth anniversary of Confederation, and even – indirectly – by establishing national and provincial parks. What private patrons attempted is examined next, with the focus very much on the heterogeneous character of what they did: everything from endowing an art gallery or a school of music to purchasing a ticket to a concert series counted. I look, finally, at the very important role played in the building of English Canada's cultural life by its international links, for the fact that artists exhibited and writers published abroad, and that grants and standards of taste and judgment derived from abroad, had a profound influence on the character, shape, and quality of what got done.

The combined effect of all this activity, the last chapter argues, was to produce a gradually increasing concern with professional standards, on the one hand, and a 'national' culture, nationally organized, on the other. This concern sharpened during the Second World War and made an interest in fostering cultural life a principal objective of the cultural producers, politicians, and bureaucrats increasingly preoccupied with the task of post-war reconstruction. The cultural community particularly became convinced that it had a critical role to play in the lives of Canadians, and so began to lobby for government recognition, financial support, and administrative assistance. The government's response to these demands, first through the establishment of the Massey Commission in 1949, then, eight years later, through the founding of the Can-

ada Council, opened a new era in the country's cultural history. After 1957 one agency would be primarily responsible for engineering the cultural life of the country. Elements of its pre–Second World War cultural life – the amateur, the autonomously minded organizations, and the private patron – would, as I know only too well from my childhood experience in Victoria, remain. But the professional producer, the national organization, and an approach to culture stressing the need to make it 'accessible' would, with the help of the Canada Council, come to dominate. These forces helped to erode the laissez-faire, ad hoc, and often élitest manner in which cultural activity had been organized and funded. The new, central source of funding, producing a quasi-official taste and a quite sizeable cultural bureaucracy, altered the way in which cultural activity was carried out. More even than that, it changed the character of what was produced, making it more professional and accomplished than what had gone before, though at the same time reducing – at least proportionally – the numbers of people involved in its making.

The story that follows is not just about educational institutions, organizations, funding agencies, and government departments. It has much to say about middle- and upper-class English-speaking Canadians whose largely amateur production of cultural artefacts conformed either to traditional standards of taste (usually long out of fashion elsewhere) or, perhaps more surprisingly, to modernist styles emanating from foreign centres of the avant-garde. It also has a host of characters: private art collectors, music and drama teachers, governors general, critics, volunteers, corporate patrons; everyone, in short, who helped make cultural activity possible finds a place in these pages. Nor is the story unique. Versions of it can be found in other new societies such as those of New Zealand and Australia. Yet what happened in English Canada from the turn of the century to the founding of the Massey Commission in 1949 has qualities that did set it apart, for in this case British, American, and indigenous influences interacted in ways not present elsewhere. What was created as a result of this interplay may sometimes have lacked focus, been concerned with the amateur rather than the professional, and, above all, manifested itself as derivative and provincial. It nonetheless bespoke the existence of a serious and deeply founded interest in cultural pursuits, one which not only gave life to the 'old' institutions but, in so doing, shaped and moulded the ones that came after the war.

Acknowledgments

Much of the credit for writing this book belongs to others. Students at Simon Fraser University, where I developed a course in cultural history, helped me to shape half-formed ideas. Faculty members from a wide variety of disciplines at York University, where I held the chair as John P. Robarts Professor of Canadian Studies from 1986 to 1987, contributed to what I have done here. The Robarts Centre for Canadian Studies itself was generous with funding as were the Social Sciences and Humanities Research Council, the Department of National Defence, the Rockefeller Foundation, and the Canadian Studies Association. To the Robarts Centre's former director, John Lennox, and its executive assistant, Sharon Harrison, I am most thankful. During my many research trips across the country, as well as in the United States and Great Britain, librarians, clerks, and archivists in public and private archives, libraries, universities, museums, and art galleries were not daunted by my many questions, by my requests for yet more boxes of manuscripts, and even by my occasional petitions to work after regular hours. Corporations, businesses, foundations, and private individuals answered letters, sent material, and sometimes let me into their archives. Most of their names appear in the notes, and I am grateful to them all for without their co-operation this study would never have come to fruition. I should like as well to express my gratitude to Eileen Koerner, who proof-read the text, to my copy-editor, Ken Lewis, and to the University of Toronto Press, which showed interest in this project from its conception and which, through its editor Gerry Hallowell, has helped in the making of this book and in the shaping of the country's cultural

history too. Finally, the support, advice, and wisdom of my companion Allan Smith of the Department of History at the University of British Columbia has been invaluable in the writing of this book.

Bowen Island, May 1989

MAKING CULTURE

ONE

From the Campfire to the Concert Hall: The Professionalization of Cultural Activity

Cultural activity was evident everywhere in English Canada during the early decades of this century despite the common view that Canadians had 'no time for the spiritual refinements of life' because they were too busy making money.[1] Along the Atlantic coast Maritimers kept 'alive the old Gaelic and Irish songs of their ancestors.'[2] Behind the doors of an Annapolis Valley farmhouse a family in Ernest Buckler's novel *The Mountain and the Valley* experienced 'a new kind of moment' when its members raised their voices in song to the accompaniment of an old organ.[3] In the living-room of John Watson's Alberta farmhouse the children in Nellie McClung's *Purple Springs* pushed the furniture to the corner of the room, suspended a curtain from the beams, and presented a tableau which taught 'the vanity of human greatness.'[4] On Robert Stead's remote Saskatchewan homestead the central character in the novel *Neighbours* took up his banjo and 'sang, dipping into little fragments of repertoire, until at last he hit upon something that Jean had learned before [they] left the East, and then her clear soprano voice joined his tenor as naturally as one brook mingles with another and both flow on.'[5] Sunday evenings during Flora Eaton's girlhood in Omemee, Ontario, ended 'almost always in the same way, with an hour of music in the parlour'; and during Watson Kirkconnell's boyhood in Port Hope, there were frequent 'song-fests.'[6] Because 'culture had not yet demanded ... its severe price of contempt for the untrained,' amateurs proudly provided an evening's entertainment.[7] 'Our party came off last night,' the Charlottetown portrait painter Robert Harris wrote of a social gathering in Montreal in 1909, because 'Mrs. Caldwell

4 Making Culture

brought her cello ... Prof. Cox played the piano and his daughter sang
... Then Lizzie Putnam sang and Frances played and Mrs. Heward
sang.'8 'The musical evening at home,' as musician Ernest MacMillan
reflected upon the years before the Second World War, 'would scarcely
be complete unless some large-bosomed contralto were available to ren-
der "The Rosary" or unless some beefy baritone were on hand to pro-
claim himself a "bandillero" or other species of bold bad man.'9

Whether real or imagined amateur performances were not always so
spontaneous. Cultural activities were organized in a variety of ways.
Amateur theatricals were staged throughout the nineteenth century by
troops garrisoned at Halifax, Fort Garry, and Victoria, or by the North-
West Mounted Police based in Regina, La Touche, and Prince Albert;
even in the eighteenth century 'a company of Gentlemen' who had
crossed the line to live on British soil in Saint John were involved in
such productions.10 From the beginning of the nineteenth century,
exhibitions of delicate watercolour drawings were held among the live-
stock, preserves, and craft exhibits at agricultural fairs, and towards the
end of the century, pictures were hung in the plush lobbies of Canadian
Pacific Railway hotels or on, above, or below 'the line' in the exhibition
rooms of the Ontario Society of Artists' and the Royal Canadian Acade-
my's annual exhibitions.

On Sunday mornings almost everyone was organized in song
throughout the country. 'Everybody sang' in the Prairie town churches
of Robert Stead's imagination. 'Not all in the same key ... not all to the
same time and sometimes not all to the same tune, but all in the same
spirit.'11 All year round brass bands performed at funerals, weddings,
and village feasts in Bella Bella, Metlakatla, and other isolated native
Indian villages along the west coast. Even Stephen Leacock's fictional
town of Mariposa had a Salvation Army band, a band that played in the
park on Wednesday evenings, an Odd Fellow's brass band, and some-
thing called the Mariposa Quartette that provided a pleasant and fa-
miliar din at every civic event.12

But choral singing, which according to music critic Fred Jacob,
brought 'Canadians into touch with the better forms of music,' was the
most popular organized cultural activity.13 This was because choirs
needed no props or musical instruments, demanded little training, ad-
mitted large numbers of people, and were led by the most able musician
in town: the church organist-choirmaster. By the turn of the century
there was music to be heard in every English-Canadian church. The
Presbyterians had settled their controversy over the use of the organ,

[margin note: choirs broke down class barriers]

and the Methodists, altering the earlier view that 'we cannot consent to religious services being transformed into "Oratorios" and God being insulted in his own house,' had admitted the voice to their services.[14] Church choirs as well as company and service-club choirs broke down class barriers, provided a social activity, and gave many towns their only form of cultural entertainment. While it was true that English Canadians were 'not brought up on *sol-fa* from childhood' and did not 'know the *Hallelujah Chorus* from memory,' they were, as Augustus Bridle assured his readers in the novel *Hansen*, 'proud to learn – if you'll have the patience.'[15]

Choirmaster A.S. Vogt possessed the patience, and the belief that English Canadians could be taught, as he showed when he enlarged his Jarvis Street Baptist Church Choir to 250 voices and formed the Toronto Mendelssohn Choir in 1894. Vogt 'had an uncanny faculty for extracting from a large body of singers a wide range of tone and colour' and a marvellous ability to instil in them devotion to the choir.[16] Not surprisingly, the Mendelssohn Choir, under his direction until 1917, quickly became well known in central Canada, as well as throughout the United States, for its a cappella singing. But few of the choral, philharmonic, or oratorio societies which flourished across the country during the heyday of the Mendelssohn Choir reached the national prominence of Vogt's group of singers. Most English Canadians sang simply for their own entertainment or as part of their weekly devotions.

[margin note: most sang own entertain. or wk. devot'n.]

Mutual entertainment was certainly one force which prompted English-speaking Canadians of the business, professional, and upper classes to form exclusive private cultural organizations. They met in one another's homes at regular intervals to make music, read poetry, put on plays, share a model for sketching, or combine all or some of these activities, as demonstrated by one early group, the Halifax Chess, Pencil and Brush Club, whose members pursued the polite hobbies of drawing, watercolour painting, and, of course, playing chess from 1787 to 1817. Participating in more than one activity was motivated by the paucity of interested and able people in any one area; by the belief that the arts and sciences – as witnessed in the formation of the Vancouver Art, Historical and Scientific Association (1894) and the prestigious Royal Society of Canada (1882) – could be simultaneously pursued; and by the fact that Matthew Arnold's stress on the ennobling nature of 'getting to know ... the best that has been thought and said in the world' was taken seriously.[17] From 1915 Toronto's Heliconian Club brought women writers, musicians, architects, and artists together for

[margin note: hobbies]

[margin note: Clubs brought people together]

[margin note: prof., business + upper class → mutual entertainment]

'social intercourse,' which meant listening to lectures, readings, and music as well as viewing art exhibitions and theatrical performances.[18] The Pen and Pencil Club of Montreal, begun in 1890 by six artists and writers, also met for the 'social enjoyment and promotion of the Arts and Letters.'[19] This exclusively male group found, as did Montreal's less conservative Arts Club Limited (1913), an audience for its poetry, paintings, and musical compositions among its own members. Other private cultural groups – the Women's Musical Clubs (the first was established in Hamilton in 1889), the Arts and Crafts Association of Hamilton (1894), and branches of the Women's Art Association (1890) – were devoted to pursuing only one artistic form.

Yet private cultural organizations were not entirely composed of those who had to participate 'in the Club's programmes at least once a year.'[20] Sometimes they granted associate membership to persons who shared the interests of the full members but not the talent to participate. Sometimes, in fact, they consisted solely of these kinds of observers. The Hawthorne Women's Club (1923) invited outsiders to speak to them on 'The Empire,' on 'Our Soldiers at the Front,' and 'Canadian Scenery and Art,' among other subjects.[21] But whether these groups specialized in one activity or several, whether they included participants, spectators, or both, or whether they were segregated or combined both sexes, they all had one thing in common: mutual entertainment.

But this was not all. Such private organizations as the Vancouver Art, Historical and Scientific Association gave their largely immigrant members a heightened sense of place by studying British Columbia's native Indians and geography and by capturing the distinctive features of the province in verse or watercolour drawings. They also helped to cultivate nascent talent. The Cavendish Literary Society, founded in Prince Edward Island in 1886 for 'the mutual improvement of its members,' gave the budding novelist Lucy Maud Montgomery a place to test her ideas.[22] The literary society that met in the Regina Public Library helped the young novelist Laura Goodman Salverson 'to creep out of my mental shell,' to gain confidence as a writer, and to meet such well-established Canadian authors as Nellie McClung.[23] The provincial branches of the Women's Art Association fulfilled 'the need of an Art Club for women where they might meet together for mutual help and improvement.'[24] And the Vagabond Club (1914) of Vancouver offered its male artists, writers, and musicians 'an outlet for whatever small talents we possessed in a city in which the buying and selling of real-estate was the preoccupation of the majority of the inhabitants.'[25]

involvement with clubs → leisure time + co. of social peers

Private cultural organizations also allowed their male members to 'forget taxes, bills ... and ... be like grown up children, enquiring, joyous [and] irresponsible.'[26] This was possible because few members were dependent for their living upon writing books, painting pictures, producing plays, composing musical scores, or casting bronzes. For them, indeed, involvement in these groups was something to do in one's leisure time and in the company of one's social peers. Becoming a member required sponsors and the resources to pay the annual dues, to make the costumes for the masquerade balls, and to buy the appropriate evening dress for the gala dinners. The Vancouver Poetry Society (1916) and Saint John's Eclectic Reading Club (1880) had a quota on their membership and a long waiting list to join. Victoria's Island Arts and Crafts Society (1910) excluded Asians from its ranks, preferring to welcome retired colonels, businessmen-hobbyists, and society ladies to its weekend sketching parties and annual exhibitions at the Willows' Agricultural Fair. And, finally, the Vagabond Club of Vancouver was 'a great rallying place for the charming, literary and usually indignant Englishmen who had drifted into' that city.[27] Private cultural organizations did not feel obliged to open their doors to the public at large. The masses, their members believed, had their own form of cultural entertainment, and it came across the Canadian-American border in plentiful, inexpensive quantities.

annual dues
costumes
even. dress
quota on membership + waiting list (racist/sexist exclusions)

It was the doing, the discussing, and the sharing of one's work that mattered to these society ladies, businessmen, and professionals. Rarely did they help a fellow member with the publication of a poem, or the exhibition or sale of a work of art. Achieving financial success or meeting with public approval through their involvement with culture and the arts was not necessary for these well-heeled hobbyists. What was incumbent upon every member was to hold up his or her end in conversation, to be witty, to be entertaining, and to avoid such topics as theology, politics, and making money. Cultural activity belonged to leisure time, to the amateur. It existed on Mount Olympus far away from the masses, from commerce, from the music, folk dances, and plays of New-Canadian cultural groups, and from the American forms of popular culture upon which ordinary English Canadians, according to Bernard K. Sandwell, had become 'absolutely dependent' by 1913.[28]

convers. witty entertain. avoiding certain topics

leisure time belonged to elite

This Olympian detachment was to be maintained by adhering to traditional, primarily British, forms of culture. The Shakespeare Reading Class (1906) in Charlottetown and the Burns' Fellowship (1924) in Vancouver were just two of the many groups devoted to the furtherance

adhered to Br. cult. trad.

of this objective. The Eclectic Reading Club in Saint John boasted that it offered an alternative to 'jazz and movies.'[29] The Vancouver Poetry Society encouraged 'the speaking of English verse.'[30] And the Ottawa Drama League (1913) had a mandate to maintain 'a strong bond between the art and life of Canada and the drama and traditions of the British Isles and other parts of the Empire.'[31] Some clung to British plays, music, and literature out of sentimentality or as a defensive measure against French and New-Canadian culture. Others saw British cultural forms as vehicles for enhancing their knowledge of British attitudes and ideals in preparation for Canada's future place in the Empire. 'At no distant date we may have a lot to say about running the Empire,' wrote Sandwell in 1913, 'and we cannot understand the Empire without understanding the people of the British Isles.'[32]

A strict adherence to British forms was not, to be sure, followed by every member of the most notable group of this kind. The Toronto Arts and Letters Club, portrayed in Peter Donovan's 1930 novel *Late Spring* as the Crafts Club, felt itself to have 'a mission – nothing less than the leavening of the coarse but vigorous substance of Canadian life with the graces and spiritual influence of art.'[33] In the view of many of its members, this mission could best be carried out by attempting to create something uniquely Canadian in music, the visual arts, literature, architecture, and drama. Certainly no other private cultural organization let its members escape so completely from 'the demands of materialism, relax in an atmosphere of congenial companionship and find inspiration and stimulation in intellectual intercourse.'[34] From its inception in 1908 it permitted professionals and businessmen interested in the arts to eat their lunch alongside Toronto's leading male artists, writers, musicians, dramatists, and critics. And itinerants, such as the British writer Siegfried Sassoon who visited the city in the spring of 1920, also found cultural sustenance there. In addition, moreover, to accommodating its diverse members and visitors, to producing a monthly journal known as *Lamps*, and to giving 'an artistic and reverent interpretation to the best things of music and drama,' the Arts and Letters Club also provided a framework within which groups and individuals could grow.[35] The Group of Seven (1920) worked, for example, in its Rosedale ravine Studio Building, but gave talks, hung its paintings, and met its patrons (as well as its critics) on the club's premises. M.O. Hammond's articles on Canadian art and literature appeared in the *Globe*, but it was at the Arts and Letters Club that, until his untimely death in 1934, he thrashed out the ideas on culture's place in society which formed the

[Margin notes, handwritten:]

why clung to Br. trad.? sentiment or defense against Fr + New-Can. Cult. + enhancing Can. place in Empire

Others did not stick strictly to → created Can. Art

eating lunch with artists

monthly journal ↳ groups + indiv. to grow within

newspaper series

substance of his stimulating Fireside Talks. And it was with the help of
the Arts and Letters Players (1908) that Roy Mitchell created his first
experimental tableaux and one-act plays on the small and inadequate
stage of the club's first premises in the Old Court House on Adelaide
Street before going on to mount more elaborate productions as the first
director of the University of Toronto's Hart House Theatre in 1919.

Few private cultural organizations outdistanced the Arts and Letters
Club in bringing together the amateur and the professional, the specta-
tor and the producer, the artist and the patron, and the holders of both
traditional and modern points of view. Few such groups turned their
attention outwards to matters of education, patronage, cultural policy,
and public entertainment. And still fewer were motivated to create a
unique culture for English Canada. Most private cultural organizations
were content to remain exclusive enclaves complacently encouraging
traditional British culture, which they believed to be infinitely better
than that produced by the New-Canadian or ethno-cultural groups in
their midst, the modernist forms appearing abroad, and the popular
forms entering from the United States. They were the preservers and
keepers of the established and familiar, and very much content to be so.

By contrast with the members of these rather élitist private organiza-
tions, the majority of English Canadians who came together to make
music, produce plays, paint, or to write poems during the first four
decades of this century did not maintain an Olympian detachment
from the rest of society. Some groups, such as the Edmonton Guild
Players (ca. 1920), did put on plays for their friends and use the theatre
as 'an avenue of expression for themselves.'[36] But most were aware that
their activity entailed more than self-fulfilment and the entertainment
of their friends. They sensed that they should be reaching outwards,
trying to work towards some broader, more general standard. They
knew, certainly, that something of this sort had to be done if the public
were to be persuaded to buy tickets, paintings, or subscriptions. They
were aware as well that their work needed an appealing content to
attract an audience in the first place. And above all they knew that the
making of culture demanded dedication, enthusiasm, and a good deal
of energy not only to create and perform, but also to attend rehearsals
and sketching classes, hang exhibitions, make scenery, set up risers for
the orchestra, sell tickets, and sometimes, as in the case of the Victoria

Little Theatre (1929), pour concrete for a furnace room, build dressing rooms, cut an orchestra pit, ramp the floor, and install 186 theatre seats (purchased second-hand from a local movie-house owner) in order to have a place in which to perform. Nor did these groups draw solely upon the business, professional, and upper classes for their members. There was, to be sure, 'the social satellite' and 'the dilettante who delights to dabble in anything that smacks of the Bohemian.' But, as the American drama critic Gertrude Lerner continued, there was also 'the more spirited amateur who, after a day of work in factory or office, spends his evening in artistic pursuit.'[37]

Not surprisingly it would be in the metropolis that, as Peter Gould lamented from his sick bed in the Algoma Hills in Morley Callaghan's novel *A Broken Journey*, 'whatever is to be done culturally, creatively, [and] economically, will all be done ...'[38] Yet despite all the activity that was undoubtedly taking place there, the modern Canadian city was not the most salubrious place for the making of culture. There was mechanization, standardization, and apartment-house living. There was a loss of individuality, on the one hand, and of community, on the other; a breakdown of religion and with it of moral values. Moreover there was an absence of the ebb and flow, the growth and decay, and all the other natural rhythms associated with rural living. Yet it was undeniably true that many urban dwellers were coming to terms with the artificial environment in which almost half the country found itself in 1921. Some of them did it by consuming goods from the newly built department stores, by attending games at the ball park, performances at the vaudeville house, and, of course, matches at the hockey rink. Others – largely of the growing middle class – attempted to regain their individuality, give their lives a spiritual dimension, and create a sense of community by forming public cultural organizations – by attempting, as playwright Herman Voaden told the Sarnia Drama League upon its formation in 1928, to work in terms of '[Matthew] Arnold's conception of an all-embracing culture rich with all the impulses towards social, artistic and spiritual development and perfection.'[39]

It was of course true that sport overshadowed art throughout the period under discussion: as one commentator observed of Montreal in 1907, there was 'seldom any excitement manifested over concert tickets' while it was 'not unusual to see a line of men two blocks in length waiting patiently for the opening of the box office where tickets for a hockey match are on sale.'[40] Yet by 1920 sufficient numbers of Winnipeggers were participating in or attending music or drama performan-

wanted draw on more amateur

modern Can. City
→ loss indiv.
Community rel'n moral values

urban dwellers learning to live with artifical env.
↳ consumed goods from dept. store
games
↳ ball
hockey
pub. cult. organiz.

more excitement over sports than concerts

[margin note: by 1935 most large cities had a theatre orchestra choral organ.]

ces and art exhibitions to make one writer describe Winnipeg as 'simply seething' with cultural activity.[41] And by 1935 'nearly every large Canadian city,' according to another commentator, 'now has its Little Theatre, its symphony orchestra, its choral organizations' as well as 'such a wealth of painting imported or exhibited in Canada.'[42]

This 'Canadian Renaissance,' as it was described in 1935, was a reaction to, rather than a celebration of, modern life.[43] The burgeoning amateur theatre was, as Herman Voaden wrote in his diary in 1927, symptomatic of 'an industrial civilization trying to redeem – to save – itself by a devotion to something more permanent than money and material things.'[44] The same could be said of the growth of other public cultural societies. Unlike the members of private cultural groups those who belonged to organizations trying to appeal to the public wanted more than entertainment; they wanted not only to add something to their own lives but also to serve, shape, and mould the lives of their audiences. The Saint John Art Club (1908), certainly, did not function 'solely for the pleasure of a few members of one age group but as a public-spirited body for the benefit of all age groups.'[45] The Vancouver Bach Choir (1930) was, its president noted, committed like all choirs to elevating 'the general level of music appreciation in the community.'[46] The Halifax Choral Union (1922) similarly sought 'to increase the appreciation of good music' by giving concerts.[47] While the Manitoba Society of Artists (1903) and the Searchlight Art Club (1910) of Winnipeg were devoted to creating 'a public awareness of the value of art.'[48]

[margin note: CAN. Renaissance reaction to modern life; amateur theatre; wanted to shape lives; choirs; Art Clubs]

Some organizations, influenced by the movement for social Christianity, went even further to ensure that what they did served the community. During the 1890s citizens in Regina gave a series of concerts to raise money for the poor. A quarter of a century later the Halifax Dramatic and Musical Club (1923) produced 'musical comedy and kindred work' to entertain the public as well as to make money for worthy causes.[49] Saint Peter's Dramatic Club in Saint John (1931) gave the proceeds of its performances to local orphans. The Coaldale Dramatic Society in Alberta was organized in 1916 'to raise funds for benevolent purposes and local community enterprises.'[50] And during both the Boer War and First World War drama, choral, art, and instrumental groups across the country gave the proceeds of their performances or exhibitions to patriotic fund-raising campaigns.

[margin note: Social Christianity → serve community]

Nor, as the existence of the drama group in Coaldale, Alberta, demonstrates, were public cultural organizations solely a product of the city and town. The rural areas of Canada, wracked by depression, drought,

[margin note: patriotic fund-raising campaigns]

depopulation, and the effects of modernization, needed, as John Mac-Dougall's *Rural Life in Canada – Its Trends and Tasks* made clear in 1913, a revivifying force. Believing 'that the lonely, shut-in life of farmers could be changed by creative enjoyment,' one minister in rural Alberta thus joined, and so sought to encourage, that province's Clive Players (1935).[51] In order 'to foster and promote the development of all the fine arts by holding exhibitions in various centres in Alberta for the purpose of displaying work done within the Province' the Alberta Society of Artists was formed in 1931.[52] Four years later the Maritime Art Association brought together fourteen independent art societies, university art departments, and public galleries from eleven rural and urban centres in New Brunswick, Prince Edward Island, and Nova Scotia 'to promote [among the public] a knowledge and appreciation of Art.'[53] Under the direction of Walter Abell, the association did what would have been otherwise impossible for any one of its member groups acting alone. It circulated exhibitions of Maritime as well as of Canadian and American art throughout the Atlantic provinces; it organized art lecture tours; it formed art libraries; it established fine art societies in Newcastle and Saint Andrews; and, in 1940, it founded a journal, *Maritime Art*, which gave Maritime as well as Canadian artists their first public forum for discussing and illustrating their work. The Manitoba Drama League (1932) also amalgamated city and rural groups in order to encourage 'an interest in the Drama' and assist with 'the development of community drama in Manitoba.'[54] Largely through the instigation of the Community Players of Winnipeg (1921), festivals were organized, and drama adjudicators and non-royalty plays made available to eighty-four drama groups in communities in and around Melita, Pilot Mound, Emerson, Birtle, Neepawa, Teulon, and Brandon. The Alberta Drama League (1929), the Saskatchewan Drama League (1932), and the London Little Theatre (1933) similarly served rural as well as urban areas in the provinces in which they were situated.

Public cultural organizations were not only committed to enriching the lives of those who viewed the exhibitions or attended the plays they sponsored: they also tried to enhance the well-being of those actually involved in the making of culture. Playing in the Saskatoon Symphony Orchestra (1932) gave as much joy to the members of the orchestra, noted one violinist, as to the audience who listened to them.[55] Choral singing, observed a writer in *Musical Canada* in 1907, was a 'social pleasure' for its participants, one the Vancouver Bach Choir attempted to enhance by bringing its members 'into close personal contact with

[margin note: newsletters → personal contact]

one another' through circulation of a newsletter.[56] Involvement in a cultural organization could, indeed, fulfil a kind of therapeutic function: the musically gifted, though spiritually vanquished, Judith West in Sinclair Ross's poignant novel *As for Me and My House* was encouraged to join the local choir by the ladies of the small community in which she lived because she needed 'a steady influence.'[57] And participation during the early 1920s in the Little Theatre Club of Saskatoon (1922) gave a lonely young school teacher from Moose Jaw some much appreciated social contact: 'We used to gather afterwards in the auditorium of the school and have refreshments and talk over the show and so on and that was my experience of getting acquainted with those people because I was new in the city and it was a real pleasure to get to know them.' Even after acquiring a family and additional duties as a teacher, she continued to participate in the drama group because '... you were able to put aside your problems for a while.'[58]

[margin note: gave soc. contact for lonely ie school teachers in remote areas]

Buttressing the feeling of camaraderie and good fellowship was the democratic way in which these groups were organized. Choirs had no 'stars' – if soloists were needed, and could not be found among the ranks, they were imported from across the border. Art societies usually had no juries or awards. Drama groups possessed 'no star system.'[59] 'Everyone, from the Director to the stage hand' in Montreal's Repertory Theatre (1932) sought 'education in the drama through experience.'[60] Participants in Dora Mavor Moore's Village Players (1938) closely adhered to the motto 'There are no small parts, there are only small players.'[61] And, as the Canadian Pacific Railway lawyer Harry A.V. Green discovered, members of the Community Players of Winnipeg could shift scenery, operate the lights, move the props, stage-manage, direct, tread 'the boards as a player,' and write plays.[62] This varied and frequently stimulating activity was particularly important at a time when, as one participant noted in 1938, 'our daily work is largely mechanical' and 'opportunities for expressing creative abilities as individuals are limited.'[63]

[margin note: manual workers ↳ so cult. allowed express creative abilities]

If playing in town bands or string quartets, acting in theatricals, writing poetry or prose, and exhibiting in sketch clubs provided both participants and observers with an antidote to the anomie that was often to be found in both urban and rural areas, it should not be thought that these public-spirited amateur groups were unaffected by the modernizing influence which had produced at least some of the alienation they experienced. They certainly had contact with the latest technology: players in the town of Richard, Saskatchewan, drawn

[margin note: modernity → alienation]

largely from nearby farms, saw their first telephone when they used it as a prop in a play. More importantly, amateur choirs, orchestras, and vocalists got involved with radio as they happily provided radio stations with live entertainment between 7:30 PM and midnight at a time when it was illegal to broadcast 'mechanically operated musical instruments.'[64] And amateur drama groups responded to the same phenomenon by creating a new genre: the radio play. The Murray Players of New Brunswick (1925) performed the first full-length Canadian radio drama, *The Rosary*, over the Canadian National Railways' station in Moncton in 1925. A year later the railway's Vancouver station organized the CNRV Players, thereby giving its announcer the opportunity to ask his listeners every Friday evening at 9:00 PM to 'turn down the lights, pull your chairs up close to the radio, and refrain from unnecessary conversation' in preparation for the performance. Between 1927 and 1932 the CNRV Players performed over one hundred full-length dramas. 'No money,' recalled Players' director Jack Gillmore, 'was available for paying the copyright or, for that matter, any compensation to the actors. The thrill of being on radio was sufficient inducement for all of the participants.'[65]

While amateur actors and musicians might have reacted very positively to radio, that device, along with the phonograph, came to have a negative effect on the musical evening in the home. Indeed that home-centred activity gradually disappeared as listening to the radio became the favoured pastime. This was not always regretted. As Somerset Maugham wrote in the context of Britain's experience, 'We all congratulate ourselves that the radio and the gramophone have driven from our drawing rooms the amateur pianist and the amateur singer.'[66] But however one reacted to it, it was a change of enormous importance.

If technology had a negative impact on the amateur musician in the parlour, it had an oddly positive one on amateur theatre. The 'growth of talking film monopolies, high costs of production and the diversion of public interest to radio and motoring combined to undermine the legitimate theatre to such an extent that,' according to Harold Sutton's comment in the 1929-30 volume of the *Canadian Annual Review* 'sending shows on "the road" [from New York or London] largely became an unprofitable venture.'[67] The 'decline in the legitimate theatre' had earlier made the 'faithful adherents of the spoken drama ... rely more and more on the various art-theatres, community play-houses and the like.'[68] The demise of these foreign touring companies was thus 'a blessing in disguise to many local people with stage inclinations.'[69] Amateur drama groups which had previously paid little attention to

box-office considerations now began to do so. 'When we find a good play,' exclaimed a character in amateur playwright Andrew Macphail's one-act satirical drama *Good Theatre*, 'we will no longer be a Repertory Theatre, nor a Little Theatre either. We shall move into His Majesty's, and run a good play for a year on strict commercial principles.' 'But we shall lose our subscribers,' responded another. 'We will have no further need of them,' was the immediate reply: 'The Box-Office will take care of that.'[70]

When 'the silvery tinkle of the thirty pieces in the cash box' was heard *off* the stage, at least some of those listening to it thought that 'production schedules [had been brought] down from a high plane to a much lower one.' Those involved in what one observer described as 'second-hand commercial' ventures simply lacked a 'knowledge of principles – principles of art, of beauty, and of drama.'[71] Money-making was no more consistent with amateur cultural activity than machines were with craftsmanship. Both debased what they were associated with, and so called the higher purposes of cultural activity – perfection, beauty, morality, community service, and spiritual fulfilment – into question.

Many amateur groups, as playwright Merrill Denison observed as early as 1923, did nonetheless aspire to professional status.[72] Feeling that they could not get any further without a professional producer the Community Players of Winnipeg pooled their resources and hired one. The Montreal Repertory Theatre made every effort to place plays by English-Canadian dramatists on a commercial footing. Moving in this direction was, of course, difficult. It was not only expensive to maintain a professional director or producer during the lean Depression years, but as members of the Little Theatre Club of Saskatoon discovered, there was 'a lack of understanding of [the] amateur's problems by [the] professional director who forgets that actors have other things to do.'[73] And there was always the concern that too great an emphasis on the professional would lead to commercialization and so open the way to a lowering of standards. *

A particularly important restraining influence on the thrust towards commercialism was the developing concern with Canadian content. Companies oriented towards the making of money would, it was felt, simply not do what they should to foster indigenous activity. That it should be encouraged was becoming a widespread notion, evident not only in the columns of English Canada's popular press but also in the constitutions, playbills, newsletters, and actions of cultural organiza-

Handwritten margin notes: Some amateur groups hired prof. producer to raise their status

Handwritten margin notes: fear too much emphasis would commercialize + lower standards

Handwritten note at bottom: Concern over Can. content

tions themselves. The Montreal Repertory Theatre was certainly 'anxious to foster and encourage [musical] compositions and [dramatic] productions by Canadians,'[74] and even before its efforts the Theatre Guild of Montreal (1930) and the short-lived Montreal Community Players (1921) had been producing plays 'primarily from Canadian sources.'[75] On the Prairies the Community Players of Winnipeg provided 'facilities for the production of plays written by Canadian authors' in order 'to lay the foundation for ... a Canadian Theatre.'[76] In Atlantic Canada the Theatre Guild of Saint John (1931) 'undertook [from 1936] to encourage play-writing among its members.'[77] And, finally, Hart House Theatre with its production and publication of plays by Canadian authors such as Merrill Denison was, according to the drama critic for the *Canadian Forum,* 'the hot-bed for the native drama in the Dominion.'[78] Those interested in music had also been moving in a similar direction. The Canadian Music Composers' Club was formed in 1933 for the purpose of encouraging western Canadian musicians to compose their own music.

Interest in Canadian themes and subjects was never exclusive. Vancouver's Little Theatre Association (1920) produced 'high-class plays by British and foreign dramatists' as well as 'plays by Canadian dramatists,' as did the Hart House Theatre.[79] The Mendelssohn Choir devoted its Christmas and Easter oratorios to the music of Bach and Handel, though after 1918 it also performed works by Healey Willan and Ernest MacMillan, among other English-Canadian composers. Amateur sketch clubs continued to show views of the Thames and the Seine along with renderings of the local landscape. Yet there can be no doubt that concern to perform Canadian plays and music and to paint and write about the Canadian scene was becoming very much a part of what cultural groups thought they should be doing.

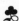

The belief that cultural activity existed 'for its own sake rather than for commercial purposes,' that it was to be done in one's leisure time, and that an indigenous culture could be fostered by the amateur did much, of course, to exalt the amateur's role.[80] But at the same time such assumptions seriously diminished the place available for those to whom writing, acting, playing musical instruments, painting, directing, and composing were chosen vocations and a means of livelihood. Nevertheless a reaction to amateurism ultimately furthered the cause of profes-

sionally minded cultural producers. In opposing the inclination of most English Canadians to 'waver between paying lip-service to home-grown products and cherishing an inferiority complex when it comes to making use of those products,'[81] they were pushed towards forming professional organizations, so that they might be seen, patronized, and above all, respected as the true makers of the country's artistic culture.

The 'line between the spare time artist and the professional' was, as art critic Graham McInnes correctly observed in 1939, 'almost never clearly drawn.'[82] The professional artist, writer, dramatist, and musician could not be defined according to income, the number of hours a week spent in artistic pursuit, or even the end to which the activity in question was directed. And while it was true that professionals would have preferred to work full-time, it was not usually possible for them to do so. They can be set apart, nonetheless, by looking at the extent to which, as a group, they attempted to place their activity on a professional footing: by integrating it into the marketplace, by lobbying the government for various forms of assistance, and by consciously trying to develop what they perceived to be a national culture.

Unlike amateur groups professional cultural organizations were not content to remain on Mount Olympus. Nor did they see themselves simply as performing a kind of service to the public. Their purpose was first and foremost to meet the needs of their members by ensuring that they could work to the highest possible standard. The Canadian Society of Graphic Artists (1904) and the Society of Canadian Painters-Etchers and Engravers (1914) were, like the Royal Canadian Academy of Arts (1880) and the Ontario Society of Artists (1872) before them, formed 'to facilitate the sharing of information among artists and to stimulate public interest in the print.'[83] The Canadian Art Club (1907) was founded by eleven central Canadian artists – Ernest Lawson, Homer Watson, Maurice Cullen, and J.W. Morrice, among others – who had been forced to seek recognition and their livelihood in the United States and in Europe. Determined to counter the inflow of foreign art and to create a market for Canadian pictures, they held exhibitions of their own work in Toronto. Other artists, such as those belonging to Montreal's Beaver Hall Group (1920), came together for practical reasons too. 'It was,' affirmed Edwin Holgate, 'a question of getting studios, working space, and keeping prices down because none of us was flush.' 'This,' he continued, 'was one way of co-operating, getting together and taking over a house [located on Beaver Hall Square], instead of little bits of individual driblets here and there scattered around.'[84]

Musicians conformed to the same kind of pattern. The Vancouver Music Council (1923) brought together professional music teachers, along with choral and philharmonic groups, in the standards-raising British Columbia Music Festival. Material circumstances were looked after too. Following the revision of the Canadian Copyright Act in 1921 – which gave composers 'the sole right of performing or authorizing the performances of the work in public' – the Canadian Performing Rights Society (1925) was established 'to collect fees for the public performance of such works and to restrain unauthorized performances.'[85] Orchestras and bands which provided music for civic celebrations, at indoor and outdoor skating rinks, in parks and silent movie-houses, at vaudeville and concert halls, and later on the radio formed 'protective associations' – the first was established in Toronto in 1887 – so that they could regulate their fees, their hours, and conditions of employment. By 1938 most professional musicians across the country belonged to the American Federation of Musicians of the United States and Canada (1901).

A particularly innovative step was the formation of musicians' co-operatives, established after the Depression and the arrival of sound films had reduced opportunities for employment in movie houses. To enable Toronto musicians to work during the summer months, the conductor-composer Reginald Stewart founded, with the assistance of the Toronto Musical Protective Association (1887), the Promenade Symphony Orchestra. From its inception in 1934 until well after the Second World War, the Promenade Symphony Orchestra presented weekly concerts – known, after their British prototype, as 'proms' – from May until October at the University of Toronto's Varsity Arena. Admission prices were low – they ranged from thirty cents (the price of a movie) to eighty cents. The music performed was more popular than classical. Smoking and eating were permitted during the performance. Not surprisingly up to seven thousand people frequently crowded into the arena. Furthermore Reginald Stewart's goal was met: musicians had jobs – even though they were part-time – when they were most needed. Clarinettist Giulio Romano attempted a similar venture in 1930 when he gathered seventy musicians together in Montreal. The Montreal Orchestra lasted until 1941 although it maintained its co-operative status only briefly. Production costs quickly exceeded box-office receipts, and the orchestra had to enlist benefactors and muster a volunteer committee to raise additional funds.

Innovations in communications technology, particularly in radio broadcasting, film production, and sound recording, prompted musi-

cians to form other kinds of professional organizations. Initially English Canada's leading musicians and critics had responded negatively to the new technology. This was not only because amateur musical groups were dominating the air-waves, but because the radio seemed to threaten the future of live concerts. Music was 'a thing of flesh and blood,' Ernest MacMillan wrote in 1922, 'and the more machinery intervenes between the artist and the art-lover, the less can the product be called truly artistic.'[86] Andrew Macphail also charged that the radio destroyed 'the subtle and rhythmic beauty ... of words or music.'[87] And 'here in Canada,' Reginald Stewart informed his readers in Toronto's *Globe* in 1933, 'we do not listen; we use the radio as an obligatto to conversation, reading, bridge, eating and snoring.'[88] Not only did radio turn music-listening into 'a mere passive recreation,' but films, too, according to the music critic Leo Smith, resulted in 'inattentive listening' because 'the ear was subordinate to the eye.'[89] The introduction of phonograph records posed yet another problem. Because of their limited duration it was impossible to play a symphonic movement in its entirety. Moreover the opportunity for multiple playings, Ernest MacMillan charged, encouraged 'a lazy habit of mind in the man who can take no pleasure in anything he has not heard before.'[90]

All of these accusations were, of course, true. Concert audiences were diminishing, recorded performances were initially only a few minutes in length, voices on the radio were sometimes fuzzy, film music was subordinated to the action, and most English Canadians treated the music produced by their radios or gramophones as background for some other activity. Yet, as its most vociferous critics soon came to realize, the mechanization of music also expanded opportunities, increased employment, and helped spread the reputations of many musicians across the country. It was, for example, shortly after the Imperial Oil Company established its radio network linking Montreal, Toronto, and London, Ontario (and eventually eleven stations from Montreal to Vancouver) that Reginald Stewart brought together thirty-five members of the Toronto Symphony Orchestra (1906) to establish the Imperial Oil Symphony Orchestra (1929). Their weekly programs, broadcast from the penthouse of Toronto's Royal York Hotel, were far from mediocre; according to Britain's *Musical Times* the Imperial Oil Symphony Orchestra was the 'finest Canadian symphony on the air.'[91] The Toronto Symphony Orchestra itself began a series of twenty-eight one-hour weekly concerts on the Canadian National Railway's Toronto station during the same year, which were broadcast from the Arcadian Court

dining-room located on the eighth floor of the Robert Simpson Company department store. The following year it received even more exposure when CNRT broadcast its Sunday afternoon concerts live from Massey Hall. The Canadian Pacific Railway also accommodated musicians; the Montreal Orchestra recorded ten concerts in its Montreal studios in 1932. After the Canadian Radio Broadcasting Commission took over the CPR and CNR radio stations in 1933, radio technicians took their broadcasting equipment to wherever a concert happened to be, transmitting, for example, the Promenade Symphony Orchestra's concerts live from the Varsity Arena.

The radio gave some symphony orchestras not just exposure but space in which to perform. Before its association with the CNR's radio network, the Vancouver Symphony Orchestra (1930) had been limited to playing fifteen concerts a year in the outdoor Memorial Shell in Stanley Park and four a year in the newly constructed Orpheum Theatre. After 1932, however, it was able to perform two concerts a week on Vancouver's CNRV radio station.

Composers and musicians were not the only people in English Canada trying to put their work on a professional footing. Early in the century, in fact, John Pringle's stock company in Saskatoon (1907) had attempted 'to give "high class people who want moral productions" a chance to see theatre.'[92] During the mid-1930s the Actors' Colony Theatre (1934) at Bala, Muskoka, tried 'to build up a repertory company, train Canadian actors and actresses, [in order to] have a theatre of their own.'[93] And, in the years between, Carroll Aikins created the Canadian Players, whose Home Theatre, located over a fruit-packing and storage house on Rekadon Ranch in Naramata, British Columbia, brought excellent productions to small local audiences.

Producing a repertory of experimental plays drawn from contemporary Canadian and non-Canadian playwrights, Aikins's company adhered to the philosophy that there were 'no stars, no big parts, no small parts.'[94] It was, however, quite thoroughly professional in its aims and organization. Much more than a collection of drama enthusiasts who came together at certain times of the year to mount one or two productions, it was a community of people whose members were drawn from all parts of the country, who lived on the ranch, who received their board at cost or worked for it by picking apples during the mornings, and who, in return, were given instruction in acting, dancing, stage-design, and playwriting by Aikins and his wife, Katherine, and by instructors who were recruited from New York's Neighborhood Play-

house. They were, as well, exposed to the most sophisticated stage equipment available and to the ' "Art Theatre" principles of Gordon Craig and Maurice Browne.'[95]

By training his group so comprehensively Aikins hoped to create a company of actors, set designers, and writers which, as the name of the group suggests, would be Canadian in every respect. He wanted not only to create a distinctive Canadian drama, but to found a company that would engage 'in open competition with the English and American companies' which monopolized the professional stage at that time.[96] But the professional status Aikins sought was not easy to acquire. Finances were always a problem, even though the venture had been initially funded by Aikins's wealthy family, and when the apple market collapsed in the autumn of 1922, so did the Home Theatre.[97]

Many professional organizations chose not to depend entirely upon the whims of the marketplace for their existence. Though most kept their distance from all levels of government, none was adverse to accepting government patronage when it was offered. When, for example, the demand for civic art mounted during the latter years of the nineteenth century and governments on all levels became involved in establishing art galleries, in adorning the lobbies, offices, and corridors of their buildings with paintings and sculptures, and in commissioning portraits and busts, professional art societies actively sought a share of the work. As early, in fact, as 1884 seven painters from Toronto formed the Society of Mural Decorators 'to devise some means of concerted action to influence municipal art, especially to guard the new public buildings from any inadequate interior decoration.'[98] (And, one might add, to place themselves in a favourable position to win civic commissions.) In January 1907 the Royal Canadian Academy of Arts petitioned the federal government to appoint an arts council to advise the government on all matters concerning the purchasing and commissioning of art.[99] And, a year later, the Ontario Society of Artists, in response to the federal government's appointment of an Advisory Arts Council in 1907, asked Ontario's lieutenant-governor to establish a similar committee to assist the Department of Education in its purchases, commissions, and plans for mural and other public decorations. Not, to be sure, as successful as its national counterpart, the Ontario Society of Artists nonetheless continued to be active during the next two decades, exerting 'a steady influence on all governing bodies of the Province to secure the appointment of properly constituted committees or persons in cases where works of Art are to be acquired for public Collections.'[100] The

Sculptors' Society of Canada (1928) did not for its part ask for the appointment of an advisory board, but sought instead to have itself placed in a position 'to act in [an] advisory capacity [to the federal government] for the erection of public memorials.' It also wanted to ensure, as it told the minister of public works in 1935, that 'all sculptural work on public buildings be done by Canadian artists,' thus preventing any non-Canadian sculptor from being awarded a public commission.[101]

Professional writers' organizations also lobbied the government in the hope of gaining a more equitable share of the market. Because Canada's copyright laws did not adhere to those of the Berne Convention on copyright, Canadian publishers and writers had no protection whatsoever against the pirating of their work by American and British publishers. To add insult to injury, the pirated editions could then be sold in Canada. As early as 1899 the Canadian Society of Authors was established for the purpose of 'rendering the Canadian market a separate one,' thereby increasing the 'already large demand for books' among the reading public.[102] In 1912 another group of Toronto writers – among them novelist Peter McArthur and journalist M.O. Hammond – attempted 'to organize a syndicate to dispose of writing by Canadians' through the popular press.[103] The Canadian Writers' Limited (or Writers Syndicate, as it was also called) never got off the ground, and it was nine years before the copyright issue was addressed by a literary organization again. The Canadian Authors' Association, formed in 1921 largely for the purpose of dealing with the copyright issue, met with a greater measure of success than any of its predecessors. When its lobbying of the government for revisions to the Copyright Act did not bring any major changes, it shifted its focus from the government to publishers, book-sellers, service clubs, and the general public. This did produce some significant results. The approach to the Association of Canadian Clubs led to reading tours by several authors. Talks with the publishers founded the Canadian Book Week (1921), an annual event at which authors gave readings and book-sellers and publishers exhibited their wares. On its own, or in co-operation with groups across the country, the association erected cairns to mark the birthplaces of deceased as well as of living Canadian authors. In 1936 it was successful in having founded the Governor General's Award for Literature, which became one – the Lorne Pierce Medal, presented biennially by the Royal Society of Canada from 1926, was the other – of the two major literary awards available to English-Canadian writers. It supported Canadian poets by

establishing the *Canadian Poetry Magazine* (1936), and playwrights by publishing their dramas in such volumes as *One Act Plays by Canadian Authors* (1926), and it even brought musicians and artists within the scope of its activities. Finally it gave glowing reviews in the pages of its organ, the *Canadian Bookman*, to books by English- and French-speaking Canadian writers. So enthusiastic, indeed, were its efforts to bring Canadian authors to the public's attention that it sometimes made absurd requests. In 1922 the Halifax branch received a directive from headquarters in Montreal asking it to address farmers' conventions in general and the United Fruit Growers Association in particular on the merits of Canadian literature; to urge furniture stores to promote the sale of bookcases; to induce libraries to specialize in Canadian authors and education authorities to use Canadian readers; and to persuade leading hotels in Halifax to install libraries containing Canadian books in their lobbies. Canadian Book Week itself, all branches were told, was precisely the time to 'get your minister to preach a sermon on the spiritual values of a national literature.'[104]

Many of these organizations, as their names suggest, were national in some real sense of the term. Members came from the many regions of the country where chapters or branches had been established. They kept in touch with one another through gossip, correspondence, newsletters, and, if they had the money, a published bulletin or journal. Once a year as many of them as could make the trip met in Toronto, Ottawa, or Montreal. There they passed resolutions, formed working committees, elected regional and head-office representatives, set professional standards for cultural producers across the country, and reiterated their determination to cajole anyone who could be helpful – whether a member of the general public or a government official – into assisting in the advancement of their cause.

Other groups, however, were national only in name. The Canadian Authors' Association itself established branches across the country at its inception in 1921 – there were ten by 1922 – but it was run by a few individuals (John Murray Gibbon, B.K. Sandwell, and W.A. Deacon, among others) who resided in Toronto and Montreal. The Royal Canadian Academy claimed to represent the entire country, but the bulk of its membership came from central Canada. Other 'national' organizations drew their entire membership from central Canada. In 1929 and 1930, for example, the Toronto Symphony Orchestra performed on the 'Canadian National Symphony Hour' as the All-Canadian Symphony. (Its programs began with the parliamentary chimes in Ottawa 'boom-

ing out the hour,' followed immediately by the strains of 'O Canada.' Canadian vocal and instrumental soloists, and sometimes music by Canadian composers, were featured. One enthusiast noted that the performances seemed 'to knit Canada in one compact whole that is readily felt.')[105] The Group of Seven's push out beyond its usual sketching grounds in northern Ontario and rural Quebec to the Rocky Mountains and the Arctic was soon followed by the claim that that Ontario-based group was now to be seen as national. Its successor, the Canadian Group of Painters (1933), drew only five of its twenty-eight members from outside of Ontario and Quebec. All of this, in fact, simply followed a pattern set over two decades earlier, when the Canadian Art Club, seeking to create 'something that shall be Canadian in spirit, something that shall be strong and vital and big, like our Northwest land,' looked solely to central Canadian artists for its membership.[106]

This national posturing was criticized, not surprisingly, by both amateur and professionals in other parts of the country. 'I always felt that most of our national art societies,' observed the Saskatoon artist-educator Ernest Lindner in 1946, 'were national only in name.' 'To judge from the exhibition catalogues,' he continued, 'it seems to me that these societies are really local Toronto or Montreal ... societies with a very small sprinkling of outside contributions.' By the late 1930s national professional organizations not only had a reputation for being 'self-satisfied "clicks" [sic] without much sincere wish or ability to expand into real national bodies';[107] they were also sometimes viewed as fossilized, dedicated to the perpetuation of outmoded ideas, and filled with self-serving writers, musicians, artists, and dramatists far past their prime. Certainly the young University of British Columbia student Earle Birney found his encounter with the Canadian Authors' Association poets Wilson MacDonald, Bliss Carman, and Charles G.D. Roberts at the Vancouver stage of their cross-Canada reading tour in the mid-1920s less than stimulating. MacDonald's performance, he recalled, was 'boring and egotistical'; Carman's reading of 'Low Tide on Grand Pré' was 'slick and verbose'; and Roberts's never rose above 'cliché and conventional thoughts.'[108]

Criticisms, however, did not prevent these groups from generally succeeding in getting themselves accepted as being, in fact, national. They were able to turn many things to their advantage: the nationalist euphoria following the First World War, the Diamond Jubilee Celebrations of 1927, the ratification of the Statute of Westminster in 1931, anti-American sentiment, and – perhaps most critical of all – their location in the country's

metropolitan centres. This in itself made it easier for them to sell pictures, get books published, and arrange concerts and recitals, while the fact that they were producing for the most populous part of the country made it almost inevitable that what they were doing should have the kind of weight, volume, and strength that would permit it to spread into other parts of the country and so define what ought to be seen as 'national.'

If many of these groups represented a nationalism that was at best imperfect, it was also true that they too readily fell victim to conventional ideas. 'It seems part of the age in which we live,' Stephen Leacock observed in 1928, 'that we must keep on substituting the artifice of collective organizations for the inspiration of individual power, the appearance for the reality, the mere body of the thing for the soul of it.'[109] By the late 1920s, as Leacock correctly perceived, many professional cultural organizations were indeed substituting formula for feeling, putting commercial goals ahead of artistic ones, and drawing on outmoded ideas for their inspiration. It was, in consequence, not surprising that one English-Canadian writer should have found them 'a stumbling block over which the aspiring younger Canadian writer must first climb before approaching his local Parnassus.'[110] Yet for all their deficiencies, they still managed to facilitate a quite considerable amount of strong and effective work. Certainly those able to take advantage of what they offered could benefit enormously – as the career of the self-taught Montreal musician George Brewer readily demonstrates. Moving in and out of private, public, and professional cultural organizations, taking on roles as actor, pianist, teacher, organist, and music critic, Brewer played his compositions to his friends at the Pen and Pencil Club, wrote incidental music for and acted in the Montreal Repertory Theatre, gave organ recitals to the Casavant Society (1936), and accompanied the performances of the Montreal Elgar Choir (1923) on the organ and the Dubois String Quartet (1910) on the piano. Those well-positioned socially, culturally, and geographically could thus enrich themselves and their communities immeasurably through activity in the various kinds of organizations available to them. Problems and shortcomings there undoubtedly were, but assistance and support were available as well, and this important fact should not be overlooked.

membership unrewarding

Some artists, writers, musicians, and dramatists, of course, did find membership in the kinds of cultural organizations thus far discussed

unrewarding. This was usually because, as a Vancouver critic put it in 1923, 'one of the great dangers to which any small and select artistic society is exposed is the danger of becoming a church' in which 'the infusion of any new doctrine is quite naturally regarded as heresy.'[111] One of two things normally happened when such a doctrine appeared: a faction supporting it might form – as was the case with the six artists who exhibited their work in the 'Modern Room' of Victoria's highly traditional Island Arts and Crafts Society's annual exhibition in 1932.[112] Or those favouring it might silently steal away – if they had not already been expelled, the fate of Maxwell Bates and Roy Stevenson after their 1928 showing of 'canvasses with non-objective overtones' at the Calgary Art Club (1918).[113]

fear at being a church

Individuals not only left private, public, and professional organizations when their views were not in harmony with the dominant views of the group, they formed groups of their own in opposition to them. English-speaking Montreal, for example, contained several loosely knit groups of artists and writers following the 'internationalist vogue demanding an end to patriotism as the standard by which art was measured.'[114] Those in the Eastern Group of Painters, founder John Lyman wrote shortly after its formation in 1938, were 'not busy about being of their own time or following any line – self-conscious regionalism, formalized pattern or social comment.' Nor were they 'racing after the band wagon of the "Canadian" ' exemplified by the Group of Seven and their followers.[115] Across the country Vancouver's Sketch Club (1920) and its Palette and Chisel Club (1926) joined the Vancouver School of Decorative and Applied Arts (1925) in wanting to challenge 'the static conservatism so long the mainstream of Vancouver art.'[116] It was, however, Montreal's own Atelier (1931), under Lyman, which, in banishing nineteenth-century romanticism and representational technique, set out most vigorously to follow the 'principle [articulated in the writings of Roger Fry and Clive Bell] that the essential qualities of a work of art lie in the relationships of form to form and of colour to colour.'[117] The Contemporary Arts Society (1939) – yet another creation of John Lyman – also followed the ideas of Fry and Bell. Its executive not only advised members to look to the latest developments in international art, but insisted that they be 'neither associated with nor partial to, any Academy.'[118] Turning its back on the legendary Art Association of Montreal (1860) and on the Royal Canadian Academy, the Contemporary Arts Society looked to modernist work produced outside Canada, sponsoring exhibitions such as 'Art of Our Day' (1930) which

draining of members from organ.

introduced the conservative Montreal public to paintings by Dufy, Derain, Frances Hodgkins, Modigliani, and other artists of the sort. Besides sending this kind of 'signal [of] the beginnings of a united effort for contemporary art and the invasion of the conservative halls of the Art Association' in Montreal, the Contemporary Arts Society also encouraged the sale and the exhibition of work by its own members. It introduced associate membership and a picture-loan system, so that those who could not afford to buy works of art could rent them for a nominal fee. In attempting 'to foster the development of a living, progressive art alive to contemporary life,' it sought to be much more than an art society.[119] Organizations such as the Atelier, the Eastern Group of Painters, and the Contemporary Arts Society did manage to bring a breath of fresh air to the Canadian cultural scene. Challenging the romantic nationalism of the Group of Seven and the narrow conservatism of the long-powerful Royal Canadian Academy, they did much to provide a milieu in which modernist ideas could flourish. Yet in scope and organization they were little different from the groups they opposed.

Other less formal public and professional organizations also sprung up in opposition to the conventional wisdom. In 1918 a group of French-Canadian arts enthusiasts established the publication *Le Nigog*, which brought twenty-five French Canadians and five English Canadians together for twelve issues in an attempt 'to educate French-Canadians about contemporary art and literature' in France.[120] And several years later what Peter Stevens has called the McGill movement, composed of student-writers A.M. Klein, Leo Kennedy, Leon Edel, F.R. Scott, and A.J.M. Smith, took form first around the university publication, the *McGill Fortnightly Review* (1925-7), and then the independent literary magazine, the *Canadian Mercury* (1928-9). In the pages of both journals, and in work published in the 1930s, they – and Kennedy, Scott, and Smith, in particular–engaged in 'a critical rejection of overblown romanticism in Canadian verse taken over from late-Victorian and Edwardian sources.'[121] They not only attacked the romantic sensibility of English Canada's traditional poets – most of whom were active members of the Canadian Authors' Association – and their reliance on native themes; they were critical, too, of the methods these figures used to promote themselves and their fellow authors: as Scott put it in his 'The Canadian Authors Meet':

O Canada, O Canada, Oh, can
A day go by without new authors springing

To paint the native maple, and to plan
More ways to set the selfsame welkin ringing?[122]

Critical of conventional theory and established aesthetic values, the McGill movement looked to the French Symbolists, the Metaphysical poets, and (since they considered themselves to be very much part of North American society) to the writings of modernist poets and novelists in the United States. But notwithstanding their international bent, and their impatience with the self-serving nationalism of the Canadian Authors' Association, they still retained an interest in encouraging a national cultural life. Indeed Scott was hardly less romantic about the Canadian landscape than the members of the Ontario Group of Seven. What he and his colleagues wanted was simply to ensure that whatever literary form became established was not out of step with modernist developments abroad or the growing movement of social protest at home.

Part of the McGill movement's fascination with particularly American literary trends, as Scott later recalled, was that American modernist authors 'provided an excitement, a sense of new directions, an immediate perception of the real world around us, more than did any other contemporaries.'[123] That art – in the form, perhaps, of such novels as Theodore Dreiser's *An American Tragedy* (1925) – could reveal 'the real world' was not, however, the discovery of the McGill movement. Shortly before the turn of the century, journalist W.A. Sherwood had observed that 'genre pictures awaken a love for the humbler walks of life, and a consequent respect for those therein depicted.'[124] Speaking at Hart House Theatre some twenty-six years later, W.B. Yeats had strongly urged Canadians to build 'A Theatre of the People' that would make audiences 'think about their own trade or profession or class and their life within it.'[125] Few English Canadians, however, were moved to take these observations very seriously. To be sure, the Maritime poet Dawn Fraser attacked the British Empire Steel Corporation, among other companies, for reducing the wages of Cape Breton miners in the 1920s; participants in the Winnipeg General Strike of 1919 wrote songs protesting the imprisonment of its leaders; and F.H. Varley implicitly questioned the purpose of Canada's participation in the Great War in the memorable canvas *For What?* But with very few exceptions English Canadians involved in cultural activity before the Depression did not reflect upon the post-war economic and social malaise, the negative economic effects of the Great War, or the problems of unskilled New

Canadians who were forced to work long hours for menial wages, live in urban slums, and face discrimination. Apart, indeed, from the few individuals mentioned above, the only cultural and artistic groups to confront the problems arising from rapid immigration, urbanization, and industrialization were those organized by New Canadians themselves.

Oriented towards the social and economic class from which so many of their members came, New Canadians did not – like many of their English-Canadian counterparts – dismiss that class to 'find amusement in the movies.'[126] The plays of the Jewish Workmen's Circle in Toronto, the *Bak Wah Kek* or skits of the Chinese dramatic societies, and the songs and dramas staged in the *Prosvita* halls or labour temples of the Ukrainians, or in the Finnish *haali,* or by the Armenian Relief Society or the Polish Alliance of Canada in fact responded powerfully to these peoples' experience both in the old world and the new. But the ethnocultural organizations that staged them were islands unto themselves. Rarely mingling with or accepted into English-Canadian cultural groups, they existed largely for the entertainment of particular groups and for the preservation of each group's language, folk-ways, history, and literature.

On the whole, then, private, public, and professional cultural organizations were content to let mass culture, on the one hand, and ethnic loyalties, on the other, dominate the leisure time of the working class even as they themselves paid little attention to issues of social or economic inequity. In 1931, however, all that changed, and in some quite basic ways. That year more Canadians were out of work than ever before. In the years following, breadlines, strikes – at Estevan in 1934 and in Oshawa in 1937 – and public protests – the Dominion Day Riot in Regina in 1935 and the occupation of the Vancouver Art Gallery and Post Office in 1938 – could not be ignored. Nor could the growing strength of the Canadian Communist Party, the labour unions, and of the emerging Co-operative Commonwealth Federation, all of which pointed to a considerable social ferment. Not surprisingly, then, issues long ignored began to receive attention. Amateur and professional drama groups staged plays such as Gwen Pharis Ringwood's *One Man's House*, which told of 'the political and personal conflicts of a Polish immigrant labour leader'; W. Eric Harris's *Twenty-Five Cents*, which considered 'the difficulties the workers have in periods of business depression and the burdens which oftentime are laid upon them'; and Millie Evans Bicknell's play *Relief*, which presented 'the intolerable

conditions existing in the West, where farmers have been forced to part with most of their implements and livestock owing to repeated crop failures and the pressure of the banks, the mortgage and implement companies.'[127] Art and print societies exhibited such socially aware work as Leonard Hutchinson's woodcuts *Protest* and *Breadline*, Miller Brittain's paintings of unemployed longshoremen in Saint John, and Carl Schaefer's watercolour paintings of rusting agricultural machinery lying in fallow fields in southern Ontario. And – though social satire and urban realism had crept into English-Canadian writing in the 1920s – it was only during the 1930s that English-Canadian writers such as Irene Baird, Morley Callaghan, and Mary Quayle Innis took up with real enthusiasm Frederick Philip Grove's call for 'socially significant' novels in which 'crises and characters must be reflective of contemporary social conditions.'[128]

Created largely, though not entirely, within the framework of the kinds of private, public, and professional cultural organizations with which this chapter has been concerned, protest-oriented work was intended for consumption by a middle- and upper-class audience. Remote, in consequence, from the section of society it was frequently attempting to depict, it left the cultural organizations responsible for its appearance open to charges of élitism. The University of Toronto's Hart House Theatre, certainly, was accused of catering to the interests of the 'cultivated minority'; the Ottawa Little Theatre, according to another critic, was a 'snobbish organization for the edification of the "creme de la creme" '; and the Winnipeg Community Theatre, insisted a third, 'catered mainly to the upper middle classes.'[129] And not only, critics claimed, did this 'socially aware' work fail to reach beyond a middle-class audience; it failed to represent its subjects with any real accuracy or force: they were, in fact, seen from a very bourgeois point of view. 'Where the theme is that of the unemployed worker' – Ruth McKenzie reviewed some of the literature produced during the interwar years in the *Dalhousie Review* in 1939 – 'he is usually regarded as one bewildered by his difficulties rather than as a class-conscious forward-looking proletarian of Marxian revolutionary literature.'[130]

The fact that these groups were not producing work by and for the working class induced a small number of writers, dramatists, actors, musicians, and other sympathizers of Marxist and socialist thought to join forces in order to fill what they saw as an obvious and important gap. They formed national organizations such as the Progressive Arts Club (1931), which had branches in Halifax, Montreal, Toronto, Lon-

don, Winnipeg, and Vancouver by 1933; they came together in independent groups such as Stephanie Jarvis's Miracle Players (1934), which operated out of Seaton House in Toronto; and they aligned themselves with New-Canadian cultural groups, with labour organizations, and with political parties. Composed of New Canadians, workers, the unemployed, university students, and a smattering of professionals, these leftist groups were determined to do more than attack conventional wisdom and satirize the capitalist system. They wanted to move culture from the drawing-room, the northern wilderness, and the romantic past into the factory, the street, the humble home, and even into the prison. Wanting change, they sought to replace private, public, and professional cultural organizations with ones that were run by people who would be dedicated to producing a culture for the working class. Having taken part in working-class protest, they had learned with Dorothy Livesay that 'it was only through demonstrating with the unemployed for work and wages, against eviction; only by demanding an end to political arrests and laws such as the Padlock Law in Quebec ... [that one came] to realize that we could assist these struggles even further by writing about them.'[131]

The Toronto Progressive Arts Club began largely as a discussion group. Its thirty-five members met on Saturday afternoons and on Sunday evenings to talk 'about writing, about literature and poetry and graphic arts and theatre.'[132] They founded a journal, *Masses* (1932), in which they published poems, plays, songs, woodcuts, and linocuts, and encouraged others to join in the production of a revolutionary culture too by holding play-writing competitions. They also established a theatre group, the Workers' Experimental Theatre (1932) – later known as the Workers' Theatre – which staged agit-prop skits, mass chants, tableaux, and one-act plays 'for trade unions, Workers' International Relief, the unemployed councils, Canadian Labour Defense League branches ... Ukrainian, Finnish, Macedonian and other ethnic organizations [as well as at] May Day celebrations [and] concerts of cultural enrichment.'[133] Limited to one-piece stage-settings and to black sateen pants-and-blouse costumes set off by red scarves, they performed in conventional theatres as well as from the backs of trucks, on bandstands, in parks and factories, and even on the picket line. Sometimes they improvised. At other times they borrowed material from American or British playwrights – Clifford Odets's pro-union play *Waiting for Lefty* and Irwin Shaw's anti-war play *Bury the Dead* were two favourites. Dorothy Livesay and musician Jan Isnai Ismay wrote words and

music for plays, songs, and mass chants too. Sidney Nicholls, a young Montreal worker and member of that city's Progressive Arts Club, created the rousing mass recitation *Eviction*, which dealt with the shooting of unemployed worker Nick Zynchuck by Montreal police in March of 1933 and the subsequent police attack on the twenty thousand workers who attended his funeral. Other plays, such as the six-act play *Eight Men Speak*, written collectively by Toronto Progressive Arts Club members Oscar Ryan, E. Cecil-Smith, Francis H. Love, and Mildred Goldberg, recreated the imprisonment and attempted murder of the general secretary of the Canadian Communist Party, Tim Buck, during the riots at Kingston Penitentiary in the autumn of 1932. When it premièred at Toronto's Standard Theatre the year following the riots, the play 'roused 1,500 people to a thunderous standing ovation.'[134]

Other left-wing cultural organizations were equally successful. When Toronto's CCF Morris Players (ca. 1933) staged William Irvine's play *The Brains We Trust* in 1935, it 'drew capacity audiences at Margaret Eaton Hall.' Irvine, a member with J.S. Woodsworth of the 1920s labour group in Parliament, wrote other plays too, which served during his political campaign tours as 'an emotional jumping off place for a firey and indeed eloquent speech on the need for change.'[135] Vancouver's Progressive Arts Club rallied its writers and artists to interview and sketch workers during their month-long vigil at the Vancouver Art Gallery in 1938. And elsewhere working-class audiences 'sometimes cheered and shouted support' during theatrical performances.[136]

Notwithstanding these triumphs, efforts to replace bourgeois art and culture were not successful, and in many cases, it was not even really challenged. In January of 1934 *Eight Men Speak* was banned by the Toronto Board of Police Commission after one performance. In Winnipeg it was never even given a premier performance, for when it became known that the Progressive Arts Club intended to stage the play in the city's Walker Theatre the police revoked the theatre's licence. And, after performing a skit during a cannery strike of New-Canadian women at St Catharines in 1933, the Workers' Theatre of Toronto was asked by local authorities to leave town. Incidents such as these might lead to increased membership – after each of them the rolls in fact increased – but they hardly meant that the new understanding of culture was having any very widespread effect.

In 1935, in fact, Workers' Theatres across the country disbanded. Replaced in Toronto by the Theatre of Action, and in Montreal, Winnipeg, and Vancouver by the New Theatre Group, they found them-

[handwritten: stree to factory stage]

selves supplanted by organizations which were groups of protest not of revolt. Geared less towards agit-prop and more towards experimental theatre, they moved their performances from the street and the factory to the stage. When this happened, they became, like Winnipeg's New Theatre Group, 'highly specialized and ... just as removed in [their] way from life in the community as were the "arty" groups.'[137]

Drama groups were not the only left-wing cultural organizations to lose their bite – and their proletarian audience – as the 1930s unfolded. The journal *Masses,* around which members of the Progressive Arts Clubs throughout the country had rallied, collapsed in 1934 and was replaced by the much less radical *New Frontier* (1937). The work of such writers as Dorothy Livesay continued to appear in its pages, but it generally catered more to writers who would never have found a place in *Masses* (for example, Leo Kennedy of the McGill movement, or the Maritime artist Miller Brittain), and even so it ceased publication due to lack of financial support and circulation difficulties after seventeen monthly issues.

Much of the cultural left's growing weakness was a result of what was happening in Europe. The Popular Front, the collapse of the Loyalists in Spain, the signing of the Non-Aggression Pact between the Soviet Union and Germany, and, of course, the outbreak of the Second World War all made it clear that change was not going to be brought about by writing poems, by performing agit-prop skits, or by publishing literary journals. Leftists therefore began to focus more and more of their energies on restructuring the political, economic, and social order by legal means.

[handwritten: cult. left grew weaker]

If left-wing cultural organizations clearly failed to replace the private, public, and professional groups they attacked and to establish a culture for the working class, they did show that militancy had a place, and that culture could best establish its claims if all of its forms – art, music, literature, and drama – were united. Their participation in the formation, in the spring of 1938, of the Allied Arts Council was thus important. That Toronto-based organization, which had branches across the country, was the first to bring together all artists, writers, musicians, critics, and dramatists, whether of radical, modernist, or conservative bent. Established 'to ensure actual creative participation rather than passive consumption' of culture,[138] it attempted to co-ordinate 'the activities and aspirations of all the isolated creative groups throughout the Dominion' by giving 'them a common policy in their relations with the public,' by promoting 'practical creative projects,'

[handwritten: wanted bring all artists together]

[handwritten: tried unite all creative groups → gov't assist.]

and by attempting to secure 'government assistance.'[139] It was this approach, building on the strengths of the various cultural groups which had been maturing over the previous decades and firmed up by the activism of the 1930s, which would become increasingly prominent over the next decade.

Far from being motivated exclusively by material concerns, English Canadians were interested in coming together either on an informal or formal basis to participate in the making of culture. The impetus for establishing organizations varied: but whether it grew out of a concern to provide private entertainment, raise public consciousness, nation-build, mitigate the isolation of those living in both urban and rural areas, standardize fees, change copyright laws, or win public commissions, there can be no doubt that the activity which took place as a result formed the backbone of English Canada's cultural life before the Second World War and paved the way for the founding of national professional organizations such as that heralded by the short-lived Allied Arts Council.

TWO

'An Identity of Tastes and Aspirations': Educating Performers and Their Audiences

English Canadians could not have participated in cultural organizations without having first received some form of training. Art and music instruction in public and private schools, academies, and conservatories and, indeed, teaching in the home itself were a very important part of the institutional substratum underpinning the country's cultural life. Because this was so, educational institutions, in their broadest sense, were the vital link between two very important elements – the concern to encourage an indigenous culture and the desire to build a strong national identity. Madame Joséphine Dandurand was very much aware of this when on a winter's day in Ottawa in February 1902 she rose from her chair and, in her capacity as president of the Committee for the Promotion of Industrial and Fine Arts in Canada, presented a report to twenty-eight members of the executive committee of the National Council of Women. She was concerned, she told the group, that drawing was not a compulsory part of the school curriculum and that there were too few art schools and museums and other 'public amusements ... [with which to] develop the artistic tastes of the people.'[1] But Madame Dandurand wanted to do more than suggest that the National Council of Women's local branches help further artistic education. Several months earlier she had invited Lady Minto, wife of the governor general of Canada, to join with senators, members and heads of provincial governments, university professors, journalists, and other influential men and women across the country in the formation of a Standing Committee for the Promotion of Industrial and Fine Arts in Canada, and in January of 1902 she had circulated among these distinguished

persons the draft of a recommendation to be sent to the federal government arguing that Canada must maintain its 'rank among civilized nations' by ensuring that talented people did not leave the country for lack of encouragement and that they were not overlooked in the first place because cultural education was 'left to chance and privilege.'[2]

Madame Dandurand's draft recommendation made it clear that it should be seen as the responsibility of all levels of government – and most especially of the federal government – to cultivate public taste, to endow schools and cultural societies, and to encourage gifted children 'whose genius can accrue to the country's renown.' Specifying 'Two Systems,' it attempted to make it clear how the federal government could do these things, preferably through a council of art composed of members of her committee itself. The first scheme, 'The Scholarship System,' would involve awarding travelling bursaries to enable students of music, painting, singing, and oratory to study abroad; establishing provincial schools where 'sound preliminary tuition' would prepare students for further study in Europe or the United States; and creating 'a Museum of Art in a central city of Canada wherein lovers of Art could study classical models in Painting and Sculpture and the public's taste [could] be enlightened by standard masterpieces, or reproduction of the same.'[3] The second scheme, 'The National Conservatory System,' added to the main elements of the first proposal the founding in either Ottawa or Montreal of a 'Canadian National Art Institute,' where courses in 'music, painting, sculpture, architecture, engraving, languages, elocution and oratory etc.' would be taught to some four hundred students by twenty of 'the greatest living authorities of the Art World.' Besides regular courses to be offered in the summer as well as during the ten-month academic year, the institute would sponsor dramatic clubs – one French and one English – a choir, an orchestra, an operatic group, and a 'National Salon,' where works by professional Canadian artists would be on display throughout the year. Scholarships corresponding to the Prix de Rome would be awarded not only to outstanding students enabling them to undertake further study in Berlin, Paris, or London but also to those unable to afford the fees for the institute's three-year program. Both the scholarship and conservatory schemes would be funded by student fees, by private donations, and by healthy contributions from every level of government. The first scheme would, the committee estimated, cost $30,033.33; the second – the institute only – $53,266.[4]

The 'Two Systems' for the promotion of art in Canada was a remark-

able document. It echoed J.W.L. Forster's earlier pronouncement, in the fourth volume of *Canada: An Encyclopaedia of the Country*, that the prerequisite for a unique national culture was the establishment, by the federal government, of art schools and galleries.[5] It was consistent with W.A. Sherwood's 1894 observation in the *Canadian Magazine* that a country's national standing was most clearly indicated by the quality of its cultural achievement.[6] And it recognized the pedagogical role that the art gallery, as Sir John George Bourinot noted in 1893, could play to 'educate the eye, form the taste and develop the higher faculties of our nature amid the material surroundings of our daily life.'[7] Furthermore it anticipated the thinking that would later go into the efforts of John Edward Hoare, Ernest MacMillan, Eric Brown, and others as they argued for the founding of national theatres in Vancouver, Winnipeg, Toronto, and Montreal, for the establishing of a national school of music, and for the granting of more funds to the National Gallery of Canada's acquisition and education programs.[8]

The idea that cultural education, broadly defined, could function as a vehicle for helping the nation mature was, then, much in evidence both before and after Madame Dandurand had assembled her committee. Some of that idea's advocates sought to have the specialist assisted, and campaigned for the establishment of new, or the expansion of old, educational programs and institutions. Others, by far the majority, tried to achieve the same goals by educating the amateur and the public in general and so chose the art exhibition, the drama and music festival, the lecture podium, and the university extension course as the preferred means. Though seemingly at odds, these approaches were in fact complementary, which was clear enough to the members of Madame Dandurand's committee – and to the commentators and cultural activists who preceded and followed its formation. All of this, however, would be worked out in practice only with the passage of time.

One of the principal obstacles to the kind of government involvement that such a program would require was the individualist bias of the age. It was, as McGill architecture professor Percy Nobbs's 1907 report to agriculture minister Sidney Fisher on 'State Aid to Art Education in Canada' argued, 'no part of a Government's business to institute or countenance art teaching.' Schools of art and design were 'best left to care for themselves' because government interference caused 'a loss of spontaneity, of individualism [and] of life.'[9] Any prospect that the Dandurand Committee's 'Two Systems' would get a favourable response in this kind of climate was small, and the education of artists, musicians,

writers, and dramatists continued to follow a path that began with instruction from parent, friend, or private teacher, continued with study in a secondary public or private institution, and ended with travel and further study abroad.

Before being put under the tutelage, at age eight, of the Toronto organist-choirmaster Arthur Blakeley, Ernest MacMillan discovered the rudiments of music from his father at the pipe organ keyboard in Reverend Dr Alexander MacMillan's Presbyterian church. Vancouver composer Jean Coulthard studied music with her mother, Mrs Walter Coulthard, who 'was a great exponent of what was then "new music" – specifically, the works of the Impressionists, the French Six, and Stravinsky.'[10] The tenor Edward Johnson got his first vocal lessons at Miss McLean's Private School in Guelph. Musician Eddie Mather 'shot jack rabbits and sold them to the butchers' in order to raise enough money to purchase a violin and bow from Eaton's catalogue – it cost him $2.25 – and to take lessons from local musicians in Saskatoon to learn how to play it.[11] And Emily Carr received drawing lessons once a week at Mrs Fraser's private school for children and, later, took classes on Saturday mornings with the San Francisco-trained painter Eva Withrow.

In the years around the turn of the century most teachers of art, music, dramatic expression, and elocution were women. They wore tight-bodiced, ankle-length, leg-of-mutton-sleeved dresses and presided over closed-off parlours and dining-rooms. If they had the right connections or the money, they taught in studios that were located above stores, in church or community hall basements, or in the backs of their husband's or father's offices. Even in the early decades of the nineteenth century such women as Maria Morris of Halifax ran schools in their homes 'for the instruction of young ladies in drawing,' oil, and watercolour painting.[12] The problem of 'what to do with girls ... with time not completely filled by domestic and social duties' brought private studios such as Morris's and later private institutions such as Toronto's Margaret Eaton School of Literature and Expression into being.[13] But it should not be thought that these schools gave young women no more than an accomplishment with which to win them a suitor; Dora Mavor Moore, for example, was inspired to pursue a career in the theatre following her attendance at the Margaret Eaton School.

The instruction of women in the fine arts – or what some pejoratively referred to as the acquisition of 'ornamental skills' – brought many of the country's first art and music institutions into being. Music, drawing, and painting were taught at the Wesleyan Academy (the forerunner

of Mount Allison University) in Sackville after a 'female branch' was added to the male institution in 1854.[14] When the Owens Art School (1884) was moved from Saint John to Sackville in 1893, it was attached to the ladies' college rather than the university at large and did not become the Owens College of Fine Arts until 1904. The Halifax Conservatory of Music (1887) was founded in conjunction with the Halifax Ladies' College. And when music was introduced as a subject at McGill University in 1884, it was taught exclusively to women until the McGill Conservatorium opened in 1904.

Yet male as well as female students were, of course, admitted from the outset at many private conservatories of music – the Music Academy of Saint John (1872), the Hamilton Musical Institute (1888), the Dominion College of Music in Montreal (1894), the Conservatory of Music in Regina (1907), and the Saskatoon Conservatory of Music (1932) – as well as at colleges of art: the Saint John Academy of Art (1878), the Halifax Art School (1881), the Art Students' Leagues in Toronto (1886) and in Hamilton (1895), the Victoria School of Art and Design (1887) – from 1925 the Nova Scotia College of Art – and the Winnipeg School of Art (1913). And wherever men were admitted, the program offered was far broader than that available in institutions open only to women. Regina's Conservatory of Music, for example, prepared its students 'not only for the drawing-room and social circle, but also for concert, church and platform work and for the teaching profession.'[15] But no matter what kind of program was available there were almost always more women than men taking it.

These academies, schools, institutes, colleges, and conservatories of art and music emerged out of a variety of circumstances. The Halifax Art School was formed after the Royal Canadian Academy held its annual exhibition in the Nova Scotia Parliament Building in 1881. The Ontario School of Art (1876) – in 1912 it became the Ontario College of Art – was begun by the Ontario Society of Artists. A school was attached to the Art Association of Montreal when that city's art gallery acquired permanent premises in 1879. The Vancouver School of Decorative and Applied Arts was founded thanks to a small group of patrons, artists, and educators who formed the British Columbia Art League (1920) to lobby the city's government for funds with which to establish an art school and a gallery. Finally, Saint John's Owens Art School, Toronto's Canadian Academy of Music (1911), and Montreal's McGill Conservatorium were established thanks to the generosity of wealthy patrons: shipbuilder and merchant John Owens, Toronto

patrons donations helped est. art schools

financier Albert Gooderham, and the Canadian Pacific Railway's Lord
Strathcona.

Universities were reluctant, because of their vocational-professional
bent and their problems with funding, to offer courses in art and music,
or to found departments in these subjects. There were exceptions, how-
ever, to this general pattern. Regina College (1907) made courses in
music, art, and dramatic expression a regular part of its curriculum
from the outset. Acadia University in Wolfville offered courses in music
as early as 1845, in Canadian literature in 1919, and in Canadian cul-
tural history in 1938. The University of Saskatchewan allowed artist
Augustus Kenderdine to open a studio on its campus in 1920 and
sixteen years later acquired the Emma Lake property thirty-five miles
north of Prince Albert on which it established the University of Sas-
katchewan Summer School of Art. Even practising writers and art crit-
ics were sometimes involved in these sorts of activity – as the University
of British Columbia demonstrated when it invited Charles G.D.
Roberts to present ten lectures on Canadian literature in 1927, and H.
Mortimer Lamb to give six lectures on art in 1925.

It was, of course, the thrust towards institutionalized, department-
and faculty-based instruction that would be the most important. Com-
plying with many forward-looking educationalists' demands that
teachers be prepared to lead their students in music, craft-making,
drama, dance, and art, universities and provincial departments of edu-
cation offered courses in these subjects during the summer months
when teachers were free to take them. And, responding to the eagerness
of some cultural organizations, conservatories, and other institutions to
acquire higher standards, and certainly higher status, universities
moved to bring these institutions into their fold. The Kingston Art and
Musical Club (1929) was the impetus, for example, behind the founding
of Queen's University's Department of Fine Arts in 1933; the Western
Ontario Conservatory of Music – which comprised the London Conser-
vatory of Music (1892) and the London Institute of Musical Art (1919) –
brought a school of music to the University of Western Ontario when it
joined that institution in 1934; the Dominion College of Music affili-
ated with Bishop's University a year after its founding in 1859; the
Halifax Conservatory of Music joined Dalhousie University in 1898;
and, finally, English Canada's most prominent school of music, the
Royal Conservatory of Music in Toronto, began as a private institution,
the Toronto Conservatory of Music (1886), became attached in 1888 to
Trinity University (later Trinity College of the University of Toronto),

moved in 1896 to the University of Toronto itself, came under its control in 1921, and was joined three years later by the Canadian Academy of Music.

The fact that English-Canadian universities were willing to take on established institutions does not mean that they always had the financial resources necessary to make a significant place for instruction in art, music, and the like. It was, in fact, only when money began to become available from private foundations that some institutions were able to move into this area at all. Acadia University, for example, established a lecture course in art history under Walter Abell in 1928 thanks to funding from the Carnegie Corporation, and aid from the same source enabled the subject to be taught by Lester D. Longman at McMaster University, Goodridge Roberts at Queen's University, and John Alford at the University of Toronto in 1932, 1933, and 1934 respectively. Chairs in music, such as that occupied by Arthur Collingwood at the University of Saskatchewan in 1931, were also instituted by the Carnegie group. Though, in sum, it was not easy, the universities moved in a variety of ways to play a part in the overall build-up of institutions and programs concerned with instruction in various fields of cultural activity in these years. Committed at one and the same time to raising standards of taste and to fostering creative work itself, their role was of major importance.

❧

netwk agencies etc to promote art + culture

The fact that an extensive network of agencies, institutions, and programs concerned with instruction in artistic and cultural endeavours had come into being by 1939 did not, of course, ensure that the activity they sustained would always be carried out at a high level. Quality of teaching was, in fact, an ideal often honoured more in the breach than in the observance. There was, certainly, damage done to music students who had been exposed to what one observer called the 'wrong methods,' and this, he continued, was always 'difficult to eradicate.'[16] Often that damage was the result of exposure to teachers who might have had some potential as musicians themselves but were ill-suited or ill-prepared to instruct others. Laura Macaulay, in Bertram Brooker's Prairie novel *Think of the Earth*, very much represented the type. Though 'a born musician,' her father's poverty and his consequent inability to 'send her away where there would be great teachers, old men with tragic faces and long white hair, like the picture of Liszt he had seen once'

made Laura abandon the idea of becoming a concert pianist and offer 'lessons in a little room across the hall.'[17] Stories abound during these years of such incompetent teachers as the man who taught 'his piano-forte pupils to play backwards, in order that they may become more familiar with the music.' According to the anonymous writer who made this observation of the Canadian scene in Britain's *Musical Times*, the teaching profession in Canada was 'badly overcrowded,' fraught with 'dollar-chasers,' and with people who possessed 'worthless diplomas' and taught because they were incapable of doing anything else.[18]

From the late nineteenth century teaching associations attempted to establish and maintain at least minimum standards of competence by requiring the registration of music teachers and by raising the standards of music examinations.[19] The music examination was enormously popular. It enabled students from all parts of the country to gain credit for their studies in harmony, counterpoint, fugue, music history, performance, among other subjects, when the examining officer passed through their communities once a year. Initially the programs were run by British institutions. London's Trinity College of Music (1872) examinations were conducted by the Dominion College of Music through Bishop's University from the mid-1890s. The Associated Board of the Royal Schools of Music (1892) and the Royal Academy of Music (1887) were also operating in Canada from the mid-1890s and, in 1902, established a link with McGill University. These, as well as the other British and American examination systems which followed, came to play what Ernest MacMillan described in 1936 as 'an important role in the life of the Canadian student of music,' serving to raise 'the general standard of work.' Yet it remained true, as MacMillan also noted, that many diplomas were earned through examining bodies 'which maintained low standards with a view to gaining high profits.'[20] English-Canadian teachers from Britain naturally preferred to have their pupils assessed in accordance with what they knew in the British system, and, as a result, helped prolong the lives of often inferior programs. It was in order to offer an alternative to just such programs that McGill University established its own in 1909, soon making its examination system – notwithstanding the fact that the University of Toronto's Conservatory of Music had been founded in 1898 – what one music student from Saskatoon described as 'the "one" ' to take during the 1910s.[21]

Attempting to improve the quality of instruction itself also became a major goal of those concerned with standards, and, again, what was

happening in the world of music made the nature of these efforts especially clear. There was, certainly, a problem, for even teachers who may have had a good background too often passed on to their students styles, methods, and conceptions which were out of date. The Conservatory of Music in Toronto 'was graced with two splendid musicians of the old school, Sir Ernest MacMillan and Healy Willan,' but, according to Jean Coulthard, 'there was not enough possibility to assimilate new musical ideas in Canada during these early years.'[22] John Weinzweig left what for him was that institution's stifling atmosphere and enrolled at the Eastman School of Music in Rochester, New York, in 1938 in order to study twentieth-century music. The difficulty of hearing contemporary music anywhere in Canada even as late as the 1930s was, in fact, astonishing: during that decade, as musicologist Helmut Kallmann put it, students 'discovered Schoenberg, Bartok or Stravinsky almost by accident; radio broadcasts and recordings of such music were still rare and music libraries were few.'[23]

Teachers inhibited their students not only by clinging to old styles, but by adhering to old forms of music. The extent to which oratorio, for example, was favoured over opera throughout the period under discussion was suggested by Morley Callaghan's 1932 novel *It's Never Over*. The principal character was, in fact, a bass soloist at a wealthy Toronto church who had 'had enough oratorio singing and ... [wanted] to study opera in another country.' Seeking help from his teacher proved a disappointment, for Hobson 'had never done much himself in opera ... had no use for teachers of it, and advised all his pupils to study for oratorio.'[24]

This sort of discouragement was not, of course, confined to the world of music. Teachers of the visual arts were similarly steeped in attitudes and possessed mind-sets that belonged to an earlier generation. While institutions such as the Toronto Art Students' League did give their students 'freedom from examinations and awards,' most did not.[25] Carl Schaefer's experience as a first year student at the Ontario College of Art in 1921 under the traditional painter William Beatty was typical:

We all had our places, our easels, and we had about six square feet marked out ... I had my initials in the middle. 'Schaefer, that's your place all year,' [Beatty told him]. 'If you can't see the model from there, well that's your hard luck.'

Beatty was clearly a 'tyrant.' And, as with many teachers of his era, he was wed to the teaching methods of 'the old Académie Julien in Paris.'[26]

[margin note: instrut. were constrained by milieu]

Even when instructors did show a certain flexibility and openness, they could be constrained by the milieu in which they were operating. Walter J. Phillips, for one, found it difficult to teach life drawing when public feeling in Winnipeg disapproved the practice of allowing students to sketch from the nude model. 'We are still provincial up over the border,' as a character in John Murray Gibbon's novel *Pagan Love* put it, 'and there is the prejudice against posing in the nude.'[27]

[margin note: prob. with instruct.]
[margin note: → instit. lacked direction + narrow- ness]

The shortcomings of the teachers were not the only factors affecting the quality of instruction: frequently institutions themselves were characterized by lack of direction and narrowness. Conservatories were generally 'conglomerations of private studios' which saw their purpose as preparing students for a career in the concert hall.[28] University departments of music, on the other hand, offered courses in 'historical background, theoretical knowledge, and analytical skill' with a view towards turning out teachers or music theorists.[29] No institution excelled in both areas.

[margin note: 2 types of instit. for music → yet did not combine both]

Art schools, for their part, tended to focus on the development of commercial skills. The Victoria School of Art and Design in Halifax encouraged 'artistic tendencies of economic value.'[30] Upon its inception in 1925 the Vancouver School of Decorative and Applied Arts announced that it would 'fill a long felt need in training not more artisans, but artists to convert British Columbia's wealth of raw material into greater wealth of artistic finished products.'[31] Even the Ontario College of Art and the Winnipeg School of Art recognized from the outset the value not just of fine but also applied art.

[margin note: pre-war ec boom ∴ demand for Can. designed prod. ∴ $ out of art]

The idea that art was the handmaiden of commerce had, in one form or another, gained popularity among artists, administrators, and politicians before the turn of the century. Several factors contributed to its emergence, ranging from the influence exerted by the British Arts and Crafts movement to the opportunities the booming pre-war economy gave for employment of designers and illustrators in such firms as Brigden's in Winnipeg and Gripp Limited in Toronto. Demand for Canadian designed products also encouraged the application of artistic skills to commercial purposes, and some educators even sought to protect the artistic profession against charges of dilettantism and Bohemianism by arguing that it could play, and was playing, a useful role in the commercial world. So important did the stressing of this link become that National Gallery director Eric Brown could note in 1920 that art was 'inseparable from commerce, because commerce is largely dependent upon design of every kind which art only can supply.'[32] The

federal government itself sought to promote the association. Having first involved itself in technical and vocational education in 1910 through the establishment of a Royal Commission on Industrial Training and Technical Education, it proceeded in 1919 to enter directly an area of jurisdiction normally reserved for the provinces alone. The Technical Education Act of that year empowered it to contribute up to 50 per cent of a province's expenditure on vocational education over a ten-year period, with the result that art courses such as that established by Violet Gillett and Julia Crawford at the Saint John Vocational School in New Brunswick burgeoned. And not only did new courses and programs get established: institutions such as the Winnipeg School of Art tailored their curricula to meet 'practical objectives' in order to qualify for a share of the ten million dollars allocated by the federal government to technical education.[33]

Not everyone was pleased with the trend towards associating art with industry and commerce. Group of Seven artist Arthur Lismer accused those who taught commercial art courses of being 'in a conspiracy, unconscious and unarmed, with Industrialism, to smother the voice of art consciousness.' In 'the adaptation of man to the machinery of production' art had capitulated 'to the economic and the utilitarian.' Courses in applied art were appropriate subjects for study in the craft or technical schools but had no place, Lismer insisted, in a school devoted to fine art.[34] Artist and advertising executive Bertram Brooker agreed that it was the craftsman's function 'to make things' and the artist's 'to *see* things.' But in the circumstances prevailing, artists' work was assigned value only if it could be shown to have practical utility. 'Not until art education is tightened into a commercial course in the technical schools, or concentrates on the making of craftsmen in art schools,' Brooker continued in 1931, 'is it taken seriously by boards and teachers.'[35] As clearly and forcefully articulated as it was, however, this kind of thinking had little effect on what was taking place: art continued to be widely subordinated to various commercial purposes.

If those involved with technical and vocational education had a clear idea – whatever it might be – of the manner in which art fitted into their enterprise, university administrators were, on the whole, rather unsure of its place. Along with most English-speaking Canadians they favoured the amateur over the professional and saw art and music as leisure-time activities, not professional ones. The cultural education of their students was thus generally left to extramural clubs and societies which 'on the one hand served as a necessary outlet for self-expression,

and on the other ... demanded a culture of conformity consistent with the "respectable" middle-class lives for which [those students] were being prepared.'[36]

Such clubs and societies were certainly very much in evidence. Choral groups – Toronto's University College Glee Club (1879) was one example – had been on the scene since the last decades of the nineteenth century. By the end of the First World War dramatic clubs were staging Christmas or spring productions once a year. By the 1930s extramural art groups such as Acadia University's Fine Arts Club (1934) were bringing students together to discuss art, partake in linocut printing and outdoor sketching activities, and share a life model. Those universities where departments of music and art did exist were, of course, able to offer their students a little more. John Alford gave fine art lectures to students at the University of Toronto during the noon-hour, and Arthur Collingwood 'drew a pretty good crowd' to his weekly music lectures at the University of Saskatchewan's Convocation Hall. Seated at the piano with the university's symphony orchestra behind him, he would introduce the students to the different instruments in the orchestra and then explain 'the structure and the formation of the symphony as the theme developed or was laid out.' In this way, one member of the orchestra recalled, 'he'd educate the unenlightened people who were perhaps only used to following melodic line.'[37]

Notwithstanding the interest that it frequently attracted at this level, cultural activity often had a difficult time establishing its right to a more serious and structured place in university curricula. Even when given financial assistance to establish chairs or departments of music and art, university administrators frequently demurred. When the University of Toronto's president, Sir Robert Falconer, was offered a chair of fine arts for his institution by the Carnegie Corporation in 1926, he suggested the money go to the Ontario Society of Artists instead on the ground that it was more suited to offer instruction in such a field.[38] McGill University experienced 'considerable reluctance to accept ... [the Department of Music] as a department of the Faculty of Arts, since it was felt not to be academically respectable, and the problem was only solved when in 1920 the department was elevated to an independent faculty.'[39] Other institutions responded in much the same way. As Ernest MacMillan boldly told a group of university administrators at the National Conference of Canadian Universities in 1927, they were 'accustomed to think of music as a mere passive indulgence in emotionalism'

and therefore had a distrust 'of admitting to an arts course any subject whose ultimate justification is purely aesthetic.'[40] This kind of thinking, in fact, not only prevented courses from being created, it also limited funds for their operation in those places where they did manage to get established. Arthur Collingwood was expected, in consequence, to teach music at the University of Saskatchewan without the aid of a permanent piano, recordings of operatic and chamber music, and a gramophone on which to play them. While attitudes did begin to change in the 1930s – by then university presidents would actively lobby foreign foundations to establish chairs and departments of music and art – the period leading up to that decade saw relatively little done to encourage the teaching of these subjects.

1930's univ. presidents lobbied to get music + art dept

Can. art ed → stepping stones to study abroad

Getting an education in art and music in Canada was not an impossibility. For the most part, however, such Canadian programs and institutions as existed functioned as stepping stones to study abroad. This almost always meant Britain and Europe, although, as cultural life in the United States matured, it could also mean going there.

In 1902 A.S. Vogt encouraged his piano students at the Toronto Conservatory 'to round up [their] ... musical training in the atmosphere which exists in some European capitals.'[41] Four years later the young Montreal music student George Brewer mused over the possibility of receiving a travelling scholarship:

If I do win this, what a break it will make in my life. From 18 years of age to 21 or 22 to be spent in England and after that what! God knows! Perhaps concert touring – perhaps a responsible church position – perhaps love – or perhaps sorrow and death.[42]

The importance both of concluding one's education abroad and of being suitably prepared before one went was made clear to art student Yvonne McKague Housser when she travelled to Paris in 1921. Housser enrolled in a class at the Académie de la Grande Chaumière and immediately set about visiting museums, art galleries, and salons where paintings were hung 'from the floor to the ceiling, room after room' – at which point, she recalled, she found herself 'sadly unprepared for the modern painting of the day to be able to appreciate it much less under-

[margin note: students unprepared to meet modern art]

stand it.' William Beatty, her teacher at the Ontario College of Art, had been opposed to 'the so-called moderns' and thus had simply done nothing to prepare his pupil to understand them.[43]

[margin note: Students encountered -ve when applied modernism]

Nor were Canadian students' encounters with 'modern' influences always aided by the kind of critical response they got after they returned home. Colin McPhee's modernist Piano Concerto No. 2 – composed under the influence of his studies at the Peabody Conservatory in Baltimore – was performed by the New Symphony Orchestra in 1924 to a unanimously negative response by Toronto critics, who did not like its 'almost riotous freedom of expression, regardless of any of the accepted notions of harmony or melody.'[44]

[margin note: Criticts → looked at wk thru. nationalism + trad. standards → looked mostly at content]

The critics were an important – if not always entirely positive – educative force in their own right. More plentiful than is usually supposed,[45] they did not, of course, function in the way their successors were to do. Hector Charlesworth, Archibald MacMechan, Roy Franklin Fleming, and others were reluctant – and, for that matter, perhaps not able – to apply critical analytical tools to the works at hand. Afraid of stifling indigenous effort, they shied away from any very rigorous judgments concerning the work they were considering. Framing their reaction in terms of the degree to which a cultural product fostered national and patriotic sentiments or adhered to traditional international standards, they were quick to criticize – the term is the late British cultural historian Raymond Williams's[46] – 'emergent' forms which deviated from those sentiments or standards. They paid excessive attention to content and almost none to formal or structural qualities and so, not surprisingly, tended towards the sort of conservative position that allowed them to take the Confederation poets' marriage of indigenous symbols and themes with standard international forms as the measure by which work should be judged. As a result they divided modernist from traditionalist; the internationally inspired modernist from the locally rooted one; and, inevitably, the English-Canadian cultural producer from the European. Though seeing themselves as helping to build the country's culture, they did just the opposite; by functioning in ways that encouraged the isolation of English Canada's cultural life from what was happening internationally, they retarded rather than enhanced its growth.

[margin note: incorp. indigenous symbols + themes]

Critics also did something else. In demanding that the poem, the play, the composition, the novel, and the painting express nationalist and patriotic sentiment as well as conform to a certain standard of moral behaviour, they were casting writers, dramatists, painters, and

[bottom margin note: thought were building cult. yet isolated Eng.Can's culture from internat. (+ retarded growth)]

musicians themselves in the role of educator. As Lilian Jory had put it in 1900, it was the poet's mission 'to open the eyes of men and women that they walk not through this great Palace Beautiful asleep.'[47] Over the next four decades even literary critics of the stature of W.A. Deacon would adhere to the idea that 'literature's basic purpose was didactic, that good literature infused its readers, willy-nilly, with directions and patterns for the moral and ethical enhancement of living, and that Canadian literature in particular had a high and holy mission in the building of Canada and her people.'[48] What the composer did, too, could be understood in essentially the same way. 'Great music,' insisted Edward Johnson, was altogether capable of bringing 'us together irrespective of birth, position, culture or ability.'[49] The artist as well had an educative function for what he or she did – the words are Brooker's – was 'more significant than ever before as the only unifying experience that remains to us' given the fact that 'orthodox religions are losing their hold.'[50] And, finally, the dramatist, asserted Herman Voaden, must see that the theatre was 'a place of immortal visions and enthusiasms' where the imagination and the beauty of art could lead man to divinity.[51]

The artist's educative role was assigned to him or her by more than what the critics were saying. A variety of circumstances were in fact giving the cultural producer that function. The decline of traditional religion, as Brooker had suggested, was one; the need to fit immigrants into their new society was another; a continuing urge to stimulate national feeling was a third; and there was also a feeling that art could teach people to cope with urbanization and mechanization.

A concern with all of these things led the newly formed United Church of Canada to commission Ernest MacMillan and E.J. Pratt to write music and verse for its Massey Hall pageant in 1927; the IODE's interest in encouraging patriotic sentiment caused it to make reproductions of Canadian paintings of the Great War and distribute them among schools in 1919; and the anxiety of ministers throughout the country to reach their congregations more effectively played a part in the many invitations extended to artists to decorate the walls of churches. Writers and poets could also be seen at work when the Canadian Chautauqua Institute (1921) brought Bliss Carman, Charles G.D. Roberts, and other poets together in 1931 at the Muskoka Assembly to stimulate 'culture, character, and the promotion of national ideals' among those gathered there.[52] Dramatists were pressed into service by Canadian National Railways, which commissioned historical radio

plays that would 'encourage Canadian national consciousness' among its listeners.[53] And Ralph Connor made it clear that song and music could stimulate faith when he had the minister in his 1901 novel *The Sky Pilot* attempt to convert an old man and his daughter to the ways of Christianity by leading them in hymn-singing. 'It was easy to pass to the old hymn, "Nearer, My God, to Thee," ' Connor wrote, and then to simply say, ' "May we have prayers?" '[54]

If seeing the artist as a kind of formal educator broadened the range of his or her activities, it very much narrowed their character. Critics and public alike maintained that art could teach only if it was of a familiar and accepted sort. 'As self-appointed guardians of the arts, women's organizations [in Toronto kept a critical] watch on every aspect of the city's cultural activities, especially the commercial play-houses downtown which were blamed for showing "unwholesome" drama.'[55] In the same city the Reverend John Coburn donned green goggles and false whiskers. In this startling costume he appeared to censor the Star Theatre's production of Legrand Howland's problem-play *Deborah*. In Montreal Andrew Macphail lashed out at the Little Theatres' obsession with 'shanty-stuff,' plays whose 'characters are mean and unworthy – miners lusting for gold, drunken lumbermen, ruined pioneers, insolent city picnickers' – all of whom spoke 'a coarse jargon.'[56] In 1933 the Toronto Public Library banned Morley Callaghan's novel *Such Is My Beloved*, while two years later his *They Shall Inherit the Earth* was available only upon request. Frederick Philip Grove's novel *Settlers of the Marsh* was kept off the shelves of the Winnipeg Public Library following its appearance in 1925. And although Ryerson Press editor and former Methodist minister Lorne Pierce had published that controversial work, he refused the following year to distribute the Canadian edition of E.J. Pratt's *The Witches' Brew*. There were limits for painters, too, as the reaction to the fact that the Fine and Graphic Arts Exhibition at Toronto's Canadian National Exhibition in 1927 included an unprecedented number of nude paintings showed: not only, as Royal Canadian academician F.H. Brigden reported, was there 'a rush to the Gallery by thousands who had no other motive than a morbid curiosity'; there was also a healthy number of letters to the editor condemning the pictures as 'indecent and demoralizing.'[57]

The insistence that art have a certain moral content had implications not only for what got produced but also for the producers of it. Just as it was held that paintings of nudes and characterizations of drunks and lumbermen gave the public poor rather than good examples of behav-

iour, so too, it was frequently asserted, the often bizarre life-style of the culture producer offered something less than a perfect example of how life should be lived. 'The public,' as Brooker noted in 1936, 'is sometimes inclined to forgive idiosyncrasies and even "immorality" on the part of the artist, once he is recognized as great.'[58] But it would not tolerate the Bohemian antics of someone who had not attained that status. Artist F.H. Varley's behaviour – he drank and frequently seduced his female students – thus cost him portrait commissions, while Morley Callaghan's fictional character John Hughes, who had an 'immoral' relationship with his girlfriend, lost his position as lead bass in a Toronto church.[59] 'The Singer,' as a writer in *Musical Canada* had put it in 1907, 'should be possessed with certain spiritual convictions in order to give a sincere rendering of the song.'[60] The same was demanded of the artist by those who believed that he or she touched 'the handiwork of the Creator' through painting.[61] Producers of art, music, drama, and literature, then, were generally expected to offer in their private lives guides to moral action which would be as exemplary as those given in their work. Proper fulfilment of their responsibility as the nation's teachers demanded no less.

♣

There was a general agreement in English-speaking Canada's cultural circles that members of the public were capable of being taught how to play a musical instrument, act, build stage settings, or paint a picture. Nor was there much doubt that people were generally willing to expose themselves to what the talented writer, musician, or dramatist might be doing – which, according to some commentators, was reason enough to educate them. As the young journalist Beckles Willson told the Montreal branch of the Canadian Club in 1914, 'Our people, I am convinced, have the receptivity – the potentiality of appreciation.'[62] And, as Walter J. Phillips's 'Art and Artists' column showed (it appeared in the *Winnipeg Free Press* from 1926 to 1941), there was a similar confidence in the capabilities of the Prairie public. That confidence was not, to be sure, always warranted. Phillips told, for example, the story of the farmer who was willing to pay a vast sum for a painting by Turner until he discovered that it was 'second-hand.' There was also the tale of the elderly woman, who, upon leaving an exhibition of a painting by Rembrandt, whispered to the uniformed attendant at the door: 'Very good, Mr. Rembrandt ... very good indeed, I do hope that you will be

able to sell it.'[63] Interest was developing, nonetheless, and it was becoming informed. Four hundred people might crowd into the Vancouver Art Gallery to hear lectures on Canadian art; there were reports of a western Canadian public 'hungry' for poetry readings by English-Canadian authors and of music festivals keeping large audiences enthralled until after midnight; and one heard of festival adjudicators listening to some fourteen thousand competitors over a two-week period.[64] The capacity of audiences to appreciate fully what was being put before them should not, of course, be exaggerated. They might, for example, respond to the novelty – especially the lighting effects – of Herman Voaden's difficult symphonic expressionist work *Earth Song* while entirely missing 'the emotional meaning of the play,' which required what R.V. Howard described to his *Saturday Night* readers in 1932 as 'a trained audience.'[65] That capacity was, nonetheless, very clearly held to exist.

The idea that adults were keen to learn and could be taught through observation or participation was not new. The Mechanics' Institute movement, begun in Scotland at the beginning of the nineteenth century, had come to St John's, Newfoundland, in 1827, to Montreal, Toronto, Saint John, and Halifax in the 1830s, and, within three decades, to such remote places as Fort Hope and Barkerville in British Columbia. Though usurped in the 1890s by the literary and scientific societies and other organizations which had also taken root early in the century, the Mechanics' Institutes' reading rooms and museums, lecture programs, evening courses, and art exhibitions had played no small part in preparing the way not only for demands by British Columbia's loggers' union that camps be provided with reading rooms, but also for the establishment of such organizations as Winnipeg's All Peoples' Mission (1907), the Workers' Education Association (1918), the Canadian Bureau for the Advancement of Music (1919), the National Council of Education (1919), the Dominion Educational Film Association (1931), and the Canadian Association for Adult Education (1935).

To those involved in these and similar associations, cultural activity – whether one was involved in it as participant or observer – had much to offer. It allowed constructive use of the public's ever-increasing leisure time and so helped prevent the disorderly behaviour which, many believed, was being induced by shorter working days; it served as an elevating alternative to unsuitable forms of popular culture; and it reinforced national sentiment. The All Peoples' Mission in Winnipeg and the YMCA in Edmonton, J.S. Woodsworth thus insisted, were to be

The handwritten margin notes read: "YMCA → counter -ve vices", "Service Clubs ↳ wholesome activities", "church entertain. for children", "ART GALLERIES ↳ public lectures", "Free Concerts to ed. public + give taste for music"

seen as positive forces because they provided a 'counter attraction to cheap theatre, the dance hall and the poolroom' by offering 'wholesome amusement [such as the production of plays] that would be interesting to young people and at the same time elevating and enlightening.'[66] Service clubs won approval through sponsorship of national literary competitions 'to encourage that which is beautiful and inspiring' in order to 'combat the harsh material spirit ... [and] the strain of every day life.'[67] Aware that education was 'an all-comprehensive process which can be used to shape a people's character and a nation's destiny,' the National Council of Education organized nation-wide performances and lectures by leading British singers, actors, and authorities in literature, drama, and fine arts.[68] Churches in Toronto turned their basements into centres of 'entertainment for children to oppose the pestilence of unwholesome attractions continually featured at downtown theatres.'[69] And summer camps – the YMCA's Canadian Recreational Institute at Lake Couchiching, Taylor Stratten's Camp Ahmikin in Algonquin Park, and the Chautauqua Institutes among others scattered throughout the country – kept men, women, and children profitably occupied during the summer months with literary, artistic, dramatic, and musical activities.

Consistent with Arthur Lismer's belief that art was 'the normal and rightful heritage of every individual,' art galleries across English-speaking Canada held public lectures and offered Saturday morning art classes to children and evening classes to adults.[70] Such cultural organizations as the Alberta Society of Artists sponsored summer schools. (A.C. Leighton took eight members to Brewster's Dude Ranch for a two-week session in the summer of 1933.) The Ontario Department of Agriculture, the Junior Farm Associations, and the Girls' Junior Institute organized drama groups in rural Ontario which, insisted one writer, 'not only ... benefit those who participate in them but ... give a great deal of pleasure to the community.'[71] 'The need to educate the listening public' was a primary impulse behind the establishment of the 'Free Concert Movement' of the 1920s in Toronto, Ottawa, and Montreal.[72] It played a key role, too, in the *Toronto Star*'s Good Music Concerts, which were intended to make 'good music available to "the people."' Seated at the piano, *Star* music critic Augustus Bridle 'would discuss the music to be heard, playing appropriate musical excerpts by way of illustration.'[73] The Prom Concerts hosted by Reginald Stewart a decade later in the same city were also geared towards developing 'a taste for music in substantial numbers of people who were able to pay

the modest admission of 80 cents for the best seats, [or] 30 cents to rent a cushion on the floor.'[74]

What, precisely, music could do was spelled out by many observers. Singing 'the popular melody, the tender ballad, the sacred song,' as a writer in the *Methodist Magazine and Review* had observed in 1902, made 'a swift and tender appeal to the sentiments of faith, love and loyalty.'[75] Playing a musical instrument, according to the Canadian Bureau for the Advancement of Music, taught hand-to-eye skills, perseverance, self-control, and mental discipline. Listening to music softened the heart and rendered it, in the mind of one 1933 commentator, 'responsive to the most sublime thoughts.'[76] And attending Saskatchewan's Chautauqua music festivals in the midst of the Depression might even mitigate the effects of that social and economic disaster: it was, recalled a 1933 audience member, 'a wonderful help in a flat, empty-pocket time.'[77] 'I do not know,' an *habitué* of the Proms wrote in a similar vein, 'anything about music but I like the effect it has on me,' adding that he left the 'concerts exhilarated and refreshed.'[78] Attending or participating in a play had its benefits too. According to some observers, the theatre taught manners and social grace, moulded 'national character and sentiment,' and provided audiences with 'an education that they could not get elsewhere in the world.'[79] During the Depression it also permitted the amateur performer 'a temporary escape from the overwhelming realities of life.' 'Think what it means to the tired wife of an unsuccessful farmer,' British Columbia dramatist Major Bullock-Webster told a group of educators in 1938, 'if she can be Queen Elizabeth for a little while.'[80]

The contemplation of pictures might not allow for exactly this kind of relief, but, asserted one observer, it did make viewers 'take a greater interest in the people and natural beauties around them,' and it improved their taste.[81] It was also, thought another commentator, 'a potent force in the moulding of national characteristics.'[82] The act of painting, it was believed, could be equally beneficial. Those who attended the Children's Art Centre established by artists Marian Scott and Fritz Brandtner and Dr Norman Bethune in Montreal in 1936, were taught to express themselves creatively through art. Three years later patients taking Brandtner's art classes in the orthopaedic ward of the Children's Memorial Hospital were able to 'regain confidence in their ability to do things, and to show themselves that, 'though handicapped they were capable of expressing experiences in their own way.'[83] The Reverend Bentley in Sinclair Ross's 1941 novel *As for Me and My House*

found the activity of painting equally therapeutic; it provided nothing less than a means through which he could transcend the spiritually debilitating life of a small Prairie town.[84]

The belief, then, that either passive or active involvement in cultural activity could 'refine and elevate' and, as another early twentieth-century commentator put it, exert a 'splendid influence upon national character' was widely shared – so widely, in fact, that it gave rise to one of the most common forms of cultural education in the period: music and drama festivals and competitions.[85] Local music festivals had existed in English Canada since the mid-nineteenth century; it was not, however, until 1903 that the first nation-wide festival, the First Cycle of Music Festivals of the Dominion of Canada, was held. In its case, it must be said, nation-building was subordinated to what was held to be refinement. The festival organizer, A.E. Harriss, considered it his *duty* and *privilege* to foster a better knowledge of British works in Canada,' which, he felt, could best be accomplished by bringing 'a great conductor and composer amongst us to stimulate and educate the musical amateurs to greater music and offer the musical profession the needed opportunity of exchanging musical thought with the foremost musicians of the times ... and fit us as a nation capable of holding place second to none as a musical community.'[86] The distinguished British composer and principal of Britain's Royal Academy of Music, Sir Alexander Mackenzie, was therefore engaged to organize thirty-three concerts in cities from Halifax to Vancouver. In each place Sir Alexander and the six vocal soloists accompanying him from London assembled local choirs and musicians, and, following a single rehearsal, staged a concert of British oratorio music, often of Mackenzie's own composition. The results of the venture were impressive: it set 'between three and four-thousand voices ... a-singing' across the country; it led Harriss to go on to organize the Festival of English Cathedral Music five years later; and it prompted others to establish festivals too.[87] In 1907, for example, Governor General Lord Albert Henry George Grey founded the nation-wide Earl Grey Musical and Dramatic Trophy Competitions, which were held in Ottawa in 1907 and 1908, in Montreal in 1909, Toronto in 1910, and Winnipeg in 1911. In 1908, partly under Grey's influence, music educators in Edmonton organized the Alberta Musical Competition Festival. The same year the Western Canadian Music Festival was organized in Winnipeg; a year after that the Saskatchewan Music Festival Association was established 'to promote the appreciation, performance, and study of music through competitive festivals

and concerts,' and in 1912 the Toronto Music Festival came into be-
ing.[88] Following the hiatus caused by the Great War the Manitoba
Music Competition Festival was established in 1918 and the Spring
Festivals of the Halifax Philharmonic Society in 1919. By 1928 the
Willingdon Arts Competitions – comprising literature and the visual
arts as well as music and drama – had been organized, followed by the
Alberta Drama Festival in 1930, London, Ontario's, Canadian Music
Festival in 1936, and festivals devoted to New-Canadian music, dance,
and crafts such as those sponsored by the Canadian Pacific Railway in
many parts of the country from 1927 to 1931 and that organized as the
Vancouver Folk Festival from 1933.

Around this myriad of competitions and festivals rose a labyrinth of
larger organizations. The Federation of Canadian Music Festivals
united the four western provinces' festival associations in 1926 largely
for the purpose of sharing adjudicators' costs, which could be substan-
tial when these officials came – as they usually did – from Britain. The
Dominion Drama Festival brought existing local and provincial ama-
teur drama associations under one umbrella in 1932 by organizing
annual provincial and national competitions. And in the early 1930s
the Canadian Music Festival Adjudicators' Association was formed 'to
promote, encourage and assist Canadian adjudicators.'[89]

Whether devoted to music or drama, or, as was less frequently the
case, to art and literature, festivals were 'a means of fostering a better
type of performance' and 'of developing a critical taste among the
public.'[90] According to two of its most enthusiastic supporters – Arthur
Collingwood and Ernest MacMillan – the music festival was 'a healthy
stimulus to the music student, [and] an ideal public forum for the
competent teacher,' for it encouraged playing 'the right kind of music
in the right way' and gave 'the student a sense of proportion, showing
him where he stands in relation to others.'[91] And besides, while all this
was happening for the student performer, the audience was 'being edu-
cated in the art of listening to music' and thereby 'developing a critical
taste' towards what it heard.[92]

Festivals did more than enhance 'the critical appreciation of the man
in the street.'[93] Their purpose, as MacMillan pointed out during a radio
talk in 1935, was 'by no means purely musical.'[94] Lord Grey intended
music and drama festivals to be 'a really useful school, both for good
manners and beauty and purity of diction.'[95] Drama adjudicators were
to deduct marks for 'flat a's and other barbarous pronunciations' as well
as for 'breaches of good manners.'[96] Governor General Lord Vere Braba-

zon Ponsonby Bessborough, founder of the Dominion Drama Festival in 1932, also saw his creation as having 'a great educational influence' in all parts of the Dominion.[97] The standards of judgment applied under Grey's auspices were evident here too: marks were deducted where 'the enunciation was careless and often vulgar, the understanding of the thought of the dramatist poor, and the manners of the depicted characters deplorable.'[98] Nor was all of this seen simply as an exercise in creating imperial solidarity. By performing British music and plays and conforming to British standards Canadians were not only bringing Canadian culture into line with that of the mother country; they were also, in Grey's words, binding the Dominion itself together by giving it 'an identity of tastes and aspirations.'[99]

Canadians took this view as well. MacMillan certainly thought these festivals and competitions could 'affect our national life as a whole.' They welded 'together the many divers[e] elements that compose the population of Canada' and, he continued, helped overcome 'the geographical difficulties that confront us as a nation.'[100] The Manitoba Music Competition Festival was, another enthusiast observed in 1938, 'a very important agency in promoting better feeling between English speaking Canadians and their fellow-citizens who had come from other countries' and who 'by reason of ... language, fail to take part in the ordinary community activities.'[101] Indeed, Manitoba's first competition in 1919 not only was composed of musical groups such as the predominantly anglophone Men's Musical Club; it also saw the participation of the Icelandic Choral Society, the Ukrainian Choir, the Young Mennonite Association Choir, and the Chorale Mixte de St Boniface. When the Canadian Pacific Railway festivals were organized at the end of the 1920s they were intended to bring various ethno-cultural organizations together in order to 'create more mutual understanding between the ... racial groups.'[102] And the Vancouver Folk League's gathering together of 'up to twenty-seven ethnic groups in the conference rooms of the Hotel Vancouver' during the 1930s was designed to make British Columbians 'more tolerant ... [of] people of other racial origin, who are willing to help us build a strong united Canada.'[103]

On whatever level it operated – whether for the benefit of the individual, the audience, the nation, or the Empire as a whole – the festival movement caught the imagination of the country. Clergymen, cinema owners, businessmen, and civic officials gladly handed over their church basements, theatres, stores, and community halls to the annual three- or four-day event. Municipal councils, provincial governments,

[handwritten: gov't, private patrons, Volun. organ. etc. → scholarships + prizes]

private patrons, and voluntary organizations contributed funds for scholarships and prizes or simply to help meet the operating costs that could not be covered by door sales and entrance fees.[104] Universities, provincial departments of education, and conservatories provided adjudicators and sometimes a venue. The public gave its support, too, by travelling for miles – frequently in poor weather conditions – in order to attend a gala performance.

The adjudicators were, or course, particularly important, for their involvement was essential to a festival's success. The job was a rigorous one. Working during the 1930s for the School and Community Branch of British Columbia's Department of Education, Phoebe Smith spent an arduous but not untypical few days adjudicating three festivals in the Peace River communities of Fort St John, Dawson Creek, and Prince George. She spent 'hours and hours of listening to elocution, choral speech and plays' performed by 'little girls in their best dresses, hair curled – and the boys having been given a good going over by their parents.' She visited a child in the hospital, so that he could recite his part. She read and listened to the poems and the plays of a group of adults who had taken a creative writing course during the winter and were anxious to have some criticism of their work. She participated in discussion panels sponsored by service clubs. She saw the Murphees, the Hoys, the Yankowls, the Shoonovers, and the McLeods whom she described as 'the new citizens of the future in the Peace River.' She witnessed the enthusiastic response of the public – so large was the turnout of the final performance in Fort St John that 'a long line of disappointed patrons' could not be accommodated. Phoebe Smith ended her tour convinced that 'pioneers in the north country, [involved in] ... growing wheat, discovering oil and minerals to enrich our province, are not neglecting the cultural side of life for a new generation.'[105]

The festival movement was one vehicle for the encouragement of an informed interest in art, music, and drama among members of the public. Another was the extension of continuing studies programs established by universities and provincial departments of education. Speaking in Montreal at the Twelfth National Congress of Canadian Universities in 1928, one participant was at particular pains to stress their importance. 'In recent years,' he said, 'the idea has spread very rapidly that universities extend their direct influence to persons other

than those who actually come within their walls for their regular work.'[106] This had been happening in a modest way since the 1870s, when English-Canadian universities 'were much influenced by the university extension movement that had originated in England.'[107] It was not, however, until the turn of the century that the trend gathered real momentum. Trinity University (later Trinity College of the University of Toronto) introduced Saturday afternoon lectures in art history in 1904 to an audience 'composed largely of ladies, but with a sprinkling of the sterner sex.'[108] Following 'the desire of the great English Universities to carry to the great mass of people information disclosed by the rapid advance of the natural sciences,' the University of Alberta established an extension department in 1912 which offered tutorial classes to working men, correspondence courses to those outside the city limits, and a travelling library to residents of isolated communities.[109] Eight years later the People's School was founded at Saint Francis Xavier University in Antigonish 'to help impoverished farmers, fishermen, lumbermen and miners to solve their problems through the formation of cooperatives and credit unions.'[110] And, in 1927, a radio station operated by Acadia University maintained 'an educational programme of high grade' by broadcasting, among other things, 'more good music ... than ... any other station' to listeners in Prince Edward Island, New Brunswick, and Nova Scotia.[111]

The idea that the university was not only the keeper of the moral and intellectual values of the country's élite but also had a role to play among its citizens at large was a function of the declining authority of the church, the rise of the social sciences, increasing public involvement in the financing of universities, the emergence of co-operative groups such as the Antigonish movement, post-war inflation, and, ultimately, the dislocation of world trade and the unemployment of the 1930s. All these factors worked together to shift many educators away from the notion that education's primary purpose was moral and patriotic; they began, as a result, to concentrate more attention on the teaching of technical skills, on helping the public understand political, social, and economic questions, and on orienting it towards international affairs. The conviction that 'continued learning throughout life was not only possible but necessary if democratic institutions were to survive' certainly motivated the formation of the Canadian Association for Adult Education.[112] Acting from 1935 as a clearing house for adult education programs in public and private cultural institutions and organizations, it sought to respond fully to contemporary circumstances: making 'bet-

ter citizens' might still be important, as University of Toronto president Sir Robert Falconer told the association in 1936, but it now had to be done 'by creating new interests' among the Canadian public.[113]

Notwithstanding its preoccupation with public affairs and the practical, the movement was far from neglecting cultural activity. As Walter Abell told a Maritime radio audience in 1935, there were four ways in which the arts could help mitigate 'the breakdown of civilization in the war and the depression.' The enjoyment of beauty 'brings us joy and peace'; the vision of the artist was a 'stimulus toward fine workmanship'; the 'love of art helps to make our country more beautiful'; and, finally, cultural activity could 'help us understand other countries.'[114] Given what so clearly seemed to be its 'practical,' 'contemporary' relevance, no small amount of attention was devoted to that activity. Concerts, lectures, play-writing competitions, exhibitions, study groups, conferences, dramatic productions, and festivals of music and drama were organized under the auspices of various adult education groups. Often these activities drew on university resources – drama and music groups, and faculty, in particular – and took place on campus. Equally, however, they might be conducted beyond the university gates. Extension departments at the Universities of Alberta, Saskatchewan, and Manitoba and provincial education departments in British Columbia and New Brunswick encouraged drama production in major rural centres by setting up play-lending libraries, by organizing festivals, and by sending instructors to coach amateur drama groups. Departments of Music at McMaster University, Queen's University, and the University of Saskatchewan conducted choral work, gave concerts, and sponsored lectures in music both on and off the campus. Classes in folk dancing, commercial art, and singing were given by the Department of Education in British Columbia's relief camps and at cultural recreation centres that were set up throughout the province 'for dealing with the leisure hours of the unemployed.'[115] At the University of Alberta an old Ford truck outfitted with picture racks, crates, and a slide projector, and accompanied by a lecturer from the extension department, took paintings, prints, and crafts borrowed from the Canadian Handicrafts Guild in Montreal, the National Gallery in Ottawa, and the Alberta Society of Artists to rural areas of the province. The same university established a permanent adult education centre off campus when it created the Banff School of Fine Arts, which offered courses in drama from 1933 and art and music from 1935. Not even those living beyond the radius of the extension circuit escaped. Concerts, plays, and lectures on art, litera-

ture, and music were broadcast by radio stations like the University of Alberta's CKUA that were owned and operated by extension departments. University and provincial government adult education programs not only provided an extensive network through which vast numbers of people became involved in cultural activity; they also gave the artists, musicians, dramatists, and others who ran the programs opportunities to practise their various crafts which could not have been found elsewhere. Ernest MacMillan's founding of the Sir Ernest MacMillan Fine Arts Clubs (1936) in secondary schools across the country gave him the chance to extend cultural activity well beyond the Toronto Conservatory of Music. McGill University's extramural relations department provided Montreal artists André Biéler, John Lyman, Elizabeth Frost, and George Holt with the resources they needed to found a progressively minded, unstructured art school modelled on the Art Students' League in New York. The Atelier, as it was called, became a 'God-send' to one student because it was 'the first sign of modern contemporary art in Canada.'[116] Herman Voaden's position as English teacher at Toronto's Central High School of Commerce gave him the base he needed to further his experimental work in the theatre of symphonic expressionism, and, in particular, the staging of plays with 'an exterior northern setting' consistent 'in mood or subject matter [with] the paintings of artists [which the dramatists] considered Canadian in character.'[117] Gwen Pharis Ringwood gained invaluable experience during 1936 when she produced half-hour radio dramas for the University of Alberta's CKUA radio station in a series titled 'New Lamps for Old.' And the same year composers Healey Willan, Leo Smith, and Arnold Walter established the Vogt Society through the alumni association of the Toronto Conservatory of Music, thereby creating a wider audience for the performance of works composed by Canadian musicians.

If musicians, dramatists, and painters could work through extramural programs and extension departments, they could also be – as the case of Elizabeth Sterling Haynes clearly shows – products of them. Haynes's interest in theatre was almost entirely a result of her sojourn as a student at the University of Toronto. Introduced to drama through the Victoria College Women's Dramatic Club (1917), of which she became president in 1919, she was 'totally converted to the cause of the theatre' by Roy Mitchell, the director of the just-opened Hart House Theatre. In 1922, a year after graduating, and with more directing and acting experience behind her, she moved to Edmonton, where she headed the University of Alberta's Dramatic Society. From 1929 she instructed teachers

of drama for the university and the provincial departments of education, became artistic director of the Edmonton Little Theatre (1929), and acted and directed in the province's Chautauqua drama festivals. In 1932 she became the first full-time drama instructor in the university's extension department. Five years later she took her enthusiasm, energy, and organizational skills to New Brunswick to assist in the establishment of a summer school for teachers of drama. Though hired for the summer-school term only, she remained a year, and when she finally left in the late summer of 1938 the province had a well-established drama school for teachers; as well, the University of New Brunswick Drama Society had an expanded repertoire; the province, a drama festival; teachers of drama, a play-lending library; and the province as a whole, the benefit of Haynes's instruction on the radio and in person, for she travelled eleven thousand miles over the course of the year.[118]

Notwithstanding that Madame Dandurand's 'Two Systems' failed to get established for lack of interest on the government's part, there was no shortage of instruction in the arts, or of people who took it seriously. Many were, to be sure, amateurs. Others were mainly educators. And even those who had credentials in the field in which they were working – MacMillan, for example – tended to see cultural activity as geared to some such purpose as nation-building or assimilation of immigrants or moral improvement. Spurred on by the declining authority of the church, the need to assimilate New Canadians, the rise of the social sciences, the growing importance of technology, the increasing presence of the university, and above all by the country's heightened sense of national awareness, institutions evolved to educate the professional and the amateur alike. They ranged from campus radio broadcasts, noon-hour concerts, continuing studies programs, and music and drama festivals to the founding of academies, conservatories, and departments of music, art, and drama within universities. And whatever form the education of the professional and the amateur took, it showed an awareness that culture was a key element in the building of a society, not just in the political sense, but in terms of what it could do to give that society's members a rounded, full, and developed sense of what a well-lived life might be.

THREE

'A Mad Desire to Bring About State Control': Government Patronage and the Arts

'When it was my privilege to arrange two or three Government House private film exhibits,' recalled R.B. Shaw of the Dominion Educational Film Association in 1935, 'I seemed to associate the fascinating Government House atmosphere with the ancestral dignity and solitary grandeur of some of those English and Scottish estates in which I learned [during the Great War] to appreciate the charm of Old Country life and hospitality.'[1] What one saw at Rideau Hall could no doubt make one think – as it so plainly did for Shaw – of the Old World. But it was what the governor general himself did that really permitted the viceregal establishment to conjure up a vision of the culture and civilization across the Atlantic.

From Confederation to the outbreak of the Second World War Canada's viceroys did more than any other group within the public service to give direction to the country's cultural life. At Rideau Hall they set an example through the paintings they hung on their walls and the musical and theatrical programs they organized for their own entertainment. Outside of their official residence they gave status to prize-giving ceremonies and to cultural events and organizations by attending them or merely by giving them viceregal patronage. Some established festivals of music and drama; others, academies of art. In doing these things governors general were recreating the cultural environment they had left behind them and setting standards of taste and excellence for the budding dramatists, writers, composers, and performers in their midst. They were also fulfilling what many of them considered to be their mandate: unifying the culturally diverse and geographically dispersed

people of the Dominion through exposing them to the institutions, sentiments, and culture of Great Britain.

Canada's third governor general, the Earl of Dufferin (1872–8), certainly believed 'the cultivation of art to be a most essential element in our national life.'[2] It was during his term that the idea for a Canadian academy of fine arts patterned after Britain's Royal Academy (1768) – which had in its turn been inspired by France's Académie Royale de Peinture et de Sculpture (1648) – was first suggested. That organization, however, did not come into being until the Marquis of Lorne and his artist-wife, Princess Louise, arrived in Canada. Only then was the Royal Canadian Academy of Arts finally established in 1880 'for the purpose of cultivating and improving the arts of painting, sculpture, architecture, and industrial design.'[3] A sponsor of annual exhibitions to which its forty elected academicians and associate members contributed, an organizer of schools of art in various Canadian cities, and a donor of travelling scholarships to promising young painters and sculptors, it also awarded medals and, from its diploma works, established the National Gallery of Canada.

On a broader front, the Marquis of Lorne also encouraged work in the humanities and sciences through his efforts to have a Royal Society of Canada incorporated in 1882, and he actively sought a home for the nation's heritage in the form of a national museum. Music, too, received viceregal attention. Wanting, as an Ottawa official put it, to 'raise the standard of musical education throughout the Empire,' Lord Aberdeen encouraged the Associated Board of the Royal Schools of Music to introduce their examination system into Canada in the mid-1890s.[4]

The usual practice, however, was not to bring in institutions from Britain, but to foster and encourage local ones. This was done in a variety of ways. Lord Lorne simply attended the Art Association of Montreal's inauguration of its permanent gallery in 1879. Lord Dufferin accepted the honorary presidency of the Ontario Society of Artists and used the position to 'chat about art, and [to offer] some good advice to the younger artists ... in a delicate way' at its May exhibition in 1878.[5] Lord Minto did much the same at the Royal Canadian Academy of Arts exhibitions in 1901 and 1902. Princess Louise gave the painter F.M. Bell-Smith letters of introduction to her mother, Queen Victoria, which eventually resulted in a much praised portrait of Her Majesty that became a permanent fixture at the National Gallery of Canada. And Lord Aberdeen gave the Iroquois poet Pauline Johnson a similar entrée

into British society in 1894, introducing her to the colonial secretary, Lord Ripon, and thereby opening the door to his and several other fashionable London drawing-rooms.

British governors general were moved to act in this and similar ways for several reasons. They all found Canada at a 'rather crude and material stage' of its development, thanks, as Earl Grey put it, to the fact that 'the energies of the people are concentrated on laying the foundations of future greatness, and there has not been sufficient time to develop the artistic and idealistic qualities of the people which are still lying to a great extent dormant.'[6] The regional orientation of English Canadians was a continuing concern: 'A chief danger in front of Canada,' as Grey put it in 1911, 'is the possibility that conflicting interests between the east and the west may give birth to a movement in favour of disintegration.'[7] The presence of immigrants – what Lord Bessborough identified in 1933 as 'alien elements' – also caused disquiet.[8] Speaking in Winnipeg – a city already well versed in the immigrant 'problem'[9] – he told the Canadian Society of Painters in Water Colour (1926) that 'the central culture of civilization [comprised] that great tradition which is the heritage of the English and French peoples.' There might be, he conceded, 'other cultures in the world,' but, he warned, 'they are not ours and ... do not mix well with ours.'[10] Overcoming all of this – frontier rawness, regional division, ethnic and cultural incoherence – was, the governors general thought, a priority and, they concluded, there was no better way to do it than through the encouragement of the kind of national culture that would at once refine, unite, and make Canada British.

If Dufferin and Lorne had done much in the 1870s and 1880s towards accomplishing this goal, it was Earl Grey who carried their work forward in the early twentieth century. Believing, as he told the Empire Club in 1910, that the time was coming when 'Canada will be the Heart, Soul, and Rudder of the Empire,' he moved in several ways to give it the kind of cultural self-consciousness that would, in his view, help it to perform the duties soon to devolve upon it.[11]

Canadian writers with the right sort of national-imperial outlook were encouraged. Stephen Leacock was sent on a lecture tour of Britain, Australia, New Zealand, and South Africa in 1907, and Grey arranged for purchase of an entire printing of Robert Stead's *The Empire Builders* (1908) because he liked the way the book dealt with practical matters – it warned 'the country against the oriental menace' – as well as

the way it treated issues of morality and character – particularly in its exploration of the contrast 'between the artificial city and the broad, unmolested prairie.'[12]

Grey also concerned himself with the encouragement of an historical consciousness among Canadians, and, indeed, subjects of the Empire at large. Seeing 'an opportunity of teaching every boy in the Empire something about his own history,' he got the Plains of Abraham recognized as an historic site and set up the Historic Landmarks Association of Canada in 1907.[13] A year later he saw in the tercentenary of Champlain's landing in Quebec an 'instrument for welding more closely together the two races and nine provinces of the Dominion, and for planting in the hearts of the People, particularly of the children the ideals and sentiments of Patriotic love and loyalty.'[14] It also provided an opportunity for the link between culture and nationalism to be made explicit. During the week-long 'monster pic-nic' staged on the Plains of Abraham Iroquois Indians made speeches in their own language, five hundred musicians and vocalists performed a symphonic ode telling 'the complete story of the discovery of America,' and, crowning these events, there was an historical pageant in which actors portraying Montcalm and Wolfe, among other historical figures, 'marched together in one grand parade of honour.'[15]

A particularly important element in Grey's strategy concerned music and drama. The way in which the tercentenary celebrations in Quebec had worked to stimulate, as one observer put it, 'an interest in our national life never before manifested in Canada,' was, of course, obvious. And the Musical and Dramatic Trophy Competitions served a no less 'useful political purpose in helping to consolidate British North America.' 'How frivolous this will sound to you,' Grey wrote to London concerning the Winnipeg festival in 1911, 'but please realise that there is more politics than frivolity in this movement.'[16] The festivals which were held from 1907 to 1911 brought what Grey called 'teams' together from across the country, so that they might 'fraternize' and thus create a sense of identity for the whole Dominion through music and drama. They also gave the participants 'an opportunity of expending their energies on something more ennobling [sic] than the hunt for dollars.'[17] That these competitions were not especially successful – the audience at Toronto's festival in 1910 was, according to a reporter for the *Toronto Star*, 'composed largely of Toronto's wealthy and fashionable folk ... evidently failing to have the popular appeal of regular theatrical productions' – and that they were not continued by Grey's

successor, the Duke of Connaught, does not alter the fact that they made clear the relationship that was held to exist between culture and national consolidation.[18]

When the festival movement was taken up again by the governors general at the end of the 1920s, the national dimension was still very much present. It could be seen in Lord Willingdon's establishment of the Willingdon Arts Competitions for Excellence in Music, Literature, Painting and Sculpture (1928), and it was particularly clear in Lord Bessborough's founding of the Dominion Drama Festival four years later. By encouraging originality, and recognizing exceptional merit, in the work of the country's leading cultural producers, Willingdon hoped to make the capital, in his words, 'the great centre for the encouragement of all the important finer arts and crafts.'[19] While Bessborough wanted 'to see, as a normal part of our life in this country, dramatic performances of plays by Canadian authors, with music by Canadian composers, with scenic decorations and costumes by Canadian artists, and with Canadian performers,' his interest in theatre was more than merely political.[20] A gifted amateur actor, he had built a theatre for the performance of amateur theatricals on his Stanstead Park estate in Portsmouth, England. Upon coming to Canada in 1931 he became active in the Ottawa Little Theatre and, as honorary president of that organization, took a direct interest in the kinds of plays that were staged, seeing to it as well that his eldest son, Lord Duncannon, obtained a leading part in several of its productions. He was not content, however, to be involved in theatre at a merely local level, and his concern to have, as it were, a larger stage on which to play had no small part in his decision to press for the formation of a national organization for the encouragement of drama. But though his personal predilections clearly moved him towards the cultivation of theatre, he remained mindful throughout of the 'Canadian,' 'national' dimension. Accordingly, when the Dominion Drama Festival was founded in 1932 – he was its honorary president – it offered a special prize for the best Canadian play. Provincial lieutenants-governor served as its presidents. The prime minister, leader of the opposition, and provincial premiers were vice-presidents. And the organizers sought to give it prominence by making its final competitions Ottawa's 'grand social affair of the year.'[21] (The black-tie affairs, composed 'almost exclusively' of the upper class, were held in what one observer described as 'the lovely "lushness" of the Chateau.')[22] But though all of this did focus a certain attention on what amateur groups had been doing for years, it did little to generate new

activity. Its pretentiousness, moreover, made it a ready target for such radical journals as *Masses*, which criticized it on the not unwarranted ground that it was 'duping the public into believing that what is taking place is the birth of a "National Drama" which finds its source in the great spiritual reservoir of the Canadian people.' But while it never, in consequence, entirely succeeded in justifying Bessborough's belief that 'drama can be made not only an artistic but a great educational influence,' it did give theatre in Canada more in the way of prominence and attention than it had ever had before.[23]

As patrons of institutions, organizations, and programs already in place, Canada's viceregal couples were highly selective. Anything with an ethnic component would be likely to find itself ignored – the case with Winnipeg's New Canadian Festival in 1928, Regina's Great West Canadian Folk Songs and Handicrafts Festival of 1929, and the Folk Festivals held in Vancouver during the 1930s. Concerts and festivals of a 'native,' 'indigenous' character would do a little better. Earl Grey presided over Edmund Morris's 1905 exhibition of native Indian artefacts and his portraits of Chief Poundmaker, Big Bear, Crowfoot, and others, and, in 1927 Lord and Lady Willingdon attended Juliette Gaultier's performance of northern Alaskan, Copper Indian, Inuit, Ojibway, and West Coast Indian songs, as well as 'chansons populaires' – all of which Gaultier sang in the original language while attired in traditional native dress. Most favoured of all were institutions and organizations with a measure of 'British' content. The Earl and Countess of Minto attended the opening of the 1903 First Cycle of Music Festivals, the aim of which was 'to lay hold and fast to the *best* and all that is the best which Great Britain can give unto us in music and talent.'[24] The Duke of Connaught presented certificates to the successful candidates of the Associated Board of Royal Schools of Music while visiting Calgary in 1912. And Lord and Lady Athlone gave their patronage to the Hart House String Quartet in 1940. Almost any organization which patterned itself after a British model could expect viceregal support, as such groups as the Canadian Federation of Music Teachers' Associations, the Canadian Guild of Organists – after 1920 known as the Canadian College of Organists – the Canadian Authors' Association, and the Sculptors' Society of Canada soon found out.

The extent to which the governors general favoured cultural activity consistent with what they saw as the country's British and imperial character was particularly clear in the case of Lord Tweedsmuir. What he approved of possessed, of course, a 'national' cast. As early as 1924,

visiting the country privately as writer John Buchan, he had paid 'warm tribute' at a joint meeting of the Canadian Authors' Association and the Canadian Historical Association 'to much he thought was good in both Canadian literature and Canadian art.'[25] And during his term of office he gave clear encouragement to Canadian writers, dramatists, and painters. He had, he wrote in 1936, 'long followed with interest the movement among Canadian artists to provide a fresh and idiomatic interpretation of Canada's wonderful and most varied landscape.'[26] He found the Canadian Authors' Association's suggestion that a national literary award be established 'admirable.'[27] He would, he insisted in 1939, 'do anything in my power' to support the Dominion Drama Festival, for it was 'a vital element in the integration of the whole country.'[28] That his interests were elsewhere than in the fostering of a uniquely Canadian cultural life was made clear, however, when he stressed before the Canadian Bookman's Association in 1936 the importance of uplifting and improving immigrants who did not have 'much of a literary education behind them, and in whom the reading habit will have to be carefully fostered.'[29] His broader concerns were evident, too, in his insisting to the University of Toronto's Canadian Poetry Night in 1937 that while 'Canada must make her own music,' she must also have a 'proper respect for, and a more intimate knowledge of, the great masterpieces.'[30] Nationalism, he implied, could too easily become particularism, and nothing was more clearly the enemy of the broad, uplifting, imperial spirit he was above all interested in encouraging.

Notwithstanding their frequently obvious predilection for the British and imperial, the governors general got a wide measure of support among members of English Canada's cultural community, many of whom, anxious to have the recognition of persons generally considered to be of taste and cultivation, sought viceregal attention in a quite vigorous way. When Earl Grey arrived in Canada, he was invited by F.M. Bell-Smith, president of the Ontario Society of Artists, to become that society's honorary president on the ground that his 'education and environment in the old land will lead you to sympathize with us in our purpose to promote in this country all that is most desirable in a national Art.'[31] Working through its president, Sir Edmund Walker, the Mendelssohn Choir invited the same distinguished personage to attend one of their concerts in January 1908. (After the performance Walker wrote Grey that his presence had been 'a great satisfaction and pleasure to the choir.')[32] And when Lady Tweedsmuir selected thirty contemporary Canadian canvases for the walls of Rideau Hall in 1936, art critic

G. Campbell McInnes wrote in *Saturday Night* that 'such an act as this cannot but be of great encouragement, especially for younger artists, while the pictures will be seen by all those who visit Government House, and our native Canadian art brought to the notice of people who, in the ordinary course of events, might not make its acquaintance.'[33]

It was, then, little wonder that Prime Minister Mackenzie King, taking his cue from all this, could invite Tweedsmuir to become honorary president of the National Gallery in 1935, on the ground that (as he confided to his diary) 'more could be achieved in this way, for the unity of Canada generally, than in almost any other way.'[34] Whatever may have been the governors general's own motives for interesting themselves in Canadian cultural life, that interest was generally perceived by English-speaking Canadians as a positive good.

Mackenzie King was far from the only prime minister to be concerned with the relationship of culture to the national life. Throughout his prime ministerial career, Sir Wilfrid Laurier spoke publicly and privately in favour of government support for the arts. In 1896 he told the future editor of the *Canadian Annual Review of Public Affairs*, J. Castell Hopkins, of a scheme whereby the government would honour and encourage scientific and literary work by offering monetary awards.[35] The same year he spoke to another acquaintance of his intention of making Ottawa 'the seat of learning, arts and letters of the Dominion.'[36] He was reported as saying at the unveiling of his official portrait at the parliament buildings in 1902 'that sometime he might ask that the walls of the House of Commons might be adorned with scenes of the history of our country, painted by Canadian artists.'[37] The following year he informed those attending the opening of the annual exhibition of the Royal Canadian Academy of Arts 'that he had been told by the minister of finance that there was now a surplus revenue of thirteen million dollars and he hoped the day would soon come when a portion of that sum could be devoted to the encouragement of Canadian art.' Artists, he concluded, should visit him in Ottawa where 'he would be pleased to do all in his power to help.'[38] Even near the end of his long tenure as prime minister, he was speaking in similar terms, alluding on one occasion 'to the necessity of [having] more art education and monumentation in our cities and towns.'[39]

Mackenzie King was capable of speaking no less enthusiastically. At a

reception for a National Gallery exhibition of Dutch and Flemish painting in 1929 he talked of art 'surviving political institutions' and of his government's willingness to provide a building for the Gallery 'if given enough time.' Speaking as leader of the opposition at the Dominion Drama Festival five years later, he not only advocated that the government provide a building in which to house the National Gallery but suggested that a national theatre as well as a national opera might share the gallery's space in a building devoted solely to the arts.[40]

The conservative prime ministers of the period, it must be said, tended to talk less and do more. At the outbreak of the First World War Robert Borden responded to suggestions that artists be sent to the front to paint the war for Canada by asking National Gallery officials to report on the feasibility of so doing. Four years later, when the work of Canada's war artists was about to go on exhibition at Burlington House in London, he took a few minutes from his preparations for the Paris Peace Conference to open what became known as the Canadian War Memorials Fund Exhibition. In 1920 Arthur Meighen presided over the opening of Carroll Aikins's Home Theatre in the Okanagan. During the Depression R.B. Bennett contributed to the cultural life of Winnipeg by allocating federal funds to a civic and provincial relief project which provided for the construction of the Winnipeg Auditorium, an eight-hundred-seat concert hall; and in 1935 he resurrected the granting of titular honours, abolished in 1919, and awarded knighthoods to composer Ernest MacMillan, writer Charles G.D. Roberts, and painter Edmund Wyly Grier and made novelist Lucy Maud Montgomery and tenor Edward Johnson officers of the Order of the British Empire. This kind of recognition, according to a writer in the *Curtain Call*, made it 'now possible to refute the common fallacy that work by Canadians in the arts must be of some definitely inferior calibre which must be treated with patronizing enthusiasm.'[41] Bennett also gave his rather less than keen approval ('grudging,' one commentator called it) to the awarding of $2,500 a year to 'the founder of the Canadian school of writers, [and] Dean of his Craft,' Charles G.D. Roberts.[42] The pension, first awarded in 1934, was made on the condition that the destitute poet, now seventy-one, head a committee to investigate cultural conditions in Canada. The report was never made, but the grant was paid annually until Roberts's death in 1943.

Much of the enthusiasm prime ministers showed for cultural activity was the product of something other than personal taste and preference. Laurier's claim that 'there could ... be no national life without litera-

ture, art and science' was no doubt related to the general euphoria with which the country's prospects were being viewed at the turn of the century and may even have reflected an awareness of the Dandurand Committee's recommendations concerning its proposed 'Two Systems of Art Education.'[43] Borden's decision to hire war artists followed upon action already taken by Lords Beaverbrook and Rothermere to inaugurate a program by endowing it themselves. Bennett responded to the plight of Charles G.D. Roberts only because the poet was a fellow New Brunswicker and because repeated pressure had been brought to bear on him by the concerned writers and literary critics associated with the Arts and Letters Club and the Canadian Authors' Foundation.[44]

That enthusiasm, moreover, frequently had its limits. Despite his claim in the House of Commons that 'literature plays a large part in determining the national character of a people,' the Depression gave Bennett all the reason he needed to do nothing in regard to W.A. Deacon's proposal calling for a government subsidized committee of authors and critics to administer pensions, cash prizes, and literary awards. 'I fear that the present is not an opportune time,' he wrote to a disappointed Deacon, 'to discuss a subject which I cannot but say is of very great importance.'[45] Mackenzie King, when he became prime minister, adopted the same attitude. When the leader of the Co-operative Commonwealth Federation, J.S. Woodsworth, suggested in the House in 1935 that some recognized method of providing for destitute authors such as Roberts be established, King all but ignored him.[46] He may have 'long felt we should have, in Canada, a federal Department of Fine Arts' to support artists, writers, and musicians, and he may have believed that the theatre was 'a mirror of the problems of life' capable 'of revealing the problems of the people,' but he made no effort to give it, or any other kind of cultural activity, the sort of support that establishing such a department would have meant.[47] The public encouragement he gave to the idea that an art gallery and a theatre should be built, along with the private encouragement he extended to Vincent Massey, who repeatedly hinted that the Massey Foundation might provide the funds for these buildings, were a manifestation of his interest in beautifying the country's capital, rather than promoting Canadian art and culture as such.[48] The same was true of his obsession with the tablets, sculptures, and memorials which he helped design and place, as well as fund. That obsession was rooted, not in a concern to encourage, employ, or celebrate the country's sculptors, but rather in an interest in beautifying the nation's capital and enhancing his own self-image. His lack of real

interest in cultural affairs was clear, too, in such things as his reaction to Pelham Edgar's 1936 suggestion that they discuss 'literary affairs in Canada' with, no doubt, the idea that the government do something about them. 'The pressure of public business' was, he told the Toronto-based literary critic, too great to permit such a meeting.[49] He did allow the soprano Sarah Fisher-Carrick to speak to him about the possibility of raising funds to establish a national opera in 1930, but was unwilling to offer assistance and in the end regretted that he had agreed to hear her out.

There were many reasons why prime ministers were frequently unsympathetic to individual or collective appeals for their support and incapable of conceiving an overall plan for government sponsorship of cultural activity. They could feel, with some justification, that enough was already being done thanks to the existence of such bodies as the Royal Canadian Academy and the National Gallery of Canada. Tangible gestures of support – an annual subsidy to the Royal Canadian Academy of Arts, the handing over of the auditorium of the Victoria Memorial Museum 'lock, stock and barrel' to the Ottawa Drama League for the production of its plays – had been made to certain individual organizations.[50] Nor were there cultural programs elsewhere that might have been adopted. Britain's Education Act of 1918 empowered local education authorities to make grants to local museums, but this was no model for a government which had no jurisdiction over educational matters. Nor was Britain's National Trust (established as a private venture in 1897 and then taken over by Parliament in 1907) or Pilgrim Trust (founded in 1930 with a two million dollar donation from the American railway baron Edward Harkness for the purpose of helping preserve Britain's cultural heritage) a suitable model. The European countries' well-endowed systems of cultural support (rooted in the patronage of the church, the guild system, the aristocracy, and the merchant class) generally catered only to the 'high' arts – a practice that would have been criticized in Canada as élitist. In the United States the Works Progress Administration's Federal Art Project, which had put thousands of writers, artists, musicians, and dramatists to work since 1935, did offer an example of how a 'democratic' government could become involved in the arts, but it was found wanting too. It did not form part of Bennett's abortive 'New Deal,' and Mackenzie King rejected it as well: it grew out of what he called a 'mad desire to bring about State control and interference beyond all bounds' and made him 'shudder.'[51]

Something that made it particularly easy for the cultural community to be disregarded was that it often spoke with a divided voice. John Edward Hoare, J.M. Gibbon, and Merrill Denison, among other commentators, felt that the government had no business promoting cultural activity.[52] J.A. Radford, Fred R. Mackelcan, and numerous others advocated just the opposite.[53] With such opposing views any issue concerning the government's involvement, such as the proposal in the late 1920s for a nation-wide chain of government-owned theatres, polarized the community and brought insufficient pressure to bear on the government. Prime ministers, finally, were sometimes inhibited in their response to culture by a basic lack of comprehension of the cultural enterprise and by a fundamental conservatism. Borden's public statement at the opening of the Canadian War Memorials Fund Exhibition that it was fitting 'that Art, the handmaiden of civilization, should be called upon to interpret the meaning of war' found its private counterpart in his admission to his wife that he had neither understood nor appreciated much of the modernist work on display.[54] Mackenzie King willingly read the poems of Wilfred Campbell and E.J. Pratt – *The Titanic* (1935) had been sent to him by the author – and he enjoyed listening to the Hart House String Quartet, found the Inuit and Indian songs interpreted by Juliette Gaultier appealing, made a point of attending the Dominion Drama Festival's final competitions – he especially liked the Canadian play *Twenty-Five Cents* (1936), by W. Eric Harris – and he supported the acquisition by the National Gallery of paintings by Homer Watson, an artist who represented stability, tradition, and the celebration of the romantic past. Yet he was 'shocked' by the 'barbaric' totem poles that flanked the doors of the Canadian pavilion at the Paris Exposition in 1937 and found modernist Canadian painting, especially that of the Group of Seven, 'frightful.' Finally, in the work of Tom Thomson and Lawren Harris, he noted in 1934, 'decayed trees' were 'made to do duty as works of Art.'[55] In his view, in sum, art had to reflect Canada's wealth and be securely rooted in European, preferably British, traditions: anything else was suspect.

Much, then, was left undone that might have been done, and for a variety of reasons. It still remained true, however, that prime ministers had paid more than lip service to the idea that cultural activity should receive government support and sponsorship. And not only had they often taken what amounted to a personal interest in that activity; their governments had been responsible for a number of well-known initiatives from all of which artists profited directly. Writers, certainly, bene-

fited from the copyright revisions of the early 1920s; dramatists, actors, composers, and musicians, from the formation of the CBC in 1936; and film-makers and artists, from the establishment of the National Film Board in 1939.[56] The time, as Ernest MacMillan put it in 1936, might not yet be 'ripe for government subsidies [to the arts] except in isolated cases,' but there was movement and it was not to be disdained.[57]

If artists and others were benefiting from the actions of government, the most obvious way in which this was happening was through the various forms of patronage it extended. Cultural producers were employed by all levels of government to help memorialize national heroes, commemorate historic events, and celebrate official ceremonies. Artists and sculptors received public commissions to design monuments, coins, and plaques, and to paint portraits. For major commissions such as the Baldwin-La Fontaine memorial, the statue of Sir Wilfrid Laurier, and the Canadian National War Memorial – all located in Ottawa – the Vimy Memorial, near Arras, France, and the new Canadian coins designed after George VI ascended the throne in 1937, artists were selected through competition. Sometimes – as was the case with the Logan memorial commemorating the Province of Ontario's first official geologist, Sir William Logan, and the stone cairn erected in memory of Pauline Johnson in Vancouver's Stanley Park – commissions were awarded outright. And frequently those charged with doing historical paintings and portraits did not have to compete; for example, Robert Harris received $4,000 (an impressive sum in 1883) for *The Fathers of Confederation*, done to celebrate 'those who consolidated the great Dominion,' on this basis.[58] Those doing portraits and busts of contemporary figures were also often selected directly. Ontario's Department of Education commissioned artists to produce contemporary portraits and busts to decorate the corridors of Queen's Park and to adorn the walls of the Normal School's picture gallery until 'the government's art acquisition program fell victim to the fiscal austerity demanded for the war effort in 1914.'[59] The government of that province also commissioned Edmund Morris to paint 'as many Indian chiefs and headmen as he could persuade to sit for him' when he accompanied the James Bay Treaty Commission to northwestern Ontario in 1906.[60] (The expedition produced not only portraits of Ojibway and Cree native Indians, but also a collection of poems – *Lunday's Lane and Other Poems* [1916] –

by Duncan Campbell Scott, who as secretary to the Department of Indian Affairs was the expedition's leader.) The next year the Ontario government asked Morris to go north again, and in 1909 the governments of Saskatchewan and Alberta agreed to his suggestion to paint portraits of Indian chiefs for the walls of their new legislative buildings.

Sometimes, of course, the process by which government commissions were awarded did not benefit Canadians. It was the English artist Richard Jack whom the Ontario government selected in 1938 to paint the portrait of former Lieutenant-Governor Herbert Alexander Bruce; another Englishman, sculptor Vernon March, won the coveted right to execute designs for the Canadian National War Memorial in 1926; and the British painter Frank Brangwyn was hired by the Manitoba government to memorialize Canada's soldiers in the rotunda of the province's legislative buildings. Perhaps most strikingly of all, only forty-three of the approximately one hundred and twenty artists hired to depict Canada's involvement in the Great War for the Canadian War Memorials Fund were Canadian.

Generally, however, these sorts of commissions did go to Canadians, and even in the case of the Canadian War Memorials Fund, the Canadians involved – and, for that matter, the Canadian art scene in general – benefited enormously. They were enabled to continue with their work during the war; that work itself underwent a profound change, for the dominating image of the war – the bleak front-line trenches – deeply affected the way they would perceive the Canadian landscape when they returned home; the exhibition of their war work in Toronto, Montreal, Ottawa, London, and New York brought them into contact with the country's leading art officials as well as important art critics and patrons elsewhere; and the program as a whole marked the first time the government entered into the business of subsidizing artists in any large-scale way.

The precise kind of government involvement in the arts that the Canadian War Memorials Fund seemed to presage did not, to be sure, come about, for, with the arrival of peace, interest in the paintings and sculptures of the wartime period flagged and, along with it, any thought that support for artistic work be continued. The fact, however, that the program was replaced by a concern with the building of cenotaphs and memorials meant that – whatever one may have thought of these objects as art (in 1915 A.Y. Jackson had unhappily forseen a time when 'monuments will disfigure every town and village in the country'[61] – a number of the country's most able sculptors and painters were

kept at work on assignments from the federal government's Historic Sites and Monuments Commission and from provincial and civic governments across the land.

Government sponsorship of pageants and ceremonies offered yet another vehicle for the subsidizing of work by artists, writers, and musicians. Vancouver's Dominion Day and Coronation Celebration in July of 1902 saw that city engage local bands, native Indian groups, and a school chorus of some 250 children to help celebrate the occasion. Prince Edward Island's 1903 celebration of the one hundredth anniversary of the arrival of the twenty-two Brundenell pioneers involved it in commissioning Mrs J.S. Brennan to write a commemorative poem on the subject. Vancouver marked its Golden Jubilee in 1936 with a historical drama, 'The Romance of Vancouver,' produced on the world's largest outdoor revolving stage. In 1937 the City Council of Winnipeg honoured the coronation of George VI by commissioning the composer Livingston Greenwood to write an anthem. On no occasion, however, was it clearer how this sort of activity might stimulate the arts than on the warm July day of 1927 when the Diamond Jubilee of Confederation was celebrated on Parliament Hill. Not only were addresses given by the prime minister, the leader of the opposition, and the governor general; and not only was Lord Willingdon's *Suite* played by the Chateau Laurier Orchestra; Bliss Carman read the poem 'Dominion Day, 1927,' written especially for the occasion; the Hart House String Quartet played French Canadian folk-songs orchestrated by Ernest MacMillan and Leo Smith; Eva Gauthier and the Hiawatha Quartet sang French-Canadian airs in their original form; and, just before the fireworks, the Dominion carillonneur, Percival Price, played 'O Canada,' 'The Maple Leaf,' and 'God Save the King.' The sound of the newly installed carillon was, thought Mackenzie King, a little disappointing – especially when it was obscured by an airplane circling the Peace Tower during Price's performance. But the occasion, the first to be broadcast across the country by CNR radio, was a success and a very clear indication of the kind of relationship existing between the state and culture.[62]

If governments frequently involved cultural producers in overtly patriotic exercises, they could also support their work in relation to other kinds of undertaking. Eager to preserve what remained of Canada's indigenous cultures and to overcome the lead taken by the foreign museums which had for so long been acquiring native Indian artefacts, the National Museum of Canada (1841) acted in 1926, 1927, and 1928 to commission artists Annie Savage, Edwin Holgate, George Pepper, Pegi

Nicol MacLeod, A.Y. Jackson, and Florence Wyle to accompany the energetic government ethnologist Marius Barbeau to British Columbia, where they made sketches or modelled sculptures of native Indian villages and the fast deteriorating totem poles towering above them. Holgate, in particular, 'found the experience profoundly melancholy' because, as he later recalled, he 'felt we were witnessing the rapid decline of a splendid race of creative well-organized people.'[63] He nonetheless produced many fine canvases as well as a mural for the one-hundred-foot-long tea-room, 'The Skeena Room,' in the new wing of the Canadian National Railways' Chateau Laurier in Ottawa. All the artists, in fact, found new themes for their work in the totem poles and villages of the Upper Skeena River. What resulted, along with the paintings of artists such as Emily Carr, was exhibited alongside West Coast Indian artefacts at the Exhibition of Canadian West Coast Indian Art jointly sponsored by the National Gallery and the National Museum at the Victoria Memorial Museum in December 1927.

Barbeau himself had begun his field work by recording the songs of the Huron and Salish Indians on wax cylinders (since deteriorated) in 1911 and 1912 and by collecting the folk-songs of the French-Canadian habitants living on the banks of the St Lawrence in 1916. The results of his field work – to be found in several song-books – enabled vocalists Juliette Gaultier, Charles Marchand, and Jeanne Dusseau to popularize both native Indian and French-Canadian songs throughout Canada.[64] Awareness of that work also prompted Ernest MacMillan to accompany Barbeau to the Nass River in northern British Columbia, so that he might learn how to transcribe native songs into Western musical notation. The few weeks MacMillan spent with Barbeau in 1927 were sufficient to convince him 'that the music of the West Coast Indians was not only an interesting field for ethnological research, but that with some adaptation it was quite capable of interesting and pleasing the average music lover.'[65] Though by the early 1930s a reaction had set in among British and European composers 'against excessive nationalism in music' and 'against the abuse of folk song material,' MacMillan nevertheless transcribed three West Coast Indian songs into works for voice and piano.[66] (Duncan Campbell Scott provided the lyrics.) The same year, 1928, MacMillan and Barbeau published a song-book, *Twenty-One Folk Songs of French Canada*. This activity led other Canadian composers – Healey Willan, Alfred Whitehead, and Leo Smith – to put the melodies of Canada's indigenous peoples and French-Canadian habitants into symphonic and choral form too.

Frequently state support for cultural activity took the form of indirect assistance rather than direct commission or the hiring of artists and writers. In 1927, for example, A.Y. Jackson and the amateur artist Frederick Banting were able to extend their sketching grounds to the Canadian Arctic by joining the government supply ship SS *Beothic* on its annual voyage to Ellesmere and Baffin islands. F.H. Varley journeyed to the same region in 1938 courtesy of the eastern Arctic patrol ship RMS *Nascopie*. Government initiatives in preserving large areas of forest, wildlife, and tourist-attracting curiosities, such as sulphur hot springs and geysers, also had a role to play in fostering cultural activity. Beginning in 1885 with the founding of Rocky Mountains Park at Banff, activities of this sort preserved virgin sketching grounds for individual artists as diverse as Augustus Kenderdine, Tom Thomson, Emily Carr, and W.J. Phillips as well as for groups such as the Alberta Society of Artists and the Group of Seven. Living in Riding Mountain National Park in Manitoba and, later, Prince Albert National Park in Saskatchewan allowed Archie Belaney (Grey Owl) to study the antics of his two pet beavers Jelly Bean and Rawhide and to write his books on the conservation of wildlife.[67] The relationship could also be reversed; Trout Lake in northern Ontario was given park status by the Ontario government and renamed Lake OSA after the Ontario Society of Artists brought pressure to bear on the government to preserve it as a sketching ground.

Government involvement in exhibitions and trade fairs, begun following the Great Exhibition of the Works of Industry of All Nations at the Crystal Palace in London's Hyde Park in 1851, offered artists, writers, and others certain opportunities. Artists displayed their sculptures, paintings, and craftwork in the art section of every international exposition.[68] They received commissions to decorate Canada's fair pavilions.[69] And working through organizations such as the Canadian Authors' Association, writers saw to it that their work was displayed at such fairs as the British Empire Exhibitions at Wembley. They also joined less conventional advertising campaigns such as the federal government's thirty-car Canadian exhibition truck-train which visited twenty-nine cities in France and Belgium in 1923. Among the display stalls, the dioramas, and the films advertising Canada as 'the granary of the World' was a selection of books in French and English by Canadian writers.[70]

Government-sponsored film production also provided an opening for cultural producers. The Department of Trade and Commerce's

Canadian Exhibition and Publicity Bureau – later the Canadian Motion Picture Bureau – founded in 1916, was the first federal film agency in the world. Also at work were the Ontario Motion Picture Bureau and the British Columbia Patriotic and Educational Motion Picture Bureau. What got done might show little awareness of the new cinematic techniques developed by the social-realist or expressionist film-makers of Russia, Germany, and France but 'in its hey-day during the 1920s,' the Canadian Exhibition and Publicity Bureau's 'one-reel travelogues and industrial shorts' made it 'the acknowledged world leader in the use of film for public purposes.'[71] Thus even prior to the founding of the National Film Board in 1939 Canadians were making, and earning a reputation for making, documentary shorts.

State involvement in radio also created a place for the growing number of writers, dramatists, actors, and musicians the country was producing. Expanding the opportunities created by early private programming and Canadian National Railway broadcasts – they ranged from performances of Montreal's Balalaika Orchestra to the reading of poetry by W.J. Drummond and Pauline Johnson – the 1930s saw a large measure of Canadian acting and writing talent employed. The decade began with the Canadian National Railway's historical drama series 'The Romance of Canada.' Following the creation of the Canadian Radio Broadcasting Commission in 1932 and from it the Canadian Broadcasting Corporation four years later, programs such as Don Henshaw's Toronto-based documentary drama series 'Forgotten Footsteps,' Rupert Caplan's Montreal-based religious series 'And It Came to Pass,' Tommy Tweed's first Canadian radio serial from Winnipeg, 'The Young-Bloods of Beaver Bend,' the series 'Opening Nights,' featuring stories by Canadian authors, and 'The Canadian Theatre of the Air' gave all those concerned in their production unimagined outlets for their work. And the CBC did much, too, for the country's musicians. It broadcast the Toronto Philharmonic Orchestra's 'Prom' concerts from the Varsity Arena; it launched a major orchestral series with the Montreal Symphony Orchestra; it formed a small orchestra under Geoffrey Waddington and broadcast the series 'CBC Music House'; and it recorded live performances of the CNR's resident hotel orchestras. Even those involved in the visual arts found an outlet. Artists Annie Savage and Elizabeth Styring Nutt, art critics Robert Ayre and Graham McInnes, National Gallery director Eric Brown, and various others all broadcast on the subject of painting and sculpture during the 1930s.

Important as it was, all of this activity could be no real substitute for

a sustained, well-funded, and comprehensive program of support for the arts. In relation to only one area, however, did the government show any inclination to move in this direction, that of painting, sculpture, and the building up of a national collection in these and related areas.

The National Gallery of Canada was established in 1880 as a result of the founding of the Royal Canadian Academy of Arts by the Marquis of Lorne. For the first thirty years of its life it was largely a repository for government purchases, donations, bequests, commissions, and the diploma works of the academy's forty academicians. Its curators were drawn from the design staff of the Dominion Chief Architect's Branch of the Department of Public Works. Its premises were always temporary. The small collection was first housed in the Clarendon Hotel on the corner of Sussex Drive and George Street. It got two sky-lighted galleries next to the Supreme Court building in 1882. Then, in 1887, it moved to a small and dingy room in the mansard-roofed, government-run museum in Victoria Hall, which it shared with an ichthyological display and the building's major attraction, a fish hatchery exhibit, for the next twenty-five years. Throughout this period the Gallery had no advisory committee or board of trustees and no exhibition program until repeated pressure from the Royal Canadian Academy finally combined with the government's growing interest in the city beautiful movement to produce a result.[72]

When this happened in 1907, the government established a three-person Advisory Arts Council 'to assist and advise the Government through the Hon. Minister of Public Works in all matters in connection with the expenditure of public funds for objects of art when requested; and to assist and advise the Government in all activities requiring correct artistic judgement.' Its object was to promote 'the growth of a true taste and general interest in public Art amongst the people of Canada.'[73] Initially the Advisory Arts Council played a modest role. Its three members – of whom Madame Dandurand's husband, Senator George Dandurand, was chairman – met at irregular intervals to adjudicate commissions for public monuments, supervise plans for federal buildings, and decide what Canadian works should be purchased from the Gallery's $10,000-a-year budget. But neither the council's activities nor the Gallery's presence on O'Connor Street was really felt until 1910. That year the Gallery got a full-time curator in the person of Eric

Brown and an increased budget totalling $35,000. Two years later, when 'the flowering of the City Beautiful in Canada' was at its height, the Gallery was given the top three floors in the east wing of the Victoria Memorial Museum.[74] (This was a much more imposing location despite the fact that visitors sometimes reached the Gallery by passing through the museum's hall of dinosaurs.) In 1913 the Gallery was incorporated by an act of Parliament, its operating budget increased to $50,000, and the Advisory Arts Council made into a board of trustees appointed by the governor general and fully responsible for operating the Gallery. This marked the beginning of the displacement of the Royal Canadian Academy as the nation's chief tutor in artistic matters. It was now becoming clear that businessmen, civil servants, and philanthropists were in the process of becoming the country's arbiters of artistic taste.

At the outset Eric Brown and his assistant from 1919, Harry O. McCurry, set numerous goals for the Gallery and its small staff: 'to preserve standards of great art' by acquiring an important collection of foreign paintings and sculptures; to create a national school of Canadian painting; and to make both collections known at home and abroad.[75] Brown felt that the acquisition of 'great art' would make 'Canada conscious of the arts as an element in civilization' and, at the same time, stimulate 'the production in Canada of works of art on an increasingly high level.'[76] It would also instruct Canadians in general as to tastes and standards and, most important of all, enhance the country's prestige, for as Brown wrote in 1913, 'No nation can be truly great until it has a great art.'[77]

The acquisition of old masters was Brown's major pursuit during the early years of the Gallery's post-1910 history.- From 1913 he, along with his wife, Maud, and Gallery trustee Sir Edmund Walker, made several collecting trips to Europe. There they not only bought works for the Gallery but commissioned British, German, and Dutch commercial gallery dealers as well as British and Canadian art historians and curators to buy for them too. Brown soon found, however, that acquiring important pictures and sculptures was no easy task. 'Things are getting scarcer & scarcer,' he complained to McCurry from Europe in 1923.[78] 'The gallery which wants to build up a sound and comprehensive collection of the arts,' he wrote three years later, 'has to take its chances as they come.'[79] But while the Gallery had come late into the field and while Brown was not a particularly experienced buyer in the international art market, he, McCurry, and their European agents were never-

theless able to lay the base of a wide-ranging collection which boasted fine examples of Peter Paul Rubens, Paulo Veronese, Constable, and Canaletto, among others.

The sheer difficulty of acquiring 'great art' during an era 'of high prices, and severe competition from American museums' made Brown urge Canada's artists to develop their work 'along national lines.' Brown's British background – he had come to Canada in 1909 – had done much to impress upon him the importance of this kind of effort. The Tate Gallery, the first of its kind devoted to British painting, had been established during his formative years in London, and a decade later St Ives's Newlyn School of Painters, of which his brother Arnesby was a member, was challenging the country's European-influenced academic artists with work that was uniquely British. Not surprisingly, then, Brown took an interest in, and tried to encourage the emergence of, a similar national group in Canada. Shortly after arriving he noted that 'a national spirit [was] being slowly born' among the younger generation of artists.[80] In 1914 he observed the further 'progress of a school or group of young painters who will be really Canadian and national in their work.'[81] And by 1916 he was convinced that there was 'no lack of talent in Canada' only a dearth of 'encouragement and appreciation.'[82] The outbreak of the First World War, of course, played no small part in the strengthening of Brown's interest in things Canadian. Denied the opportunity to travel and the money to acquire new works, he, along with McCurry and the energetic chairman of the board, Sir Edmund Walker, turned his attention to the artists in his midst by becoming involved in the Canadian War Memorials Fund. Initially this shift involved little more than suggesting to Lord Beaverbrook, the fund's organizer, the names of artists who were best suited to paint the war abroad. Soon, however, the three were supervising artists in the recording of war-related activities on the home front, becoming, as a result, acquainted with the younger generation of Canadian painters. This development not only brought them into closer contact with people Walker had once described as 'intolerable' but also exposed them to artists – mainly in the Ontario Group of Seven – who had, they became convinced, the potential to form a national school of painting for Canada.[83]

The Group appealed to Brown and McCurry – not to mention Walker and the small group of intellectuals and businessmen centred around the University of Toronto and the Arts and Letters Club – for several reasons. First, its work was not too advanced – an important

consideration for Brown, who 'condemned Futurism and other distortions of art,' and for Walker, who also abhorred what he saw as extremism in art.[84] It did blend elements of commercial art nouveau and Scandinavian Symbolism, but it could also be represented, in F.B. Housser's words, as drawing 'its inspiration from the backwoods' and being 'inspired as the result of a direct contact with nature.'[85] It thus occupied a kind of middle ground between modernist and traditional modes of painting – the 'modern painter in Canada,' as A.Y. Jackson would tell the Empire Club in 1925, 'is not much concerned with abstract problems in art' – and so conformed perfectly to the Canadian prejudices of the day.[86]

Second, it appealed because, as historian Frank Underhill was to argue in 1936, it captured the wilderness in a way that made one think that in having contact with the cottage country north of Toronto – where most of the Group's work was done – one was in touch with the raw, untamed forest frontier itself.[87] In thus representing the accessible and familiar as something distant, remote, and challenging, it allowed the city-dweller – and Brown, McCurry, and Walker were certainly city-dwellers – to feel that he or she had some direct and immediate contact with the nature and wilderness which, it was beginning to be argued, defined the national character.

Third, these men were drawn to it because insofar as it had a kind of philosophical, intellectual content, that content was one with which they were very comfortable. Christian Scientists like Brown or Walker could find much to approve of in the transcendentally inspired work of Theosophists like Lismer and Harris, while those – F.B. Housser was one – who subscribed to Theosophical ideas themselves were bound to approve.

Finally – and on quite a different level – the Group's work (and the work of Canadian artists generally) appealed because of its attractive prices. While the National Gallery might not have been able to purchase often expensive and difficult-to-get European works, it certainly could afford Lawren Harris's *The Drive* at $400 in 1912 or three Emily Carr watercolour paintings for half that price twenty years later. Gallery officials thus found in the Group of Seven – and in those artists who shared their approach to Canadian painting – what it wanted: an art which seemed Canadian, which was born of the land, which was complementary to their spiritual beliefs, which was affordable, and which was free from both the stodgy traditionalism of many Canadian

painters and the modernist extremes of Europe's more advanced artists. Brown, convinced that he had found a national school of painting, certainly did everything in his power to make the Group's work known. He exhibited it at home and abroad, made silkscreen prints and post-card reproductions of it for distribution, talked about it when he travelled across the country to lecture or when he spoke on the radio, and arranged for the Gallery to purchase a considerable number of its canvases. And all of this was of critical importance, for while others, such as C.W. Jefferys and his associates at the Toronto Art Students' League, had been dealing with 'all manner of northern Canadian subject-matter' since the 1890s, and while Maurice Cullen might, as an irate friend exclaimed, have been 'tramping on snow-shoes in the Laurentians and exhibiting ... pine trees [and] frozen rivers at the Paris salons when Lawren Harris was still at his ABC's,' they lacked the kind of organized support the National Gallery was able to provide and so remained relatively obscure.[88] As A.Y. Jackson wrote to his friend Mortimer Lamb in the early 1930s, 'We artists go on existing thanks to a few enthusiasts and Eric Brown.'[89] Hardly an exaggeration, Jackson's observation accurately reflected the fact that no group of Canadian artists has had a keener or more powerful patron, something which permitted this work – despite its regional character and derivative style – to emerge as the national school of painting.

Brown and the Gallery were active in other ways as well. In the early 1930s Lilias Torrance Newton was asked by Brown to paint his portrait. *Portrait of Eric Brown* 'was important to the development of Newton's reputation,' winning her further commissions from Vincent and Alice Massey, H.S. Southam, the federal government, and various provincial institutions.[90] Brown also arranged a portrait commission in 1936 for the destitute F.H. Varley, getting him in touch with the wealthy businessman H.S. Southam, thus giving Varley 'the opportunity to come east and make a start in a new environment which might be more sympathetic and appreciative than that of the Pacific Coast.'[91] The National Gallery itself purchased three of Emily Carr's watercolours, leaving Carr, as she put it, 'fearfully excited' because the purchase 'will help me and enable me to go north this summer.' The Gallery's arrangement of a Canadian Pacific Railway pass for Carr was also 'a great help' for it made possible her extraordinarily productive trip to the North in 1928.[92] Walter J. Phillips, too, was assisted by the Gallery. 'Very seriously embarrassed financially,' he asked Brown 'to buy my two

lectures.' The following month a cheque arrived, and 'for the first time in months,' Phillips told McCurry in gratitude, 'the rent is paid up to date.'[93]

The Gallery not only fostered and encouraged Canada's artists at the same time that it was building a prestigious collection of European works; it did much to make its collections known to Canadians. A program of travelling exhibitions, modelled on the French government's system of lending works to provincial galleries, was inaugurated in 1913 when the Gallery sent a selection of works to the Saint John Art Club. The scheme, according to one reporter, was likely to encourage the development of Canadian art in several ways:

It will directly benefit the artist whose work of art is purchased; it will benefit the exhibition from which the work of art is purchased in that it will encourage the artist to send his best work there; it will benefit the National Gallery by permitting a wider choice for the artists's representation there; it will stimulate the formation of art societies and schools throughout the Dominion by providing them with the nucleus of an exhibition of the work of Canadian artists, and it will benefit the individual who is able to visit these exhibitions by giving him some knowledge of the art of his country, and so, perhaps, inspire him with the desire to possess it himself.[94]

The program became fully operative in 1916 – thanks to the disaster that befell the Parliament Buildings that year. Their destruction by fire made it necessary for members of Parliament to occupy the National Gallery's premises, and that, in its turn, allowed the Gallery – indeed required the Gallery – to distribute its collection throughout the country.[95] So successful did all of this become that one Vancouver organization could suggest in 1926 'that the B.C. Art League in cooperation with associations in the West take steps to promote the establishment of branches of the National Gallery throughout the West.'[96] And by 1931 McCurry could boast that 'our efforts are now beginning to rapidly bear fruit and one of our main objects, the rousing of local interest to the point of establishing municipal art galleries and schools is now being realized with surprising swiftness.'[97]

Complementing the travelling exhibitions at home and abroad was the Gallery's nation-wide lecture program. Eric and Maud Brown made the first lecture tours, singing the praises of the Gallery and of the artists they chose to support wherever they happened to be. In 1921 they went to Winnipeg 'on a mission ... of telling [that city] something

about the history and growth of Canadian art and all it could and would do for the common weal when the need was seen and genius harnessed to the task.' They also spoke 'at luncheons and at Canadian clubs, at formal evening lectures, and informal receptions afterward.'[98] Six years later, still involved in what had become a very worthwhile exercise, and still very much concerned to promote Canadian art, they told a Victoria audience that in Emily Carr 'you have here in Victoria one of the most interesting painters in the whole of Canada.'[99] Not content to stop there they went on to praise other British Columbia painters such as Victoria's Ina D.D. Uhthoff and Vancouver's Charles Scott and J.W.G. Macdonald.

The lecture tour became, in fact, one of the National Gallery's most used instruments for the promotion of art. Lismer travelled west four times between 1928 and 1935. Phillips, art history professors John Alford and Walter Abell, and the prestigious British art historians John Constable, Eric Newton, and J.E. Barton all crossed Canada in the service of the Gallery. Talks were also given in the Gallery itself. Brown, McCurry, and others talked of the great art of the past, related contemporary art to industry, and spoke of native Indian art, craftmaking, and art's relationship to everyday life. All of this – the lectures, the travelling exhibitions, and the distribution of reproductions and post-cards of works in the collection – reached a climax in 1939 with the founding in the Gallery of the National Art Centre. Arthur Lismer, who headed it, offered a weekly public lecture, gave demonstrations in modern art teaching, held Saturday morning art classes for the children, and made lecture tours across the country. By doing these things Lismer was fulfilling his long-held belief that the art gallery had moved 'out of the narrow possessive atmosphere of a few who desire to see art retain the element of pride of possession in a few chosen works – into a sphere of service.'[100]

In all that they did Brown and McCurry were very much aware of the bureaucratic exigencies of their position. They worried about budgets, about having a building of their own, and about staff, skilfully manoeuvring among the country's politicians, the Gallery's board of trustees, and, above all, the artists, art critics, and the cultural community in general.

The National Gallery was of course subject, as were all institutions dependent upon the public purse, to economic, social, and political constraints. First war and then the Depression diminished its budget, made the purchase of important European works and the running of

the National Art Centre difficult, put an end to the hoped-for new building, and terminated moves towards 'the formation of a Canadian Society for the aid to the National Gallery along the lines of the [British] National Arts Collection Fund.'[101] Political interference presented another problem. Mackenzie King annoyed Brown and McCurry by pressing them to purchase the work of his friend, the academic artist Homer Watson. Various members of the House of Commons criticized the Gallery's buying policies and its requests for increasingly large sums for acquisitions. In 1924 one member of Parliament even wondered whether the Gallery's acquisition budget could not be cut altogether to serve as an example of government restraint.[102] On another occasion government officials vetoed the Gallery's purchase of Jacob Epstein's bronze portrait of Ethiopian emperor Haile Selassie 'on the absurd ground that its purchase would be regarded as an indication of Government policy in the Italian-Abyssinian War!'[103] While prime ministers, members of Parliament, and government bureaucrats may have agreed with MP William McQuarrie that the Gallery was 'something we should all be proud of,' pressure was nevertheless constantly brought to bear upon it and upon its officials.[104]

Difficulties, too, were created by the fact that the board of trustees and the politicians who hovered around it were often divided over the competence of the Gallery's director and his assistant. Sometimes it was merely Brown's Englishness, his high-pitched, slightly nasal voice, his 'unfortunate manner,' and his tweed jackets which led one irritated official to exclaim: 'Why doesn't he throw the monocle away and wear eye glasses and become a Canadian.'[105] More often, the complaints were serious. According to Brown, one trustee sought to make him 'a continual scapegoat for imaginary gallery shortcomings.'[106] McCurry, for his part, was brought by trustee Newton McTavish before the Civil Service Commission 'in an attempt to frame me and destroy my clear record of twenty years.'[107]

In addition to dealing with board members, prime ministers, and the bevy of government bureaucrats surrounding them, Brown and McCurry had to placate the cultural community and the general public. The Gallery was not merely a storehouse for works of art, a museum displaying artefacts. It was an institution intent on setting standards of excellence. This was accomplished by purchasing and exhibiting works of art. Whom the Gallery chose to support often made or broke an artist's reputation and frequently his or her livelihood. One of the Gallery's greatest problems was setting standards and, at the same time,

catering, as a national institution, to the country as a whole. Not surprisingly there was continual criticism over what the Gallery chose to buy and whom it chose to exhibit. First, the Advisory Arts Council, then the board of trustees, was chastised for purchasing more European than Canadian works. 'Rumour has it,' went one complaint in 1913, 'that the board sometimes leans unduly to old masters, and spends a disproportionate amount of money on them.'[108] (This charge was echoed a year later in a letter to the Toronto *Globe* by Lawren Harris.)[109] After the First World War, during which Brown and the board began to purchase more Canadian works, there were criticisms of a different kind. Now the Gallery was accused of having an 'obsession in favour of one school of Canadian painting' – the Group of Seven – which meant that 'certain standards of poetry and beauty ... [were being allowed] to languish and die.'[110]

Criticism became even more hostile when the Gallery failed to include a broad selection of artists in its major exhibitions. Controversies arose over the Gallery's selection of works for the 1924 British Empire Exhibition at Wembley – it included only one work from British Columbia and five from western Canada as opposed to one hundred and twenty from the central part of the country. Artists were equally outraged over the choice of work for the Annual Exhibitions of Canadian Art held in Ottawa from 1926, as well as the Exhibition of Canadian Art at the Jeu de Paume in Paris in 1927, and the Sesquicentennial Exhibition in Philadelphia a year earlier. Feelings reached a climax in 1932 when a group of artists emerged who, according to Brown, were determined 'to establish control of the National Gallery' and thereby, as he saw it, crush 'out any freedom of art in Canada.'[111] Over one hundred artists sent a petition to the governor general the burden of which was 'that until a radical reform has taken place in the management and policy of the National Gallery at Ottawa, particularly in the selection of pictures for its annual show, and for representative Canadian exhibitions in Britain and abroad they ... [would pledge] themselves to refuse to send any of their works to the National Gallery or to any exhibition initiated by it.'[112] This was countered, some months later, by a document in which three hundred artists professed their confidence in the Gallery's fairness 'to all Canadian artists and all phases of Canadian art' and in its director, Eric Brown.[113]

No matter what it did to assuage the anxieties of the country's artists – and notwithstanding its support of Emily Carr – the National Gallery of Canada remained centralist in outlook. Ideas, such as those offered

by Winnipeg's Walter J. Phillips for films, demonstrations, lectures, and the founding of a magazine devoted to Canadian art, were simply not taken up unless their author was close at hand to lobby for them. And not only was the Gallery centralist: it catered to one medium – paint – and one style – exemplified in the 'conservative modernism' of the Group of Seven. Painters such as Bertram Brooker, Kathleen Munn, and Lowrie Warrener were too advanced for it, while academicians such as Homer Watson were dismissed as too traditional. Even when it came to the European field, it did not look much beyond its own resources. The Montreal Museum of Fine Arts, only a day's train ride away, had little contact with it, notwithstanding that institution's interest in the art of the Old World. If, however, the Gallery's singlemindedness was a weakness, it was also a strength, for its capacity – and especially Brown and McCurry's capacity – to concentrate resources in one area does much to explain why it was able to make the transition from being an institution largely under the thumb of the governor general, and then subject to the influence of the Royal Canadian Academy of Arts, to one run by laymen and bureaucrats for the benefit of a wider audience. In this the National Gallery's experience was no different than that of such institutions as London's Tate Gallery also faced with the need to escape the control of a very narrow group.

The goals set out by Brown in 1913 were accomplished by his death in 1939. The Gallery had assembled an impressive collection of old masters. Through its unfailing support of the Group of Seven and like-minded painters it had established a national school of painting. It had developed a far-reaching educational program consisting of lectures, exhibitions, reproductions, and an Art Centre. To be sure – and the point will be explored below – private patronage and foreign philanthropy played an important part in all of this. But none of it could have been sustained without the steady, continuous, and direct support of the Canadian government, which was persuaded that painting and sculpture, more than any other form of art, had a permanent, tangible character. 'These,' said a member of Parliament in 1938, 'are the things that last. When we pass away these elements of art, whether carvings in stone or paint on canvas or music on paper, are the things which will be Canadian.'[114] Officials of all kinds were therefore prepared to support the visual arts, in a measure that would allow them not only to develop domestically, but also to take their place 'on the foreign maps.'[115]

The obverse of this granting of a privileged status to visual arts was that other kinds of cultural activity, such as music and drama, were

neglected. This was more than just the result of visual arts being fa-
voured as a nation-builder: many of those active in other fields simply
failed to understand that what the government had done – however
imperfectly – for painting and sculpture it could do for other kinds of
cultural activity, and so they did not make the appropriate kinds of
demand. Concentrating instead on the seeking of special benefits for
themselves, particular groups – Dandurand's and the Allied Arts Coun-
cil were exceptions – failed in these years to develop any kind of picture
of what government might do specifically to foster and encourage cul-
tural endeavours. And since governments themselves had little sense of
this, the activity undertaken by governors general, prime ministers,
civil servants, and government departments, remained concerned only
with some of what might have been done. Nonetheless all levels of
government did do much to support the arts during the years prior to
the Second World War. Sometimes it came indirectly, almost by default,
through the founding of national parks and a radio broadcasting sys-
tem, by sending a supply ship to the Arctic, or by participating in
international trade fairs. At other times, especially when the governors
general and, less frequently, prime ministers were motivated to consoli-
date the country, strengthen British and imperial ties, and memorialize
the country's past, it came more directly in the establishment of a na-
tional gallery, the celebration of national holidays and pageants, and the
holding of music and drama festivals. Whatever form it took and for
whatever reason it was taken, it does much to challenge the popular
view that government patronage of the arts began only with the found-
ing of the Canada Council in 1957.

FOUR

Volunteers, Subscribers, and Millionaires: The Character of Private Patronage

Views of the relationship between private philanthropy and culture varied as much during the first forty years of the century as did opinions regarding government patronage. While there was a widespread feeling that 'the generosity of wealthy Canadian citizens' had not 'been awakened,' no one could agree as to why this was so.[1] Some blamed the country's youth and rawness. 'Culture is born of leisure and the refinements of existence, the love of the beautiful, or taste in literature or art,' the critic and art patron Mortimer Lamb wrote in 1908, 'usually require for their development a more congenial and peaceful environment than that engendered by the pioneer's hard struggle.'[2] English Canada's preoccupation with building railroads, with ploughing fields, and with establishing financial institutions left many people, so the argument went, with little time to read, listen to music, attend art exhibitions, and partake in activities which might lead them to found galleries, music schools, theatres, and concert halls. 'Music, like all other forms of culture[,] is a growth,' Sir Edmund Walker told the Mendelssohn Choir in 1917, and 'must be planted in the hotbed of leisure.'[3] Without leisure time there would be no aristocracy from whom standards of taste and appreciation as well as financial support through endowments and bequests would come.

Others blamed the paucity of private patronage on the failure of English Canada's wealthy to spend their money inside the country. With its 'oriental rugs, three ormolu clocks, walnut tables, chairs covered with rose brocade, imitation Constables surrounded by ponderous

gilt frames, two bronze statuettes on marble bases and several Dresden figures' – all imported from Europe – Huntly McQueen's drawing-room as described in Hugh MacLennan's 1945 novel *Two Solitudes* could have been that of railway baron Sir William Van Horne, shipping magnate Robert W. Reford, Canada Steamship Lines president William H. Coverdale, or any other prosperous turn-of-the-century English-speaking Montreal collector.[4] 'These Canadians with money are a bad lot,' Duncan Campbell Scott complained to the painter Clarence Gagnon in 1926; 'they would rather spend $5,000 on an inferior Dutch painter than $700 on a Canadian masterpiece.'[5] The vogue for collecting Dutch art – it prompted the dry-goods merchant E.B. Greenshields to write *Landscape Painting and Modern Dutch Artists* for his fellow Montreal collectors in 1906 – was not due to a lack of Canadian paintings. According to Eric Brown, Canadian 'artistic production' was, by 1913, 'increasing in leaps and bounds in quality and quantity.'[6] Yet collectors preferred acquiring foreign work because the possession of a European or British scene wrapped in 'a landscape like wool' won for its owner a reputation for cultivation, affluence, and good business sense.[7] There was, too, a distinct feeling that 'the growth and enlargement of private collections...[was] one of the signs that a nation is emerging from its adolescence.'[8] A wealthy English Canadian, therefore, amassed old masters 'partly as a business investment, partly because he liked them, but chiefly to help his social status by housing something rare, precious and of proven value.'[9]

The tendency to collect European work notwithstanding, there was a general conviction that Canadians of wealth and status lacked refinement and cultivation. Novelist and short story writer Robert Barr wrote in 1899 that his fellow citizens might have money 'but would rather spend it on whisky than on books.'[10] In 1911 Governor General Earl Grey accused Canadians of possessing what he felt was a unique North American disease; they were 'Dollaristic,' involved in pursuing money for its own sake.[11] In 1929 the journalist Martyn Howe charged that 'American materialism' – along with the country's immense size – was responsible for the absence of an aristocracy which would support art and literature.[12] And even when they did support cultural activity, it was not at all clear that this was done with any real understanding or sympathy. After seeing Montreal's wealthy at the concert debut of the soprano Pauline Donalda in the Montreal Arena in 1906, the budding musician George Brewer noted in his diary:

The boxes and centre seats were filled with society bugs – men in the conventional evening dress and women with scarcely any dress whatever ... And yet these fat, red-faced, pasty looking creatures of society are 'patrons' of music and art. These idiotic asses who know of no other gods than money and dress and who look down in a lofty way at all 'petty' artists, these d----d fools are 'patrons.'[13]

Seeking to acquire status by attending cultural events and by collecting works of art, borrowing standards of excellence and taste from older and more seasoned cultures, these specimens perfectly embodied what Thorstein Veblen described as 'conspicuous consumption.'[14] They were, as well, being led by their concern to associate themselves with established, status-conferring activity to the neglect of the cultural work being done in their midst.

Some observers thought that the wealth which the country was so clearly generating would be bound to lead to support for cultural activity. 'We have reason to believe,' the historian Sir John Bourinot wrote in 1900, 'that the material success of this confederation will be fully equalled by the intellectual efforts of a people who have sprung from nations whose not least enduring fame is the fact that they have given to the world of letters so many famous names that represent the best literary genius of the English and French races.'[15] There was, to be sure, some dissent from this proposition. Prosperity, thought John Murray Gibbon, could breed a softness and luxury not really conducive to work of the proper sort: 'the artificial stimulus of wealth is not likely to produce a greater or more distinctive Canadian literature than we already have.'[16] Generally, however, opinion tended to agree with Bourinot. This did not mean that the impulse to give always and immediately resulted in support for culture. The sick and the poor, who were assisted by established charities along with religious organizations, usually had priority, for cultural activity was still widely viewed either as entertainment – a commercial enterprise that could pay for itself – or as a part-time amateur activity not needing, and certainly not deserving, any help whatsoever.

The tax system, too, worked against cultural philanthropy. Beaverbrook and Rothermere had been able to get the Canadian War Memorials Fund recognized as a charity under the British War Charities Act of 1916, but the situation in Canada itself remained clouded until changes in the Income Tax Act in 1930 allowed corporations to give up to 10 per cent of their net taxable income to charities, with 'cultural' organiza-

tions such as the Winnipeg Foundation and the Canadian Association for Adult Education usually qualifying.[17] Even the attitude of the beneficiaries themselves sometimes discouraged the well-to-do from supporting them and their work. Writers, musicians, dramatists, and artists, wrote one observer, had in fact acquired a reputation for thinking 'too little of the public who after all must be their customers.'[18]

All of this meant that 'private or institutional patronage remained an isolated phenomenon' in Canada during the four decades before the Second World War.[19] But if figures such as Ernest MacMillan found themselves looking 'with envy across the border where millionaires with a respect for culture and a sense of responsibility to the arts ... provided unrivalled opportunities for the young students [of music]' while at home 'our wealthier citizens' did relatively little, it most certainly did not mean that there was no activity at all.[20] Never, to be sure, as keen to contribute to the support of cultural activity as their American counterparts, the well-to-do in Canada nonetheless found themselves acting in ways altogether consistent with Bourinot's prediction.

The most obvious way for people to give to the arts in Canada was through an outright gift or bequest. New Brunswick shipbuilder John Owens thus left part of his estate 'to provide instruction in art and music for children,' a stipulation that led to the opening of the Owens Art School in Saint John in 1884.[21] In 1895 Donald Smith of the Canadian Pacific Railway set up a scholarship fund which sent young Montreal musicians to the Royal College of Music in London for three years of study. Nine years later, as Lord Strathcona, he endowed the McGill Conservatorium of Music. In 1903 Goldwin Smith bequeathed his Georgian mansion, the Grange, to the three-year-old Toronto Art Museum. This enabled the institution, renamed the Art Gallery of Toronto and now the Art Gallery of Ontario, to move in 1918 from rooms in the Toronto Public Library to a building of its own. Toronto financier Colonel Albert Gooderham and his wife, Mary, founded the Canadian Academy of Music in 1911 'for the purpose of keeping gifted students in Toronto and bringing outstanding teachers from Europe,' and during the 1920s they sponsored the New Symphony Orchestra's hour-long 'Twilight Concerts' at Massey Hall, which came 'as a blessing to the musicians, many of whom, previously engaged in picture houses, were thrown out of work ... [by the] "talkies." '[22] A collection of drawings,

paintings, and objects relating to Canadian history from the private collection of Montreal lawyer David Ross McCord established McGill University's McCord Museum in 1919. In Atlantic Canada, the family of artist Robert Harris donated $20,000 in cash and $60,000 worth of paintings from the artist's estate towards the founding of a public art gallery, prompting the city of Charlottetown and the government of Prince Edward Island to contribute $10,000 each. This in its turn led to the building in 1930 of the Harris Memorial Art Gallery. In 1929 Regina businessman Franklin N. Darke constructed the 740-seat auditorium, Darke Music and Arts Building, which provided facilities not only for students at Regina College but also for the Women's Musical Club, the Regina Symphony Orchestra, the Regina Philharmonic Society, and the Regina Little Theatre. The University of Regina also profited from the generosity of lawyer Norman Mackenzie, who left it his comprehensive collection of western Canadian and European paintings and sculptures along with enough capital to construct an art gallery in which to house them. Seventeen years later, in 1953, the Norman Mackenzie Art Gallery opened its doors.

Some individuals and groups were given accommodation and a hand in selling their work. Vancouver businessman and former mayor W.H. Malkin financed the construction of the Marion Malkin Memorial Bowl – a two-thirds-size replica of the Hollywood Bowl – in Stanley Park. A memorial to his wife, it served from its completion in 1934 as a summer home to the Vancouver Symphony Orchestra. In 1932 Rosa and Spencer Clarke of Toronto inaugurated the Guild of All Arts on a 16.2 hectare parcel of land on the Scarborough Bluffs known as Raelagh Park. Intended to 'revive an interest in arts and crafts' and thereby encourage people 'to earn their livings as artists by creating public acceptance of their work,' it provided one hundred local artists with equipment, material, and studios.[23] Finally, Edmonton merchant Richard Secord had other reasons for financing the Edmonton Newsboys' Band: he hoped to reduce juvenile delinquency by keeping the boys occupied during their leisure hours.

Many private patrons, of course, lacked the time, funds, or imagination to instigate projects of their own and so tended to give to organizations, institutions, or projects already in existence. In 1879 a generous bequest from businessman Beniah Gibb put the Art Association of Montreal 'on its feet' by providing it with a building on Phillips Square.[24] (It was the first public gallery erected in Canada.) *Ottawa Citizen* owner H.S. Southam floated a bond issue for Ottawa's Drama

League in 1915, thus permitting conversion of the Eastern Methodist Church into a five-hundred-seat theatre for the company. He also purchased works for the National Gallery of Canada and eventually gave his own collection of paintings to the same institution. In 1920 a generous gift from the Montreal merchant and educational philanthropist Sir William Macdonald allowed the McGill Conservatorium to become a faculty of music within McGill University. Edward Johnson, internationally acclaimed tenor and from 1935 the general manager of the Metropolitan Opera Company in New York, gave $25,000 to Guelph's Civic Board of Education, so that public schools might become a better 'means for giving music the place in North American life it ought to have.'[25] And Mrs B.T. Rogers, married to Benjamin Tingley Rogers of the British Columbia Sugar Refinery, purchased instruments and music for, and made up the annual deficit of, the Vancouver Symphony Orchestra from 1930 to 1950.

Private patrons were also motivated to give simply because they loved the arts. Frank Meighen's passion for opera compelled him to use his father's railway and milling-trade fortune to finance the short-lived Montreal Opera Company from 1910 to 1913. While Dr James MacCallum, an ophthalmologist with a flourishing private practice and an appointment at the University of Toronto, helped finance the construction of the Studio Building, which provided space for several artists in Toronto from 1914, supported A.Y. Jackson and Tom Thomson by guaranteeing them sales, and put his frame-and-shingle cottage in Go-Home Bay at the disposal of the Group of Seven. His love of the wilderness rooted in his early experiences – as a boy of eleven MacCallum had 'sailed and paddled' up the east coast of the Georgian Bay and later, in 1898, he had become one of the first members of the University of Toronto's alumni and faculty retreat at Go-Home Bay, the Madawaska Club – gave him an immediate 'sympathy for the grim, fascinating northland' depicted by the Group.[26] As A.Y. Jackson recalled, 'he knew and loved the north country and looked for the "feel" of it in pictures with the same sense a lumberjack has for the "feel" of an axe, or as the trapper has for a paddle.'[27] The realization that there were people of means willing to give to the arts made institutions and organizations cultivate the wealthy. While in London during the 1920s Eric Brown of the National Gallery of Canada was optimistic that he could persuade Vincent Massey and other well-to-do Canadians resident in Britain to contribute money to and use their influence for the benefit of the Gallery. By 1927 Brown's assistant, Harry McCurry, could boast to

Prime Minister Mackenzie King that 'we have succeeded in getting gentlemen of wealth and artistic taste to become sufficiently interested in the building up of the institution to be willing to make it a very fine and generous gift indeed.' 'Such interest, once started,' McCurry continued, 'is sure to spread and grow and it is to such public generosity that we should be able to look for a great deal of support.'[28] The Manitoba Society of Artists also attempted to cultivate patrons. It offered special art classes to businessmen 'as a means to secure a wider appreciation of art and as a consequence greater financial assistance.'[29] And Montreal's Contemporary Arts Society offered patrons associate membership in order to encourage them 'to give support to contemporary trends in art and to further the artistic interest of its members.'[30]

Sometimes businessmen did not need to be encouraged but would move to support cultural activity spontaneously and for reasons of their own. Their business sense itself might be the spur. Members of the Winnipeg Industrial Bureau suggested an art school for the city in 1912 because they thought 'commercial art was itself an industry sorely in need of development' and that 'better designed products would help Canadian industry compete more effectively abroad.'[31] While in Vancouver the same sort of thinking lay behind the British Columbia Art League's sponsorship of an art school and gallery. Occasionally a kind of civic pride, a simple conviction that action was necessary to enable a city to attain cultural standards it was capable of meeting but had not so far managed, was responsible for what they did. Vancouver businessman Harry Stone thus donated $50,000 to the British Columbia Art League after his city defeated two proposed bylaw changes in support of an art gallery. Inspired by his example, two hundred other citizens also gave. This led to the creation of a fund of some $130,000 which moved the city to make land available for the facility. On other occasions such action was explicitly founded on feelings that recalled those of seventeenth-century Dutch burghers anxious to make their cities centres of art and culture. Professing their belief 'that an art gallery would be a sign of cultural development that would lend eminence to their city and advertise its progressiveness beyond its borders,' members of the Winnipeg Industrial Bureau thus moved in 1912 to help their city get a Museum of Fine Arts.[32]

If there were many reasons to give, there were many ways in which giving could be organized. One of the most common was the group effort. Sometimes, to be sure, the 'group' was quite small. Lords Beaverbrook and Rothermere established the Canadian War Memorials Fund

with a donation of $25,000 each in 1916. Two years earlier Sir Edmund Walker, Joseph Flavelle, and Edmund Osler 'nobly came to the rescue' of the University of Toronto Musical Society, which had overextended itself by engaging artists it was unable to pay.[33] Donations from twenty-five citizens saw the Community Players of Montreal through their 1920–1 season. And long before this, sixty shareholders had come together to found the Toronto Conservatory of Music in 1886. More often, however, the number of patrons was not precise. In 1869 citizens in Halifax 'considered it absolutely ridiculous' that a city 'with a population of nearly 30,000 should not have "a respectable looking" Theatre or Concert Hall.'[34] In order to remedy this, associations were formed which took on the responsibility of erecting, among other buildings, the Academy of Music. Not to be outdone by their neighbour, a number of 'leading citizens' in Saint John formed broadly similar groups for the purpose of building four concert halls.[35] By 1872 the city was capable of entertaining between nine hundred and twelve hundred people at a time. Farther west, and much later, 'several benefactors were enlisted to cover the year-end deficit' of the Montreal Symphony Orchestra; 'a number of patrons made up of prominent, public spirited businessmen and professional men' saw Charlottetown's Little Theatre Guild through the season; and in Guelph wealthy residents came together to found the Guelph Italian Musical Club, all during the late 1930s.[36]

Important though this kind of action on the part of the well-to-do was, it did not dominate the process by which patronage was extended. Very much involved in that activity were people of more modest means, usually appearing in the guise of the private subscriber. What the Halifax Community Concert Association referred to in 1933 as its 'co-operative association of music lovers' did much to sustain it after its founding in 1931; while money raised through members' subscriptions permitted the Art Association of Montreal to build its 'noble museum' with a 'magnificent Greek facade and marble stairs' early in the twentieth century.[37] Admission to the performances of the Philharmonic Union Choir in the same city was by a ten dollar subscription, of which only three hundred were available. During the Depression Lethbridge, Alberta's, local amateur theatre charged 'subscribers' a bushel of wheat a seat for its performances, while the Community Players of Winnipeg, the Montreal Repertory Theatre, and most other amateur drama groups persuaded their patrons to purchase a fixed number of seats.

Subscriptions also kept art galleries afloat and helped to build their collections. A $50,000 subscription drive established the Toronto Art

Museum in 1900. The British Columbia Art League's gallery existed on annual subscription fees. The Memorial Art Gallery at Saskatoon's Nutana Collegiate Institute acquired funds for its impressive collection, including works by Florence Carlyle, G.A. Reid and F.M. Bell Smith, by forming a joint-stock company in which some four thousand students purchased shares over a five-year period. Symphonies, too, benefited. The Calgary Symphony Orchestra raised enough through subscription lists and guarantors to finance its first 1913–14 concert season – though the failure of the Digman oil discovery in the Turner Valley in May 1914 deprived the city council of the funds it would need to follow through, and so this second attempt to establish a symphony orchestra in that city failed.

A variety of devices were thus used to get money from those who had it to those who needed it. Little of what was done came with guarantees; most funding was one-time or short-term; but what was accomplished nonetheless permitted activity where none would otherwise have taken place and so, like so much else of what was going on, played its part in the laying of the country's cultural foundations.

If some patrons chose to give money, others elected to give time. This form of 'charitable' work was, like the giving of money, frequently a product of the liberal-capitalist-Protestant disposition to help those who were helping themselves, though it also had roots in the increasing tendency for women to be active outside the home. And, like the giving of money, it took a variety of forms. Marius Barbeau, Newton McTavish, Mortimer Lamb, and Duncan Campbell Scott sold paintings for their artist friends. Annie York Secord gave her energy to organizing the Edmonton Museum of Fine Arts. Mrs Erichsen Brown held exhibitions for A.Y. Jackson in her Toronto home when the artist returned from his annual spring sketching trip. On a more ambitious scale and at a time when artists were 'woefully divorced from the public,' art collector and book designer Douglas Duncan, with the help of art teacher H.G. Kettle and artist Norah McCullough, launched the Picture Loan Society. The Toronto group, established in 1936, had a dual purpose: to help young artists exhibit and sell their work and 'to promote a new understanding between the artist and the people.'[38] The venture made it possible for those unable to afford works of art to rent them for 2 per cent of their purchase value. And the artists who came to Duncan's

Charles Street West apartment-gallery, 'trudging the three flights of stairs with their portfolios or canvases under their arms,' had a chance to exhibit, rent, and even to sell their work. Though highly unorganized and unorthodox in his management of the society, Duncan nevertheless 'managed to aid and promote an extraordinary large number of artists.' His 'satisfaction came from what he could do for art and artists, not what he could do for himself, by collecting paintings.'[39]

Writers, too, received a similar kind of assistance. Peter McArthur arranged a reading recital for the destitute poet Bliss Carman when he returned to Canada in 1920 after years of living abroad. Literary men such as W.A. Deacon and Lorne Pierce 'recommended publishers to writers and writers to publishers, set up readings and literary tours, founded and edited literary periodicals, then wrote articles and solicited subscriptions for them, and tried to make sure that the right books were reviewed in the right places.'[40] In 1931, writers, critics, and publishers, along with representatives of the National Council of Women, the Canadian Authors' Association, the Royal Society of Canada, and the Association of Canadian Clubs, set themselves the time-consuming task of establishing 'a perpetual fund for the benefit of any man or woman of distinction in Canadian letters.'[41] Volunteer efforts by members of the Canadian Authors' Foundation raised substantial – though never sufficient – sums of money from private benefactors. Similar expenditures of time on their parts also played a major role in persuading the federal government to give Charles G.D. Roberts a pension in 1934.

These acts of service were not on so grand a scale, however, or of so diversified a kind as those carried out by Bank of Commerce president Sir Edmund Walker. Upon his death in 1924 Harry McCurry of the National Gallery lamented that when 'looking around for someone to do even a fraction of the things he did, one is astonished at the contrast.'[42] Possessing an insatiable curiosity, an unrelenting sense of duty to his fellow citizens, a romantic attachment to the exotic and no attachment whatsoever to any orthodox religion, Walker was the epitome of the independently minded private patron who gave his time and used his influence to help foster the kind of British-based cultural life of which he so enthusiastically approved. While he questioned the ability of both the government and the cultural community to manage cultural affairs, he had utter confidence in the capacity of the businessman to deal with them. With his organizational skills, his appreciation of painting, music, and the theatre – 'things which helped a nation just as much as tariffs or the actual making of money' – and, most important

of all, his sound financial judgment, the man of affairs could, Walker believed, bring much to cultural activity.[43] ' "We should feel," ' he told his banking colleagues in 1920, ' "that our business is not simply to build up our own private fortunes, our business is to build up Canada as a whole." '[44]

Taking his own advice very much to heart, Walker moved to encourage cultural activity not so much by giving large sums of money to cultural organizations – though the University of Toronto and the Toronto Art Museum, among other institutions, did benefit considerably from gifts from him – as by giving his time and using his influence. His sense of civic duty saw him participate in the founding of the Toronto Art Museum, take on the presidency of the Mendelssohn Choir, become a guarantor of the Toronto Conservatory of Music Orchestra, and play a leading role in establishing the University of Toronto's museum (the future Royal Ontario Museum) and the Toronto Guild of Civic Art. National pride made him urge the National Gallery of Canada's Advisory Arts Council, of which he was a founding member, to purchase more Canadian works for the Gallery even though he felt they were not up to the standard of those imported from Europe. It also accounted for his involvement in the Canadian Society of Artists, the National Battlefields Commission, the Manuscripts Commission of the National Archives, the Canadian Committee of the Canadian War Memorials Fund, and the Champlain Society. And, finally, his understanding of what the nation required to meet the challenges posed to it by French-Canadian and American influences led him to help found the Toronto branch of the Round Table Group in 1909.

McCurry's fear that he would find no one to take Walker's place was justified. Few had his energy, and, in any case, by his death in 1924 his kind of service to the arts was clearly out of fashion. This had happened partly because various levels of government, as demonstrated in the previous chapter, were becoming increasingly involved in the arts as in other areas of national life; it was owing in no small measure to the fact that artists and the cultural community in general were becoming more organized, forming societies and groups capable of handling their own affairs; and it also reflected how the country's British orientation was beginning to weaken. The coming to fruition of Walker's own work in getting business and culture to work together was another factor; and, finally, the new prominence of volunteer groups as against able individuals had something to do with it.

Critically important to the formation of those groups were, of course, women. Just as they formed art, literary, and dramatic societies and schools of music, art, dramatic expression, and elocution, so they came together as private patrons. Though frequently depicted in the fiction of the period as social butterflies preferring the bohemianism of the artist's studio or the glitter of the concert hall to the works which were actually being painted or performed, they were nonetheless exemplary voluntary patrons.

'The public interest in good music has during recent years been greatly fostered in the large town and cities in Canada, by the establishment of musical clubs,' wrote A.T. Drummond in *Queen's Quarterly* in 1901.[45] And, he could have added, these clubs were usually organized by women. As pointed out in chapter 1, the process usually began with women meeting for their own musical entertainment during the morning. Then, after a time, they would come together during the evening, perhaps in the local school auditorium or church basement, where professional as well as local amateur musicians would be featured, with the doors opened to the public. When pianist Louise McDowell returned to Winnipeg in 1904 following studies in Leipzig, she found that the Women's Musical Club of Winnipeg, whose members had previously 'met in one another's homes to keep alive the culture gained in former places of residence,' was now installed in the concert hall of the YMCA.[46] And not only did these musical groups entertain their members and even the public; they used what their concerts took in to offer scholarships and bursaries to students of music and also, of course, gave them a place to perform. In fact the Victoria Women's Musical Society – from 1930 the Musical Arts Society – existed 'primarily to provide the means of public performance to promising young musicians.'[47] The Calgary Women's Musical Club and the Vancouver Women's Musical Club also gave local musicians a 'critical but sympathetic audience.'[48] Such groups as the Women's Musical Club of Toronto even brought in musicians of international standing. Others – the Ladies' Morning Musical Club of Saint John, the Women's Morning Musical Club of Regina, and the Kingston Ladies' Musical Club – featured works by Canadian composers and invited such well-known English-Canadian musicians as Edward Johnson, Reginald Stewart, and Harry and Frances Adaskin to perform at their evening concerts.

Women not only patronized Canada's musicians and composers; they also gave their time and energy to the country's art and sculpture. From

1892 to 1914 the Women's Art Club of London, Ontario, 'sponsored exhibitions, bought the work of outside artists, arranged lectures and presented papers dealing with various aspects of art.'[49] The Women's Art Association, established in Toronto in 1890 with branches in other cities across the country before the turn of the century, arranged exhibitions, lectures on and by Canadian artists, as well as tours of artists' studios. When Emily Carr was in Toronto for the first time in 1927, members of the association's branch in that city took her to the Studio Building, where she met A.Y. Jackson, Carl Schaefer, and, more importantly, Lawren Harris. Later, in 1935, they sponsored an important exhibition of her oil-on-paper sketches at the Women's Art Association's premises on Prince Arthur Avenue.

Women were also involved in the exhibition, promotion, and sale of native Indian and New-Canadian arts and crafts. In fact they were largely responsible for creating a revival in craft-making in Canada, a process which began in 1896 when a committee from the Women's Art Association in Montreal became committed to 'reviving and making profitable all such crafts as could be carried out in the cottage or castle, in town or in the remotest part of the country.'[50] They staged a series of exhibitions of craftwork from 1900, opened a Handicrafts Shop, and in 1906 broke their ties with the Women's Art Association and incorporated themselves as the Canadian Handicrafts Guild with branches and displays in several towns across the country. From 1902 they sent handicrafts to trade fair pavilions around the world, organized craft classes, mounted native Indian tableaux, and encouraged native Indians and New Canadians alike to enter their craft competitions and attend their lectures. By 1910 the Canadian Handicrafts Guild had branches in Toronto, Prince Edward Island, Winnipeg, Kenora, Victoria, Vancouver, Edmonton, North Bay, and Mundare, Alberta.

The Canadian Handicrafts Guild and similar organizations – New Brunswick's Charlotte County Cottage Craft, the Saskatoon Arts and Crafts Society, the Ukrainian Women's Association of Canada, the Ontario Handicrafts Association of Canada, and the Don Valley Craft Guild – all shared an aversion to mass-produced goods. They also feared that the rural way of life, of which the arts and crafts and the family were so intrinsically a part, was being destroyed by the depopulation of the countryside and by the introduction of machinery into it. Craft-making, they believed, could offer a solution to some of these problems. It could 'give employment to those who would otherwise be in distress, thus giving them a chance to help themselves'; it could help

preserve the family and the rural way of life during an era of rapid social change; and, by serving 'the cause of National art,' it could create a base from which a national culture could grow.[51]

Men supported cultural activities in groups as volunteer patrons too. In 1915 forty businessmen in Winnipeg pledged 'to encourage and assist anything for the promotion, extension or elevation of the art of music.'[52] The Men's Musical Club brought distinguished international performers to its two concert halls. It also sponsored local cultural organizations such as the Winnipeg Male Voice Choir, the Manitoba Music Competition Festival, the Winnipeg Orchestral Club, and the Winnipeg Boys' Choir. Men, too, frequently sat on the boards of civic fairs, which, according to one 1936 commentator, were 'the People's University.'[53] All of these – the Winnipeg Industrial and Agricultural Fair, the Canadian National Exhibition, the Saint John Exhibition, the Saskatoon Exhibition, the Pacific National Exhibition in Vancouver, Prince Edward Island's Exhibition, and others as well – gave a wide audience to local, national, and sometimes international artists, dramatists, and musicians. Men also worked closely with cultural organizations themselves, even insisting, as one put it, that 'those laymen and musicians who are concerned in musical activities must ceaselessly strive to perfect their organizations from the business standpoint and to avoid overproduction and excessive competition.'[54]

That businessmen, in particular, were motivated to work closely with cultural organizations did, in fact, frequently arise out of their feeling that those who participated in the arts were poor administrators and organizers. Proud of their financial know-how and eager to increase their status through association with cultural organizations, they served in large numbers as governors, board members, or trustees of institutions ranging from the National Gallery of Canada and the Dominion Drama Festival to the Theatre Arts Guild of Halifax, the Mendelssohn Choir of Toronto, and the Little Theatre Association of Vancouver.

By the late 1920s both men and women were giving their time to already established amateur and professional organizations more often than they were forming new ones. Ladies' or women's committees and all-male boards served art societies, drama groups, and symphony orchestras. 'To be assured of continued usefulness to the community,' wrote B.E. Chadwick of the Montreal Elgar Choir in 1923, 'the Choir must be financially sound; must have public support in a large measure and have an Executive Committee to whom [it] may confidently entrust

its management.'[55] It was the same with the New Symphony Orchestra founded in Toronto in 1923. It is 'unfortunately necessary,' wrote Herbert Davis in the *Canadian Forum*, 'to accept a financial committee [composed of women] and a business manager [a man] as an essential part of every good symphony orchestra.'[56] Reginald Stewart, the conductor of another Toronto orchestra, the Promenade Symphony, asked businessman Floyd Chalmers and his wife, Jean, to assist his group. 'He wanted Jean to set up a volunteer committee to raise enough money from private sources to guarantee the musicians a humane existence,' Chalmers recalled. 'Jean agreed to build a women's committee and I[,] sufficiently impressed with the cause[,] agreed to approach corporations and wealthy individuals.'[57]

The evolution of boards composed of businessmen and male professionals and fund-raising committees of women – queen bees and drones – did not eliminate women's musical clubs and art associations altogether. Yet women were drawn to the larger, and frequently more prestigious, organizations. And, once there, their role was central for, although they might have been out of the limelight and out of management, the money they raised was frequently the only thing which permitted a symphony orchestra, a dramatic society, or an art gallery to exist. Without their fund-raising drives, their bake-sales, their teas, and their public subscription campaigns there would have been no money for their male counterparts to transfer from one column to the other in the ledger book.

Service clubs, religious institutions, and other organizations could function as patrons too. In British Columbia the Canadian Legion sponsored an orchestra, the Order of the Knights of Pythias an annual music festival, and the Vancouver branch of the IODE an annual literary competition. In the Maritimes women's institutes 'conducted Handicraft Exchanges and stimulated interest in some home industries.'[58] New Brunswick's Rotarians helped fund the annual music festival and paid literary figures to speak at their meetings, while Halifax's Kiwanis Club sponsored a production of *The Mikado* in 1935. In Winnipeg the Manitoba Club purchased paintings from Edmund Morris in 1910 to hang in its smoking rooms. The YMCA in Saskatoon gave over its premises in 1933 to a production of the Little Theatre Club. In Ontario Canadian Clubs and League of Nations' Associations sponsored literary competitions and readings. Oshawa's Rotary Club secured a building in which the Oshawa Little Theatre could perform. Petrolia's Knights of Pythias allowed the local orchestra to practise in its club-

room. And, not least, churches of every denomination throughout the country gave over their auditoriums to the production of plays, musical events, and literary recitals.

'In the 30's,' recalled pianist Chester Duncan, 'Service Club luncheons were often a last chance for those musicians who were starving, and an opportunity for pianists to accompany unsteady singers through the fields of corn.' Duncan, who got 'to play the piano at a good many banquets and luncheons of the Kiwanians and Rotarians and Moose and Goldeyes' on the Prairies, 'always' found 'food, and sometimes a little money too if one was playing for an assisting artist generous enough to share her five bucks with him.'[59] The journals and magazines of the voluntary and religious organizations also gave writers and artists an outlet for their work. The Association of Canadian Clubs' *Canadian Nation*, the United Church of Canada's *New Outlook*, the Native Sons of Canada's *Beaver Canada First*, the Anglican Church of Canada's *Canadian Churchman*, and the IODE's *Echoes*, to mention only a few, published short stories and poems, book reviews, woodcuts, reproductions of paintings, and articles on Canadian music, art, and literature.

These organizations were not established, of course, solely to promote cultural activity. They had, to be sure, a purpose: 'every club must have a definite objective,' the governor of the Kiwanis Club wrote in 1932, and it 'must dominate and control all the club's activities.'[60] This, however, could be any one of a number of things: the founding of fresh air camps, the giving of vocational or religious guidance, or the enhancement of national or imperial sentiment. But no matter what it was, artists, writers, dramatists, and musicians often found that it allowed them plenty of scope for activity. Frederick Philip Grove counselled over twenty Canadian Clubs in 1928 on Canada's place in the British Empire and on the challenge that the word *Americanization* offered to every Canadian nationalist. That same year Howard Angus Kennedy gave a 'thoughtful speech' to Montreal's Lion's Club on 'what in literature should be local, and what international.'[61] In 1930 the poet A.M. Stephen told IODE and Canadian Club organizations throughout western Canada how Canadian literature could serve as a nation-builder if it were made a part of the school curricula. And, speaking at the Empire Club a few years later, Grey Owl reinforced that association's anti-American sentiment.[62]

In most cases, then, the relationship between the voluntary or religious organization and the cultural producer was complementary.

Writers, musicians, dramatists, and artists found an outlet for their work. The voluntary or religious organization raised money and gained yet another ally and another medium through which it could propagate and express its ideas about religious devotion, Canada's place in the empire, or its situation vis-à-vis the United States. All of this meant that what those organizations chose to publish in their journals or hang on their walls and whom they allowed to perform in their clubrooms or speak from their lecture podiums did not leave much room for the unconventional. New Canadians or writers, composers, dramatists, and musicians devoted to modernist forms could hardly find a place in activities intended to reinforce the ideas, values, and world-view of these essentially conservative organizations. But even at that – and this is the real point – a forum and a framework for cultural activity were provided where, otherwise, there would have been none at all.

English-Canadian business, large and small, sponsored cultural activity for many of the same reasons religious or service organizations did. At the beginning of the twentieth century, business and the arts could not have been further apart. With few exceptions private businessmen-patrons gave their money or their time to cultural activities in order to satisfy private rather than corporate needs. There were no tax incentives until 1930 to induce them to give; no fund-raising agencies among the cultural community (apart from the Canadian Authors' Foundation) to solicit contributions; and no public relations officers in their own companies to show managers, presidents, stockholders, and advisory boards how involvement in the arts could uplift employee morale, offer unique ways of advertising, and demonstrate to government and public alike that those companies were aware of their responsibility to society. When it did begin to develop, business support for the arts was a result of many factors. It was linked in a general way to the increase in leisure time, the shift in use of that time from religious to secular activity, the evolution of communications systems, and a growing concern for what kind of society Canada was to become. But it really became part of corporate thinking only when businesses, realizing the advantages to be gained from a careful burnishing of their public image, and specifically concerned with countering government's increasing involvement in all areas, began to view it as a useful tool in the advancement of the corporate interest.

From the corporation's point of view, it was important to represent what was being done as a service to the community, a kind of payment in recognition of the fact that the corporation had benefited from its involvement there, and so owed something in return. What was actually done might take a number of forms. Artists could be patronized by hanging their work in cafeterias, boardrooms, and offices, or, perhaps, by being commissioned to paint murals in foyers and other public spaces. The Canadian Pacific Railway had hired artists in the 1880s to produce works of art for their hotels, log châteaux, railcars, and offices, and to illustrate their publicity brochures and to design posters. Even before this, the Hudson's Bay Company had made Paul Kane's epoch-making 1846 painting tour of western Canada possible by providing lodging and transportation – the artist accompanied the late spring canoe brigade. By the 1930s some businesses were responding to the view that art ought to be part of everyone's life and commissioned artists to enliven their premises with wall paintings. Arthur Crisp painted murals at the Canadian Bank of Commerce in Toronto and in the press room of the Parliament Buildings in Ottawa. Frederick Challener produced a mural for Loblaws' Toronto office, and, in the same city, J.E.H. MacDonald, assisted by Carl Schaefer, painted the ceiling of the Claridge Apartments on Avenue Road and then produced a mural for the Concourse Building in downtown Toronto. With the help of artists Caven Atkins and Harold Ayres, Charles Comfort painted eight murals for the Toronto Stock Exchange dealing with transportation and communication, mining, smelting, pulp and paper, refining, agriculture, oil, engineering, and construction. During the same year, 1937, he produced a twenty-foot mural, *The Romance of Nickle*, for the International Nickle Company's pavilion at the Paris International Exposition. Not all of this work was confined to Ottawa and Toronto. Walter J. Phillips painted the United Grain Company's storehouse in Port Arthur and made Wolseley's 1870 expedition to Red River the theme of his work for the Hudson's Bay Company headquarters in Winnipeg. Pegi Nicol MacLeod executed murals on the walls of Woodstock's Vocational High School in New Brunswick, while Marion Scott did the same at McGill University's medical school. Calling themselves the Western Canadian Brotherhood, Paul Goranson, E.J. Hughes, and Orville Fisher won mural commissions from the Malaspina Hotel in Nanaimo on Vancouver Island and from Vancouver's First United Church and its Oriental Gardens, among other religious and commercial establishments. Finally Miller Brittain painted two murals depicting aspects of

the University of New Brunswick's physical sciences education program in the lobby of the Beaverbrook Gymnasium in Fredericton.

Awarded during the Depression these murals and paintings gave university students, parishioners, employees, and the public in general a visual representation of an institution's history, its accomplishments, and its goals. When murals and paintings appeared on the walls of commercial establishments, they were a challenge to the view that all businessmen were philistines who either left cultural matters to their wives or patronized them 'out of a sense of duty.'[63] They suggested that businesses were something more than mere money-making establishments with no interest in the arts. And, as Canada Packers president J.S. McLean noted, they increased 'the *esprit de corps*' of employees.

McLean was among the first businessmen to hang paintings in the work place on a grand scale. He had begun, he recalled in 1952, collecting Canadian works of art for his own enjoyment in 1927 but soon found that he did not have 'enough room in my own house to hang them all.' 'So,' he continued, 'I began to think of using the wall space at the office.' The decision to hang paintings and drawings in executive suites, clerical offices, canteens, and in the firm's meat-processing plants across the country resulted in the first large-scale purchase of Canadian art for corporate use. 'At the beginning there were jokes from some members of the staff about the "old man's new fad," ' McLean recalled, 'but the jokes were soon replaced by requests for more canvases from local managers who thought they had been allotted less than their share.'[64] By 1952 McLean had acquired over three hundred works; of that number 192 hung in Canada Packers plants across the country.

A less visible, but equally important, way in which companies sought to enhance their image was by giving transportation passes. Vancouver's British Columbia Electric Company allowed that city's bandsmen to ride its streetcars free-of-charge when travelling to or from a concert. The Canadian Pacific Railway gave Dominion Drama Festival finalists a round-trip ticket to Ottawa for the annual competitions for the price of a one-way fare. The Canadian Northern Railway offered special excursion rates to both participants and observers of the Alberta Music Festival in Edmonton. And the Grand Trunk Pacific Railway, the Union Pacific Steamship Company, and the Canadian Pacific Railway gave artists, writers, and dramatists free passes, so that they could read their poems or stories in towns and cities across the country, gather material for their plays, paint the splendours of the Rockies, attend

exhibitions, or, as in the case of painter F.H. Varley, simply relocate from one end of the country to the other.

While this kind of activity enhanced the prestige of business in the public's mind, no sort of corporate patronage did more for a company's image than the providing of a venue in which cultural events could take place. Department stores – G.W. Robinson in Hamilton, Morgan's in Montreal, Spencer's in Vancouver, and the many branches of the T. Eaton Company and the Hudson's Bay Company across the country – did this. Cafes and restaurants – the Green Lantern in Halifax, the Criterion Cafe in Saskatoon, Jack Moore's Restaurant in Winnipeg, among others – encouraged artists both to show their work and to meet as a group on their premises. The Canadian Pacific Railway employed string quartets and orchestras to perform in the lobbies and dining-rooms of its hotels and in the lounges of its ocean liners. Simpson's department store allowed the Toronto Symphony Orchestra to broadcast from its premises, while the Ontario Society of Artists held its 1924 annual exhibition there. Until the building of the Vancouver Art Gallery the Hudson's Bay Company gave over its exhibition rooms to the shows of the British Columbia Art League. It also encouraged the British Columbia Musical Festival Association to use its auditorium for its annual competitions.

The T. Eaton Company in Toronto had by far the most impressive concert hall of any department store in the country. Located on the seventh floor of the company's College Street premises, the 1,275-seat Eaton Auditorium with its ninety-stop Casavant Organ was from 1931 a popular venue for recitals and concerts, lectures and films, dramatic and operatic productions. 'Almost overnight' the auditorium became 'the logical rendezvous for significant musical and social gatherings.'[65] (Only Massey Hall, also located in Toronto, outdid it in size and acoustic excellence.) The Eaton Auditorium, along with the Margaret Eaton Gallery, the display space allotted to the Canadian Handicrafts Guild, and the employment of artists as window-dressers, made Eaton's College Street store one of the most prominent centres of artistic and cultural activity in Canada. This development was fully in accord with Eaton's belief 'that the day of patronage of the arts by private initiative has not yet passed.'[66]

Businesses also polished their image by establishing awards, offering scholarships, and giving cash donations to cultural organizations. Sometimes they administered the awards themselves. The Canadian

Pacific Railway presented cash awards at the 1928 Folksong and Handicraft Festival in Quebec for musical compositions based on French-Canadian folk-songs. And the Winnipeg Free Press honoured the best-produced play at the Manitoba Drama League's annual festival with an award. Other companies gave scholarships, prizes, or specific amounts of money to existing organizations. The Edmonton District Music Competition Festival received cash awards from Mason and Risch Limited and Henry Birks and Sons. Students at the Toronto Conservatory of Music were awarded scholarships by Heintzman and Company and, once again, by Mason and Risch. And the Canadian Bookman's Association received donations from such corporate benefactors as the T. Eaton Company, Simpson's, and the Hudson's Bay Company in support of its work in 'elevating taste and increasing the number of book readers' by establishing book clubs and organizing Canadian Book Week.[67]

Contributing to the staging or production of a cultural event could be a source of publicity too. Lending furniture or other effects to theatrical and operatic groups brought free advertising on posters, in programs, or simply as a result of having the company's products in full view of the audience. Sponsoring a musical group on the radio could fulfil the same objective – as 'The Imperial Oil Hour,' the Bell Telephone Company's 'Blue Bell Broadcasts,' the CPR's 'Canadian Pacific Hour of Music,' Canadian Industries Limited's 'Opera House of the Air,' and Home Oil's Home Gas Concert Orchestra performances on Vancouver radio showed. The Toronto Star got its publicity in other ways. It financed the two-thousand voice Exhibition Chorus which performed from 1922 to 1934 at the Canadian National Exhibition; it founded a series of free concerts over which the newspaper's music critic, Augustus Bridle, presided; and it funded the Fresh Air Benefit concerts at Bigwin Inn on Lake of Bays. And when, finally, the Bell Telephone Company mounted its production of The Maid of Toyko at Massey Hall it did so in part to erase the 'erroneous ideas concerning telephone operators' held by the public. Seeing these employees perform would make audience members realize 'that the girls require training, endurance, and skill; and that in this instance, the very attributes which help to make them successful performers are those which they exercise daily as efficient operators.'[68]

If much of what businesses did was intended to enhance their public image, no small part of it – as the example of McLean at Canada Packers suggests – was carried out with a view towards the benefits that

could accrue to them for involving their employees in cultural activities. Sometimes this was done by providing an outlet for those with a literary bent. Company newspapers and journals provided a place where employees with literary talent could publish stories, sketches, essays, and poems or simply review the company's musical or theatrical events. British Columbia's David Spencer Department Stores' publication, the *Diamond-S Store Topics*, reviewed the performances of the David Spencer Choir and the Diamond-S Dramatic Society, announced company-sponsored essay competitions, and published the writings of employees. The Bell Telephone Company's *Blue Bell*, Imperial Oil's *Imperial Oil Review*, and the various journals the Hudson's Bay Company published across the country – *Bay Breeze* in Edmonton, *Bayonet* in Winnipeg, *Bay Builder* in Vancouver – did the same.

More important were the choral, dramatic, and other activities that permitted participation by large numbers of employees. Since the eleventh century the German *Meistersinger*, or singing craftsmen associated with the craft guilds, had assembled in the town hall or church during the evenings or on Sunday afternoons to study composition, perform songs, and – not altogether incidentally – cultivate a sense of camaraderie and *esprit de corps*. This practice, expanded during the sixteenth century to include the formation of bands as well as choirs, became widespread, and, by the late nineteenth century, could be seen throughout English Canada. The Taylor Safe Works and Heintzman and Company of Toronto formed bands among their employees. The Anglo-Canadian Leather Company of Huntsville, Ontario, established 'one of the finest industrial plant bands in the world' among sixty-nine of its tannery workers at the turn of the century.[69] Company owner Charles Orlando Shaw not only provided uniforms, instruments, and rehearsal rooms, but he recruited musicians from existing Canadian and American bands and hired a professional bandmaster to tutor them. Other companies had bands and orchestras too: the Canadian National Railways Employees Band, the British Columbia Electric Symphony Orchestra, and the Bell Telephone Company's Blue Bell Orchestra are only the most prominent among them.

Company-sponsored choral societies were more popular because they were at once less expensive and less musically demanding. The T. Eaton Company's two-hundred-voice group, the Eaton Choral Society, the Bell Telephone Choir, and Canada Packers' Operatic Society brought in solo performers when none was available among the company's ranks, and for their operatic productions they hired costume designers, profes-

sional directors, and vocal teachers. With this kind of professional assistance Canada Packers' Operatic Society was able to stage – to wide public acclaim – a lavish production of Gilbert and Sullivan's *The Gondoliers* in the Eaton Auditorium in 1943. 'If you like good clean fun, you will get it in every line,' went one pre-concert announcement to the company's employees. 'If you want to forget the war and its worries,' the notice continued, 'The Gondoliers will give you the key to two-and-a-half hours' escape.'[70]

Not only audiences but performers benefited from these kinds of productions. Coaching (often professional) was a part of them all, and a participant with enough talent could turn this to good account. A worker in Canada Packers' sausage kitchen who took on the role of the Duchess of Plaza-Toro in *The Gondoliers* profited from such instruction to the degree that the company newspaper could single her out for her excellent performance. 'Once she gets a taste of footlight fever,' went the *Maple Leaflet*'s report, 'they'll never be able to wiener [her] away from the stage again.'[71]

It was the company, however, which got most of the advantages to be derived from this sort of thing. Operatic productions such as *The Gondoliers* – as well as the dramatic productions staged by branches of the T. Eaton Company's nation-wide theatre group, the Masquers' Club, the Imperial Oil Players Guild, Robert Simpson's Employees' Dramatic Society, New Brunswick Telephone Company's drama group, or British Columbia Electric's Dramatic Club – were clearly intended to build company solidarity. 'Wait till you see your department representative either in principal or choral part acting and singing ... you are going to be agreeably surprised and get a real thrill,' Bell Telephone Company informed its employees just before the opening of a Blue Bell Operatic Society production in 1938. 'So let enthusiasm permeate throughout the staffs of all our departments,' the notice continued, 'and who knows what new avenues of service, friendship and social acquaintances may be opened up?'[72] Moreover, that this was not seen as an end in itself is also plain. Canada Packers told its employees that participation in cultural activities 'will not only help us to know one another better, it will help us to team up better: and almost surely help us to get more fun out of our jobs.'[73] Simpson's made the point explicit; the morning staff singsong, according to company officials, tended 'to increase the efficiency of the staff in so far as it sent everyone to their daily duty with a song in their heart,' and so was to be seen as an important instrument in the realizing of the corporate purpose.[74]

Sometimes companies measured their willingness to involve themselves in cultural activity in straight dollars-and-cents terms. The British Columbia Electric's generosity in giving band members free transportation and in helping the Vancouver Parks Board subsidize its concerts was, it made clear, contingent upon what might be earned by carrying passengers to and from the concerts, and so, when profits for so doing fell below the 40 per cent subsidy donated to the Parks Board for the concerts, the company withdrew its support.[75] Occasionally, however, what a corporation hoped to get would tend to come in the long rather than the short term, and nowhere can this kind of thinking be seen more clearly than in the Canadian Pacific Railway's encouragement of cultural activity as a means of consolidating the kind of nation that would permit it to thrive and prosper. Short-term profit motives were not, of course, absent even here. CPR president E.W. Beatty – whose ignorance of cultural matters ('What,' he once asked, 'the hell is the Canadian Royal Society?')[76] was monumental – could thus be brought to favour company-sponsored folk festivals because, in leading to a more accepting view of immigrants, they might prompt a return to the immigration policies of the Sifton period, while, at a minimum, they would stimulate hotel and rail business during the slow spring and autumn seasons. The ultimate goal, however, of this kind of cultural sponsorship was more subtle: establishment of a social and political environment conducive to the health of the company. Central to that goal, in turn, was the stability and the unity of the country, and among the various means used to attain that end was the organizing of festivals of music and art, and the funding of publications and lectures, all of which would be directed towards defining a place in the national life not simply for the French and English but for later arrivals and even the native Indians.

The CPR began celebrating the folk-songs, dances, and handicrafts of French Canada at the first of its festivals, organized in 1927 at the Château Frontenac Hotel in Quebec. Two similar festivals, sponsored again by the CPR and located in the same venue, followed in 1928 and 1930, while other festivals devoted to the games, songs, and dances of British and native Indian cultural groups were held from 1927 to 1931 at CPR hotels in Toronto, Banff, Vancouver, and Victoria until the Depression put an end to them.[77]

The interest in French-Canadian music demonstrated in the Quebec festivals grew out of the collecting of habitant songs, begun in French Canada by Ernest Gagnon in the 1860s and continued from the early

part of the twentieth century by Marius Barbeau, William McLennan, George T. Lanigan, Lawrence Burpee, Archibald MacMechan, Roy Mackenzie, and Helen Creighton.[78] That concern, and a similar interest shown in British song and dance, were products of the vogue which saw composers 'explore racial roots and utilize their musical treasures for modern use.'[79] The CPR's aim in encouraging these endeavours was more than an attempt 'to foster the development of music in Canada'; it was an attempt to remove any 'misconceptions and prejudices between Canadians of French and British origin' and so help build national unity.[80] Yet, in practice, the Quebec festivals in particular served only to reinforce the patronizing view of the habitant that English Canadians had already been encouraged to take by the paintings of Cornelius Krieghoff and Clarence Gagnon, the poems of W.H. Drummond and Duncan Campbell Scott, and the writings of William Parker Greenough.[81] Each of them, moreover, saw a shift in emphasis from the presentation of habitant folk-songs in their original forms to their re-interpretation by English – and even French–Canadians in a contemporary idiom, an integration of the different into the standard accepted form that was even clearer in the transcription of native Indian themes in art and music into essentially European formulations.

The treatment given the music and dance of such ethno-cultural groups as the Ukrainian, Italian, Icelandic, German, and Scandinavian immigrants showed that they were being handled in essentially the same way. Initially, of course, there was a tendency to suppose that the festivals were making too much of these exotic and different importations. The first New Canadian Folk Song and Handicraft Festival, held in Winnipeg in 1928, met with 'an army of critics who said that the Canadian Pacific had no right to encourage these immigrants to be anything but good Canadians.'[82] Believing these newer arrivals to be culturally inferior, many English Canadians feared that, given a chance, they would pollute the dominant culture and, more to the point, upset its economic and political hegemony. Yet once under way, the Winnipeg festival served to show that, notwithstanding the racist stereotypes that permeated the writings of Ralph Connor and other English-Canadian authors, the immigrants were quite willing to accept the dominance of the charter group with which they were most closely in touch. On the final night of the festival there was standing room only at the Fort Garry Hotel. Following their performances the '400 and more "New Canadians" ' clad in 'national' costumes and sitting on a raised platform before a predominantly English-Canadian

audience suddenly 'rose ... and in glorious harmony of voice and heart ... sang "O Canada" and "God Save the King." ' 'It was then,' continued the festival's music director, Harold Eustace Key, 'that the big Canadian audience fairly "went to pieces"; they cried for sheer joy, as they, too, sang.'[83]

This willingness on the part of the ethno-cultural groups to operate within the parameters established by the 'dominant' culture did, of course, pay certain dividends. It represented a move away from the kind of rigorously assimilationist, melting-pot approach criticized by Frederick Philip Grove when he pointed out in 1928 that 'assimilation to the Anglo-Canadian norm meant the forced acceptance by aliens of English-Canada's socio-cultural status quo.'[84] It could also prompt abandonment of the worst of the old stereotypes.[85] And, from the point of view of the 'dominant' groups, it certainly played a part in the nation-consolidating enterprise then very much under way. Festivals similar to the Winnipeg one were held – at the suggestion of Premiers James Gardiner and John Brownlee – in Saskatchewan and Alberta, and they, no less clearly than their predecessor, gave the ethnic groups every opportunity to show that they fitted in. Their worth was, in fact, considerable: as a commentator on the Calgary festival put it, they

stimulate interest in art and the human agent, against 'canned' music and drama and other products of the machine age we live in. They inspire and promote original musical composition in a national, Canadian style ... They help bring Eastern and Western Canada together ... They carry to remote points the 'metropolitan' critical standards of special writers from Toronto, Montreal, New York, Chicago. They give the Dominion the most desirable kind of 'publicity' or reputation internationally ... The uniting of these widely divergent elements in our population through a medium which shows them that we value here what they have valued most in their European homelands, is evidently of great practical usefulness to the Dominion.[86]

By moving into this sort of framework, however, the ethno-cultural groups were making real concessions. It was clear that only the part of their ethnic and cultural world which could be fitted into the whole around it would be accepted. CPR festival organizer and publicity agent John Murray Gibbon certainly showed no interest in the kind of New-Canadian cultural activity exemplified in the novels of Laura Salverson, Martha Ostenso, and Frederick Philip Grove, in the plays of Icelanders, Ukrainians, and Finns, or even, indeed, in the theatrical

productions concerning New Canadians by English-Canadian play-
wrights. Believing that 'the Canadian Pacific was not merely a railway
carrying passengers and freight, but was through its colonization work
helping to build a new nation,' he directed all of his work – the folk
festivals, the publication of monographs such as the *Canadian Mosaic:
The Making of a Northern Nation*, the song-books such as *Canadian
Folk Songs, Old and New*, and the lectures he gave on such themes as
'European Seeds in the Canadian Garden' – towards reinforcing na-
tional-imperialist views and preparing that nation for what he saw as
its future place in the empire.[87] By using folk-songs, dance, and other
such things to promote fellowship among Canadians, Gibbon was thus
focusing 'on the broader social application of folklore rather than on
the nature, function, and meaning of the traditions within the groups
to which they belonged.'[88] Hailed as 'a champion of foreign cultures in
Canada,' as one who was 'performing a unique patriotic service ... [by]
making "Old Canadians" more cosmopolitan and more tolerant – one
might even say "less boorish" – towards the newcomer from various
centres of Europe,' he nonetheless favoured the creation of a society
which, for all that it might do to leave a place for ethno-cultural
groups, would situate British cultural values and traditions clearly at
the top.[89] Not only, indeed, were the British privileged in an obvious
way (a fact made even clearer by the CPR's end-of-the-decade effort to
promote 'closer relations between Great Britain and Canada through
music' in the form of six concert programs by British composers at its
hotels)[90]: anything that was new, different, or out of the ordinary was
almost automatically excluded from Gibbon's range of possible choices.
While, in consequence, a production such as composer Healey Willan's
opera *The Order of Good Cheer*, written for the 1928 Quebec festival,
might pass muster, Herman Voaden and Lowrie Warrener's *Symphony:
A Drama of Motion and Light for a New Theatre*, celebrating the Cana-
dian landscape as both beautiful and malign, was rejected although
Gibbon had given the dramatist and the artist free railway passes, so
that they could carry out the research preliminary to its preparation. 'I
do not see how we can make use of the latter,' Gibbon told Voaden after
considering the script (which, possessing no dialogue, depended en-
tirely on a symphony orchestra, a *corps de ballet*, and lighting and was,
moreover, rather sombre in its overall tone). 'It does not appear to have
the slightest relation to the CPR which is essentially an optimistic
undertaking and can not be identified with anything so gloomy and

morbid.'[91] A preference for the familiar was thus to triumph in form as well as in content.

There was a sharp distinction to be made between company patronage for corporate purposes and the kind of sponsorship of the arts given by well-to-do families. Both were interested in the maintenance of the status quo and in legitimating, and winning acceptance for, existing power relationships in society. But while the concern of the first with these things was often clear and palpable, that of the second was masked behind a veneer of taste, style, and discernment which suggested that cultural activity was being encouraged for its own sake and not in fulfilment of some business, commercial, or class purpose. To be sure, English Canada did not have a Carnegie or a Rockefeller. It did have one family, however, which was involved over a considerable number of years in virtually every form of private giving considered in this chapter. The Massey fortune was begun by the agricultural land developer Daniel Massey. In 1830 he had travelled to New York, where 'he saw a mechanical thresher and was fascinated by it'[92] Seventeen years later he began manufacturing farm machinery. His son, Hart, expanded the business to take advantage of the opportunities created by the National Policy, and his sons Charles, Frederick, and Chester enlarged it in their turn. By 1879 the Massey Manufacturing Company – which merged with Ferguson in 1890 to become the famous Massey-Ferguson – had become an enthusiastic patron of the arts. Coincident with its move from Newcastle to Toronto it established a company band – the Massey Cornet Band – a glee club, an employees' orchestra, a library and reading room, a Workman's Library Association, and, finally, one of English-Canada's finest literary magazines, *Massey's Illustrated*, which ran from 1882 to 1895. Following the principles of Christian stewardship, the Methodist Masseys also supported the arts outside of the family business. They purchased a number of organs for Methodist churches in Toronto. As a memorial to Chester's wife, Anna, they presented a carillon to Metropolitan United Church in Toronto. And in 1894 they built the magnificent Moorish-styled, air-conditioned, and acoustically excellent Massey Music Hall – later known as Massey Hall – in memory of Hart's son Charles.

When Hart Massey died in 1896, monies earned by the Hart Massey

Estate helped sustain the nascent Toronto Symphony Orchestra and the Mendelssohn Choir and eventually funded the University of Toronto's Hart House, which allowed male students at that institution to participate in 'that true education that is to be found in good fellowship, in friendly disputation and debate, in the conversation of wise and earnest men, in music, pictures and the play, in the casual book, in sports and games and in the mastery of the body.'[93] The same year Chester's son, Vincent, transformed the Hart Massey Estate into the Massey Foundation with cash assets of $2,654.083.77. Modelled on American charitable foundations, it was the first of its kind in Canada. The chairman was Chester Massey, and upon his father's death in 1926, the chairmanship fell to Vincent.

From the moment Vincent Massey joined the board of the Massey Foundation, 'it became a pure expression of his own personal interest and ideas.'[94] Keeping with his grandfather's, and indeed his own, concern for education, he appointed a commission in 1919 to examine 'in detail the resources and curricula of the eleven methodist secondary schools and colleges spread across the dominion.'[95] He channelled money into, though did not establish, the National Council of Education, a policy-making body composed of businessmen and educators who were attaching 'the culture of the Dominion to its English roots' through a rigorous adult education program of which Massey became president three years after its founding in 1922.[96] The Massey Foundation also supported symphony orchestras in Calgary, Ottawa, and Toronto; contributed to the National Gallery of Canada and the Dominion Drama Festival; and gave generously to cultural groups at Hart House.[97]

During the first ten years of its existence Hart House Theatre was the leading Little Theatre in English Canada. A sophisticated lighting system enabled its first artistic director, Roy Mitchell, 'to create novel effects of shape and texture by the play of lights upon specially prepared surfaces.'[98] Its commitment to producing three original Canadian plays a year gave a forum to playwrights such as Merrill Denison. Its attention to originality saw artists J.E.H. MacDonald, Arthur Lismer, Pegi Nicol MacLeod, and Lawren Harris paint stage settings and the composer Healey Willan write musical scores to accompany its productions. And Hart House not only supported theatre; it had an art gallery for which it purchased a substantial number of works, a chapel decorated by the artist William Ogilvie in 1924, and, following an unsuccessful attempt to support an orchestra through public subscrip-

tions, a string quartet. Hart House String Quartet's four gifted musicians – Geza de Kresz, Boris Hambourg, Harry Adaskin, and Milton Blackstone – received an annual salary of $10,000 plus concert earnings in return for performing ten recitals a year at Hart House and a number of concerts at the University of Toronto's Convocation Hall. The members of the quartet not only fulfilled these obligations until their contracts expired in 1941; they also gave recitals throughout Canada, made two concert tours of Europe, and frequently performed in New York. Within a few years the Hart House String Quartet earned a reputation for being 'one of the dozen or so best [quartets] on the international scene.'[99]

Vincent Massey not only provided financial support to the arts through the Massey Foundation, but, as Sir Edmund Walker had done, he gave generously of his time and, when necessary, used his considerable influence. In 1921, for example, he helped found the Chamber Music Society in Toronto. In 1925 he joined the board of the National Gallery of Canada, and in 1932 he took on the presidency of the Toronto Symphony Orchestra and became chairman of the Dominion Drama Festival. He also acted as a less formally involved patron of the arts by entertaining John Buchan – the future Lord Tweedsmuir – during the novelist's 1924 sojourn in Canada; by visiting the studio of, among other artists, Emily Carr; by viewing the art collection of Norman Mackenzie in Regina; by writing articles on Canadian drama and publishing plays by young Canadian playwrights; and by undertaking many other activities associated with the arts such as visiting the daughter of Sir William Van Horne to talk about the future of her father's valuable collection of paintings.[100]

Nor did Massey forget Canada's artists, writers, and musicians when he and his wife, Alice, moved to Washington, DC, in 1927 – he was Canada's first minister to the United States – or, eight years later, when he became Canadian high commissioner in London. In the American capital he arranged exhibitions of Canadian art and performances by Canadian musicians. Later in London he saw to it that twenty-four Canadian choristers were invited to take part in the Coronation Choir in 1937. He entertained the naturalist writer Grey Owl though 'was not a little disturbed when some time later it was discovered that Grey Owl was not an Indian at all.'[101] He hung Canadian paintings at Canada House and helped organize the impressive exhibition A Century of Canadian Art at London's Tate Gallery in 1938. And, finally, he gave sherry parties for transient Canadian artists, musicians, and writers at

his Portman Square residence (one of which Arthur Lismer memorably described as 'a crush – cocktails & gush').[102]

Massey's involvement in the arts was not always so public. He was very much a patron of the arts in his private life too. Soon after their marriage, he and Alice began collecting paintings by British artists. Then, after meeting the Group of Seven and with the help of one of its members, A.Y. Jackson, they began acquiring Canadian works. In 1934 they even embarked on 'a unique experiment in art patronage' by purchasing the entire studio contents of the reclusive artist David Milne.[103] (The collection, comprising some three hundred works, dated from 1929, the year Milne returned to Canada from his lengthy residence in the United States.) Alice and Vincent also assisted other artists – Pegi Nicol MacLeod, Lilias Torrance Newton, Florence Wyle, and F.H. Varley – by purchasing their works directly or by commissioning family portraits.

Massey's less public interest in the arts entailed not only commissioning and collecting works of art, but participating in cultural activities himself. He enjoyed sketching in oils, reading prospective scripts submitted to Hart House Theatre for possible production, and acting in its and the Arts and Letters Club's various productions. He even had a hand in directing. After he left Toronto for Washington in 1927, his involvement in the theatre diminished considerably but his enthusiasm for, and envy of, his successful actor-brother Raymond Massey never waned. 'My wife and I long to get into Hart House Theatre for a quiet evening,' he wrote from Washington; 'in fact we are quite homesick for the fun of watching a rehearsal and talking over a production with the Director.'[104]

While opportunities for participating in cultural organizations as a patron or amateur actor were rare after 1927, there was one place where Massey continued to be both the amateur participant and the impresario: his baronial Canadian residence, Batterwood House, located near Port Hope some sixty-two miles east of Toronto. It was here that he and Alice gathered musicians, artists, actors, playwrights, writers, critics, and even politicians – Prime Minister Mackenzie King, known to them as 'Rex,' was a frequent visitor – for weekend house parties. Over cocktails, afternoon tea, lingering dinners, or lavish fancy dress parties Massey entertained his guests by showing film plays which he had both written and produced and by skilfully engineering the conversation so that his guests were cajoled into lively conversation. Often the Hart House String Quartet entertained the Masseys and their guests. 'The

Masseys' dinner parties were dazzling,' recalled the quartet's second violinist, Harry Adaskin, 'and we met people from all over the world.' 'Sophisticated, completely attentive and warmly responsive,' the guests at Batterwood were a pleasure to play for.[105]

These weekend parties were a microcosm of the kind of cultural life that Vincent envisioned for the entire country – and, indeed, that he had attempted to create by sitting on boards, by lecturing, by writing articles, and by supporting cultural producers and organizations both privately and through the Massey Foundation. He possessed an élitist vision of culture, one that made it accessible only to the educated and the well-informed; and one that involved harmonizing Old World British cultural institutions and traditions with New World vitality. The emphasis, however, was clearly on the established and familiar, and not on the innovative. Certainly Massey made no room for Herman Voaden's symphonic expressionist multi-media theatrical productions, for controversial English-Canadian poets such as F.R. Scott, for abstract painters such as Kathleen Munn, or for many of the forms derived from French-Canadian, native Indian, or ethno-cultural art. Nor was there any tolerance of such 'hard-headed young intellectuals' as Alice Massey's much younger brother, Raleigh Parkin, who to Massey's mind possessed 'radical views and [the ultimate disqualification] a dislike of the Lib. Party.'[106] Massey's touchstone was the Britain where he had travelled as a boy, studied as a young man, and frequently visited as an adult. It is not surprising, in consequence, that Balliol, Massey's former college at Oxford University, received generous amounts of money from the Massey Foundation or that when he resided in London as Canadian high commissioner he took his leisure on the fringes of the Cliveden Set or gave his time to London's National Gallery, where he served as a trustee from June 1941 and as chairman of the board from 1943. Nor was it out of character when at the outbreak of the Second World War he should have hired British artists to paint Canada's contribution to the war, persisting in this until there were complaints from home. For him Canada's culture was always to be seen under its British aspect, a fact which became clear when he headed the Royal Commission on National Development in the Arts, Letters, and Sciences in 1949.

Massey was not always able, of course, to put his stamp on what he did. Once he had created a cultural organization, it often took on a life of its own. Following its heyday in the 1920s, Hart House Theatre came under severe criticism. Some commentators blamed 'the lack of courage and vision and imagination of its controlling Board of Syndics and the

sterility of the University which surrounds it.'[107] Others claimed that the students were 'apathetic and the theatre regarded as a "town" project in which the "gown" would have little part.'[108] The Hart House String Quartet underwent changes too. In 1936 its members made their permanent headquarters in New York. A year later the second violinist, Harry Adaskin, left the group to play in CPR hotels. Attempting to forestall his resignation, Massey offered Adaskin more money and a chance to play first violin. 'When the Masseys finally realized that I was leaving,' Adaskin later recalled, 'they were very disappointed in me.'[109]

Massey also found that it was as difficult to give away the foundation's money as it was to maintain the continuity of the cultural organizations he had created. In 1932 and again in 1934 he told Mackenzie King, then leader of the opposition, that the Massey Foundation would build an art gallery and a concert hall in Ottawa. In 1937, with King again prime minister, Massey raised the subject once more, suggesting that if the government would merely donate the land the foundation would pay for the building.[110] Mackenzie King – notwithstanding his promise while leader of the opposition to build these facilities – now felt obliged, however, to throw his weight behind the construction of a new supreme court. The National Gallery of Canada thus missed an opportunity of securing a building of its own at little cost to the people of Canada, and Massey lost the chance to memorialize the family name on a national scale.

Nor were money, enthusiasm, and connections enough to bring about the kind of cultural life Massey envisioned for Canada. While he could shape the artistic environment at Batterwood House, doing the same for the country as a whole was quite another matter. Massey tended to blame this state of affairs on the encroaching culture from the south. But as one acquaintance pointed out, 'what Massey failed to appreciate was that the philistinism against which he felt Canadians had to be protected was not, as he seemed to feel and certainly implied, wholly an invasion of the less desirable aspects of American culture over our border, but to an important extent a native element in Canadian life and very much a part of our own Canadian make-up.'[111]

Much of what Massey tried to do failed to strike deep roots in the country, and, in particular, it had little success in resisting the tide of mass culture that was spreading over the country's length and breadth. It did establish a certain standard, however, and notwithstanding Massey's lack of sympathy for the new and innovative, it grew out of a genuine feeling for the substantial and accomplished. As such it stood

at odds not only with the popular culture of the period but also with much of the ulteriorly motivated corporate and business patronage evident as well. Whatever one's final judgment on the role played by this sometimes enigmatic figure, there can be no doubt that he stood virtually alone not only as a patron but also as something like a true connoisseur.

Although private patrons acted from a variety of motives, only in a few cases – some of the individual subscribers at one end of the spectrum, Massey, in a sense, at the other – was an authentic and informed love of culture and the arts among them. Prestige, status, nativism, and a concern with the British tie all loomed far larger in directing them to do what they did. And not only did motives for giving tend to operate within a narrow and defined limit; the fact that patronage was usually confined to the well-to-do in business centres such as Saint John, Halifax, and Montreal and, after the turn of the century, Toronto, Winnipeg, and Vancouver indicated that there were class and geographical boundaries as well. All of this meant that only those cultural producers whose moral, political, and aesthetic views were in line with those of specific donors – women's musical clubs, wealthy railway barons, private corporations, voluntary service clubs, religious or professional organizations – would get support. It also meant that the assistance rendered was sporadic, discontinuous, and, above all, uncoordinated.

Seeking in the late 1930s to come to grips with the explanation for this lamentable 'lack of co-ordinated thought in the business of giving in Canada,' Massey's prodigal brother-in-law, Sun Life Assurance Company executive Raleigh Parkin, thought he saw several reasons for it. Central to them was the prominent place occupied by self-interest. 'The individual giver,' wrote Parkin, '... as often as not has his own pet interests and his own strong views of how to carry them out and is seldom subject to the influence of the sort of people who are interested in creative imaginative thinking.' Frequently, too, Parkin continued, 'he is looking for a memorial to himself and finds it in the endowment of the established and probably outworn idea.' What culture in Canada needed was not more of this serving of one's own rather limited interests but 'one or two or three individuals who could make it their entire business to think about these sorts of things; or see to it that the thinking gets organized or done; who could be available to make their knowl-

edge of Canadian facts and needs or to make their connections with informed Canadians and so on available to any givers who have a serious and responsible need for just such information or suggestion.'[112]

This conviction that an overall and coherent view of things had to be taken was not new; Martyn Howe had observed a decade earlier that sustaining the proper sort of cultural activity in Canada would require a 'co-ordinated vision' and a unified 'means of expression.'[113] There were also groups – the Canadian Radio League, the Canadian Film Society, the Institute of Adult Education – and individuals – Graham Spry, Graham McInnes, E.A. Corbett, Alan Plaunt – who operated on the premise that something much like this had to be done. In no case, however, had a comprehensive Canadian vision – and program – of the sort Parkin had in mind emerged.[114] There was, then, more than a touch of irony – as well as much that needs explaining – in the fact that when such a program did finally appear, it should have been based outside the country.

Leaning 'on Foreign Walking Sticks': Cultural Philanthropists, Influences, and Models from Abroad

During the first four decades of this century both the cultural product – play, painting, musical composition, poem – and the institutional framework sustaining it – educational and cultural organizations, public and private patronage – were shaped by forces emanating from outside the country. Sometimes these forces were sought and encouraged by English-Canadian cultural producers and organizers. At other times, they swept uninvited into the country. Whatever their source they were a manifestation of English Canada's colonial past; of the dynamism of Canada's more powerful and established English-speaking neighbours, the United States and Great Britain; and of the internationalization of culture made possible by innovations in travel and communication systems. Operating with great strength, they made it seem that English Canada's culture leaned 'on foreign walking sticks,' that its theatre was 'on the road to New York,' and, as the pianist Mark Hambourg noted, that following the First World War 'life was much Americanized, and the public gaze was concentrated on New York rather than on Europe, as the source of everything worth considering in art, fashion, and literature.'[1] Indeed, of all the arts, only painting – as practised mainly by the Group of Seven and its followers – seemed to view Canada 'through Canadian eyes,' though some commentators were prepared to let it share this distinction with the theatre created by such playwrights as Merrill Denison.[2]

Some English Canadians did not like this absence of the national and indigenous. 'Imitating Hemingway or Sinclair Lewis or any other successful writer from outside one's own country,' the young writer Hugh

MacLennan felt, was 'bound to result in a lack of "the drive and compulsion of genuine native work." '[3] It would, insisted another commentator, ensure that the 'cultural and creative life of Canada' would continue to be inhibited by 'timidity; staticness; a sense of inferiority; a lack of confidence,' and, even more significantly, by 'a wholesale looking outwards for ready-made standards or complacent acceptance of existing things as "good enough." '[4]

Others, however, thought an openness to international influences was natural and commendable. As Stephen Leacock noted in 1928, the world was 'changing into an intellectual unity, drawing on all sources.'[5] 'Surely,' wrote Norman Rogers in the *Canadian Forum* in 1932, 'it is a mistake to expect Canadian culture to assume a form and expression wholly different from the sources of its inspiration.' 'The days of isolation have passed,' he continued; 'distinctive national achievements in the realm of culture belong in the main to an earlier period when countries were compelled by comparative isolation to depend upon their native resources.'[6]

Whether one took the view that what was happening bred a kind of outer-direction, or whether one saw it representing a healthy eclecticism (some observers have even suggested that the many influences simultaneously operating on the cultural lives of such new societies as Canada, Australia, and New Zealand made them the first post-modern cultures), it was clear that a kind of cosmopolitanism characterized what was happening in the country's cultural life.[7]

Geography, of course, was responsible for some of this, for the proximity of American cultural resources made it virtually inevitable that there would be no small amount of involvement with them. Artists, for example, often had more to do with their American counterparts just across the border than with those in more remote provincial or federal capitals. Charles Comfort happily joined American artists in The Great Lakes Exhibition, which visited Chicago, Milwaukee, Detroit, Cleveland, Buffalo, Rochester, as well as Toronto during the winter of 1938–9. And members of Victoria's Island Arts and Crafts Society exhibited their coastal and forest landscape paintings more frequently with the Seattle Fine Arts Society than with Vancouver's British Columbia Society of Fine Arts.

Canada's proximity to the culturally more institutionalized United States saw musicians interacting with their American neighbours to an even greater extent. Even though most English-Canadian cities had, from the turn of the century, amateur symphony orchestras, conductors,

and music festival directors of their own, they preferred to engage individuals and groups from the United States. A.E. Harriss brought in American orchestras to accompany the First Cycle of Music Festivals in 1903. The Minneapolis Symphony Orchestra served many Prairie towns: it performed at the Western Canadian Music Festival from 1908 to 1924 and at the Saskatchewan Music Festival in 1931; and it provided 'the backbone and the programmes' for the Manitoba Music Competition Festival in 1919.[8] It also accompanied Winnipeg's Male Voice Choir and the Winnipeg Oratorio Choir. American symphonies were used by central Canadians too. When Toronto's Mendelssohn Choir was not singing a cappella, it hired orchestras from Pittsburgh, Chicago, Philadelphia, Cincinnati, and Detroit. Montreal's choral group, the Philharmonic Society, did the same, engaging the Pittsburgh Symphony Orchestra, while Hamilton's Elgar Choir hired the Cleveland Symphony Orchestra for its performances.

Vocal and instrumental soloists – and conductors and composers as well – also readily crossed the line. The Eaton Choral Society was pleased to be the first Canadian organization to engage the Chicago Opera Company diva, Florence Macbeth, for its 1924 concert in Massey Hall. Even Europeans arrived via the American route: when Igor Stravinsky conducted the Toronto Symphony's performance of *The Fire Bird* in 1937, he had just come from the United States. This tendency to rely on resources from the United States for the broadening and enriching of local programs was not universally approved. Ernest MacMillan chastised the Mendelssohn Choir for borrowing New York soloists for its 1923–4 concert season and, indeed, the Canadian public in general for allowing itself to be 'hypnotized by the name of New York.'[9] But the tendency to react negatively was limited. Performers and organizers (even including MacMillan) enjoyed contact with the more mature musical organizations and performers; so, too, did audiences. As Robert Harris, anticipating the attendance at a skating concert in Montreal, wrote home to Prince Edward Island, 'They are bringing in a good orchestra from the United States and everyone is expecting big things.'[10]

Canadians, of course, were not limited to contact with American performers. As the presence of Stravinsky makes clear, there was real interest in overseas performances, works, and models, and overseas institutions as well. Norman Mackenzie had assembled his important collection, part of which included old master drawings, Greek, Oriental, and Roman antiquities, and Renaissance paintings, from his Regina base by relying on art advisers and dealers in Cairo, Florence, and

London who chose the works and then made the purchases for him. Canadian National Railway had 'fitted up a studio' according to plans and specifications provided by the British Broadcasting Company in order to produce 'The Romance of Canada.'[11] And Douglas Duncan's Picture Loan Society came into being after one of its founding members, H.G. Kettle, had encountered the British Picture Hire Society on a visit to Britain during the summer of 1934.

The framework within which Canadians operated was, in fact, transatlantic as well as North American. Cultural organizations such as the Ottawa Drama League, the Civic Musicians' Unions, the Dalhousie Music Club, British Columbia's League of Western Writers, and the Manitoba Music Competition Festival might be founded as off-shoots of the Drama League of America, the American Federation of Musicians, the National Federation of Music Clubs, or the American League of Western Writers, but their establishment could also reflect the influence of the Federation of British Music Festivals. And while such literary magazines as the *Canadian Forum* and the *Masses* owed their titles, their layout, and many of their ideas to the American magazines *Forum*, *Masses*, and *New Masses*, the *Canadian Mercury* was as much influenced by Britain's *London Mercury* as by Mencken's *American Mercury*.[12]

If collectors, festival organizers, and magazine publishers were oriented towards the larger world, so too were those interested in painting. 'It is only by seeing the work of the men of our country in conjunction with that of the artists of countries older and richer in artistic achievement and tradition,' wrote an observer of the Canadian and European paintings at the Canadian National Exhibition in 1913, 'that it is possible to rightly understand the aims of Canadian art and to perceive the direction in which it seems to be developing.'[13] A 1925 exhibition of Contemporary Russian Art at the Art Gallery of Toronto might thus be seen as displaying 'a certain Northern unity with our own Canadian work,' thereby heightening the feeling that the paintings of the Group of Seven and their followers, unique though they sometimes seemed, were not being done in a vacuum.[14] The painters who gathered around the more traditional Royal Canadian Academy could take satisfaction from the fact that the Royal British Colonial Exhibition held in Winnipeg in 1921 and the British Exhibition at the Winnipeg Art Gallery in 1925 'codified British art as the impeccable art standard' and so offered continuing legitimacy to what they were doing.[15] And other exhibitions – the display of work from New York's famed Armory Show

at Toronto's Eaton's Fine Art Galleries in 1913, the Société Anonyme's International Exhibition of Modern Art at the Art Gallery of Toronto in 1927, the Canadian National Exhibition's Surrealist Art show in 1938, and the Contemporary Arts Society's Art of Our Day exhibition in Montreal a year later – might awaken central Canadian artists to an interest in the most recent work of the European and American avant-garde.

If English Canadians' feelings that they were part of a larger art world could be enhanced by their contact with exhibitions, their sense that they could measure up in that world was heightened by what foreign visitors told them. British and American art historians, touring the country under the auspices of the National Gallery during the late 1920s and the 1930s, frequently made mention of the merits of what they had seen. Britain's Stewart Dick, who made three lecture tours from Halifax to Vancouver in the late 1920s, said 'some very pleasant things about the [National] Gallery' and spoke 'very enthusiastically about Canadian painting.'[16] Speaking at Eaton's gallery in Toronto in 1925, the British landscape painter Leonard Richmond 'gently chaffed the audience for the Canadian habit of buying Dutch and other European pictures when, at their very doorsteps, vital art works were being produced and ignored.' Accompanying his talk with glass lantern slides illustrating the paintings of Tom Thomson, Lawren Harris, A.Y. Jackson, and Maurice Cullen, all of whom were producing work which 'compared favorably with anything being produced in the British Isles,' Richmond left no doubt as to whom he thought were being neglected.[17] This was precisely what the English-Canadian art community wanted to hear: it was backing the right horse and that horse was capable of competing in any derby in the world.

English Canada's cultural producers were getting in touch with metropolitan standards not simply through their contact with non-Canadian performers but also through the presence of musicians and dramatists brought in to officiate at music and drama festivals, to preside over music examinations, and to assess institutions. Ernest Hutcheson, president of the Juilliard School in New York, was asked by Toronto Conservatory of Music officials in 1937 'to study and report on the restructuring of the institution.'[18] Sir Hugh Allan, principal of the London Conservatory of Music, composer Vaughan Williams, Paul Vidal of the Paris Conservatoire, and Eric Delamorter, associate director of the Chicago Symphony Orchestra, were judges of the musical scores based on French-Canadian folk music associated with the CPR's

1928 Quebec festival. And British musicians Harry Plunket Green, Sir Hugh Robertson, and Granville Bantock presided over music festivals across the country. The presence of these people did not, to be sure, always sustain the feeling that the cosmopolite was the best judge and only source of wisdom. By the late 1930s the British adjudicator was being seen by one observer as 'a stock figure ... who has come to the colonies to show the flag, to set up temporarily an outpost of the empire.' 'Not always out of the top drawer at home,' he was 'an inveterate name-dropper' and did not 'permit anything to register upon his hearing which might suggest an indigenous musical achievement.'[19] According to another commentator he viewed competitors as 'just a bunch of hams, who shoul'nt [sic] be performing in the first place, [and so] takes a deep breath and proceeds to mow them down.'[20] On balance, however, their services were generally seen as justifying the conceit that in music, as in art, Canadians were at last beginning to rise to international standards.

Whatever may have been happening in the case of the reaction to music adjudicators, there is no doubt that the response to the drama judges was almost always favourable. If one can credit one observer's reaction to J.T. Grein's adjudication of the Dominion Drama Festival finals in 1935, the critic's audience 'respected his judgement, revelled in his reminiscent interpolations, loved him for tempering justice with kindness, and felt that he brought to his task an enthusiasm akin to their own.'[21] Whether exaggerated or not this kind of respect was forthcoming partly because British adjudicators were sensitive to, and indeed advocated, something that English-Canadian dramatists had long wanted: a national theatre built, as Dublin's Abbey Theatre or Birmingham's Repertory Theatre had been, on the country's amateur theatre movement. Harley Granville-Barker 'stirred us up about the establishment of a National Theatre,' one writer reported in the *Curtain Call* following the dramatist's adjudication of the Dominion Drama Festival in 1936.[22] 'You will not get a genuine Canadian drama,' he told audiences across the country, 'until you get a genuine theatre.'[23] Another British dramatist, Sir Barry Jackson, brought into the country in 1929 by the National Council of Education to lecture to English-Canadian theatre groups and again in 1931 to tour the country with his company of British Players, saw it as his mission 'to see Canadian cities take as much pride in their theatres as they do in their grain elevators' and helped bring community theatres such as the Edmonton Little

Theatre into being.[24] He adjudicated for the Dominion Drama Festival on yet another visit and instituted an award, the Sir Barry Jackson Challenge Trophy, for the best original play written by a Canadian.

Other visitors brought their talents to bear more fully and for longer periods of time. The American director of the University of North Carolina's drama department, Frederick Koch, introduced Canadian students at the Banff School of Fine Arts to the concept of the folk play when he taught playwriting and experimental production there during the summer of 1938. After adjudicating Vancouver's Kiwanis Music Festival in 1939, the Australian composer and pianist Arthur Benjamin remained in the city for the duration of the war. During that time he began the *Vancouver Sun*'s Promenade Symphony Concerts and 'did his utmost to stimulate [such] young composers' as Jean Coulthard by performing their compositions and by introducing their work to central Canadian musicians.[25] Attempting to foster a 'distinctly national Canadian literature,' the British publishing firm Macmillan and Company – it had opened a Canadian branch in Toronto in 1905 – tried to ensure that 'only such work by Canadian authors sees the light as is good work, measured by the yardstick of accepted British and continental standards.'[26] The British director Tyrone Guthrie produced and directed Merrill Denison's drama series 'The Romance of Canada' for the CNR long before he became associated with the founding of the Shakespeare Festival at Stratford, Ontario. And, finally, Scottish film-maker John Grierson, having arrived in Canada in 1938 for the purpose of studying the Canadian government's Motion Picture Bureau, became the principal architect of the National Film Act, which led to the establishment of the National Film Board in 1939.

The contact English-Canadian cultural producers had with international styles, standards, and ideas was not limited to what they got from those who came into the country. They were also involved with the international infrastructure of exhibitions and competitions, prizes and publication houses, and concert and theatre auditoriums, association with which made it possible for them to allay their feelings of isolation and inferiority, test their ideas, receive outside approval for their work, gain greater financial security through access to foreign markets, and get what many of them wanted most: recognition and respect in their own country by showing that they had won it from organizations, galleries, magazines, publishing houses, and critics outside. Moved into this larger orbit by a concern to go beyond nationalism and traditional

values, enjoying travel, experimentation, and expatriate living, they found a satisfaction in it that a purely domestic orientation could never have given them.

Canada's most successful exponent of the colour woodcut print, Walter J. Phillips, was able, for example, to cultivate an international reputation while remaining on the Prairies. It was in Winnipeg where Phillips first experimented with the colour woodcut technique in 1913. (He had been introduced to the process by reading an article in the London-based art journal, the *Studio*.)[27] He quickly mastered the skill and became part of the international woodcut print revival, following which he joined every print-making association in North America and Europe and became a leading exhibitor at their shows, frequently winning medals and prizes.[28] He found dealers in London and New York who not only marketed his work but published, in 1926, his book on *The Technique of the Colour Wood-Cut*. By 1919 six of his own colour woodcuts had been reproduced in the *Studio*, and articles praising his work had appeared in the *American Magazine of Art* and in the *Original Colour Print Magazine*.[29] A major international reputation had thus been earned, all of it from a base in Winnipeg.

Other artists might not have attained the critical success of Walter J. Phillips – and even he had his lean years – but they nevertheless benefited by integrating their work into the international cultural network. If they were lucky, that work was purchased by a prestigious institution (London's Tate Gallery bought A.Y. Jackson's *Entrance to Halifax Harbour* in 1924); taken up by a private gallery (the same city's Goupil Art Gallery handled Edmund Morris's Indian portraits before the First World War); singled out for praise at international art competitions (Ernest Lawson won a medal at the St Louis Universal Exhibition in 1906); or given helpful criticism (in 1918 the Vancouver artist Statira Frame received praise from New York artist and well-known member of the Ash Can School Robert Henri for her good sense of form, fine orchestration of colour, and uninhibited approach to the British Columbia landscape).

English-Canadian writers gained recognition by joining international networks too, and international competitions often provided points of entry. Martha Ostenso, for example, submitted her 1925 novel *Wild Geese* to the *Pictorial Review*'s competition and won its $13,500 prize for the best novel of the year, while Mazo De la Roche gained the *Atlantic Monthly*'s $10,000 prize for her 1927 novel *Jalna*. Others – among them Morley Callaghan, Wilson MacDonald, Arthur Stringer,

and Ernest Thompson Seton – established their reputations not by winning prizes but by publishing in the pages of journals such as the *Atlantic Monthly, London Mercury, Everybody's Magazine, Country Life, Scribner's Magazine, Boy's Life, American Caravan*, and the *Quarter*. Still others received recognition through membership in associations outside the country – William D. Lighthall, Duncan Campbell Scott, and Bliss Carman all became fellows of the Royal Society of Literature in Great Britain.

Dramatists developed contact with and received approval from the outside world by having their plays produced on the foreign stage. Herman Voaden's *Wilderness* had its first performance at Yale in 1931. Gwen Pharis Ringwood's Prairie-based plays *One Man's House, Chris Axelson, Blacksmith*, and *Still Stands the House* were premièred at the University of North Carolina by the Carolina Playmakers. And Carroll Aikins's *The God of Gods* was staged for the first time by the Birmingham Repertory Theatre in 1919.

Musicians followed the same practice as others in the cultural field. Barbara Pentland had two of her compositions premièred in New York's Juilliard Concert Hall and in the Carnegie Chamber Music Hall.[30] She also sought criticism of her compositions from foreign musicians such as Britain's Vaughan Williams and Walter Cramer, the editor of *Musical America*. Ernest MacMillan ensured his standing as English Canada's premier musician by maintaining an active association with such British associations as the Royal College of Music, the Royal Academy of Music, and the Royal College of Organists (of which he became vice-president). And Percival Price made his name by submitting his four-part romantic symphony, *The St Lawrence*, to the Pulitzer Prize Committee in New York, winning its travelling scholarship and spending a year studying at Basel's Musikschule with Felix Weingartner. (*The St Lawrence* had been earlier rejected by the University of Toronto's music school when submitted to that institution in partial fulfilment of Price's degree requirements.)

Foreign journals and magazines also played an important role in shaping English Canada's culture. One read critical reviews of concerts in Toronto, Vancouver, and Montreal in such British publications as the *Musical Times, Musical Opinion*, and the *Musical Standard*; of Canadian folk-music in the *Journal of American Folklore*; and of English-Canadian exhibitions of painting and sculpture in the United States *Art News*, in Britain's *Studio*, and in Germany's *Die Kunst*. Short stories, essays, and poems by English-Canadian writers were evident in foreign

literary magazines. It was in the *New Yorker* that the young Montreal writer John Glassco encountered the writing of Morley Callaghan; in another American publication, the *Theatre Arts Magazine*, that Carroll Aikins's experimental Home Theatre, located in British Columbia's Okanagan Valley, was written about for the first time; and in Britain's *Manchester Guardian* that the amateur Winnipeg actor-playwright Harry A.V. Green experienced his 'proudest achievement' by publishing an article on the Little Theatre in Canada.[31]

Anyone who depended upon the international network of organizations, prizes, awards, and publishing houses was not merely acknowledging the sometimes inadequate character of English Canada's own cultural institutions and the sense of inferiority which made outside approval a condition of acceptance at home. He or she was also demonstrating that the setting of standards, the exchanging of ideas, the winning of reputations, and even the earning of one's livelihood had become an international matter. It is not surprising, then, that artists, writers, musicians, and dramatists were motivated not only to link up with institutions and movements on the outside, but to move themselves to the centres where standards were set, reputations made, and styles developed.

Everyone had a different reason for leaving. Some went to pursue formal study. In 1933 Herman Voaden studied for five weeks with Kurt Jooss – choreographer of *The Green Table* – at his school of dancing in Essen, Germany. Two years earlier he had taken a year's playwriting course with George Pierce Baker at Yale. Emily Carr attended art schools in San Francisco, London, and Paris. Composer John Weinzweig did post-graduate work at the Eastman School of Music in Rochester, New York. And in the autumn of 1930 the budding actress Toby Ryan attended the Workers' Theatrical Alliance School in New York. Study abroad gave each of these people a new mode of expression. Voaden developed his non-realist, multi-media approach to drama production which led to his unique symphonic expressionist plays celebrating the northern wilderness of Ontario. Carr discovered 'the bigger methods' of the Fauves, which resulted in a freer interpretation of the West Coast forest and native Indians.[32] Through his encounter with the music of Alban Berg and Igor Stravinsky, Weinzweig was able to explore the serial technique in musical composition. And Toby Ryan was introduced to a theatrical form – agit-prop theatre – which gave her a vehicle for addressing her country's social ills when she returned home in 1932.

Others left Canada simply so that they could absorb the atmosphere of American and European centres of culture. Morley Callaghan recalled being 'wonderfully at home in my native city' of Toronto in the 1920s, yet he remembered that 'intellectually, spiritually, the part that had to do with my wanting to be a writer was utterly, but splendidly and happily, alien.'[33] Strolling along Paris's crowded boulevards and partaking of its café and studio life, Callaghan found an antidote to what he perceived to be Toronto's stifling atmosphere. The same sense of freedom was enjoyed by John Glassco, for whom the French capital of the late 1920s was 'an even better city than it was in the books.'[34] Poet Dorothy Livesay spent her Paris sojourn 'associating with what was going on politically.'[35] Others lived quite a different sort of expatriate life. Ernest MacMillan, in Germany during the summer of 1914 to attend the Bayreuth Festival, was arrested and then interned at the outbreak of the Great War, the duration of which he spent at Ruhleben Camp in Berlin – where, however, he met musicians and composers from many countries, studied Italian and German, and was introduced to the music of Rachmaninoff and Schoenberg and to the writing of Mann, Dostoevski, and Nietzsche. Still other English Canadians were able to expose themselves to a double range of external influences. Students E.K. Brown and Leon Edel wrote their dissertations on British and American authors Edith Wharton and Henry James at Paris's Sorbonne University. And, finally, in 1933 seventy-two members of the Canadian Authors' Association sought their literary roots by travelling to Britain, where they visited the grave of Lewis Carroll and the homes of George Meredith, Thomas Hardy, and John Keats, among other British writers.

Some writers – Pauline Johnson, Grey Owl, and Stephen Leacock – travelled abroad to give readings and thus popularize their work. During Pauline Johnson's English tours of 1894 and 1906 the British responded enthusiastically to what one reviewer called her 'clever and effective verse.' They found it easy to empathize with Johnson's aristocratic background – she descended, her billboard poster stated, 'from the chiefs of the Iroquois race' – and with the fact that her family had rallied on the side of England during the American Revolution.[36] And during her performance when a costume change transformed her from 'Tekahionwake' the Mohawk princess (dressed in buckskins complete with wampum belts, a Huron scalp, and moccasins) to someone with the appearance of a well-costumed Englishwoman clothed in formal evening dress, her capture of them was complete. Grey Owl, who for-

sook European dress altogether, enjoyed equal popularity with British audiences. Despite his English heritage, Archie Belaney was able to fool everyone because he wore the well-known Indian movie kit (hair parted in the middle, braids, darkened face, buckskins) and because he appealed to a romantic concern for the disappearing North American Indians and the forest they inhabited.

If some Canadians maintained the focus of the relationship between Canadian culture and British homeland – the mission of painter Wellington London in Francis Pollock's novel *Jupiter Eight* was to become 'an Imperial painter, a Kipling of the canvas, an artistic interpreter between Canada and the Mother Land,' while the Group of Seven's F.H. Varley 'had dreams of arousing the [British] populace into ecstacy over the prophetic utterances of [his] work in paint' – others struck a chord with British audiences for different reasons.[37] Bodley Head publisher John Lane – who had brought out the works of Robert Service and Pauline Johnson – lost no time, following the death in 1910 of his best-selling North American author Mark Twain, in seeking a replacement, and Canada's Stephen Leacock seemed more than suitable. Lane secured the British rights to Leacock's *Literary Lapses* that same year, and when Leacock went to Britain to promote the work he found himself hailed as the Canadian Mark Twain. (As if to confirm this sobriquet Leacock received the Mark Twain Medal in 1935.) In the eyes of his appreciative British audience Leacock's work contained 'all that is best in the humour of both hemispheres.'[38] It thus exemplified precisely the sort of 'judicious mixture' of British and American cultures that some commentators felt would enable Canada to become 'the hub of the intellectual English-speaking ... world,' or, as another put it, 'the natural interpreter between Britain and the United States,' or even, as the historian Reginald Trotter hoped, the go-between in British and American affairs.[39]

Other cultural producers left Canada simply for the purpose of overseeing the installation of their exhibitions or the musical or dramatic performance of their work. Still others were motivated to leave because they believed that fame and fortune awaited them elsewhere. English-Canadian novels of the period are filled with characters who followed this line of thinking. Leslie Bishop's nascent playwright in the novel *Paper Kingdom* lamented the fact that 'I've written three radio-operas, any one of which would make my fortune in New York, – but d'you think they'll look at them here?'[40] A young painter in *Jupiter Eight* exclaimed of her painting: 'I'll take it to New York or London. It would

make my reputation quick enough.'[41] Similar thoughts frequently moved real-life writers, artists, and composers. 'I must go to a foreign country in order even to get an engagement,' a young Toronto actress told the literary critic B.K. Sandwell in 1911; which meant, she continued, that 'by the time I get anywhere in my profession everybody, myself included, will have forgotten that I ever was a Canadian.'[42]

Residence abroad was particularly attractive for English-Canadian female musicians and artists. Pursuing a professional career in music usually meant paying an initial fee of fifty dollars to join the Musicians' Union and then accepting employment at a 'ladies' college or in a CPR hotel orchestra, where women's salaries would be smaller than men's in order 'to curtail expenses.'[43] Outside Canada, however, opportunities were greater. Gena Branscombe, whom *Maclean's Magazine* described as 'without question ... the most distinguished woman composer who has gone forth from Canada,' had a successful career as a composer in the United States (her 1928 *Quebec Suite* was premièred by the Chicago Women's Symphony Orchestra) and as a cultural organizer (she was president of the Society of American Women Composers).[44] Women artists worked within similar female cultural networks. When Quebec-born artist Sybil Kennedy moved to New York in 1925, she became director of the New York Society of Women Artists and was a three-time recipient of the National Association of Women Artists of the United States painting award.

Success abroad was not, of course, automatic. E.J. Pratt travelled to Britain in 1924 for the specific purpose of finding a publisher for *The Witches' Brew*. Once there he arranged to have the poem appear in the *London Mercury* – 'a signal distinction for a Canadian author' – and he also got a publisher (Selwyn and Blount, after both Jonathan Cape and Constable had rejected him).[45] But his hopes for wide acceptance in Britain came to naught, for *The Witches' Brew* was far more successful in Canada itself. David Milne lived for years in the United States, exhibited at the 1913 Armory Show in New York, and found a patron in the businessman James Clarke, but received scant recognition and little financial reward. 'Sales,' he consoled himself, 'have less to do with the quality of the pictures than with the personality of the painter.'[46]

Others, however, did do at least moderately well outside the country. Merrill Denison (whom critic Arthur Phelps called the country's premier 'observer and interpreter of our Canadian pattern')[47] went to New York, where he wrote and supervised such National Broadcasting Corporation radio programs as 'Great Moments in Our History' based on

episodes in American history and modelled on 'The Romance of Canada' series he had written earlier for the CNR. Former Hart House Theatre artistic director Roy Mitchell also went to New York, where after three years of writing, producing, and lecturing he landed a position in New York University's Faculty of Dramatic Art, from where he produced the seminal work *Creative Theatre* (1929).

Of those men and women who did leave and achieve success many remained abroad. As Charles G.D. Roberts told a New York audience in 1894, 'Your poet's eyes *must* recognize / The side on which your bread is buttered.'[48] Many did. As James Strand observed almost thirty years later: 'The further the wolf gets from the author's door the greater his tendency to become an expatriate.'[49] As expatriates, many English Canadians capitalized on the Canadian content of their work: Sir Gilbert Parker on a Canadian northwest he had never seen; Charles G.D. Roberts on the animals that had populated New Brunswick's Tantramar Marshes of his youth; Robert Service on the lore of the Yukon; and Sara Jeannette Duncan on the genteel British immigrant life of Brantford, Ontario. Some – artist James Wilson Morrice is one example – buried their Canadianness altogether as they sojourned in exotic places. But whether they kept an English-Canadian awareness or not; whether they visited for short periods of time or remained abroad indefinitely; or whether they achieved success or missed it, travel was a rite of passage on their way to becoming a musician, an artist, a writer, or a playwright.

Almost without exception, residence abroad gave English-Canadian work greater respect and acceptance at home. Even though the fictional artist Wellington London in Francis Pollock's *Jupiter Eight* had 'made no headway in London' playing 'the role of a colonial genius,' in Toronto 'all the Anglophile circles encouraged him, took him up, all the English, all the would-be English, the official, [and] the rich.'[50] Bliss Carman encountered unprecedented enthusiasm for his work when he returned to Canada in 1921 after years of living in the United States. At a banquet sponsored by the Canadian Authors' Association to celebrate his homecoming, he was ceremoniously crowned with a wreath of laurel to the strains of Harold Eustace Key's 'The Dance of the Maple Leaves.' As the song reached its final verse, young maidens wearing Grecian gowns danced in a circle around the poet, and 'at the final line, they fluttered to the ground about him.'[51] This auspicious welcoming marked the beginning of Carman's profitable cross-country reading recitals which lasted until his death in 1929. Encouraged by the

success of his cousin, Charles G.D. Roberts came home, too, after many years of exile in New York, London, and Munich. His return was even more rewarding than Carman's. The Canadian government found him a pension long before pensions existed; audiences throughout the country gathered in large numbers to hear him read his poems; literary associations elected him as their president; and, crowning all of these honours, he was knighted in 1935.

Foreign residence might not only lead to acceptance at home; it enabled many to gain a new perspective on their country and on their work. A number of Morley Callaghan's Toronto-based stories as well as his 1930 novel *It's Never Over* grew in his head as he loafed along the streets of Paris during the summer of 1929. Emily Carr discovered the forest as a motif for her art in 1901 while painting in a small wood above St Ives Harbour in Cornwall. Wilson MacDonald found his 'native land' in 1902 while living under what he called 'London's ghastly arcs.'[52] Four years later Pauline Johnson was inspired to write the poem 'The Trail to Lillooet' during the intermission of a London performance of Somerset Maugham's Canadian-based play, *The Land of Promise*. And A.Y. Jackson was moved by his experience of the devastated countryside in war-torn France and Belgium to paint 'swampy, rocky, wolf-ridden, burnt and scuttled country with rivers and lakes scattered all through it' in the new, austere way that would become characteristic of much of the work done in the northern Ontario wilderness in the 1920s.[53]

Whether, then, English Canada's cultural activity was influenced by imitating foreign models, affiliating with foreign organizations, bringing cultural specialists into the country, associating with movements based abroad, or taking up residence outside the country, it developed in ways that kept it from being provincial and narrow and able to do no more than meet the standards of a small and closed community. Moving onto the international stage at once fostered the growth of cultural activity in English Canada and gave it a quality and a finish it would not otherwise have had.

The situating of Canada's cultural life in an 'international' context was as much a product of the economic strength and hegemonic aspirations of the United States and Great Britain as it was of English Canada's desire to be part of an international network. Professional and popular

culture – books and magazines, theatre and music groups, radio and film – were simply not controlled and shaped by Canadians. Professional theatre in English Canada was dominated from the 1890s by such theatrical trusts as the New York–based Theatrical Syndicate. Then, in order 'to displace as far as possible the wretched stuff which comes here from the u.s. under the Theatre rings which control the amusements of all North America,' the London-based British Canadian Theatrical Organization Society came on the scene in 1912, in its turn being replaced by the not-so-successful Trans-Canada Theatre Society in 1919.[54] Professional music was dominated by such American booking agencies as New York's Community Concert Service and the Columbia Artists Management Inc. Popular songs and instrumentals came into Canada courtesy of American sheet music publishers, record companies, and, in time, radio stations. And the sale of books in English Canada was very largely dictated by the presence from the 1920s of American book clubs such as the Literary Guild of America, the Book-of-the-Month Club, and the Book League of America.

Canadians who were involved in these areas of cultural activity were not, of course, altogether pleased with what was happening. 'By absorbing the Canadian reading public' the American book clubs were 'taking away the only reading public on which Canadian writers can naturally depend.'[55] The Community Concert Service struck a devastating blow at 'the limited opportunities native-born Canadian concert artists have to gain even a first hearing in their own country ... and the limited opportunities Canadian composers therefore have to hear their works performed.'[56] The presence of foreign entertainers also cut into what profits might be earned by English Canadians. 'The bringing of mediocre musicians here from New York who take large sums of money from this country for themselves and their New York managers,' one writer observed in 1939, 'is a question which should be considered as many thousands of dollars are lost annually in this country.' The theatrical trusts were thought to cause other problems: keeping Canadians off the professional stage; and – since as B.K. Sandwell observed in 1914, 'All shows produced in New York are shows manufactured to suit purely American tastes' – affecting their values and outlook.[57]

The English-Canadian public, on the other hand, tended to welcome cultural products from outside the country. Sometimes this was the result of simple nostalgia. An Irish immigrant dressmaker in J.G. Sime's 1921 novel *Our Little Life* could enjoy listening to the soft west-country rhythms of a visiting Irish poet's voice though 'for all she *knew*

the whole thing might have been Sanscrit.'[58] At other times, an interest in what was held to be quality drew Canadians in the direction of the external. When, for example, the Halifax Philharmonic Society held its annual festival in 1928, attendance was poor because the city's concert and theatre goers were patronizing Martin Harvey's British theatrical group. Most often, however, the tendency to look outwards came in response to the simple attractiveness of what was being produced to the south: Canadians, as Ernest MacMillan put it, had an almost irremediable weakness for anything that came to them 'stamped with ... New York.'[59]

Observers reacted to this growing preference for American culture – popular and 'high' – in a variety of ways. One took the view that it could be accepted because it posed no threat to Canada's British orientation and character: Canadians might be socially American – 'never has one country been so peacefully penetrated by another as Canada by the United States,' wrote Douglas MacKay in 1926 – but they continued to function within a British and imperial political framework, a fact which would prevent them from being absorbed by their southern neighbour.[60] Others, however, stressed what they saw as the country's essentially North American character, citing this as a factor that must lead to greater cultural involvement with the United States. 'Canada is North American; she is in the new world,' observed Raleigh Parkin in 1938, and therefore 'she is to adapt her life and thought and institutions to this fact.'[61] 'Our art,' Reginald Trotter had told an informal session at the Conference of Canadian-American Affairs a year earlier, 'while retaining much of European heritage, will be more distinctively North American as distinguished from European, and perhaps American and Canadian as distinguished from one another.'[62] This kind of thinking was of fundamental importance, for it not only allowed, but actually encouraged, Canadian producers and organizers of cultural activity to turn to, and to draw upon, American ideals and styles. Confident that Canada could be North American and Canadian at the same time, English-Canadian educators, artists, writers, dramatists, and others happily involved themselves with their counterparts in the United States.

One of the principal manifestations of this involvement was the marked willingness on the part of English-Canadian cultural producers to accept aid and assistance from American philanthropic foundations. This, it should immediately be added, did not mean that British organizations of this type had no involvement at all. The Imperial

Relations Trust of Great Britain, or the Baldwin Trust as it was also known, gave the National Film Society of Canada $71,750 in 1938 'for the establishment of a non-commercial library of British and Dominion educational and documentary films and for the promotion and the circulation of these films in Canada.'[63] American involvement, however, was much more extensive. Two American foundations were particularly important: the Carnegie Corporation, established in 1911, and the Rockefeller Foundation, created two years later. Setting out his ideas regarding the stewardship of wealth in two seminal articles written in 1889, Scottish-born steel magnate Andrew Carnegie suggested that 'the "surplus wealth" of the few would be used for the benefit of the many; [and that] economic advance would become a means for restoring the kind of community harmony that he associated somewhat wistfully with an earlier day.'[64] Carnegie's philanthropy extended beyond the American border to Britain and all of the English-speaking Dominions. The Rockefeller Foundation, setting out 'to promote the well-being of mankind throughout the world,' directed its attention to South America, India, Africa, and Canada.[65] In both cases the impetus for giving was multifaceted. It lay in a wish to alter the unpleasant aspects of early twentieth-century American life – brought on, ironically enough, by the capitalist industrialization the profits from which were now being applied to their amelioration. It was rooted in a belief that a 'scientific' approach to the distribution of wealth could aid in this. It was concerned with giving the United States a cultural identity of its own. And, finally, both Carnegie and Rockefeller hoped that they would secure their own salvation by giving to others less fortunate than themselves. Needless to say, and quite apart from the motives of those involved, the outcome of all this produced 'a new form of cultural hegemony ... based upon State corporate capitalism,' and very much concerned with the propagation of the social and cultural values out of which that form of economic organization had come.[66]

Even before the Carnegie Corporation was founded, Carnegie had built libraries, donated organs, and subsidized universities across Canada. And prior to the Rockefellers' funding of the National Film Society of Canada and, from the early 1940s, of literary and drama conferences, they had endowed medical schools from Dalhousie University in Halifax to the University of British Columbia in Vancouver. Both foundations had a continuing sympathy for their neighbour to the north; Canada got the lion's share of the grants given to foreign countries. This was because Canadians, according to John D. Rockefeller, were

'closely bound to us by ties of race, language, and international friendship.'[67] They had, as Andrew Carnegie told a gathering of the Toronto branch of the Canadian Club in 1906, a mission in the world: 'the bringing together of the two great nations,' the United States and Great Britain.[68]

Before the 1940s the Rockefeller Foundation's involvement in Canada did not run in any very large measure in the direction of arts and culture. In fact, it did little in this area apart from the grants to the National Film Society in the late 1930s and the awarding of scholarships to individuals. (Dramatist Gwen Pharis Ringwood was one recipient, using her award to study from 1937 to 1939 at the University of North Carolina with the hope that this might do something to stimulate 'the writing of Canadian plays in Alberta.')[69] The Carnegie Corporation, however, was very active indeed.

The Carnegie Corporation began funding cultural activity – apart from libraries – in the mid-1920s when 'the decision was made to include art among the major interests of the Corporation.'[70] Its president, Frederick Keppel, saw a need to establish more art galleries and to expand existing ones because the Americans, he wrote, were 'rapidly becoming the custodians, public and private, of much of the world's treasure in painting and sculpture.'[71] Ensuring the proper display of those objects, and encouraging the development of music and drama groups and institutions, was essential because the proper achievement of the Corporation's 'primary objective,' what Keppel called 'adult or after-school education,' required that it be done.[72]

The foundation's fostering of cultural institutions in Canada began modestly enough in 1926 when the University of Toronto and Dalhousie and Queen's universities each received an 'Arts Teaching Set' consisting of books, prints, textiles, and photographs dealing with the history of Western art. Seven years later the University of Saskatchewan and Acadia University, and then the University of Alberta and Mount Allison University, were given 'Music Study Material' to be used 'by non-music students' as well as by those specializing in music.[73] Assistance in the form of cash grants was also forthcoming to help university extension departments establish non-credit courses and organize programs in music, art, and drama for the surrounding community. Money came, too, for the founding of university departments, chairs, and schools of art, music, and drama. Walter Abell, a teacher of fine arts and culture in general, received the first Carnegie-sponsored appointment in fine arts in 1928 at Acadia University. Using that position, he orga-

nized extracurricular activities through the vehicle of the Maritime Art Association and the Acadia Fine Arts Club and, from 1934, taught credit courses in fine arts. In 1930 a Carnegie grant allowed the University of Saskatchewan to establish a chair of music, and later, a department of fine arts with what would turn out to be an important summer school at Emma Lake in Prince Albert Park. In 1932 McMaster University was able to begin extension work in fine arts, and, the same year, the extension department of the University of Alberta received support for 'certain experiments in popular appreciation of drama, music, and art' which led to the creation of the Banff School of Fine Arts.[74] In 1933 Regina College got help to found a music department, and Queen's University, to begin programs in both music and art. In 1934 the University of British Columbia's extension department was awarded a sizeable grant to further its cultural activities. In 1935 the University of Western Ontario received assistance to continue its music program, while the University of Toronto – whose Fine Arts Department had received a grant the year before – got funding to establish a chair of art history.

Grants were obtained in various ways. When Carnegie official W.S. Learned heard 'of the innovative educational experiments in Alberta,' he visited E.A. Corbett's Extension Department at the University of Alberta. Impressed, he arranged funding out of which came drama and art programs among rural communities in Alberta and, eventually, the Banff School of Fine Arts.[75] President W.S. Fox of the University of Western Ontario, on the other hand, travelled to New York, where he asked the foundation's President Keppel for help to continue the music program begun by private benefactor Edward Johnson (on hand to help Fox explain the merits of training teachers, so that they might foster the appreciation of music among southern Ontario's school children). Canadian patrons, too, might be directly involved. From the 1920s Vincent Massey met with Keppel to discuss the funds awarded to Upper Canada College, of which he was a board member. Provincial premiers did not scruple to ask a foreign agency for money. Alberta's Premier William Aberhart, acting in his capacity as minister of education, successfully urged the Carnegie Corporation to continue its support of the Banff School of Fine Arts after that institution's grant expired in March 1937. University officials – W.H. Fyfe, principal and vice-chancellor of Queen's University, Walter Murray, president of the University of Saskatchewan, F.W. Patterson, president of Acadia University, and H.J. Cody, president of the University of Toronto – wrote lengthy applica-

tions explaining how grants to their institutions would benefit not only the student body but also the community at large. No matter how the requests were made, they all stressed that unless help was forthcoming the program, agency, or department they were designed to assist would not get under way or, if already established, would end.[76] Nor were these pleas exaggerated. As Walter Abell noted in 1941, over the previous fifteen years 'philanthropic individuals and foundations have acted as patrons in a time when there was none other to call upon.'[77]

The Depression, certainly, made a difference. As mentioned earlier, University of Toronto president Sir Robert Falconer had turned down the Carnegie Corporation's 1926 offer to establish a department of fine arts at his university, but by the mid-1930's he was willing to accept any amount the Corporation could give. Grants were especially sought after to continue or to establish extension departments. These, indeed, were important, for keeping them going would not only, as *Winnipeg Free Press* editor J.W. Dafoe put it, sustain something of 'educational and citizenship value'; it would keep universities involved in the community and so 'might induce a greater willingness on the part of governments to admit that universities are growing concerns instead of being educational frills to be dispensed with or restricted in times of stress.'[78]

While the Carnegie Corporation was responsible for putting art, music, and, less frequently, drama into the university curriculum and for making it possible for Canadian students to study abroad by awarding scholarships to them through such organizations as the Royal Society of Canada, its primary interest remained with the part-time education of adults and children. It sought to encourage this not only by funding university extension programs, but also by supporting private cultural organizations. From 1931 to 1935 it gave grants amounting to $38,000 to help the Canadian Bureau for the Advancement of Music promote the study of music in Canadian schools. In 1936 it made possible the amalgamation of numerous Canadian organizations involved in adult education by funding the Canadian Association for Adult Education (which was formed with the help of, and patterned after, the American parent organization). And from the mid-1920s it made the visual arts more accessible to the public by enabling art galleries to finance fine art lecture programs, travelling exhibitions, and classes in painting and drawing. A seminal study of Canadian museums and art galleries was also funded. *A Directory of Museums and Art Galleries: Report of a Canadian Survey* (1932) called for the construction of further galleries and museums, short curatorial training courses, the founding of a re-

gional museums' association, and the establishment of a national committee comprising 'a small group of informed persons who would informally discuss Canadian museum problems and proposals with a view to advising the Corporation as to significant opportunities for service.'[79] The recommendations of the *Report*, which 'created a great stir in museum circles in Canada,' were, as shall be seen, almost fully implemented.[80]

Grants were given for specific periods of time – one to three years – and renewed if Carnegie officials were convinced that more money meant more adult education. They were terminated if the Corporation felt that the organization in question was not fulfilling its goals, or, on the other hand, had become capable of functioning on its own. This, of course, was the ultimate aim of the Carnegie Corporation. 'As believers in democracy,' Frederick Keppel wrote in *The Foundation: Its Place in American Life* (1930), 'we are bound to look forward to the day when the community will take over the functions now performed by the foundations.'[81] As one Canadian observer put it, 'The real test to which ... the Carnegie Corporation subjects Canada when it finances some demonstration or experiment in education is whether, after a few years, Canadians have the intelligence and the public spirit to appreciate the value of what has been done and to carry on the work under their own steam.'[82] Many Canadian programs did pass that test. The music department at Regina College, the fine arts department at Queen's University, the Banff School of Fine Arts, and the Canadian Bureau for the Advancement of Music all wondered how they would carry on without Carnegie support, but they did manage once it was withdrawn. It was only when an institution such as the National Art Centre in Ottawa had barely got established that the withdrawal of Carnegie funding caused it to fold.

In the awarding of grants Carnegie officials not only relied upon the written applications or personal visits of those bold enough to ask for money. They sent their own officials – John M. Russell was one – to assess Canadian institutions and organizations at regular intervals.[83] They commissioned impartial observers such as Sir Henry Miers and S.F. Markham of the British Museum Association and Laurence V. Coleman of the Smithsonian Institution.[84] They relied, too, upon the advice of Canadians. From J.W. Dafoe, Keppel sought 'informal and confidential views on the university situation in Western Canada.'[85] From Raleigh Parkin, whom Keppel had met in 1930 when he was a

trustee of the Institute of Current World Affairs in New York, he asked for advice on all matters concerning cultural activity in Canada. From a group of Canadian men and women – among them H.S. Southam, René Morin, Sir Joseph Chisholm, Thérèse Casgrain, Lawrence Burpee, Maude Grant, and Parkin himself – whom he assembled at the Seigniory Club at Montebello, Quebec, for a two-day meeting in February 1938, he tried to get a sense of 'the Corporation's program in Canada.'[86] Most important of all, following the suggestions made in Markham and Miers's 1932 *Report* on Canadian museums and galleries, he established a group of nine – private patrons, university administrators, and museum and art gallery officials from across the country – to decide on programs and to administer funds to them. This 'Canadian Committee' was given 'full executive powers, subject only to veto or advice of the Carnegie Corporation.'[87] With such private patrons as Vincent Massey and H.S. Southam and such gallery officials as Eric Brown and H.O. McCurry as members, the Canadian Committee promised to provide what many had long felt was vital for the maturation of the visual arts: not only the funding but also the direction to co-ordinate artistic activity throughout the country.

With Robert C. Wallace, president of the University of Alberta, as chairperson and H.O. McCurry of the National Gallery as secretary, the Canadian Committee assembled for the first time in Ottawa on 4 September 1933. McCurry opened the meeting by explaining that the Carnegie Corporation's purpose in setting it up was to help promote the idea 'that the modern museum [or art gallery] had become one of the most active cultural agencies, whether devoted to Art, Science, History or Industry,' and for that reason was to be 'recognized as a highly essential factor in the education of both adults and children.' 'Canadians,' McCurry continued 'had not developed the Museum field as actively as desirable'; they now, however, had an opportunity 'to study plans and to recommend the best means to place the Museums of Canada abreast of the times.'[88] The committee began by responding to Markham and Miers's *Report*. Members were not in favour of its suggestion that associations of regional galleries and museums be established and that more museums and galleries be constructed throughout the country. What they did agree with, and wanted, were scholarships to train the curatorial staff, further Carnegie support for art lecture programs and travelling exhibitions, and more art classes for children and adults. Over the course of the next nine years the committee chan-

nelled funds to accomplish these goals and to incorporate the suggestions made by the British art historian W.G. Constable, whom they commissioned in 1933 to give them advice too.[89]

The Canadian Committee's work was evaluated in 1942 when the Carnegie Corporation asked the Smithsonian Institution official Lawrence Coleman to make 'a follow-up visit' to Canada in order to learn what had become of the grants – totalling $75,000 – made upon its recommendation from 1933 to 1942. At the end of his three-week visit Coleman reported that he felt 'strongly that the [Canadian] Committee did a good job.' 'Surely,' he wrote in his official report, 'the Corporation may be well pleased.'[90] Subsidies to such galleries as the Edmonton Museum of Fine Arts had 'enabled that institution not only to survive the Depression but to expand its work and especially to establish a system of art classes for children.'[91] 'Designed to popularize art galleries and to inject new inspiration and new character into art teaching in the schools,' such classes had flourished not only in that city but also in Toronto, Montreal, Vancouver, and Winnipeg.[92] The establishment of the National Art Centre in Ottawa with its impressive program of lecture tours, study groups for adults and teachers, art classes for children, and its plan to co-ordinate art activities across the country, had kept its director, Arthur Lismer, from returning to a teaching position at Columbia University and, as well, induced the federal government to support the centre by agreeing to bear half its cost. Of the twenty-one recipients of the travelling scholarships the committee had awarded to Canadian students of art, ten had returned to take up positions within the Canadian art community. Gordon Snelgrove, for example, became professor of fine arts at the University of Saskatchewan; Alfred Bailey, director of the New Brunswick Museum; Donald Buchanan, secretary of the National Film Society of Canada and art critic for *Saturday Night*; Alexander Musgrove, curator of the Winnipeg Art Gallery; and Alan Jarvis, director, following the Second World War, of the National Gallery of Canada. The art lecture program had been equally successful. Scholars from Britain and the United States had spoken to enthusiastic audiences across the country, as had such Canadians as Walter J. Phillips, Alice Johannson, and Arthur Lismer. Support for travelling exhibitions had provided Canadian artists with greater exposure in their own country and abroad through such exhibitions as the 1936–7 Southern Dominions Exhibition, which took their work to South Africa, Australia, and New Zealand. Finally, the Canadian Committee had used Carnegie funds to help purchase works for the National

Gallery and to help found, in 1936, the National Film Society of Canada, devoted to disseminating educational and cultural films among Canadian children and adults.

All these activities put Canadian art galleries 'well on the road to a measure of advancement which might have required fifty years to achieve unaided.'[93] Just over a year after the Canadian Committee came into existence McCurry could report that 'moribund museums are coming to life, new organizations are being formed and established, institutions are adopting better methods and expanding their interests and activities.'[94] After returning from a lecture tour of western Canada a year later, Arthur Lismer could write enthusiastically about 'the new deal in art education.'[95] And by 1938 Graham McInnes could look back upon the five previous years and claim that 'the depression years have forged a national interest in art, and a national solidarity of outlook on problems related to art – born of the courage and enthusiasm of local groups and the support and foresight of the local [Canadian] Committee.'[96]

Certainly there was much to justify the view that the Canadian Committee was 'the fairy godmother to art in Canada.'[97] It was also possible to agree with Parkin that the kind of programs which it, and the Corporation in New York, sponsored could do much to help solve 'Canada's greatest single problem ... that of achieving some sense of national unity and finding some national purpose.'[98] Still, as Parkin himself told Keppel, 'the programme in Canada seemed ... to lack a certain coherence and direction.'[99] The committee, first of all, was composed largely of museum and gallery officials, so that its allocation of funds 'had tended quite naturally in practice to take the form of a "saw off" among the various museums represented on the Committee.'[100] Second, it had met only '4 or 6 times from 1933 to 1936' and had come to be pretty much run by Harry McCurry and so remained 'closely linked in many minds with the National Gallery.'[101] Outlying areas of the country suffered particularly from all of this. Atlantic Canada – with only one representative on the committee – was, as Arthur Lismer reported in the spring of 1940 following a lecture trip to Sackville, Charlottetown, Halifax, Wolfville, and Saint John, 'the most backward in any sort of aesthetic and creative activities in education.'[102] Things were little better in Quebec, notwithstanding the fact that six years earlier McCurry had singled that province out for special attention, though there the difficulty was created by what Keppel termed 'the special circumstances under which education was controlled by the church.'[103]

The Corporation, seeing the National Gallery as exerting 'the only national leadership there is among Canadian museums,' did not object to its dominance, and, indeed, there was something to be said for encouraging it to play a central role.[104] In other ways, however – and Parkin's criticisms were relevant here, too – what the Corporation did was clearly not as effective as it might have been. It had much to do – Canada was only one of several countries to which it gave attention – and so relied too much on written applications for grants and not enough on the sending of its own agents into the field. The result, as Parkin put it, was that its officials 'do not know nearly enough about the things they are giving to.'[105] In addition to this, Corporation officials had 'their own fairly clearly defined interests' which sometimes made them insensitive to the 'time lag' that existed between the two countries.[106] A given program might be suitable for a cultural organization in the United States, but it was not always appropriate for a parallel organization in Canada. Then, too, there were problems created by the fact that giving might benefit one Canadian institution or group while harming another. When, for example, the Corporation set up what the Toronto Conservatory of Music considered 'a rival examination system' at the University of Saskatchewan, the older institution was unable to meet its financial obligations. And when it proceeded to establish a similar program at the University of Western Ontario, the Toronto Conservatory felt even more threatened. 'Several grants made to Canadian musical institutions of the late years,' Ernest MacMillan reported to the Conservatory's board of governors in 1936, 'have worked to the actual or potential disadvantage of the Toronto Conservatory.'[107] Rivalry due to Carnegie funding was also caused among amateur cultural organizations. The British Columbia Provincial Drama Association received no grants from either the Rockefeller or the Carnegie foundation, something owing, its Alberta counterpart sarcastically suggested, to the fact that 'its work has not been of quantity or quality to merit it.'[108]

The lack of a structured, coherent approach was perhaps at its clearest in relation to what came out of the Corporation's decision generally to concentrate on 'educational' institutions and programs. This meant, for one thing, that amateur groups were at a disadvantage. In Saskatoon, Drama League officials discovered 'the futility of competition with the trained personnel and the greater financial resources of the universities,' while the Kingston Arts and Musical Club, once the domi-

nant cultural organization in town, had to take second place to the university extension program which, adding insult to injury, it had helped to establish.[109] The same policy also produced problems in relation to the very programs it supported. In concentrating almost entirely on the training of artists, musicians, and theatre people, the Corporation did little to build the institutions – theatres and orchestras – in which they might have found work. It thus helped create a system which virtually ensured that significant numbers of trained Canadians, lacking opportunities at home, would leave the country. The Corporation's programs also fostered the Americanization of institutions and groups in quite direct ways. From 1938 its 'Arts Teaching Sets' included colour reproductions of the work of American painters Grant Wood, Thomas Hart Benton, and others who had been influencing English Canada's artists since the Carnegie-sponsored Exhibition of Contemporary American Art had toured Canada in 1934. And from the early 1930s such American teachers as Walter Abell at Acadia University and Joseph F. Smith, Frederick Koch, and Jacques Joles at the Banff School of Fine Arts had occupied Carnegie-funded positions. Their presence, particularly at Banff whether for long or short periods of time, attracted American students and, according to Banff director E.A. Corbett, made that institution, at least, 'more of an international Centre than a Canadian' one.[110] Certainly styles in vogue in the United States, but not necessarily appropriate to Canada, were taught with a real vigour. Elsie Park Gowan, who studied playwriting at Banff with Frederick Koch, recalled, 'I always felt he was trying to turn us back. The people who were there in his writing classes were living in modern communities and this business of the folk play [which he introduced to his students] was kind of phoney.'[111]

While it is evident in retrospect that there were certain problems with the Carnegie approach, and while it is also true that contemporaries such as Parkin were aware of at least some of them, it must be emphasized that most observers continued to be struck by what they saw as the great service the Corporation was doing for cultural life in Canada. In their view, nothing could be plainer than that things were being done which would otherwise not be taking place, a fact which was, they thought, enough to excuse a multitude of deficiencies. Few, in consequence, would have argued with what Columbia University professor R.M. MacIver told the Carnegie-sponsored Conference of Canadian-American Affairs in Kingston, Ontario, in 1937: 'Canada,' he asserted,

'can work together freely with the United States in the building of a greater continental culture, yet at the same time, within that larger co-operation, can retain, may develop, her self-hood as a distinct nation.'[112]

That sojourns abroad, contact with 'foreign' culture at home, and sub-sidies from American foundations made Canadian writers, artists, and performers something other than narrowly provincial is clear. Evident, too, is the fact that the influences they were exposed to and the assis-tance they were receiving were producing a cultural community not a few of whose members were performing, composing, writing, or paint-ing to the international standards set by the supranational contest they found themselves in. Certainly foreign agencies did not hesitate to deal with their work. The British Broadcasting Symphony Orchestra per-formed the music of composers Hector Gratton, Ernest MacMillan, Leo Smith, and Healey Willan on an international broadcast in 1935. A Finnish publisher sold 'thousands of copies' of a translation of Nellie McClung's novel *Painted Fires* (1925), which recounted the trials of a high-spirited young Finnish immigrant in Canada.[113] Australian and New Zealand painters learned much from the Southern Dominions Exhibition which toured South Africa and the Antipodes from 1936 to 1937. The staff of the International Petroleum Company in Peru were introduced to the Little Theatre movement when Lionel Charlesworth, son of Toronto critic Hector Charlesworth, formed the Negritos-Talara Players from the company's employees in 1927. The Metropolitan Opera Company in New York hired Guelph, Ontario, tenor Edward Johnson, as mentioned earlier, as its general manager in 1935. Judges at the International Tanzweltspiel, held in conjunction with the 1936 Olympics in Berlin, had a high enough regard for Boris Volkoff's To-ronto-based ballet company to place them fifth out of thirty-nine com-panies in the competition. And finally, in the 1930s the Basil Ballet Russe invited several Canadians to join the ranks of its *corps de ballet*, completing their transition to the international stage by insisting that Patricia Meyers from Vancouver become known as Alexandra Denisova, Betty Low of Ottawa as Ludmila Lvova, Robert Bell from Montreal as Boris Belsky, and the youngest member of the company, fifteen-year-old Jean Hunt from Nanaimo, British Columbia, as Kira Bounina. There was, to be sure, a long way to go before English Canada's cultural life as a whole would be capable of taking a place even remotely resembling

that occupied by the great powers of the cultural world. And it would be some time before artists such as Margaret Laurence, Alex Colville, Glenn Gould, and Maureen Forrester could win solid international reputations for themselves while remaining on Canadian soil. A start had, however, been made. Though from one point of view what was being done demonstrated the still dependent, other-directed character of the country's cultural life, from another it showed that life clearly capable of being taken seriously at the highest possible levels.

SIX

'The Beginning of a Co-ordinated Artistic Life': The Second World War and Its Aftermath

With the outbreak of war in 1939, a new period in the history of cultural activity in Canada began. Although that great conflict at first served simply to reinforce the existing trends, it soon led to a conviction that the country's cultural life had to be put on an altogether different footing than that on which it had stood for the previous forty years. Manifest most clearly in growing support for the idea that culture had a role in society which the state should help it play, the feeling developed through a series of stages and eventually culminated in the critically important move to establish the Royal Commission on National Development in the Arts, Letters and Sciences in April 1949. From that point forward, things were never to be the same again.

The fundamental shift in thinking about culture that the 1940s would produce was not, to be sure, evident in the very early years of the decade. Getting the nation ready for war, in fact, turned out to mean taking resources away from culture. The budgets of such institutions as the National Gallery were reduced. The need to accommodate the expanding bureaucracy administering the war effort saw the New Brunswick Museum in Saint John, the Theatre Arts Guild in Halifax, and the National Gallery's newly created National Art Centre in Ottawa lose all or part of their premises. 'In order to provide more time for the Dominion's political leaders to speak to the nation, and for the spokesmen of the Government Departments to describe what is being done to prosecute the War,' the Canadian Broadcasting Corporation reduced the number of programs devoted to drama and music.[1] The demand for recruits robbed Little Theatres of their male actors and choirs of their

baritones and basses. (Drama groups confined their activity to play-readings, while such choirs as Vancouver's Bach Choir simply disbanded for the war's duration.)

Music conservatories and art schools as well as university departments of art and music were equally affected by the outbreak of hostilities in September 1939. Some lost their teachers along with their students. The Toronto Conservatory of Music survived by hiring women to replace the male teachers who had enlisted. Acadia University's Fine Arts Department, on the other hand, simply folded when Water Abell moved to Ottawa in 1943 to help run the dislocated National Art Centre and to take on the editorship of *Canadian Art*. (Abell, however, did not get on with Harry McCurry at the National Gallery and soon returned to the United States.) Herman Voaden's experimental Play Workshop, attached to Toronto's Central High School of Commerce, where he taught English, was also unable to carry on. The Dominion Drama Festival suspended its activities. In order 'to meet contingencies arising from ... enemy conditions,' the Carnegie Corporation curtailed much of its funding in Canada.[2] Finally, the feeling that one's leisure time and money should be devoted to the war effort and not to frivolous cultural activities robbed some cultural organizations of their volunteers and individual cultural producers of their private patrons.

Concerned to avoid any suggestion that it was trying – as its totalitarian enemies were doing – to make culture the servant of the state, the federal government at first did little to ameliorate the precarious position the cultural community had been thrown into by including it in propaganda activities. Early in 1940 a Bureau of Public Information, which distributed pamphlets through the mails among other things, was reluctantly attached to the prime minister's office. Later the same year Mackenzie King agreed to transfer the bureau to the newly created Department of National War Services. Even after this organization was replaced in June 1942 by the more effective War Information Board, headed first by Charles Vining and then by the energetic founder of the National Film Board, John Grierson, propaganda continued to be conducted largely through such already existing agencies as the National Film Board and the Canadian Broadcasting Corporation, though establishment of the War Information Board's Department of Cultural Affairs provided a new administrative framework for such activity abroad. A handful of script writers, musicians, composers, actors, and visual artists did find employment as a result of this activity. Others were given

jobs assisting social scientists in the Directorate of Auxiliary Services. Attempting to provide men and women in the services with 'an absorbing and interesting free-time activity,' artists helped establish art clubs, mount art exhibitions, and hold art competitions.[3] (The first exhibition devoted to the work of largely amateur artists in the services, Canadian Armed Forces: Art Exhibition, held at Hart House in 1942, drew some seven thousand visitors over a two-week period.) Artists were also hired to compile 'How to Get Started' art manuals which were made available to those in uniform through the YMCA's War Services Committee and the Canadian Legion's Educational Services. But whether they were created by the War Information Board or by the Directorate of Auxiliary Services, the jobs available to English Canada's cultural producers during the early years of the war were few and far between. While most governments recognized that propaganda was a primary weapon of modern warfare and moved quickly to enlist the cultural community in its prosecution, Canada's 'propaganda activities' were, as one commentator put it in 1942, quite simply 'conducted on the scale of a peanutstand.'[4] It was, then, little wonder that Arthur Lismer could note of 'The Artist in Time of War' that he 'is perplexed but he is aroused[.] His world is slipping. He sees his clients – his subjects – his crafts and his lifes [*sic*] work of little value.'[5]

If the government was not altogether committed to the idea that culture could play an important role in the prosecution of war, the cultural community itself soon came to the conclusion that this was so. Romantic notions of the artist or writer as a remote, even beleaguered, figure pursuing his or her own vision of what truth was without any connection to the larger world – the kind of view epitomized in Bertram Brooker's statement that 'art is not ... and should not be ... *useful* to society, *in any sense whatever*!'[6] – yielded to quite a different conception of how he or she was to be understood. Cultural producers began to see themselves, in the words of *Saturday Night* writer Raymond Davies, as '*opinion moulders*' who could 'help rally the people for the offensive.'[7] The amateur theatre, insisted Donald Cameron of the Banff School of Fine Arts, could 'play a vital role in moulding morale, and in helping the war effort through benefit performances and money raising drives.'[8] 'The task of literary men and women, as the interpreters of a people's faith and idealism,' was, the Canadian Authors' Association executive told its membership in 1942, 'a vital one in these days of stress and anxiety.'[9] 'Music, literature and other arts,' Ernest MacMillan wrote a year earlier, were 'more than a mere means of escape for tired

workers.' These things were 'symbols of the very things our brothers-in-arms are fighting for.'[10] Even folk festivals, according to one commentator, had a role to play in celebrating 'not so much national characteristics of each race, but rather the idea of a common unity which prevails despite the differences and the traditional diversities which make up the Canadian scene.'[11]

This kind of 'common unity' would continue, of course, to turn on encouragement of the sort of anglo-conformity which had been so central in cultural programming and institution-building before the war. The operation did receive, however, a new twist. Cultural producers and organizers were now concerned not so much with imbuing Canadians with manners, deportment, and a sense of their place in the empire or even with creating an indigenous or internationally attuned culture; they sought rather to unify the nation through giving its people an understanding of Canada's role in the war and by using their art to restore 'the mind to health by giving us a sense of poise, proportion and serenity.'[12] Yet no matter what kind of unity they had in mind, they all – and this is the central point – operated on the assumption that the cultural producer, far from occupying a sort of Brooker-approved place remote from society, was deeply involved in the business of teaching its members exactly what values the war was being fought to preserve.

The extent to which the country's cultural producers attempted to explain what they saw as the war's higher purpose was evident from the early years of the hostilities. Editors of the *Canadian Review of Music and Art* – perhaps, along with *Food for Thought* and *Maritime Art*, the most outspoken magazine of cultural affairs – published the work of 'young poets now engaged in the fighting force.'[13] In 1941 the Vancouver Little Theatre Association produced the anti-Nazi play *Watch on the Rhine*, by American writer Lillian Hellman. Through the encouragement of the National Council for Canadian-Soviet Friendship, the Winnipeg composer Barbara Pentland arranged and orchestrated Russian works to create *The Birth of Russia*. Putting aside her adjudicating duties in northern British Columbia, dramatist Phoebe Smith penned the wartime play *Shall Not Perish* John Coulter wrote the libretto for Healey Willan's radio opera *Transit through Fire*, which dealt with the 'sacrificial death of democracy's fighting-men.'[14] Willan himself set Duncan Campbell Scott's patriotic poem 'Hymn for Those in the Air' to music, while other composers – Alexander Brott, Maurice Blackburn, Ernest MacMillan, and Barbara Pentland – also found subjects in the war. Visual artists were no different. Frederick Taylor dis-

covered that 'industrial workers offered infinite and inspiring possibilities as subjects for art' while sketching in the Canadian Pacific Railway's Angus Shops, in the explosive and shell-filling plants of Defence Industries Limited, and in United Shipyards in Montreal.[15] Louis Muhlstock, Alma Duncan, and Fritz Brandtner were equally excited by what they saw in such war-producing plants as the Canadian Vickers Aircraft and Shipbuilding Plant in the same city. Other artists, however, preferred military to industrial subjects. Arthur Lismer got permission to sketch the defence forces at Halifax – just as he had done during the Great War; Rowley Murphy, to paint the activities of the Royal Canadian Navy there; and in Toronto's Union Station Nancy Burden painted the mural, *Royal Canadian Air Force* to commemorate the Commonwealth Air Training Plan. So preoccupied were artists with portraying military and industrial subjects relating to the war that art societies – the Canadian Society of Painters in Water Colour, the Association of Art Galleries in Western Canada, and the Ontario Society of Artists, among other groups – devoted part of their annual exhibitions to the war theme. This, according to one observer, was in fact a revitalizing move: the Ontario Society of Artists' exhibition in 1943 showed 'a sense of novelty and vigour which has been lacking in O.S.A. exhibitions for many past years.'[16] Indeed dealing with war-related subjects gave many artists an opportunity to turn away from the familiar business of painting the Canadian landscape in favour of a variety of different subjects.

Individual artists, composers, writers, and theatre people were not the only members of the English-Canadian cultural community to concern themselves with the war. Those involved with public and private institutions and amateur and professional cultural organizations also helped to assist the struggle. The Montreal Museum of Fine Arts organized the exhibition Masterpieces of Dutch Art to raise money for children living in occupied Europe. The Comox District Theatre Club on Vancouver Island, the Little Theatre Club of Saskatoon, and many other amateur drama groups donated the proceeds of their performances to war charities. Hoping to raise public morale or simply to entertain the troops, other institutions and organizations charged no admission whatsoever to their performances. Working through the National War Services Committee of the YMCA, the Society of Canadian Painters-Etchers and Engravers developed a comprehensive plan whereby art societies held exhibitions in military camps. The Vancouver Art

Gallery and the Art Gallery of Toronto organized free concerts in their exhibition halls for men and women in uniform. (These were no doubt inspired by Britain's National Gallery concerts begun in 1939.) Efforts were also made to get men and women in the services actively involved in culture. The London Community Centre distributed phonographic records with 'How to Listen Kits' to army camps and RCAF stations in southern Ontario; the Vancouver Little Theatre Association took its theatrical productions to military camps scattered throughout the lower mainland of British Columbia; the drama section of Edmonton's Allied Arts War Services Council, headed by Elizabeth Sterling Haynes, also staged plays for the troops; and the Nova Scotia Society of Artists established a studio class for servicemen.

The production of silkscreen prints reproducing Canadian works of art represented yet another attempt to boost morale during the war years. The venture brought the Directorate of Auxiliary Services and the National Gallery into co-operation with military officials, private patrons, and artists. The idea of producing silkscreen prints for display in military establishments was conceived by A.Y. Jackson and presented in 1940 to Harry McCurry, who had replaced Eric Brown as the director of the National Gallery in 1939. McCurry, taken with the proposal, persuaded twenty-one artists to donate their work for reproduction. He also encouraged private patrons – insurance companies, chocolate and cereal manufacturers, and newspapers, among others – to each pay $650 for a set of three hundred reproductions. And he arranged for Department of National Defence personnel to act as distributors. The venture was a success. During the 1944–5 fiscal year alone 163,210 prints found their way into canteens, mess halls, recreation rooms, and service clubs across the country and in military establishments in Europe, Britain, Ceylon, and India. The austerity of military life was thus somewhat abated by the presence of familiar scenes from home.

Nor did private patrons neglect support of cultural organizations and producers despite the number of non-cultural, war-related causes demanding their time and their money. The Nova Scotia businessman Hugh O. Mills organized the Halifax Concert Parties Guild, which staged over 2,400 concerts for men and women in the services, and, near the end of the war, sent the guild's dramatic and musical contingent to perform for the troops in Britain and Europe through the sponsorship of the *Halifax Herald*. In Montreal the House of Seagram commissioned Stephen Leacock's *Canada: The Foundations of Its Future* (1941)

and then distributed it to naval vessels, military establishments in Canada and abroad, to members of the government, schools, public libraries, and, indeed, to anyone who asked for it. In Ontario the Algoma Steel Corporation hired Frederick Taylor to illustrate its *Globe and Mail* advertisements supporting the purchase of Victory Bonds; Canada Packers employed Carl Schaefer to produce six paintings relating to war production; and the John Inglis Company commissioned the same artist to execute a series of drawings and paintings depicting war production. In the same city Canada Packers' Operatic Society played a full week at the Royal Alexandra Theatre to raise money for the Red Cross, while the T. Eaton Company's Masquers' Club staged musical productions which they took overseas in 1945 'to entertain the men awaiting repatriation.'[17] Private patronage was not, of course, always directed towards wartime activities. Intercontinental Packers' president Fred Mendel gave the Saskatoon Art Association 'the financial and moral strength to conceive and carry out' its program during the war.[18] A bequest from Elsie Perrin Williams saw the building of the London Community Centre in 1942. And from 1944 grants from the Canadian Authors' Foundation (from 1945 the Canadian Writers' Foundation) aided such aging and destitute writers as Wilson MacDonald, Audrey Brown, and Frederick Philip Grove.

If the war gave already established organizations, institutions, and patrons a chance to broaden their range of activities, it also brought new cultural groups into being. Montreal's Seven Arts Club was formed in 1941 'to bridge the existing gap between the artist and the public.' Under the direction of Hazen Sise and Peter Dawson it set out 'to study the social function of the arts and bring about a new harmony among them based on the realities of life as it is lived TODAY.'[19] The Writers', Broadcasters' and Artists' War Council, founded a year later in Toronto and then in Saskatoon, Vancouver, Victoria, Calgary, and Edmonton a year after that, was no less committed to interpreting 'the nation's mind and mood' and by so doing sweeping 'away confusion of thought and conflict of purpose by holding up and glorifying those things which are universally acknowledged to be true and so create unity of purpose, emotional solidarity and a common understanding among our people.'[20]

Many of these groups and organizations, whether old or new, were assisted in their endeavours by a force that had been active in shaping English-Canadian culture since the mid-1920s: the foreign philanthro-

pist. John Marshall of the Rockefeller Foundation gave grants to the National Film Society of Canada for the purchase of American films; money to scholars for the collecting of folk-songs and the surveying of the humanities; and fellowships to help write histories of Canadian universities and biographies of national figures (Donald Creighton's monumental biography of Sir John A. Macdonald was begun in 1944 with Rockefeller funding).[21] The Rockefeller Foundation also supported two areas of cultural endeavour to which the Carnegie Corporation had given little attention: writing and drama. In 1945 Rockefeller officials funded a chair of drama at the University of Saskatchewan, the first of its kind in the country. A year earlier they had supported the Western Canadian Writers' Conference, which brought sixteen writers to the Banff School of Fine Arts to discuss the mechanics of writing plays, novels, and poems and to consider the best ways of preserving the history and folklore of Alberta so that it could be used by authors, playwrights, and radio producers. During the same year and in the same venue the Rockefeller Foundation also organized the Western Canadian Theatre Conference. Its purpose was to forge 'a link between all organizations and individuals interested in amateur theatre in the four western provinces.'[22] Those attending considered how they could establish 'a National People's Theatre in Canada,' promote 'the study of drama in schools and universities,' foster 'an appreciation of better plays particularly for small communities and schools,' and encourage playwrights by purchasing 'the four best new plays written each year and submitted by Canadian authors.'[23] They also gave attention to such practical matters as the construction and lighting of school and community auditorium stages, thereby reaching in their concerns well beyond those of the earlier Dominion Drama Festival organizers.

Carnegie Corporation funding also found its way to the Banff School of Fine Arts – in 1945 the Corporation helped establish a department of applied art – though most of it was channelled to central Canada. Urged by Raleigh Parkin that funding was 'vital' because Canada was not only 'culturally isolated due to the war' but in danger of falling prey to 'an attitude of defeatism toward civilized processes,' the Corporation sent exhibitions and lecturers to the National Gallery of Canada.[24] (The Works Progress Administration's Federal Art Project's 1940 Mural Designs for Federal Buildings from the Section of Fine Arts, accompanied by the project's organizer, Edward Rowan, was one significant undertaking.) Foreign philanthropical societies also – and this

was perhaps their most important contribution to cultural activity during the war – enabled visual artists to come together for the first time on a national level.

The idea of holding 'a kind of weekend house party,' so that Canadian artists could 'learn from an outsider something about the modern technical aspects of painting in which they are especially ignorant' and study the position of the artist in society came about in 1941 as a result of discussions between Queen's University professor of art André Biéler and Carnegie Corporation officials.[25] In 1937 Biéler had given a rousing address on the 'National Aspects of Contemporary American and Canadian Painting' at the Carnegie-sponsored Conference of Canadian-American Affairs. Mexican and American art programs were reviving mural painting and using 'the large decorations for social and political propaganda,' and Biéler's proposal to Corporation officials that Canadian artists might do the same, and that, in particular, they be brought together to think about art's relationship to society, to learn something about the technical methods of mural painting from the Boston Workshop artists, and simply to have an opportunity to exchange their ideas and their experiences got a favourable response.[26]

One hundred and fifty artists, critics, educators, and curators from all regions of the country congregated in Kingston, Ontario, on 26 June 1941 for the Conference of Canadian Art. Over the course of the next four days they listened to lectures on art and democracy, on government sponsorship of the arts, and on the artist's place in the war effort. From Works Progress administrator Edward Rowan, they heard details of the Federal Art Project, which had given hundreds of artists employment since the autumn of 1935. From Canadian artist Albert Cloutier of the War Information Board's Art Department they learned how the wartime poster was 'a psychological combination of message and design, coordinated into a clear statement, which must be read by the public.' Visual arts writers John Alford and Walter Abell instructed them on the importance of adapting their art to industry and of making it relevant to society in general. And during his two-and-a-half-hour talk the American Scene painter Thomas Hart Benton told them how 'a local art, based upon local experiences ... becomes part of the culture of the world.'[27] Finally, on the last day of the conference, the participants were bussed to Ottawa, where they viewed an exhibition of Canadian painting at the National Gallery of Canada.

The Conference of Canadian Art in Kingston was, André Biéler told Carnegie officials at its conclusion, 'a great success.' 'It was interesting,'

he added, 'to see the eagerness with which the artists assembled, listened, argued and applauded.'[28] Naturally everyone who attended had a different view of the proceedings. For the young Prairie artist Ernest Lindner

the conference was *the* major event in my career in Canada. To meet members of the Group of Seven and the many other artists, to see their work at the National Gallery, when I knew it only from reproductions, to have Robert Ayre, Lismer, Muhlstock, Brandtner, etc., look at and criticize the work I had fortunately brought along, how can I describe what this meant to a young artist and art teacher from the West.[29]

The contingent of artists from Atlantic Canada, comprising Jack Humphrey, Pegi Nicol MacLeod, Miller Brittain, Lucy Jarvis, and Julia Crawford, experienced the conference differently. 'The idea of the organization of art repelled us,' Lucy Jarvis recalled, 'and Mr. Rowan did not impress us at all – except as a phenomenon that might threaten.' In addition to this they found that 'the activity which we called "the cooking show" [Thomas Hart Benton's Boston Workshop demonstration] did not particularly impress us because we had been doing the same kind of research.'[30]

One aspect of the conference which struck a favourable chord with all participants was the fact, as Vancouver artist Jack Shadbolt has recalled, that 'it was the first time that Canadian artists right across the country achieved any sense of social identity.' The conference made it obvious to Shadbolt and many others 'that a new concept of art in relation to the everyday scene in Canada was emerging.' That concept had little to do with what Shadbolt called the 'landscape oriented and somewhat remote and romantic' paintings of the Group of Seven to which many of the conference participants still adhered. It had, however, a lot to do with the 'everyday detail of local involvement, political involvement, the workers' cause and domestic scenes in general.'[31] As André Biéler indicated in his opening remarks to the conference, art was a process whose formal qualities were clearly subordinate to human activity.[32]

After the lectures, the workshops, and the out-of-session discussions conference members gathered for a general meeting. During it they put forth several recommendations: that the federal government, working through the National Gallery, 'set up machinery for the creation of works of art recording the various phases of the Dominion's war effort'; that instruction in art and in art history be expanded in educational

institutions across Canada; and that the National Gallery 'institute a national exhibition of Canadian drawings and if possible establish this as an annual feature' of its exhibition program.[33] They also proposed that research be carried out on problems concerning the general development of Canadian culture, on the relationship of art to public opinion, and on the economic status of the artist.[34]

The way by which these and the other recommendations put forward at the general meeting could be implemented was suggested in a letter from Lawren Harris which was read before the assembled crowd. Anticipating that the conference participants would be sympathetic to the view that some sort of national body was needed to co-ordinate the activities and serve the interests of Canada's artists, Harris argued that 'the time has come when the artists of the country should contribute consciously and designedly to the growth of a more highly socialized democracy by forming a nation-wide and inclusive organization and by working through the organization to serve the cultural needs of the Canadian public.'[35] And in order to keep this and the other recommendations alive, a continuation committee was struck with members André Biéler, Arthur Lismer, A.Y. Jackson, Walter Abell, Jean-Paul Lemieux, and, due to the insistence of Paraskeva Clarke that a woman be included, the sculptor Frances Loring. When this group met a few months later in Toronto, the Federation of Canadian Artists, consisting of individual artists from across the country, came into being. Harris, appropriately enough, was chosen as president.

Over the course of the next two years the Federation of Canadian Artists, thanks to the continuing support of the Carnegie Corporation, became the country's visual artists' most powerful lobby group. It established branches in British Columbia, Alberta, Saskatchewan, Manitoba, Ontario, and Quebec and maintained close contact with the independently minded Maritime Art Association. To give a voice to its members it persuaded the journal *Maritime Art* to move to Ottawa in 1943, where it was renamed *Canadian Art*. To involve the artists 'in a total effort for victory' it gathered a thousand signatures and petitioned the federal government in February 1943 to establish a war artists' program and an arts council that would embrace not only artists 'but writers of all kinds, poets, playwrights [and] radio-dramatists.'[36] It encouraged its members 'to work at making war posters, arranging canteen exhibitions, helping with decoration of army post club rooms, and recording the war.'[37] Through the unceasing activity of its president, it helped found community centres throughout the country. And in west-

ern Canada it established the Western Canadian Art Circuit, which enabled member galleries in Winnipeg, Brandon, Saskatoon, Calgary, Edmonton, and Vancouver not only to exchange exhibitions among themselves but also to bring in shows from the National Gallery in Ottawa.

By amalgamating the country's professional and amateur artists along lines that had nothing to do with their affiliation to a region, an art gallery, or an art society, the federation was able to challenge the long-standing antipathy between art societies and individual artists, professionals and amateurs, and among western, eastern, and central Canadian artists. In so doing it successfully persuaded the federal government to hire several artists to paint the war.[38] It prompted its branches – the Quebec branch in Montreal was one – to hold meetings with labour to consider how the artist could stimulate morale on the industrial front. And it gave new life to such organizations as the Canadian Society of Painters in Water Colour 'at a time when it almost looked as though the wisest course would be just to let things go.'[39] As Lawren Harris wrote in 1944, the federation was 'designed to further [the artists'] ... country-wide aims which no one art society could either devise or carry out and to integrate the arts with the life of the Canadian people.'[40] And this is precisely what it did.

In carrying out these various programs, the Rockefeller Foundation and the Carnegie Corporation employed the same methods they had used before the war. Both foundations brought American specialists into the country: the Rockefeller Foundation to preside over the Western Canadian Writers' Conference, and the Carnegie Corporation to instruct at the Conference of Canadian Art. Both foundations modelled Canadian organizations after their own: the Western Canadian Theatre Conference after the National Theater Conference in the United States, and the Federation of Canadian Artists on the American Federation of Artists. But both foundations also encouraged the use and the preservation of local subject matter as demonstrated in the collecting of Maritime folk-songs, the use of local subjects for paintings and murals, native designs for applied arts, and myths, legends, and folk-songs for plays, radio productions, and novels. While Raleigh Parkin had some justification for his charges that they repeatedly failed 'to appreciate what would be the significant thing to do in Canada' and never managed 'to treat Canada as a community having its own problems,' by war's end they had done much to make English Canada's cultural producers more sensitive to the human aspects of their region, more aware

of their right to demand a role in the prosecution of the war, and more conscious that by joining forces they had a better chance of achieving their various goals.[41]

Far from being remote from the scene, English Canada's cultural community was actively involved in the life of the surrounding society. Cultural producers, concerned, as always, with helping their fellow citizens understand themselves and their lives as members of the human community, were also much preoccupied with the war effort and what they could do to help it. All of this gave them a distinctly heightened sense of their importance, for they now saw themselves more clearly than ever before, not simply as nation-builders or educators but as the custodians of the values their civilization was struggling to preserve. They had developed, too, a strong conviction that it was in fact they, and not governors general, or itinerant festival adjudicators, or even foreign foundations, who were giving shape and meaning to the country's culture. When, therefore, attention began to be paid during the last years of the war, not to its prosecution, but to the reconstruction that would follow it, they were very much in the foreground with plans and ideas about their place in the society that Canada was to become.

The war shook almost everyone 'out of old ruts'; people from the government down, Lawren Harris recalled, were prompted 'to plan and project and establish new ventures.'[42] As early as 1941 Walter Abell and Frances Loring had urged artists at the Conference of Canadian Art in Kingston to prepare themselves to play a role in 'cultural reconstruction following the war.'[43] Public lecturers and radio commentators had talked about art for the community, art and democracy, art's relationship to industry, and art and social reconstruction. The prime minister had been moved to claim in 1942 that 'the significance of the present war, the growing strength of our national consciousness, and the part which we will be called upon to play in the remoulding of a better world, will need and receive the inspired interpretation of those among us who have the grace of words and the gift of song.'[44] A commentator in the *Canadian Review of Music and Art* had written that Canada had 'established herself as a nation, strong and capable of tremendous effort to achieve the common good,' and that following the war she 'must maintain that position' with the help not only of every citizen but with 'the vision and ability of the artists and craftsmen.'[45] And reflecting the

views of many cultural producers, Arthur Lismer had observed in 1943 that 'if democracy is to survive we need the artist, the rebel, to help fashion its idealism and its purpose.'[46]

To many observers, then, it seemed a certainty that cultural producers would help build a better society in post-war Canada. They might even show Europe the way. Thanks, as Ernest MacMillan told a meeting of the Institute of International Americans at Columbia University in 1945, to North America's isolation from the devastation and collapse now so evident across the Atlantic, 'we shall ... be several laps ahead of Europe in post-war reconstruction.'[47] Indeed – as Bertram Brooker, F.B. Housser, and others had long hoped – Canada's culture, characterized by what Brooker once termed 'the new, the natural, the open, the massive – as contrasted with the old, artificial, enclosed littleness of Europe,' would now be able to infuse the Old World with a new spirit.[48] Certainly, thought the art critic Robert Ayre, there could be no doubt that Canadian culture was displaying a quite unprecedented strength: 'no longer a wallflower, sitting demurely on the sidelines and wistfully hoping to be asked to dance. She is out on the floor, changing partners. She is even going so far as to do something about calling the tune.'[49]

There had been many indications, of course, as to what that tune might be well before the end of the war. The Willistead Art Gallery in Windsor, the Observatory Art Centre at the University of New Brunswick, the Saskatchewan Reconstruction Council, the Allied Arts War Services Council in Edmonton, and the London Community Centre in southern Ontario were showing how a number of cultural activities and cultural organizations could be co-ordinated on the local level. The Labour Arts Guild, established in 1944 under the direction of John Goss in Vancouver, was demonstrating how amateur and professional cultural producers could identify 'their talents and abilities with the labour movement and the politically and culturally progressive forces throughout the community.'[50] During the same year F.R. Scott, A.J.M. Smith, and A.M. Klein of Montreal similarly attempted to prepare writers for the post-war world by organizing the Federation of Canadian Writers to lobby for grants, establish a literary magazine, and obtain time on the radio. And in 1945 Herman Voaden, John Coulter, Marcus Adeney, and Earle Grey tried to place drama on a national and professional footing by creating the Canadian Theatre Council.[51] Moreover, if things were happening at home, examples were also being offered abroad of what might be done. Anyone who read the newspapers could not have failed to notice how the creation in 1939 of the

government-subsidized Council for the Encouragement of Music and Arts in Great Britain had involved that country's cultural community in the war effort. Nor could he or she have missed seeing how the British Arts Council created from it in June 1945 had put government patronage of culture on a peacetime footing.

It was at this point that a distinctly dark spot could be seen on the horizon: however enthusiastically cultural producers might be seeing themselves and their role in the post-war world, there was – despite Mackenzie King's 1942 pronouncement – little indication that the government took anything like the same view. Indeed, as the sculptor Elizabeth Wyn Wood put it, it seemed clear that 'the social powers of the arts are being totally ignored by the planners and by the drifters' responsible for reconstruction.[52] Certainly it was true that the federal government's leaflets, radio programs, and commissioned studies on post-war reconstruction focused largely on agriculture, forestry, construction, transportation, and trade.[53] Much, then, would have to be done if the arts were to get their place in the government's reconstruction program – and it seemed clear that it would have to be carried out by the cultural community itself.

Activists turned with a will to the task of convincing the government that they were as vital to Canada in peace as in wartime. In 1943 art critic Blodwen Davies encouraged members of the Writers', Broadcasters' and Artists' War Council to write to Pensions and Health Minister Ian Mackenzie (in charge of reconstruction) 'asking for a statement as to how the post-discharge plans' would affect them.[54] That same year she was in touch with Mackenzie King himself, suggesting the establishment of 'a department of cultural affairs.' (The prime minister's reply, she told H.O. McCurry, was 'as sympathetic a response as I could have hoped for' – though he nevertheless passed the matter on to the Department of External Affairs.)[55] In January 1945 poet Dorothy Livesay also wrote to Ian Mackenzie to inquire about plans for the post-war rehabilitation of writers.[56] And members of the exclusive women's private cultural organization the Heliconian Club of Toronto addressed the issue of culture's future place in post-war society with even greater force.

Believing that Canada could be 'more than a country providing material things,' the Heliconian Club executive wrote first to the prime minister, and then sent a delegation to Ottawa in February 1944. There they met with Ian Mackenzie and asked that 'in the proposed rehabilitation and employment of the armed services at the conclusion of the war,

provision be made to ensure employment to citizens desiring to continue their work' as actors, musicians, writers, and artists. They also requested that a 'Commission' be set up to ensure that the cultural producer, like the farmer and the miner, receive the support and the attention of the government following the war.[57] Mackenzie assured the delegation that 'artists would have the same consideration as other citizens at the conclusion of the war, and that plans would be made now, in the same way as plans had been made for farmers and fishermen.'[58] This is indeed what happened. Eight months following the delegation's visit, Mackenzie announced that 'provision is now made under the Post-Discharge Order for the professional training of actors, artists, musicians, and writers under the same arrangements as applied to other students.' The Heliconian Club was less successful, however, with its other proposal. The establishing of a cultural commission, Mackenzie told it (thus sounding a refrain that would become very familiar over the next few years), involved education and so would require 'the specific approval of all the Provincial Governments.'[59]

The absence of a commission, ministry, or department specifically concerned with culture did not mean, of course, that there was no agency to which the country's cultural producers could address themselves. The House of Commons Special Committee on Reconstruction and Re-establishment, set up in 1942 under the chairmanship of James Grey Turgeon 'to study and report under the general problems of reconstruction and re-establishment which may arise at the termination of the present war,' in fact received many submissions from cultural groups and organizations.[60] By far the most important of these were brought together under the auspices of sixteen major cultural organizations in May 1944. Meeting at the executive offices of the Art Gallery of Toronto, representatives of the Royal Canadian Academy of Arts, the Royal Architectural Institute of Canada, the Sculptors' Society of Canada, the Canadian Society of Painters in Water Colour, the Canadian Society of Painters-Etchers and Engravers, the Canadian Group of Painters, the Canadian Society of Graphic Artists, the Federation of Canadian Artists, the Canadian Authors' Association, the Société des Écrivains Canadiens, the newly formed Music Committee, the Canadian Society of Landscape Architects and Townplanners, the Dominion Drama Festival, the Canadian Handicrafts Guild, the Canadian Guild of Potters, and the Arts and Letters Club, as well as individuals such as Herman Voaden, all set aside their differences, pooled their resources, and condensed sixteen individual reports concerning how

the government could help their particular organizations into one memorandum. The resulting 'Artists' Brief to the Reconstruction Committee' was set out in three parts. The first section called for the founding of a government body to administrate the arts; the second for the establishment of nation-wide community art centres; and the third listed twenty-nine items which needed government attention, ranging from copyright laws and the creation of a national library and a government publishing house to conducting a study of the National Film Board, the National Gallery of Canada, and the Canadian Broadcasting Corporation.[61] An astounding document, the 'Brief' managed to diagnose both the strengths and the weaknesses of the country's cultural life with a quite unprecedented force and accuracy.

Read before the Turgeon Committee by dramatist John Coulter on 21 June, the 'Brief' made its appearance a mere six weeks after representatives of the sixteen groups had first assembled. The swiftness with which it had been prepared did not, however, diminish its impact. 'It was,' wrote one observer, 'one of the most businesslike statements ever submitted to a parliamentary committee. Their story was neat, direct and understandable. No redundancy. No exaggeration. No class-consciousness, axe-grinding, self-seeking argument. Nothing but honest common sense, clearly stated and sincerely argued.' This was remarkable, he continued, because it had been 'submitted by "the starry-eyed folk" of Canada, the dreamers of dreams, a reputedly unbusinesslike tribe.' Other members of the press echoed these thoughts. Critic W.A. Deacon noted in the *Globe and Mail* that the occasion signalled 'the beginning of a co-ordinated artistic life in Canada.'[62] And another commentator, writing in the Canadian Association for Adult Education's journal, *Food for Thought*, called the presentation 'a cultural landmark.'[63] Representatives of the sixteen organizations who had attended also spoke with enthusiasm. 'Voaden was very eloquent and made good points about the general benefits of Community centres,' observed H.G. Kettle. And Ernest MacMillan came into the discussion, too, adding his 'prestige and reputation' to the occasion.[64] Members of the Turgeon Committee, all of whom were members of Parliament, were equally impressed. Following Coulter's presentation, Dorise Nielsen stated that she had 'been longing for something of this kind to come before us.' D.A. McNiven announced that he was 'strongly for it' and, in his concluding remarks, said that he thought 'all members of our Committee will agree that during the three years we have been in session this meeting ... is unique.'[65]

'The thing which really captured [the committee's] ... imagination and which occupied the larger part of the discussion' – and to which Voaden had given much weight – 'was the Community Centre idea.'[66] Here was a plan which served the amateur and the professional; which made the municipal, provincial, and federal governments financially responsible for culture; and which addressed the problems created by central Canadian domination, the country's vast size, and its reliance upon foreign cultural producers, organizers, and philanthropists. So impressed was 'one rugged and battle-scarred member' of the committee by this and the other recommendations put forward in the 'Brief,' that at the end of the discussion he 'moved a formal vote of thanks and appreciation to the delegation, and it was passed unanimously.'[67]

As prescient as the recommendations of the 'Artists' Brief' were – many of them appeared some nine years later in the report of the Royal Commission on National Development in the Arts, Letters and Sciences – there were some startling lacunae in what it proposed. Many of the country's major cultural organizations, institutions, and individuals were not represented. There was a heavy concentration on visual artists as opposed to writers, dramatists, and musicians and no representation whatsoever from dance or photography. Few French-Canadian organizations and cultural producers were included. (The delegate from Montreal representing La Société des Écrivains Canadiens did not attend the hearing.) Only two women's cultural organizations were represented, a fact which left such important groups as the Women's Art Association and the Heliconian Club aside. Not one of the many ethno-cultural groups by then in existence was invited to offer a brief. Nor were such radical cultural organizations as the Writers', Broadcasters' and Artists' War Council involved. But above all the 'Artists' Brief' was centralist. Even the community centre plan – which might have offered a way of decentralizing cultural activity – was to be partly controlled by such an essentially central Canadian institution as the National Gallery of Canada.[68] And while fourteen of the sixteen groups represented were 'national,' all were headquartered in central Canada, most notably in Toronto.

Despite these characteristics – all in keeping with the central Canadian, male-anglophone domination of cultural activity prior to the war – the 'Artists' Brief' did offer the most comprehensive program for organizing and funding the arts since Madame Joséphine Dandurand's 'Two Systems to Be Submitted to the Consideration of the Federal Government' in 1902. And – unlike the Dandurand scheme – it had been

presented by the artists, writers, musicians, and dramatists themselves. It won respect, too, not only because it was 'a project to give the artist dignity and importance,' but also because it was something 'to make life more pleasant and abundant for our people, to raise our status in the community of nations, [and] to make us important in the arts as we have become in industry and trade.'[69] It did not, to be sure, get the kind of response its advocates wanted; as Ernest MacMillan recalled in 1956, the 'Artists' Brief' 'achieved practically no immediate result.'[70] Its presentation did bring into being, however, the Canadian Music Council, which established the first national organization for musicians and music teachers. More importantly still, it initiated serious discussion of the idea that responsibility for cultural activity should be assumed by government. For that contribution alone, it takes a place among the key events in Canada's recent cultural history.

The enthusiasm with which the 'Brief' was received and endorsed by the Turgeon Committee and by the press prompted its creators to meet again. Coming together first under the name of the Arts Liaison Committee, they were soon meeting as the Arts Reconstruction Committee. Finally, at a December 1945 meeting just six months after the formation of the British Arts Council, they decided to call their organization the Canadian Arts Council. Gathering in the rooms of the Arts and Letters Club in Toronto, they elected an executive committee of which Herman Voaden of Toronto became chairman; Arthur L. Phelps of Montreal, vice-chairman; Claude Lewis and Erma Lennox Sutcliffe, secretary and treasurer respectively; and John Murray Gibbon, Elizabeth Wyn Wood, D.M. Le Bourdas, and G.H. Kettle, members at large. They also set out their mandate: 'to correlate all information and to act in collaboration when desirable on matters affecting the common interests of the member societies.'[71] With the founding of this organization some seven thousand individuals active in the arts and culture could be sure that they would have a stronger and more effective voice than ever before.

The 'matters affecting the common interests of the member societies' were considered to be much the same as those which had been raised in the 'Artists' Brief.'[72] They were dealt with by executive committees whose task it was to lobby government officials in person, by letter, and by petition and to work with member organizations. The Community Centre Committee, for example, helped towns and cities across the

country to found community centres in art galleries, public libraries, service clubs, labour halls, or, whenever possible, in buildings of their own. This spurred the provincial government in Alberta to establish cultural boards in 1946 in order to encourage, co-ordinate, and expand 'different aspects of the cultural life of the Province, and in particular, library facilities in both urban and rural districts, music, art, drama, handicrafts and physical recreation.'[73] Along with the example of the British Arts Council, the Canadian Arts Council also prompted the government of Saskatchewan to found, two years later, the Saskatchewan Arts Board, whose purpose was 'to make available to the citizens of the province greater opportunities to engage in creative activities in the fields of drama, the visual arts, music, literature, and handicrafts, with qualified guidance and leadership, and to establish and improve the standards for such activities in the province.'[74] And it 'played an important part' in making departments of education and recreation in Nova Scotia, British Columbia, Ontario, and New Brunswick devote part of their programs to the arts.[75] Equally committed to making Canadian culture known abroad as well as at home the Canadian Arts Council organized and juried two international exhibitions of women's art with the National Council of Women, and it selected artists, architects, musicians, and writers to represent Canada at the arts competitions held in conjunction with the Olympic Games in 1948. It answered inquiries and prepared reports for the Department of External Affairs' Canadian Information Service, which had taken over the duties of the War Information Board in 1946. And, perhaps most important of all, two Canadian Arts Council members, Herman Voaden and Elizabeth Wyn Wood, represented Canada at the first general assembly of the United Nations Educational, Scientific and Cultural Organization (UNESCO) held in Paris in 1946.

The Canadian Arts Council's involvement in UNESCO was important because it made Article VII of UNESCO's constitution, which called for the appointment in each member country 'of a National Commission or Co-operating Body, representative of principal associations interested in the work of the Organization,' something of an issue in Canadian public life.[76] Seeking, in conformity with it, to make the government establish a national arts board, the council envisioned a 'National Commission' under the aegis of the Department of External Affairs which would be composed of several leading scientific and educational organizations and a national arts board in which it would play a major role. Following the Paris conference in 1946, the Canadian Arts Council

executive expended a great deal of energy trying to convince officials in the Department of External Affairs as well as the prime minister himself that they could work 'as partners of the government ... in mobilizing people for peace' if Article VII of the UNESCO constitution were implemented in Canada.[77]

The Canadian Arts Council was as unsuccessful in getting the federal government to comply with the UNESCO constitution (which the government had ratified in August 1946) as it was in persuading the Ministry of Health and Welfare's National Council on Physical Fitness to establish community centres across the country.[78] As Secretary of State for External Affairs Louis St Laurent informed members of the council's executive during an Ottawa meeting in 1947, the provinces' jurisdiction over education created 'constitutional difficulties' with regard to the founding of an arts board. Furthermore, he told them, 'music, literature, theatre and the visual arts did not really have a wide appeal in Canada – their place having been taken by the movies, the radio and the more popular magazine.'[79] It was clear, then, that the creation by the government of a 'National Commission' or a national arts board, or cultural community centres, or, indeed, any of the programs recommended in the 'Artists' Brief' or the UNESCO charter depended upon realities which had little to do with the arts as such.

Despite its continuing and extensive activity – all dutifully reported in the *C.A.C. News* – the Canadian Arts Council found it difficult to prevail against the kind of thinking represented by St Laurent. Reluctant to ask foreign foundations for assistance, it remained financially dependent upon what it received from member organizations and occasionally from such provincial officials as the secretary of the Province of Quebec. The 'great devotion and enthusiasm on the part of its voluntary officers, and committee members' was, in fact, its greatest asset.[80] It was therefore able to do little more than hobble along attempting to perform the functions of an arts board without either the financial resources or the government co-operation necessary for the task. By 1949 it was hardly closer to the attainment of its goals than it had been at its founding.

The Canadian Arts Council was not alone in attempting to organize and sustain cultural activity at the end of the war. Amateur playwright and former executive secretary of the British-Canadian wartime educa-

tional organization known as the Canadian Committee, Walter Herbert was active, too, though in a quite different way. Where the council placed much faith in government, Herbert did not. Something, to be sure, might be done at the provincial level – the provinces, Herbert conceded, might be able to 'foster an official, national cultural program' – but a federally controlled ministry of arts and culture was unlikely to emerge, much less prove itself capable of gathering together 'the ravelled ends of Canadian cultural life.'[81] (As he would tell the secretary of the Canadian Arts Council in 1946, 'We must not kid ourselves that there is any genuine desire on the part of the Government to aid the development of cultural activities in Canada.'[82] In establishing the Canada Foundation in May 1945, therefore, Herbert moved off in a direction very much his own.[83] This did not mean heading south. While willing to seek advice from American philanthropists about how to set up the Canada Foundation, he was loathe to see Canadian scholars and cultural institutions 'scurrying across the world's largest undefended border to beg [financial] assistance from our American cousins.'[84] Nor did it mean going towards groups that were too politically minded: while he appreciated the ability of radical groups such as Vancouver's Labour Arts Guild to arouse interest in the arts among members of the working class, he was suspicious, he told the president of the British Columbia Federation of Trade and Industry, of their communist tendencies.[85] And, finally, while he sought the counsel of such individuals as Vincent Massey, he was reluctant to see the Canada Foundation run, as Massey advised, by 'a small, tight, little group of wealthy men.'[86] What Herbert wanted was to establish a co-ordinating agency that would give 'stimulation and encouragement to producers and consumers in the cultural field' by subsidizing the activities of the Canadian Arts Council through 'gifts, donations, bequests, and endowments of any kind' received from private patrons and corporations.[87] He also envisioned something that individuals such as Raleigh Parkin, Alan Plaunt, and Martyn Howe had advocated and organizations such as the National Council of Education, the Canadian Association for Adult Education, and even the Carnegie Corporation had attempted to establish: an agency or group composed of disinterested persons whose task it would be first to define cultural policy and then to get cultural groups and government departments to co-operate in implementing it.[88] But, above all, what he had in mind owed much to the belief – held by such early private patrons as Sir Edmund Walker – that the institutional and financial framework sustaining cultural activity should be handled, not

by the artists, writers, and musicians whose talents lay elsewhere, and certainly not by government, but by private persons.

Working out of a small office in the Ottawa Electric Building, Herbert set out to co-ordinate government, individual, and group activity in order 'to promote, both at home and abroad, wider knowledge and better understanding of the life and thought of Canadian people' through the arts.[89] He lobbied 'the boys in External Affairs' to ensure that the Canadian Arts Council was represented at the first UNESCO general assembly.[90] He advised the Department of Trade and Commerce against the idea of establishing a Canada Council that would, like the British Council, 'encourage, foster, and develop "cultural" interest in Canada and Canadian affairs in countries abroad.'[91] He worked closely with the Canadian Arts Council, the Federation of Canadian Artists, and any other cultural organization with whom he could establish contact. He made 'a Canadian-wide survey of all the current forms of assistance available to writers, musicians, composers, and painters.'[92] He administered the scholarships which the Canadian Amateur Hockey Association gave to a handful of cultural producers like musician Harry Sommers from 1949. And he spent a major part of his time asking individuals and corporations for donations.

All of these activities were initially financed out of Herbert's own pocket; then, thanks to some five hundred private donors, the foundation was able to build up a fund of $45,000 by 1947.[93] Though surprised that the foundation's status as a charity – which gave donors a deduction according to the terms of the Canada Income War Tax Act – had not yielded more, he remained optimistic. 'These boys move in packs, like wolfs [sic],' he wrote of Canada's businessmen in 1947, and 'one of these days a couple of leaders will turn toward my temptation – and then the whole bloody pack will want to climb onto the bandwagon.'[94] But this never happened. The Canada Foundation remained a 'one-man circus.' It was not able to overcome either the 'indifference, lack of understanding, and non-realization' of government bureaucrats or the tight-fistedness of the business community.[95] By 1949 Herbert found it necessary to ask the federal government for financial assistance to help meet the cost of running the Ottawa office. And a year later, much to the shame of one foundation trustee, he turned to the Carnegie Corporation for help. Neither request was, however, successful.[96]

♣

Both the Canadian Arts Council and the Canada Foundation had lobbied, cajoled, and even co-operated with, the federal government. They had taken what Blodwen Davies called in 1943 'a scientific approach' to the problem of organizing cultural activity by collecting and evaluating data.[97] They had come together in 1948 with more than sixty service clubs, educational associations, and cultural organizations to form the Canadian Council for Reconstruction through UNESCO, which, with External Affairs' funding, attempted 'to penetrate the Iron Curtain' by participating in programs to raise money for UNESCO.[98] And – as the Cold War made its influence felt – they had even dropped their involvement with such East-bloc connected agencies as the International Post War Music Council, the National Council for Canadian-Soviet Friendship, and the Association of United Ukrainian Canadians. All of this – and everything else they had done – appeared, however, to have been in vain. No matter how strenuous their efforts, they simply seemed incapable of getting cultural and artistic activity onto the kind of solid, stable, and well-supported foundation it had been their object to create.

Just how far short of the mark they seemed to be falling was made clear in 1947 when B. Ilfor Evans, vice-chairman of the British Arts Council, toured Canada. Present at their invitation to talk about the council, Evans made a great impact not only because he covered some 6,500 miles by boat, bus, and railway during the course of thirty-nine days, or because he attended 109 meetings and gave forty-nine lectures. What gave his trip its importance was the extent to which it focused attention on the need for 'a new climate of popular governmental interest in the arts,' particularly at the federal level.[99]

The tour began at the Canadian Club in Ottawa, where Ilfor Evans had 'a long practical discussion on the organization of the [British] Arts Council in which many problems affecting the Canadian Arts were raised' with representatives of the Canada Foundation, the Canadian Broadcasting Corporation, the Ottawa Drama League, the National Film Board, the University of Ottawa, the National Film Society, the Federation of Canadian Artists, the Ottawa Symphony Orchestra, the editors of *Canadian Art*, the National Council of Women, the National Gallery, the Canadian Information Service of the Department of External Affairs, and private patrons such as H.S. Southam.[100] Similar discussions were held with government officials, educators, private patrons, service club organizers, amateur and professional cultural producers, and executives of cultural organizations in Moncton, Halifax,

Saint John, Montreal, Quebec City, Hamilton, Toronto, London, Winnipeg, Regina, Saskatoon, Edmonton, Calgary, Vancouver, and Victoria.

During his travels, Ilfor Evans wrote, he was much impressed by the programs he saw at the Banff School of Fine Arts and at London, Ontario's, Community Centre – they had, after all, pre-dated those established by the British Arts Council and its forerunner, the Council for the Encouragement of Music and the Arts – and, though he pleaded his 'incompetence' regarding French Canada, he took in the assurance that 'in the theatre, in the visual arts and probably in music there ... [were] very promising young French-Canadian artists.' He also appreciated the extent to which cultural activity in Canada was largely amateur, carried out over an immense area, and organized through a wide variety of programs and institutions, ranging from music and drama festivals, symphony orchestras, and university extension courses to community centres, provincial arts' councils, and organizations devoted to literature, art, drama, and music. He saw clearly the difficulty the Canadian Arts Council and the Canada Foundation were having in co-ordinating and subsidizing this vast array of geographically dispersed activity – a fact which made him realize why almost everyone he met was seeking solutions by 'studying the [British] Arts Council both to see how its machinery works and how help for the Arts can be obtained from the State.'[101] He even plumbed the mysteries of the Canadian constitution, noting that, since the federal government had given a grant to UNESCO the previous year, it could hardly claim that education and culture were beyond its jurisdiction. Certainly, he concluded in his official report, it was 'puzzling ... that there is no support from the Federal Government.'[102]

In pointing to this anomaly, Ilfor Evans had put his finger, of course, on something that had been disturbing the cultural community, and the Canadian Arts Council in particular, for some time: while the federal government had generally respected the provinces' jurisdiction over formal education (though even here there were exceptions, for it had assisted in the establishment of technical training), it had never hesitated to become involved in cultural matters. Artists, musicians, dramatists, and others had been employed by the federal government in wartime. The National Gallery of Canada had been operating for years. Financial support had been given to individuals such as Charles G.D. Roberts and to cultural organizations such as the Royal Canadian Academy of Arts. The Departments of External Affairs and Trade and

Commerce had drawn upon the resources of both the Canada Founda-
tion and the Canadian Arts Council. Given all of this, arts and cultural
activists were as bemused as Ilfor Evans was by the claim that there
could be no federal involvement in culture because it was a provincial
responsibility.

If Ilfor Evans's presence did something to focus attention on the idea
that – whatever the constitutional niceties of a particular situation
might be – government agencies and government funding could play a
solid and constructive role in the cultural field, it is clear in retrospect
that circumstances themselves were changing in ways that made that
idea seem more attractive. These changes had partly to do with the
steadily strengthening conviction that art and culture had an important
role to play in international affairs. The use to which they had been put
during both wars had already demonstrated the strength of the belief
that they could help maintain and project 'civilized' values in times of
international crisis, and after 1945 Western governments particularly
developed a strong attachment to the idea that they could be used in the
fostering of the habits, outlook, and life-patterns those governments
preferred. UNESCO was created partly in the service of this idea, and, in
time, individual nations introduced their own programs – of which the
United States Fulbright scheme was the best known – to aid in the
attainment of this goal. The Canadian government became caught up
in this movement, sending individual musicians and exhibitions of art
abroad, and – as has already been noted – actively supporting the for-
mation of UNESCO itself.[103] If all of this was necessarily strengthening
the federal presence in the fields of culture and education – External
Affairs had organized the music and art trips as well as Canadian
attendance at the 1947 and 1948 UNESCO conferences in Mexico City and
Beirut – what really began to heighten its profile in those areas was
what was happening on the domestic scene.

Culture, education, and the media were, quite simply, beginning to
be perceived as such important elements in the national life that bu-
reaucrats and politicians alike were finding it increasingly difficult to
resist movement in the direction of some sort of coherent policy for
dealing with them. As the war-stimulated diversification of the econ-
omy continued to carry it in new directions, it was becoming increas-
ingly clear that post-secondary education would have to change and
expand in order to provide additional numbers of trained people. Of
the ways to accomplish this that began to be considered, some involved
suggestions that the federal government do on the post-secondary level

what it had once done in the field of technical education. So far as the media were concerned, broadcasting was already a federal responsibility. Arguments that the federal role in that field should become even more prominent were intensified by the advent of television: radio, certainly, had proved itself to be a nation-building tool of importance, and given the fact that the new medium was likely to have even more impact, the need for a strong policy, and a strong agency, to manage it seemed clear to many observers.

Much of the concern about these matters was rather diffuse and unfocused: it began to become more sharply concentrated, however, thanks to what the Liberal government of the day saw as an increasingly worrisome political reality. The CCF, in power in Saskatchewan since 1944 and showing disturbing strength in Ontario and even at the federal level, had a policy for dealing with these and related matters and was clearly appealing to the artistic and intellectual community so obviously in existence across the country. This needed a response, and, thought some leading Liberals, that response could best come in the form of a strong and dramatic Liberal initiative in the cultural field.

One of those who saw this requirement most plainly was Minister of Defence Brooke Claxton. In a lengthy memorandum summarizing the discussion which had been going on in the party for months, he drew newly appointed Prime Minister Louis St Laurent's attention to what he considered to be some important facts. There was, he wrote, a burgeoning group of people in the country – '50,000 or more teachers ... a very large number – sometimes estimated at half a million – who regularly attend the showing of films arranged through ... the National Film Board, as well as university staffs and students and a good proportion of the people who read books, and so on' – who 'ordinarily would be Liberals' but were 'becoming supporters and advocates for the CCF because of the CCF's greater sympathy with matters of this kind.' 'These activities,' he continued, also 'had a very definite appeal to those Canadians who have a distinct national consciousness and feel that more should be done to encourage national culture and strengthen national feeling.' Moreover, what the CCF was proposing – and here he addressed St Laurent's anxieties about a strengthened federal presence in these areas – was by no means unprecedented. 'Other federal governments' – the United States and Australia, notably – Claxton continued, 'have not hesitated to spend money on such purposes.' In view of all this, he argued, a resolution considered but not actually passed at the Liberal Party convention a few months before should get active attention. Pro-

moted particularly by the Canadian University Liberal Federation, it had advocated action on

the planned development of Ottawa as a national capital; the progressive improvement of our national parks; support of the Canadian Broadcasting Corporation and the National Film Board; the creation of a national library; the extension of the work of the National Archives; the erection of a suitable gallery and museum; assistance along the lines of the scholarships awarded by the National Research Council; travelling exhibitions and other undertakings which will add to the variety and richness of community life in all parts of the country, rural as well as urban, and increase the understanding and love of Canada.

Given, concluded Claxton, the increasing legitimacy of government involvement in such matters, and given the clear need to outflank the CCF, Liberal action was desirable and perhaps mandatory. 'It might,' he therefore told St Laurent, 'be advisable to set up a Royal Commission,' which august body – here was the finishing touch – could best function 'under the chairmanship of the Right Honourable Vincent Massey.'[104]

The idea of giving Massey – soon to leave his post as high commissioner in London – some task of this general kind had already been broached by J.W. Pickersgill. The matter of finding him something to do in Canada was now, however, given particular urgency by the news – heard by Lester B. Pearson on a visit to London – that Massey had been offered the mastership of Balliol College at Oxford. An ardent anglophile and, as Pearson reported, 'somewhat restless,' Massey was 'naturally attracted by it.' Equally, however, he 'was very reluctant to leave Canada if there is anything to do in his own country.' In these circumstances, concluded Pearson, 'the Royal Commission idea' was 'an imaginative and excellent one and Massey would, of course, be admirable for that work.'[105]

Changing domestic and external realities, political necessity, and a concern to find one of the country's few cultural patrons worthy employment in Canada combined to move St Laurent, who was not particularly interested in the arts and fearful of treading on Quebec's toes, in the direction of accepting Claxton's recommendation. Therefore, when Massey visited the office of the prime minister on 6 January 1949, he was asked to accept the 'chairmanship of a Royal Commission on the relationship of Government to the Cultural field, coordination of existing institutions, radio, television, museum etc.' Nor, he was assured,

was this an empty gesture. As Pearson told him following the interview: 'the Gov't means business on this matter.'[106] It did. On 26 January the speech from the throne announced that the government intended to make an inquiry into the activities of

all government agencies relating to radio, films, television, the encouragement of the arts and sciences, research, the preservation of our national records, a national library, museums, exhibitions; relations in these fields with international organizations, and activities generally which are designed to enrich our national life, and to increase our own consciousness of our national heritage and knowledge of Canada abroad.[107]

On 8 April Order-in-Council PC 1786 announced the establishment of a Royal Commission on National Development in the Arts, Letters and Sciences to carry out this task. Massey would of course head it, with University of Saskatchewan historian Hilda Neatby, Laval University dean of social sciences Father Georges-Henri Lévesque, University of British Columbia president Norman A.M. Mackenzie, and Montreal civil engineer Arthur Surveyor as his fellow commissioners. Less than a month later the five held their first meeting, and shortly after that they were on the road – following, as it happened, much of the route taken by Ilfor Evans as he had moved across the country speaking to groups and individuals in community halls, church basements, school auditoriums, clubrooms, and university lounges, and making, as it became clear, many of the same observations.

By the end of the 1940s, then, the federal government had shown itself prepared to act in response to the demands for state involvement in the arts which cultural activists had been making with increasing insistence since the beginning of the century. Recognizing that its ad hoc involvement in the field was already considerable, noting that the field's scope, nature, and importance were making it of increased national and international significance, and fully appreciating the fact that a failure to act might create an opening for the CCF, it took the first step in the direction of a coherent, state-supported, federal policy for culture and the arts. With that move, the activity of the previous several decades began to lose its shapeless, inchoate, and random character. Now – at a minimum – recognized as an appropriate object of state attention at the

highest level, cultural activity emerged – at first tentatively, then with increasing confidence – into the mainstream of the federal policy-making process. Thus prepared to receive the public ministrations that would stabilize its foundations, streamline its organization, and permit its work to be carried forward with new confidence and enthusiasm, it already showed signs of feeling itself to be operating at an unprecedented level of achievement and competence. As the *C.A.C. News* put it upon hearing that a Royal Commission on National Development in the Arts, Letters and Sciences had been appointed, cultural activists would now have 'a chance again to speak with the united voice of Canadian artists and their organizations for a *new deal for the arts in Canada.*'[108]

Epilogue

The changes in approach to the fostering and encouragement of cultural activity which were at once responsible for, and signalled by, the creation of the Massey Commission found their institutional embodiment in 1957. A year earlier succession duties from the estates of Atlantic Canadian entrepreneurs Isaac Walton Killam and Sir James Dunn had put an unexpected $100 million into the government's hands and so permitted it to establish the cultural funding agency which the commission had called for.[1]

The heavy government involvement in cultural life which this move presaged turned out to have, on the whole, the kind of agreeable consequences which advocates of it had long argued it would. Amateurs, to be sure, lost their once important role: central figures earlier in the country's cultural life, they now found themselves occupying a distinctly indifferent position, transformed by the new emphasis on professionalism and the increasingly easy access to galleries, concerts, and plays into consumers, rather than producers, of culture. But the very factors producing this change were generally seen as good. Higher standards became more widely applied. Professional dramatists, actors, musicians, writers, and visual artists discovered that they did not have to go abroad to pursue their careers. Study, research, and travel became easier. And the sheer volume of work done on the professional level expanded almost, it sometimes seemed, exponentially.

But - the point should by now be clear - none of this emerged from a vacuum. Work funded by the Canada Council attained whatever distinction it came to have at least in part because those doing it had a

tradition on which to draw, while the council itself was a product, as much as it was a creator, of a distinguished history of cultural activism. Without the lobbying of the 1940s, the careful and thorough-going work which preceded that, and the entire corpus of involvement which it has been the object of this study to survey, it is hardly possible that the Canada Council would have come into existence at all. That this has not generally been seen to be so is, of course, a function of the council's own success in sidelining, and so turning attention away from, activities of the very sort out of which it grew. But once one goes back into the past, sees how things worked, and so becomes aware of the amateur tradition, what private patronage did, the results the ad hoc activities of politicians and governors general had, how the educational function was discharged, and the role played by such organizations as the Canadian Arts Council, it becomes possible to see that the Canada Council – and the activity it has supported – has a very long lineage indeed.

If this book has a single lesson to teach, it is this: in being mindful of the critically important role which the Canada Council has played in the country's cultural life, one must not overlook, or underestimate, what went before. An important part of what led to the shaping of a coherent cultural policy – as well as having meaning and significance in its own right – the cultural activity of the century's first five decades simply demands to be taken seriously. Failure to recognize this basic reality – the point is critical – not only further distorts the record which it has been the object of this book to set straight; it also does a major disservice to the many women and men whose collective story has been set out in these pages.

Abbreviations

AO	Archives of Ontario
CCA	Carnegie Corporation Archives, New York
CCAA	Confederation Centre of the Arts Archives
CPRCA	Canadian Pacific Railway Corporate Archives
GAIL	Glenbow-Alberta Institute Library
MAUA	Mount Allison University Archives
MCAUT	Massey College Archives, University of Toronto
NAC	National Archives of Canada
NBM	New Brunswick Museum
NGCA	National Gallery of Canada Archives
NLC	National Library of Canada
NSPA	Nova Scotia Public Archives
PAA	Public Archives of Alberta
PABC	Provincial Archives of British Columbia
PAM	Public Archives of Manitoba
PANB	Provincial Archives of New Brunswick
PANS	Public Archives of Nova Scotia
PAPEI	Public Archives of Prince Edward Island
PRO	Public Records Office, Kew Gardens, London
QUA	Queen's University Archives
RFA	Rockefeller Foundation Archives, New York
SAB	Saskatchewan Archives Board
SPLA	Saskatchewan Public Library Archives
TFRBL	Thomas Fisher Rare Book Library, University of Toronto
UAA	University of Alberta Archives

UBCSC University of British Columbia, Special Collections
UMA University of Manitoba Archives
URA University of Regina Archives
VCA Vancouver City Archives

Notes

PREFACE

1 Peter L. Janssen, 'Political Thought as Traditionary Action: The Critical Response to Skinner and Pocock,' *History and Theory* 24 (Mar. 1985) 123

CHAPTER 1 From the Campfire to the Concert Hall

1 J.G. Sime, *Our Little Life* (New York 1921) 179
2 E.M.M. [Ernest MacMillan], 'Music in the Maritimes,' *Curtain Call* 7, no. 6 (Mar. 1936) 14
3 Ernest Buckler, *The Mountain and the Valley* (1952; Toronto 1961) 251
4 Nellie L. McClung, *Purple Springs* (Toronto 1921) 187
5 Robert Stead, *Neighbours* (Toronto 1922) 118
6 Flora McCrea Eaton, *Memory's Wall* (Toronto 1956) 6; Watson Kirkconnell, 'Music from the Sidelines,' *Canadian Music Journal* 1, no. 4 (Summer 1957) 18
7 Robert Stead, *Grain* (1926; Toronto 1967) 66
8 CCAA, Robert Harris Papers, 'Diaries,' 28 Jan. 1909, n. pag.
9 NLC, Ernest MacMillan Papers, 'Is Canada Progressing Musically?' Convocation Address, Mount Allison University, 11 Aug. 1956, 5
10 Wilma L. Sansom, 'Some Aspects of the Development of Drama in New Brunswick' (MA thesis, University of New Brunswick, 1957) 38
11 Stead, *Grain*, 66
12 Stephen Leacock, 'Sunshine Sketches of a Little Town,' in *The Penguin Stephen Leacock* (1912; Markham, Ont. 1981) 118

13 Fred Jacob, 'On Earthly Choirs,' *Canadian Forum* 6, no. 61 (Oct. 1925) 18

14 'Instrumental Music in Methodist Churches,' *Christian Guardian* 13, no. 17 (Aug. 1842) 170. See also the novel *Duncan Polite, the Watchman of Glenoro* (Toronto 1905), by Mary Esther MacGregor [pseud. Marian Keith], for a fictional account of the Presbyterian controversy.

15 Augustus Bridle, *Hansen: A Novel of Canadianization* (Toronto 1924) 121

16 NLC, Ernest MacMillan Papers, 'Some Choral Reminiscences' [typescript in 'Writings III'] 1

17 Matthew Arnold, *Culture and Anarchy*, ed. J. Dover Wilson (1869; Cambridge 1963) 6

18 Heliconian Club Archives, Toronto, 'The Heliconian Club Constitution' (1915) n. pag. These papers have been recently deposited in the AO.

19 Leo Cox, 'Fifty Years of Brush and Pen,' *Queen's Quarterly* 46, no. 3 (April 1939) 343

20 SAB, Women's Musical Club of Saskatoon Papers, 'Constitution' [1912]

21 PAM, Hawthorne Women's Club Papers, 'Minutes,' 30 Oct. 1923, n. pag.; NBM, Fortnightly Club Papers, programs

22 PAPEI, Cavendish Literary Society Papers, 'Constitution' (1886)

23 Laura Goodman Salverson, *Confessions of an Immigrant's Daughter* 1939; Toronto 1981) 399

24 Robert F. Gagen, 'History of Art Societies in Ontario,' in J. Castell Hopkins, ed., *Canada: An Encyclopaedia of the Country* 4 (Toronto 1898) 364

25 UBCSC, The Vagabond Club Papers, Box 1, A.C. Cummings to Jackie Hooper, 30 Sept. 1967

26 Ibid., Box 2, 'Vancouver Vagabond Club' [typescript], 4 July 1917, 1

27 Ibid., Box 1, Lionel Stevenson to Charlie [illegible], 9 Feb. 1969

28 Bernard K. Sandwell, 'Our Adjunct Theatre,' in *Addresses Delivered before the Canadian Club of Montreal 1913–1914* (Montreal 1914) 97

29 NBM, Eclectic Reading Club Papers, 'Report of Annual Meeting,' 22 Oct. 1925, n. pag.

30 VCA, Vancouver Poetry Society Papers, vol. 1, 'Constitution' (1932) n. pag.

31 NAC, Ottawa Little Theatre Papers, MG 28, I 30, vol. 1, 'A Canadian Drama League' [1913] n. pag.

32 Sandwell, 'Our Adjunct Theatre,' 102

33 Peter Donovan, *Late Spring* (Toronto 1930) 32

34 AO, Arts and Letters Club Papers, 'Scrapbook' clipping from *Maclean's Magazine*, 1 May 1936

35 Ibid., 'News Letter by Charles W. Jefferys,' *Lamps* 1, no. 2 (Dec. 1911) n. pag.

36 Mary H.T. Alexander, 'Little Theatres of the West,' *Maclean's Magazine* 36, no. 17 (1 Oct. 1921) 54

37 Gertrude Lerner, 'Footlights in Canada,' *Little Theatre Monthly* 21 (June 1931) 17

38 Morley Callaghan, *A Broken Journey* (1932; Toronto 1976) 195

39 Herman Voaden, 'Address to the Sarnia Drama League,' 6 Mar. 1928, as quoted in Anton Wagner, 'Herman Voaden's Symphonic Expression' (PHD diss., University of Toronto, 1984) 60

40 'Unmusical Montreal,' *Musical Canada* 2, no. 4 (July 1907) 163

41 UMA, Bertram Brooker Papers, Box 1, Eva Clare to Brooker, 5 Dec. 1922

42 'Greetings,' *Curtain Call* 7, no. 3 (Dec. 1935) 1

43 Ibid.

44 Herman Voaden, 'Diary – Autumn 1927,' as quoted in Wagner, 'Herman Voaden's Symphonic Expression,' 58. In this passage Voaden recalls his comments to the Sarnia Drama League, 6 March 1928.

45 PAPEI, Maritime Art Association Papers, 'Mimeograph Memo re the Saint John Art Club,' n.d. These papers have not yet been catalogued.

46 Harvey Wyness, 'Choir Spirit,' *Bach Choir Bulletin* 1, no. 1 (Nov. 1932) 7. This issue of the *Bach Choir Bulletin* is deposited in the Bach Choir Archives, a private collection of Thelma Reid Lower, Vancouver.

47 PANS, Halifax Ladies College and Conservatory of Music Papers 1923–30, vol. 750, President of the Halifax Choral Union to Rev. James W. Falconer, 21 Nov. 1933 [copy]

48 Angel E. Davis, 'Laying the Ground: The Establishment of an Artistic Milieu in Winnipeg: 1890–1913,' *Manitoba History* no. 4 (Autumn 1982) 12

49 J.L. Robertson, 'The Little Theatre Movement in Nova Scotia,' *Canadian Review of Music and Art* 5, no. 1 (1946) 14

50 Coaldale Historical Society, *Coaldale Gem of the West, 1900–1983* (Coaldale, Alberta 1983) 343

51 RFA, Box 25, John Marshall, 'Canadian Drama Survey, 31 March–21 April 1942,' 20

52 PAA, Alberta Society of Artists Papers, W.F. Irwin, 'The A.S.A., a Brief History of the Alberta Society of Artists' (Calgary 1974) 5

53 CCAA, Robert Harris Papers, John N. Meagha, 'Maritimes More Conscious of Art' [newspaper clipping, in 'Scrapbook'], 30 Nov. 1935, 5. By 1936 the Maritime Art Association had seventeen member groups.

54 PAM, Manitoba Drama League Papers, 'First Annual Report of Manitoba Drama League,' 29 Oct. 1932, 5

55 SAB, Florrie Elvin Papers, taped interview [transcript], 2–7 May 1975, 24

56 *Musical Canada* 2, no. 6 (Oct. 1907) 263; the first issue of the *Bach Choir Bulletin* appeared in November 1932 (see above, note 46).

57 Sinclair Ross, *As for Me and My House* (1941; Toronto 1957) 12

58 SAB, Louise Olson Papers, tape interview [transcript], Mar. 1974, 5, 14

59 Jean Burton, 'The Little Theatre in the Country,' *Canadian Forum* 7, no. 79 (April 1927) 212

60 NBM, Jean Sweet Papers, 'The Montreal Repertory Theatre, 1932–33' [pamphlet] 2

61 TFRBL, Dora Mavor Moore Papers, Box 5, [Mavor Moore], 'The Village Players' [typescript], 1940, n. pag.

62 NAC, Performing Arts Collection, MG 28, I 139, vol. 29, *The Bill* [Winnipeg] 6, no. 3 (Jan. 1934) 1

63 Yvonne Firkins, 'Stagecraft for School and Community Players,' *Curtain Call* 10, no. 2 (Nov. 1938) 13

64 This was done in order to protect the sale of sheet music and gramophone records. See T.J. Allard, *Straight Up: Private Broadcasting in Canada 1918–58* (Ottawa 1979) 13.

65 PABC, Jack Gillmore Papers, 'British Columbia's Early Days of Radio' [typescript, n.d.] 4, 1

66 W. Somerset Maugham, *The Summing Up* (1938; London 1977) 119

67 Harold F. Sutton, 'Music, Art, History and Drama,' in *Canadian Annual Review 1929–1930* (Toronto 1930) 574

68 'What about the Canadian Drama?' *British Columbia Monthly* 25, no. 2 (Sept. 1925) 6

69 QUA, Lorne Pierce Papers, 'Scrapbooks,' no. 3 (1923–6), newspaper clipping [1924] 117

70 NAC, Andrew Macphail Papers, MG 30, D 150, vol. 6, 'Good Theatre' [typescript, in 'Scrapbook'], Montreal Repertory Theatre, 20 May 1931, 2

71 Lockie Campbell, 'Reflections on the Decline of the Little Theatre,' *Curtain Call* 2, no. 2 (Nov. 1939) 19–20

72 M.D. [Merrill Denison], 'The Theatre in Canada,' *Canadian Bookman* 5, no. 1 (Jan. 1923) 8

73 Marshall, 'Canadian Drama Survey,' 28

74 NBM, Jean Sweet Papers, 'The Montreal Repertory Theatre, 1932–33' [pamphlet] 1

75 NAC, Ottawa Little Theatre Papers, MG 28, I 30, vol. 1, 'Theatre Guild of Montreal' [pamphlet], Feb. 1930

76 Landon Young, 'The Little Theatre in Winnipeg,' *Canadian Forum* 7, no. 84 (Sept. 1927) 371

77 PAPEI, Maritime Art Association Papers, 'To the Royal Commission on

National Development of the Arts, Letters and Sciences' [mimeograph], 1949, 3

78 Fred Jacob, 'The Stage,' *Canadian Forum* 6, no. 61 (Oct. 1925) 28. See Vincent Massey, ed., *Canadian Plays from Hart House Theatre*, 2 vols. (Toronto 1926).

79 VCA, Vancouver Little Theatre Association Papers, 'The Vancouver Little Theatre Association, a Short History' [typescript, in 'Scrapbook, vol. XVIII'] n. pag.

80 Barrett H. Clarke, 'As I See the Canadian Stage,' *Curtain Call* 9, no. 7 (April 1928) 5

81 Ernest MacMillan, 'Problems of Music in Canada,' in Bertram Brooker, ed., *Yearbook of the Arts in Canada 1936* (Toronto 1936) 185

82 Graham McInnes, 'Amateurs vs. Professionals,' *Saturday Night*, 17 June 1939, 25

83 Patricia Ainslie, *Images of the Land: Canadian Block Prints 1919-1945* (Calgary 1985) 17

84 QUA, Frances K. Smith Papers, Smith's interview with Edwin Holgate, 21 Sept. 1968 [transcript] 5

85 NAC, Canada Foundation Papers, MG 28, I 179, vol. 35, 'Composers' Authors' and Publishers' Association of Canada Ltd.,' Constitution, n.d., 1. The Canadian Performing Rights Society became CAPA in 1938.

86 Ernest MacMillan, 'Potted Music,' *Canadian Forum* 2, no. 16 (Jan. 1922) 497

87 Andrew Macphail, 'Our Canadian Speech' [from *Saturday Night*], as quoted in Brooker, ed., *Yearbook of the Arts in Canada*, 238

88 Reginald Stewart, 'Impressions and Comparisons,' *Globe* [Toronto], 15 July 1933

89 MacMillan, 'Potted Music,' 497; Leo Smith, 'Music: Some Problems of To-day,' *Queen's Quarterly* 39, no. 3 (Aug. 1932) 477

90 MacMillan, 'Potted Music,' 497

91 *Musical Times*, 72, no. 1059 (1 May 1931) 461

92 SPLA, Joseph Parsons, 'The History of Theatre in Saskatoon 1906-1910,' in D.A. Erikson et al., 'The History of the Theatre in Saskatoon 1897-1959' [typescript, n.d.] 4. The company failed after completing one season.

93 Kay Gibbons, 'The Actors' Colony Theatre,' *Curtain Call* 7, no. 6 (Mar. 1936) 7

94 Ailen Beaufort, 'Carroll Aikins: Home Producer,' *Canadian Magazine* 60, no. 6 (April 1923) 561

95 James Hoffmann, 'Carroll Aikins and the Home Theatre,' *Theatre His-*

tory of Canada 7, no. 1 (Spring 1986) 50

96 TFRBL, William Deacon Papers, Box 50, 'A Theatre on a Farm' [typescript, 1923) 2–3

97 Aikins moved to Toronto, where he directed Hart House Theatre from 1927 to 1929. He then returned to British Columbia and eventually moved to Hollywood, California.

98 TFRBL, James Mavor Papers, Box 56, 'Society of Mural Decorators' [typescript, n.d.] 1

99 TFRBL, Edmund Walker Papers, Box 27, G.A. Reid, 'RCA of Arts Memorial Regarding the Present Conditions and Needs of Canadian Art,' 7 Jan. 1907

100 AO, Ontario Society of Artists Papers, 'Ontario Society of Artists Memorial Regarding the Appointment of an Art Commission for Ontario' [memorandum, Feb. 1908] 1; 'Minute Book, January 1916–March 1931,' 7 Nov. 1916 and 5 April 1927

101 NAC, Sculptors' Society of Canada Papers, MG 28, I 185, vol. 1, 'Constitution,' 25 Nov. 1931; Frances Loring to the Hon. Mr P.J.A. Gardin, Minister of Public Works, Ottawa, 20 Nov. 1935, as quoted in Charles Hill, *Canadian Painting in the Thirties* (Ottawa 1976) 17

102 TFRBL, James Mavor Papers, Box 34, 'The Copyright Question' [flyer, 1899] 2. See also James Mavor, 'Canadian Copyright,' *University of Toronto Monthly* 1, no. 5 (Jan. 1901) 139–45.

103 AO, Melvin Ormond Hammond Papers, 'Diaries,' 14 Sept. 1912, n. pag.

104 NSPA, Canadian Authors' Association, Nova Scotia Branch Papers, vol. 1, 'What the Individual Members of the Canadian Authors' Association Can Do for Canadian Book Week,' CAA *Bulletin* no. 1, 1

105 John Hurley, in *Winnipeg Magazine* (April 1931), as quoted in E. Austin Weir, *The Struggle for National Broadcasting in Canada* (Toronto 1965) 46

106 *The Canadian Art Club 1907–1911* (Toronto 1911) 4

107 SAB, Ernest Lindner Papers, Box 1, Lindner to Joy Bain, 8 Feb. 1946

108 Earle Birney, *Spreading Time* (Montreal 1980) 11

109 Stephen Leacock, 'The National Literature Problem in Canada,' *Canadian Mercury* 1, no. 1 (Dec. 1928) 8

110 Leo Kennedy, 'The Future of Canadian Literature,' *Canadian Mercury* 1, nos. 5–6 (April–May 1929) 99

111 J. Butterfield, 'B.C. Fine Arts Society Exhibition,' *Province*, 19 May 1923, 6

112 The exhibition included Emily Carr, Max Maynard, Jack Shadbolt, Edythe Hembroff, Ina D.D. Uhthoff, and Ronald Bladen.

113 Karen Wilkin, *Art in Alberta: Paul Kane to the Present* (Edmonton 1973) [1]. The Calgary Art Club had been evicted from the basement of the city's public library in 1922 for sketching from the nude model.
114 Marlene Shore, ' "Overtures of an Era Being Born": F.R. Scott: Ideas of Cultural Nationalism and Social Protest 1920-39' (MA thesis, University of British Columbia, 1977) 9
115 John Lyman, 'Art: The Eastern Group ...' *Montrealer*, 1 Dec. 1938, 32, as quoted in Louise Dompierre, *John Lyman 1886-1967* (Kingston 1986) 77
116 William Wylie Thom, 'The Fine Arts in Vancouver 1886-1930' (MA thesis, University of British Columbia, 1969) 160
117 'The Atelier in New Quarters,' *Montreal Star*, 5 Oct. 1932, 8. See Roger Fry, *Vision and Design* (London 1920), and Clive Bell, *Art* (London 1913).
118 QUA, André Biéler Papers, Box 2, 'Constitution,' Contemporary Arts Society, enclosed in Fritz Brandtner to André Biéler, 6 Mar. 1939
119 Hill, *Canadian Painting in the Thirties*, 132
120 *The Canadian Encyclopedia* (Edmonton 1985) 2: 1260. The English-Canadian contributors were George M. Brewer, John Murray Gibbon, Bernard K. Sandwell, J. Roxburg Smith, and Ramsey Traquair.
121 Peter Stevens, ed., *The McGill Movement: A.J.M. Smith, F.R. Scott and Leo Kennedy* (Toronto 1969) vii. See the Montreal group's joint publication *New Provinces: Poems of Several Authors* (Toronto 1936), which also includes E.J. Pratt and Robert Finch; and Leon Edel, 'When McGill Modernized Canadian Literature,' in Edgar Andrew Collard, ed., *The McGill You Knew: An Anthology of Memoirs 1920-60* (Don Mills 1975) 112-22.
122 F.R. Scott, 'The Canadian Authors Meet,' *McGill Fortnightly Review* 2, nos. 9-10 (April 1927) 73
123 F.R. Scott, 'A.J.M. Smith: A Personal Memoir,' *Canadian Poetry* 9 (Fall/Winter 1982) 80-1
124 W.A. Sherwood, 'A National Spirit in Art,' *Canadian Magazine* 3, no. 6 (Oct. 1894) 499
125 'Yeats Speaks on the Theatre,' *Globe* [Toronto], 3 Feb. 1920, 9
126 R.E.S., 'The Theatre - Highbrow or Lowbrow?' *Rebel* 3, no. 5 (Mar. 1919) 197
127 Anton Wagner, 'Gwen Pharis Ringwood Rediscovered,' *Canadian Theatre Review* no. 5 (Winter 1975) 66 (*One Man's House* is no longer extant according to Wagner); Preface, *Twenty-Five Cents*, by W. Eric Harris (Toronto 1947) 3; Ruth I. McKenzie 'Proletarian Literature in Canada,' *Dalhousie Review* 19, no. 1 (April 1939) 62

128 Nancy W. Fraser, 'The Development of Realism in Canadian Literature during the 1920s,' *Dalhousie Review* 57, no. 2 (Summer 1977) 298

129 'A Bold Move,' *Curtain Call* 7, no 1 (Oct. 1935) 1; NAC, Ottawa Little Theatre Papers, MG 28, I 30, vol. 1, Rupert Caplan to D.C. Scott, 27 May 1930; Joe Zuken, quoted in Toby Gordon Ryan, *Stage Left: Canadian Theatre in the Thirties, a Memoir* (Toronto 1981) 82. For an acerbic comment on the cultural scenes of Winnipeg and Toronto during the interwar years see Frank Pickersgill to George Ford, 2 Dec. 1936, in George H. Ford, ed., *The Making of a Secret Agent: Letters of 1934–1943 Written by Frank Pickersgill* (Toronto 1978) 56.

130 McKenzie, 'Proletarian Literature in Canada,' 63

131 UMA, Dorothy Livesay Papers, Box 106, 'Talk Given by Dorothy Livesay on Her Own 1930's Poetry and Its Relation to Social Activism,' 2

132 Ryan, *Stage Left*, 26

133 Ibid., 31

134 Sandra Souchotte, 'Canada's Workers' Theatre, II,' *Canadian Theatre Review*, no. 10 (Spring 1976) 92

135 Anthony Mardivos, *William Irvine: The Life of a Prairie Radical* (Toronto 1979) 99, 204

136 Ryan, *Stage Left*, 42

137 Robert Orchard, quoted in Marshall, 'Canadian Drama Survey,' 35

138 MCAUT, Graham McInnes Papers, 'Scrapbook' (Art [Canada] II), 'Canadian Group to Extend Arts,' *Christian Science Monitor* (Jan. 1939) n. pag.

139 Graham McInnes, 'The Allied Arts Council,' *Saturday Night* 54, no. 16 (18 Feb. 1939) 24

CHAPTER 2 'An Identity of Tastes and Aspirations'

1 NAC, National Council of Women Papers, MG 28 I 25, vol. 6, 'Minutes of Annual Meetings of the Executive Committee,' 14 Feb. 1902, 145–9

2 AO, RG 2, P-2 no. 13 Temporary Box 10, 'To the Members of the Art Committee' [Jan. 1902, 1–2]. Members of the committee included, among others, Lord Strathcona, Senators George Drummond and Raoul Dandurand, Premiers Frederick Haultain of the Northwest Territories, George Henry Murray of Nova Scotia, and L.J. Tweedie of New Brunswick, Adelaide Hoodless, founder and president of the Ontario Normal School of Domestic Science and Art, Lady Margaret Taylor and Lady Grace Julia Drummond of the National Council of Women, and Ontario minister of education Richard Harcourt.

3 Ibid., 'Two Systems to Be Submitted to the Consideration of the Federal Government. Preliminary Suggestions Scholarship System,' 3–6

4 Ibid., 'Canadian National Art Institute,' 1–7

5 J.W.L. Forster, 'Art and Artists in Ontario,' in J. Castell Hopkins, ed., *Canada: An Encyclopaedia of the Country* 4 (Toronto 1898) 352

6 W.A. Sherwood, 'A National Spirit in Art,' *Canadian Magazine* 3, no. 6 (Oct. 1894) 498–50

7 John George Bourinot, *Our Intellectual Strength and Weakness* (Toronto 1973) 54. The title essay of this collection, from which the quotation is taken, was originally published in the *Week* [Montreal], 2 June 1893, 630.

8 John Edward Hoare, 'Plea for a Canadian Theatre,' *University Magazine* [Montreal] 10, no. 2 (April 1911) 239–53; Ernest MacMillan, 'Canadian Musical Life,' *Canadian Geographical Journal* 19 (Nov.–Dec. 1939) 336, and 'Music in Canada,' in *Calendar of the Royal College of Organists 1935–36* (London 1936) 181; NAC, Eric Brown Papers, MG 30, D 25, series 3, vol. 2, 'Typed Notes,' n.d., 12

9 TFRBL, Edmund Walker Papers, Box 22, Percy Nobbs, 'Report on Proposals for State Aid to Art Education in Canada,' 4 May 1907, 6

10 Jean Coulthard, 'Canadian Music in the 1930s and 1940s: A Personal Remembrance,' n. pag. [copy in author's possession] (transcript of talk given at 'Pioneers and Pioneering: Music in Canada in the 1930s and 1940s,' Queen's University, Kingston, Ont. 8 Nov. 1986)

11 SAB, taped interview with Eddie Mather, 8 April 1974 [transcript] 2

12 *Collections of the Nova Scotia Historical Society* 18 (Halifax 1914) 138

13 'Margaret Eaton School of Literature and Expression,' *Musical Canada* 4, no. 9 (Dec. 1909) 240

14 John G. Reid, *Mount Allison University: A History to 1963* (Toronto 1984) 61, 59

15 URA, Regina Conservatory of Music Papers, *Regina College, Annual Calendar 1907–08* (Regina 1907) 1

16 Ibid., 2

17 Bertram Brooker, *Think of the Earth* (Toronto]1936]) 74, 16

18 'The Truth about Music in Canada,' *Musical Times* 74, no. 1087 (Sept. 1933) 846–7

19 Among the first organizations of this sort was the Ontario Music Teachers' Association (1885), which became the Canadian Society of Musicians in 1887. The Canadian Federation of Music Teachers' Associations (1935), comprising the four western provinces, and the Nova Scotia Music Teachers' Association (1937) were formed for the same purpose.

20 MacMillan, 'Music in Canada,' 192

21 SAB, Florrie Elvin Papers, taped interview [transcript], 2–7 May 1975, 3. The Regina Conservatory of Music developed an examination program in 1932.

22 Coulthard, 'Canadian Music in the 1930s and 1940s,' n. pag.

23 Helmut Kallmann, 'Music Composition in Canada, from 1867,' *Musicanada* no. 20 (1969) 9

24 Morley Callaghan, *It's Never Over* (1932; Toronto 1972) 37, 91

25 Bertram Brooker, ed., *Yearbook of the Arts in Canada 1928–29* (Toronto 1929) 65

26 Carl Schaefer quoted in Margaret Gray, Margaret Rand, and Lois Steen, *Carl Schaefer* (Toronto 1977) 7

27 John Murray Gibbon, *Pagan Love* (Toronto 1922) 123

28 Arnold Walter, *Aspects of Music in Canada* (Toronto 1967) 251

29 'Music in Canada Higher Education' (Appendix B), in Watson Kirkconnell and A.S.P. Woodhouse, *The Humanities in Canada* (Ottawa 1947) 218

30 *Annual Report of the Superintendent of Education of Nova Scotia, Province of Nova Scotia, for the Year Ending 31 July 1915* (Halifax 1916) 184

31 Vancouver Board of School Trustees, *Twenty-Third Annual Report for the Year Ending December 31 1925* (Vancouver 1925) 19. The Vancouver School of Decorative and Applied Arts did offer courses, however, in both fine and applied art and there was some move to interest manufacturers in art. See A.C. Ferguson, 'Work of the BC Art League, Successful Manufacturing Depends upon Art,' *Province* [Vancouver], 5 Aug. 1922, 24.

32 PABC, Provincial Arts and Industrial Institute Papers, Eric Brown to the Secretary of the Provincial Arts and Industrial Institute, 11 Nov. 1920

33 Marilyn Baker, *The Winnipeg School of Art* (Winnipeg 1984) 62. The school was rescued from bankruptcy in 1924 when funds became available from the federal government.

34 Arthur Lismer, 'The Value, Meaning and Place of Art in Education,' *Dalhousie Review* 8, no. 3 (Oct. 1928) 383

35 Bertram Brooker, 'Nudes and Prudes,' in William Arthur Deacon and Wilfred Reeves, eds., *Open House* (Ottawa 1931) 100

36 Paul Axelrod, 'Class, Culture, and Canadian Youth: Student Life at Dalhousie University in the 1930's,' in *Canadian Historical Review Papers* (Montreal 1985) 27

37 SAB, Eddie Mathers Papers, taped interview with Eddie Mather, 8 April 1974 [transcript] 17

38 CCA, University of Toronto Papers, Falconer to F.P. Keppel, 25 Feb. 1926

39 Stanley Brice Frost, *McGill University: For the Advancement of Learning*

(Montreal 1984) 2:144

40 Ernest MacMillan, 'The Place of Music in a University Curriculum,' in *Eleventh National Conference of Canadian Universities* (London, Ont., 1927) 69

41 A.S. Vogt, 'Piano Study at Home and Abroad,' *Conservatory Bi-Monthly* 1, no. 1 (Jan. 1902) 10

42 NLC, George Brewer Papers, 'O-vyelopadia,' 4 (3 June 1906) n. pag.

43 NAC, Yvonne MacKague Housser Papers, MG 30, D 305, vol. 2, 'Biography of Story of My Life as a Painter,' n.d., 14

44 Kallmann, 'Music Composition in Canada, from 1867,' 8

45 See, for example, J.A. Radford, 'Canadian Art and Its Critics,' *Canadian Magazine* 29, no. 6 (Oct. 1907) 517–18; A.J.M. Smith, 'Wanted – Canadian Criticism,' *Canadian Forum* 8, No. 91 (April 1928) 600–1; A.M. Stephan, 'Canadian Poets and Critics,' *New Frontier* 1, no. 5 (Sept. 1936) 22–3; and Brooker, ed., *Yearbook of the Arts in Canada 1928-29*, 7–10.

46 Raymond Williams, 'Base and Superstructure in Marxist Cultural Theory,' *New Left Review* 82 (Nov.-Dec. 1973) 11

47 Lilian Jory, 'Some Canadian Poets,' *Canadian Methodist Magazine* 51, no. 5 (May 1900) 425, as quoted in Karen C. Altfest, 'Canadian Literary Nationalism, 1836-1914' (PHD diss., City University of New York, 1979) 240

48 Clara Thomas and John Lennox, *William Arthur Deacon: A Canadian Literary Life* (Toronto 1982) 13–14

49 Edward Johnson, 'The Singer and His Audience,' in *Singing: The Well-Spring of Music* (New York 1933) 42. This book comprises a series of radio talks given under the auspices of the American Academy of Teachers of Singing.

50 Brooker, 'Nudes and Prudes,' 102

51 Voaden quoted in Anton Wagner, 'Herman Voaden's "New Religion,"' *Theatre History in Canada* 6, no. 2 (Fall 1985) 190

52 QUA, Lorne Pierce Papers, Box 6, Janet C. Perrins, 'The Canadian Chautauqua' [1929, untitled clipping, in 'Historical Scrapbook, 1923-31'] 46

53 NAC, E.A. Weir Papers, MG 30, D 67, vol. 26, *Barrier Examiner*, 21 May 1931 [clipping]

54 Reverend Charles Gordon [pseud. Ralph Connor], *The Sky Pilot* (Toronto 1901) 130

55 R.B. Scott, 'A Study of Amateur Theatre in Toronto, 1900-1930' (MA thesis, University of Western Ontario, 1966) 28

56 Andrew Macphail, 'Our Canadian Speech,' *Saturday Night* 50, no. 34 (29 June 1935) 2

57 F.H. Brigden, 'Fine and Graphic Arts at the Canadian National Exhibition,' *Journal* [Royal Architectural Institute of Canada], serial no. 26, 4, no. 10 (Oct. 1927) 370. For a response see Brooker, 'Nudes and Prudes,' 93-106.

58 Bertram Brooker, ed., *Yearbook of the Arts in Canada* (Toronto 1936) xvii

59 Callaghan, *It's Never Over*, 121

60 Edmund Hardy, 'The Soloist in the Church,' *Musical Canada* 2, no. 5 (Sept. 1907) 214

61 J.W.L. Forster, *Under the Studio Light: Leaves from a Portrait Painter's Sketch Book* (Toronto 1928) vii

62 Beckles Willson, 'Canada's Undeveloped Literary Resources,' in *Addresses Delivered before the Canadian Club of Montreal 1913-1914* (Montreal 1914) 202

63 Walter J. Phillips, 'Second-Hand Pictures,' *Winnipeg Evening Tribune* [undated clipping], and 'On Appreciation,' *Winnipeg Evening Tribune*, 4 Feb. 1928, as quoted in Maria Tippett and Douglas Cole, eds., *Phillips in Print: The Selected Writings of Walter J. Phillips on Canadian Nature and Art* (Winnipeg 1982) 11, 10

64 NLC, Arthur Lismer Papers, Charles H. Scott to H.O. McCurry, 5 April 1932; QUA, Lorne Pierce Papers, Box 1, A.M. Stephen to Pierce, 14 July 1924; Edgar L. Bainton, 'A Tour through the Dominions of Canada and Australia,' *Musical Times* [London], 1 Mar. 1931, 220

65 R.V. Howard, 'Earth Song,' *Saturday Night* 48, no. 8 (31 Dec. 1932) 6

66 J.S. Woodsworth, *My Neighbour* (1911; Toronto 1972) 208

67 T.A. Browne, 'The National Literary Competition,' *Canadian Magazine* 53, no. 4 (Aug. 1919) 365

68 NAC, National Council of Education Papers, MG 30, D 245, vol. 5, 'National Lectureship Scheme' [typescript], Ottawa 1920, 2

69 Scott, 'A Study of Amateur Theatre in Toronto, 1900-1930,' 25

70 Arthur Lismer, 'Art Education and Appreciation' [incomplete manuscript, n.d.], Montreal Museum of Fine Arts, as quoted in Gemey Kelly, *Arthur Lismer: Nova Scotia, 1916-1919* (Halifax 1983) 14. Art courses were given at, among other galleries, the Vancouver Art Gallery, the Art Gallery of Toronto, the Winnipeg Civic Art Gallery, the Edmonton Museum of Fine Arts, the Owen's Museum of Fine Arts, and the Norman Mackenzie Art Gallery.

71 G.E. Patton, 'Drama in the Community,' *Echoes* no. 129 (15 Dec. 1932) 15. Manitoba's Department of Agriculture encouraged drama groups in rural areas of that province by providing over five hundred study groups with a play-lending library and a travelling drama instructor,

Helen Watson.

72 Clifford Ford, *Canada's Music: An Historical Survey* (Agincourt, Ont., 1982) 12

73 Peter Frederick Bishop, 'Canadian Music Criticism from 1918 to 1939 As Shown in the *Toronto Star* and *Saturday Night*' (MA thesis, University of Victoria, 1979) 29

74 Floyd S. Chalmers, *Both Sides of the Street: One Man's Life in the Business and the Arts in Canada* (Toronto 1983) 118

75 T.E. Colling, 'The Ministry of Music,' *Methodist Magazine and Review* 55, no. 2 (Feb. 1902) 143

76 Bruce A. Anderson, 'Education, Beauty and Culture,' *Musical Life* 1, no. 3 (Mar. 1933) 4

77 [no author, no title], *Student's Bulletin* [Regina] 1, no. 3 (30 May 1933) [1]

78 Reginald Stewart, 'Good Music Made Popular,' address given to the Empire Club of Canada, 13 Dec. 1934, in *Empire Club of Canada, Addresses Delivered to the Members during the Year 1934-1935* (Toronto 1935) 175

79 Herbert A. Bruce, 'The National Drama League of Canada,' address given at the conclusion of the performance of the Dominion Drama Festival Finals at Hart House Theatre, 26 Mar. 1934, in *Our Heritage and Other Addresses* (Toronto 1934) 201; William Faversham, 'The War As It Affects the Theatrical Profession,' address delivered to the members during the session 1915-1916, in Alfred Hall, ed., *Empire Club of Canada* (Toronto 1917) 8

80 PABC, Department of Education Papers, Box 12, 354, L. Bullock-Webster, 'Community Drama As a Part of Adult Education,' lecture delivered to the 10th Annual Conference, Western Teachers of Speech, Seattle, Washington, Nov. 1938, 8. Bullock-Webster was director of school and community drama for the Department of Education from 1932.

81 PAPEI, Harris Family Papers, James Harris, 'Charlottetown Public Library and Harris Memorial Art Gallery: The Library As a Civic Institution,' talk given at the Gyro Club, 20 Jan. 1930, 7. See also NAC, Eric Brown Papers, MG 30, D 25, 3, vol. 2, 'Typed Notes,' n.d., 11.

82 John Edgcumbe Stanley, 'To Foster Canadian Art,' *Maclean's Magazine* 27, No. 113 (July 1914) 17

83 Helen Duffy and Frances K. Smith, *The Brave New World of Fritz Brandtner* (Kingston 1982) 37

84 J.A. Wainwright, 'Motives for Metaphor: Art and the Artist in Seven Canadian Novels' (PHD diss., Dalhousie University, 1978) 136

85 'An Art Museum,' *Mail and Empire*, 10 Feb. 1900; NAC, Royal Canadian

Academy of Arts Papers, MG 28, I 126, 'Scrapbook,' undated clipping [1906], 33

86 NLC, A.E. Harriss Papers, Harriss to Lady Minto, 10 Dec. 1902; Charles A.E. Harriss, 'Introduction,' *First Cycle of Music Festivals of the Dominion of Canada*, 31 Mar.-9 May 1903, 1

87 Sir Alexander Campbell Mackenzie, *A Musician's Narrative* (London 1927) 209. The Festival of English Cathedral Music was held in numerous cities and towns across the country and was conducted by the Westminster Abbey organist Sir Frederick Bridge, who formed and trained a choir which then gave musical examples of English cathedral music to accompany his lecture on the same subject.

88 Helmut Kallmann et al., eds., *Encyclopedia of Music in Canada* (Toronto 1981) 844

89 Ibid., 149

90 Ernest MacMillan, 'Problems of Music in Canada,' in Bertram Brooker, ed., *Yearbook of the Arts in Canada 1936* (Toronto 1936) 199

91 CCA, University of Saskatchewan Papers, 'University of Saskatchewan: Carnegie Chair of Music, Report and Financial Statement Re Carnegie Grant Dated October 19th 1933,' 4 [report most probably made by Arthur Collingwood]; NLC, Ernest MacMillan Papers, Box 8, MacMillan to Mrs J.H. Farmer, 21 Mar. 1939

92 Stanley Bligh, 'Music Festivals in B.C.,' *Curtain Call* 7, no. 6 (Mar. 1936) 13; MacMillan, 'Problems of Music in Canada,' 199

93 MacMillan, 'Music in Canada,' 190

94 NLC, Ernest MacMillan Papers, Box 3, 'Radio Talk, Calgary Festival 8 May 1935,' [typescript] 1

95 NAC, Grey of Howick Papers, MG 27, II B2, vol. 12, Grey to Lewis V. Harcourt, Colonial Office, 2 May 1911

96 Ibid., *The Earl Grey Musical and Dramatic Trophy September 1906–April 1911*, 55

97 Betty Lee, *Love and Whisky: The Story of the Dominion Drama Festival* (Toronto 1973) 88

98 'The Front Page,' *Saturday Night* 51, no. 22 (4 April 1936) 3

99 NAC, Grey of Howick Papers, MG 27, II B2, vol. 12, Grey to Lewis V. Harcourt, 20 April 1911

100 MacMillan, 'Radio Talk, Calgary Festival 8 May 1935,' 1

101 NAC, Governor General's Office Papers, RG 7, G 26, F.H. Coleman to A.S. Redfern, 7 Jan. 1938

102 CPRCA, E.W. Beatty quoted in John Murray Gibbon, 'The Autobiography of John Murray Gibbon' [typescript, n.d.] 49

103 PABC, Department of Education Papers, Box 25, L. Bullock-Webster, 'Vancouver Folk Festival' [typescript of a speech], 30 Oct. 1937
104 For a good example of the diversity of funding see the 'Cash Book' of the Lethbridge Music Festival (1921–39), in PAA, Lethbridge Music Festival Papers.
105 VCA, Phoebe Smith Papers, 'Drama Festival in the Peace River' [typescript, 1930s] 2, 3, 6
106 Dean J. Matheson, 'Extra-Mural Work in Canadian Universities,' in *Twelfth National Congress of Canadian Universities* (Montreal 1928) 71
107 Rod J. MacLennan, Joan Gregson Evans, and William S. Shaw, *Royal Commission on Post-Secondary Education* (Halifax 1985) 225
108 TFRBL, Edmund Walker Papers, Box 6, Rev. Dr. Macklen to Walker, 4 Nov. 1904
109 UAA, Department of Extension Papers, Director's Files [no title, no author, no date, typescript]
110 MacLennan et al., *Royal Commission on Post-Secondary Education*, 229
111 CCA, Acadia University Papers, F.W. Patterson to F.P. Keppel, 27 Dec. 1935
112 E.A. Corbett, *We Have with Us Tonight* (Toronto 1957) 110
113 Falconer's speech to the Canadian Association for Adult Education meeting in Toronto, 23–24 Nov. 1936, as quoted in *Annual Report of the Department of Education New Brunswick 1936* (Fredericton 1937) 331
114 RFA, Outside Activities–Organizations, Radio Broadcasts File, Walter Abell, 'Radio Talk Given from Station CKIC at Wolfville, Nova Scotia, February 1935,' entitled 'The Fine Arts and Good Citizenship,' 1–4
115 PABC, Department of Education Papers, Box 12, [L. Bullock-Webster], 'Notes for an Address on Adult Education in British Columbia' [1936] 2–3
116 QUA, Frances K. Smith Papers, Allan Harrison to Smith, 18 Feb. 1975. The Atelier's association with McGill University lasted only one year. According to its chairperson, Hazen Sise, it was accused of being 'a suspicious and probably subversive organization of which McGill had better beware.' See Hazen Sise, 'The Thirties: A Very Personal Memoir,' in Victor Hoar, ed., *The Great Depression* (Toronto 1969) 193.
117 Herman Voaden, ed., *Six Canadian Plays* (Toronto 1930) viii
118 Moira Day and Marilyn Potts, 'Elizabeth Sterling Haynes: Initiator of Alberta Theatre,' *Theatre History in Canada* 8, no. 1 (Spring 1987) 8–35

CHAPTER 3 'A Mad Desire to Bring About State Control'

1 NAC, Governor General's Office Papers, RG 7, G 26, vol. 37, R.B. Shaw to A.F. Lascelles, 26 Sept. 1935

2 William Leggo, *History of the Administration of the Earl of Dufferin in Canada* (Montreal and Toronto 1878) 491

3 NAC, Royal Canadian Academy of Arts Papers, MG 28, I 126, vol. 17, 'Minute Book,' 6 Mar. 1880, 42

4 SAB, 'Secretary of State: Examinations of Royal Academy of Music,' Under Secretary of State to Lt. Governor of the North-West Territories, 10 Nov. 1897

5 George Stewart, *Canada under the Administration of the Earl of Dufferin* (Toronto 1878) 603

6 NAC, Grey of Howick Papers, MG 27, II B 2, vol. 28, Grey to Lord Mountstephen, 13 Mar. 1906

7 Ibid., vol. 12, Grey to Lewis V. Harcourt, 2 May 1911

8 Walter J. Phillips, 'The Canadian Water-Colour Society' [*Winnipeg Evening Tribune*, 1933], as quoted in Maria Tippett and Douglas Cole, eds., *Phillips in Print: The Selected Writings of Walter J. Phillips on Canadian Nature and Art* (Winnipeg 1982) 81–2

9 See, for example, J.S. Woodsworth's *Strangers within Our Gates* (Toronto 1909) and Ralph Connor's *The Foreigners: A Tale of Saskatchewan* (Toronto 1909).

10 Phillips, 'The Canadian Water-Colour Society,' 81–2

11 Grey quoted on 5 May 1910 in J. Castell Hopkins, ed., *Empire Club Speeches* (Toronto 1910) 251

12 QUA, Lorne Pierce Papers, Box 1, J.D. Logan to Pierce, 7 Feb. 1924; PAC, Robert Stead Papers, MG 30, D 74, vol. 1, Earl Grey to Stead, 6 Mar. 1911

13 NAC, Grey of Howick Papers, vol. 28, Grey to [?] Graham, 15 Feb. 1908

14 TFRBL, Edmund Walker Papers, Box 7, Grey to Walker, 29 Dec. 1908

15 A.S. Doughty, 'The Tercentenary of Canada,' in Frank Carrel and Louis Feiczewicz, eds., *The Quebec Tercentenary Commemorative History* (Quebec 1908) 3, 9

16 TFRBL, Edmund Walker Papers, Box 7, Angus Macmurchy to Walker, 18 Aug. 1908; NAC, Grey of Howick Papers, vol. 12, Grey to Lewis V. Harcourt, 2 May 1911; Ibid., Grey to Harcourt, 20 April 1911

17 Ibid., Grey to Harcourt, 2 May 1911

18 *Toronto Star*, 5 April 1910

19 Alison Taylor Hardy, 'The Ottawa Little Theatre – Past and Present,' *The Curtain Call* 11, no. 4 (Jan. 1941) 3

20 'Earl of Bessborough and the Ottawa Drama League,' *Star* [London], 9 Dec. 1931

21 David Pressman, 'The Drama Festival,' *New Frontier* 2, no. 2 (May 1937) 26

22 Mona Gould, 'On to Ottawa,' *Curtain Call* 8, no. 6 (Mar. 1937) 2; Pressman, 'The Drama Festival,' 26

23 'The Ottawa Drama Festival,' *Masses* 2, no. 9 (May–June 1933) 7

24 NLC, A.E. Harriss Papers, Harriss to Earl Grey, n.d.

25 'John Buchan Dinner,' *Author's Bulletin* [Canadian Authors' Association First Quarterly Bulletin], 2, no. 1 (Nov. 1924) 13

26 Tweedsmuir quoted in the introduction to 'The Southern Dominions Exhibition – South Africa, New Zealand and Australia Exhibition in 8 October 1936,' in *The National Gallery of Canada: Annual Report of the Board of Trustees for the Fiscal Year 1936–37* (Ottawa 1938) 8

27 David G. Pitt, *E.J. Pratt: The Master Years, 1927–1964* (Toronto 1987) 183. For a further discussion of how reluctant Tweedsmuir was to become involved in the establishment of the Governor General Literary Awards see Watson Kirkconnell, *A Slice of Life* (Toronto 1967) 298.

28 Tweedsmuir quoted in *Dominion Drama Festival Program* (Ottawa 1939) n. pag.

29 NAC, Association of Canadian Bookman Papers, MG 28, I 74, vol. 1, 'The Canadian Bookman's Association, Lord Tweedsmuir, Royal York Hotel, Toronto,' 22 Feb. 1936

30 'Poetry Comes First: Lord Tweedsmuir Address Given at Convocation Hall in the University of Toronto on Canadian Poetry Night,' *Saturday Night* 53, no. 5 (4 Dec. 1937) 14

31 Roger Boulet, *Frederic Marlett Bell-Smith (1846–1923)* (Victoria 1977) 31

32 TFRBL, Edmund Walker Papers, Box 20, Walker to Grey, 9 Jan. 1908; Ibid., 1 Dec. 1909

33 G. Campbell McInnes, 'World of Art,' *Saturday Night* 51, no. 17 (29 Feb. 1936) 16

34 NAC, W.L. Mackenzie King Papers, MG 26, J, 'Diaries' [typescript], 5 Nov. 1935 [Tuesday] 9

35 'Canadian Literature, Art and Music,' in J. Castell Hopkins, ed., *Canadian Annual Review of Public Affairs 1922* 22 (Toronto 1923) 311

36 NAC, George T. Denison Papers, MG 29, vols. 7–8, Charles Mair to Denison, 1896, as quoted in Karen C. Altfest, 'Canadian Literary Nationalism, 1836–1914' (PHD diss., City University of New York, 1979) 253

37 Sandra Gwyn, *The Private Capital: Ambition and Love in the Age of Macdonald and Laurier* (Toronto 1984) 432

38 NAC, Royal Canadian Academy of Arts Papers, vol. 14, 'Sir Wilfrid Encourages Art' [undated clipping, ca. 1903, in 'RCA Scrapbook,' 27]. In response to Laurier, Robert Harris, the academy's president at the time, sent out a list of specific proposals suggesting that a government advisory art board

be established and that the National Gallery be given a building. Nothing, however, came of the suggestion. See Rebecca Sisler, *Passionate Spirits: A History of the Royal Canadian Academy of Arts 1880–1980* (Toronto 1980) 80.

39 This talk was given by Laurier at the National Club banquet, 7 Jan. 1910. See *Lamps*, Jan. 1910, n. pag.

40 NAC, Mackenzie King Papers, 'Diaries,' 18 Oct. 1929 [Friday] 291, and 27 April 1934 [Friday] 117

41 *Curtain Call* 6, no. 9 (June 1935) 2

42 QUA, Lorne Pierce Papers, Box 4, Pierce to R.B. Bennett, 26 Jan. 1931. See also Kirkconnell, *A Slice of Life*, 301; John Coldwell Adams, *Sir Charles God Damn: The Life of Charles G.D. Roberts* (Toronto 1986) 172–4.

43 NAC, Denison Papers, Charles Mair to Denison, 1896, as quoted in Altfest, 'Canadian Literary Nationalism,' 253

44 Several applications were made to R.B. Bennett regarding financial assistance to Charles G.D. Roberts. Lorne Pierce wrote to Bennett on 26 Jan. 1931 (QUA, Pierce Papers, Box 4); William Arthur Deacon had an interview with the prime minister (TFRBL, W.A. Deacon Papers, Box 2, Bennett to Deacon, 13 April 1931); and, Pelham Edgar called a meeting at the Arts and Letters Club to form the Canadian Authors' Foundation on 30 April 1931.

45 NAC, R.B. Bennett Papers, M 1318, no. 392393, 'From the Prime Minister for Authors Week' [1932]; TFRBL, W.A. Deacon Papers, Box 2, Deacon to R.B. Bennett, 7 Nov. 1930; ibid., Bennett to Deacon, 27 Feb. 1931

46 Canada, House of Commons, *Debates*, 20 June 1935, 3861. See also ibid., 23 June 1936, 4113–14.

47 Undated letter of Mackenzie King located in the W.L. Mackenzie King Papers at the NAC, as quoted in Patrick B. O'Neill, 'The British Canadian Theatrical Organization Society and Trans-Canadian Theatre Society,' *Journal of Canadian Studies* 13, no. 1 (Spring 1980) 66; NAC, Mackenzie King Papers, 'Diaries,' 27 April 1934 [Friday] 127

48 See Mackenzie King Papers, 'Diaries,' for his meetings with Vincent Massey: 27 Jan. 1932 [Wednesday] 27; and 30 Nov. 1934 [Friday] 151.

49 TFRBL, W.A. Deacon Papers, Box 29, Mackenzie King to Pelham Edgar, 15 Jan. 1936

50 Beverley Baxter quoted in 1915 in Alison Taylor Hardy, 'The Ottawa Little Theatre – Past and Present,' *Curtain Call* 12, no. 4 (Jan. 1941) 3

51 NAC, Mackenzie King Papers, 'Diaries,' 8 Sept. 1933 [Friday] 251

52 See John Edward Hoare, 'Plea for a Canadian Theatre,' *University Magazine* 10, no. 2 (April 1911) 251; J.M. Gibbon, 'Where Is Canadian Litera-

ture?' *Canadian Magazine* 50, no. 4 (Feb. 1918) 333-40; and Merrill Denison, 'Canada Can Have No National Theatre,' *Toronto Star*, 19 Nov. 1929, 6.

53 See, for example, J.A. Radford quoted from the *Canadian Magazine* (1894) in J. Castell Hopkins, ed., *Canada: An Encyclopaedia of the Country* 4 (Toronto 1898) 398; Mary J.L. Black, 'The Development of American Magazines in Canada,' *Canadian Bookman* 1, no. 2 (April 1919) 12; Lewis Hunt, 'A Plea for Art,' *Dalhousie Review* 4, no. 4 (Jan. 1925) 510-12; and Fred R. Mackelcan, 'An All-Sibelius Programme,' *Queen's Quarterly* 43, no. 3 (Autumn 1936) 300-4.

54 *Canadian Daily Record* [Ottawa], 8 Jan. 1919; TFRBL, Robert Borden Papers, Box 5, Borden to Mrs Borden, 5 Jan. 1919

55 NAC, Mackenzie King Papers, 'Diaries,' 24 June 1937 [Tuesday] 597; 17 July 1932 [Wednesday] 209; 14 April 1934 [Saturday] 104

56 See, for example, the 1921 Copyright Act proclaimed in 1924 dealing with performing rights; the Canadian Broadcasting Act (1932); the National Film Board Act (1939); the Aird Report (1929) on the Royal Commission on Radio Broadcasting; House of Commons, Special Committee on Radio Broadcasting, *Proceedings and Report* (1932); and the Canadian Tariff Legislation (1931) on American magazines.

57 Ernest MacMillan, 'Problems of Music in Canada,' in Bertram Brooker, ed., *Yearbook of the Arts in Canada* (Toronto 1936) 191

58 W.A. Sherwood, 'The National Spirit in Art,' in J. Castell Hopkins, ed., *Empire Club Speeches* (Toronto 1907) 150

59 Fern Bayer, *The Ontario Collection* (Toronto 1984) 4

60 Jean S. McGill, *Edmund Morris: Frontier Artist* (Toronto 1984) 61. The portrait studies resulting from this trip are in the Royal Ontario Museum.

61 Naomi Jackson Groves Papers, Ottawa, Private Collection, Jackson to Mortimer Lamb [inscribed Dec. 1915]

62 NAC, Canadian National Railway Broadcasting Papers, M 715, 'Diamond Jubilee of Confederation Programme, 1 July 1927 (Ottawa 1927)'; NAC, Mackenzie King Papers, 'Diaries,' 1 July 1927 [Friday] 129

63 Dennis Reid, *Edwin Holgate* (Ottawa 1976) 14

64 See Marius Barbeau and Edward Sapir, *Folk Songs of French Canada* (New Haven 1925). Barbeau was not the first Canadian to collect these songs. The German anthropologist Franz Boas and others had been collecting songs among the West Coast Indians from the late nineteenth century, and Ernest Gagnon had made a seminal collection of French-Canadian folk-songs in 1862 entitled *Chansons populaires du Canada*

(Québec 1865).

65 'List of Canadian Music Inspired by the Music, Poetry, Art and Folklore of Native Peoples' [unpublished list compiled by the Canadian Music Centre, Toronto, 1980] 17

66 Constant Lambert, *Music Ho! A Study of Music in Decline* (London 1934) 149. MacMillan's works were titled 'Three West Coast Indian Songs.'

67 *Pilgrims of the Wild* (London 1935), *Sajo and the Beaver People* (London 1936), and *Tales of an Empty Cabin* (London 1936) are among Grey Owl's books.

68 Among the many exhibitions to which Canadian artists contributed, sometimes at the request of the government and at other times at the request of the Royal Canadian Academy of Arts, were the Dublin Exhibition of 1865, the Colonial and Indian Exhibition in London in 1886, the World Columbian Exposition in Chicago in 1893, the Wembley Exhibitions in London in 1924 and 1925, and the First International Congress of Popular Arts in Prague in 1928.

69 Edwin Holgate, assisted by Albert Cloutier, William Ogilvie and Stanley Cosgrove, was hired by the Department of Trade and Commerce to paint murals for the Canadian pavilion at New York's World Fair in 1939. Fritz Brandtner painted the three-hundred-foot mural for the Saskatchewan government exhibit at the World Grain Exhibition in Regina in 1933. And a West Coast Indian artist from Fort Rupert, Mungo Martin, received a commission from the Department of Mines and Resources in 1938 to carve two seventeen-foot totem poles for the Canadian pavilion at New York's World Fair in 1939.

70 NAC, Arthur Meighen Papers, MG 26, I, vol. 89, 'A Canadian Caravan in France,' *Boston Evening Transcript*, 23 Jan. 1924 [clipping]. In 1921 a similar French exhibition train had travelled through Canada, but the scheme conceived in 1916 by the head of Trade and Commerce was a Canadian one.

71 Marjorie McKay, 'History of the National Film Board of Canada,' National Film Board Document, 5 Aug. 1964, 6, as quoted in Juliet Thelma Pollard, 'Government Bureaucracy in Action: A History of Cinema in Canada, 1896–1941' (MA thesis, University of British Columbia, 1979) 90

72 TFRBL, Edmund Walker Papers, Box 27, G.A. Reid [President of the Royal Canadian Academy of Arts], 'RCA of Arts Memorial Regarding the Present Conditions and Needs of Canadian Art' [to the governor general], 7 Jan. 1907

73 NGCA, 'Advisory Arts Council' [mimeograph, 1 page]; TFRBL, Edmund
Walker Papers, Box 32, 'P.C. 673, Extract from a Report of the Committee
of the Privy Council, Approved by the Governor General on the 3rd of
April 1907,' 1. It is interesting to note that Britain did not found a similar
body, the Royal Fine Arts Commission, until 1924.

74 Margaret Anne Meek, 'History of the City Beautiful Movement in Can-
ada, 1890–1930' (MA thesis, University of British Columbia, 1979) 55

75 Eric Brown paraphrased in 'Have Painters but Lack Appreciation,' Colo-
nist [Victoria], 26 June 1921

76 NGCA, W.G. Constable, 'Eric Brown' [typescript], 14 Oct. 1946, 3

77 Eric Brown, 'Canada and Her Art,' The Annals of the American Academy
of Political and Social Sciences 45 (Jan. 1913) 172. Brown was certainly
alive to the thought expressed by Martin Arthur Shee as early as 1809 that
the arts were 'instruments of national glory and honor' civilizing and
ennobling a nation (Rhymes on Art; or, The Remonstrance of a Painter
[London 1809], as quoted in Janet Oppenheim Minihan, 'The Nationali-
zation of Culture: The Development of State Subsidies to Art in Great
Britain' [PHD diss., Columbia University, 1975] 1).

78 NAC, H.O. McCurry Papers, MG 30, D 186, vol. 2, Brown to McCurry, 21
Mar. 1923

79 Eric Brown, 'Recent Acquisitions for Our National Gallery,' Canadian
Forum 6, no. 67 (April 1926) 213

80 NGCA, W.G. Constable, 'Eric Brown' [typescript] 7; Brown, 'Canada and
Her Art,' 171, 176

81 NGCA, Brown to Walker, 11 Feb. 1914

82 Eric Brown, 'The National Gallery,' Maclean's Magazine 29, no. 9 (July
1916) 34

83 TFRBL, Edmund Walker Papers, Box 34, Walker to Beaverbrook, 18 Mar.
1918

84 Eric Brown paraphrased in 'Have Painters but Lack Appreciation,' Colo-
nist [Victoria], 26 June 1921

85 F.B. Housser, A Canadian Art Movement: The Story of the Group of
Seven (Toronto 1926) 24

86 NGCA, A.Y. Jackson, 'The Modern Canadian Artist's Point of View' [read
before the Empire Club in 1925]

87 Frank H. Underhill, 'False Hair on the Chest,' Saturday Night 51, no. 48
(3 Oct. 1936) 1

88 Robert Stacey, 'Jefferys and the Toronto Art Students' League:
1888–1904,' Northward Journal: A Quarterly of Northern Arts 20 (1981)
15; NAC, McCurry Papers, vol. 2, Clarence A. Gagnon to McCurry, 18 Feb.

1927
89 Naomi Jackson Groves Papers, Jackson to Mortimer Lamb, 6 Jan. [ca. 1930]
90 Dorothy Farr, *Lillias Torrance Newton* (Kingston 1981) 14-15
91 NGCA, Brown to Charles Camsell, Commissioner of the Northwest Territories, Department of Mines and Resources, 30 June 1938; ibid., Camsell to Brown, 1 July 1938
92 Ibid., Carr to Brown, 9 Mar. [1928]; ibid. 29 April 1928
93 Ibid., Phillips to Brown, 21 July 934; ibid., Phillips to McCurry, 28 Aug. 1934
94 'National Gallery Will Encourage Art,' *Globe*, 28 May 1914
95 Among the Gallery's most important foreign exhibitions during the 1920s and 1930s were the British Empire Exhibition at Wembley, England, in 1924 and 1925; the Exposition d'art canadien at the Musée du Jeu de Paume in Paris in 1927; the Southern Dominions Exhibition – South Africa, New Zealand and Australia during 1936-7; and A Century of Canadian Art at the Tate Gallery in London, 1938.
96 VCA, British Columbia Art League Papers, vol. 2, 'Minutes,' 12 Feb. 1926, 97
97 CCA, National Gallery of Canada Papers, McCurry to Keppel, 25 April 1931. See also Charles H. Scott, 'Art in British Columbia,' *Canadian Forum* 12, no. 142 (July 1932) 382; and McCurry's advice to Julia Crawford upon establishing an art gallery in Saint John, New Brunswick, in NBM, Julia Crawford Papers, McCurry to Crawford, 'On an Art Gallery' [1938].
98 NGCA, [Eric Brown], "Art in Winnipeg' [typescript; inscribed: 'Lecture tour 1921-22'] 2,1
99 'Victoria Artist Outstanding,' *Colonist* [Victoria], 14 Sept. 1927
100 Arthur Lismer, 'The Art Gallery of Toronto,' *Journal* [Royal Architectural Institute of Canada] 3, no. 2 (Mar-April 1926) 71
101 NAC, McCurry Papers, vol. 2, Brown to His Excellency the Governor General of Canada, 14 Sept. 1929. The years during the First World War saw the Gallery's budget fall from $100,000 a year in 1914 to $8,000 a year in 1919.
102 Canada, House of Commons, *Debates*, 13 July 1924, 3208
103 Vincent Massey, *What's Past Is Prologue* (Toronto 1963) 91
104 Canada, House of Commons, *Debates*, 13 July 1924, 3209
105 NAC, McCurry Papers, vol. 2, George Henderson [legal counsel of the insurgent artists and academicians who were trying to press for an investigation into the Gallery's affairs] quoted in a transcript of a meeting of

the National Gallery Board of Trustees, 8 Feb. 1934, 33
106 Brown to Massey, 2 April 1926, as quoted in Claude Bissell, *The Young Vincent Massey* (Toronto 1981) 181
107 NAC, McCurry Papers, vol. 2, McCurry to Norman Mackenzie, 14 Dec. 1929
108 'The National Art Gallery,' *Toronto Star*, 9 June 1913
109 Lawren Harris, 'The Federal Art Commission,' *Globe*, 4 June 1914
110 NAC, Royal Canadian Academy of Arts Papers, vol. 14, undated clipping from *Saturday Night* [Dec. 1922, in 'RCA Scrapbook,' 125]
111 NGCA, Brown to Carr, 21 Dec. 1932
112 Walter J. Phillips, 'Eric Brown and the National Gallery Controversy,' *Winnipeg Evening Tribune* [Dec. 1932] as quoted in Tippett and Cole, eds., *Phillips in Print*, 82–3. The petition was addressed to the Governor General in Council and organized by the traditional painter Ernest Fosbery.
113 Sisler, *Passionate Spirits*, 159–60. This petition was organized by Toronto sculptors Frances Loring and Elizabeth Wyn Wood.
114 Canada, House of Commons, *Debates*, 7 June 1938, 3633
115 'Canadian Art in Paris,' *Canadian Forum* 8, no. 84 (Sept. 1927) 361

CHAPTER 4 Volunteers, Subscribers, and Millionaires

1 Mary H.T. Alexander, 'Little Theatres of the West,' *Maclean's Magazine* 36, no. 17 (1 Oct. 1921) 52
2 Mortimer Lamb, 'The Art of Curtis Williamson, R.C.A.,' *Canadian Magazine* 32, no. 1 (Nov. 1908) 65. See also 'Two Canadian Poets: A Lecture by Archibald Lampman,' *University of Toronto Quarterly* 13, no. 4 (July 1944) 408 [delivered on 19 Feb. 1891 to the Literary and Scientific Society in Ottawa]; S.M. Beckow, 'From the Watch-towers of Patriotism: Theories of Literary Growth in English Canada, 1864–1914,' *Journal of Canadian Studies* 9, no. 3 (Aug. 1974) 10–11.
3 TFRBL, Edmund Walker Papers, Box 27, *Globe* [clipping] 18 Oct. 1917
4 Hugh MacLennan, *Two Solitudes* (Toronto 1945) 230
5 NAC, D.C. Scott Papers, MG 30, D 100, Scott to Gagnon, 9 June 1926
6 Eric Brown, 'Canada and Her Art,' *The Annals of the American Academy of Political and Social Sciences* 45 (Jan. 1913) 172
7 A.Y. Jackson quoted in J.E.H. MacDonald, 'A Whack at Dutch Art,' *Rebel* 2, no. 6 (Mar. 1918) 257
8 G. Campbell McInnes, 'Five Private Collections of Art,' *Winnipeg Free Press*, 23 Jan. 1937

9 MAUA, G.J. Trueman Papers, 'Interview with Professor Stanley Royle, Director of the Department of Fine Arts,' 1

10 Robert Barr, 'Literature in Canada, Part I, *Canadian Magazine* 14, no. 1 (Nov. 1899) 6

11 NAC, Grey of Howick Papers, MG 27, II B2, vol. 12, Grey to Lewis V. Harcourt, 2 May 1911

12 Martyn Howe, 'Wanted – A Gospel,' *Canadian Mercury* vol. 1, no. 4 (Mar. 1929) 88

13 NLC, George Brewer Papers, 'Reminiscences of Music and the Stage,' vol. 1, 25 Nov. 1906 [Sunday] 4

14 Thorstein Veblen, *The Theory of the Leisure Class* (1899; New York 1922) 68-101

15 Sir John Bourinot, 'Literature and Art in Canada,' *Anglo-American Magazine* 3 (Feb. 1900) 110. See also J.E. Wells, 'Canadian Culture,' *Canadian Monthly and National Review* 8, no. 6 (Dec. 1875) 459-67.

16 J.M. Gibbon, 'Where Is Canadian Literature?' *Canadian Magazine* 50, no. 4 (Feb. 1918) 337

17 NAC, Canada Foundation Papers, MG 28, I 179, vol. 40, 'Foundations' [typescript], n. pag. It should be noted that the author was not given access to the archives of the Winnipeg Foundation, which established the first community trust in Canada to which individuals and corporations contributed. See also *Statutes of Canada 1930*, vols. 20-1 (Ottawa 1930) 232.

18 AO, M.O. Hammond Papers, 'Diary,' 22 Mar. 1917

19 Helmut Kallmann, *A History of Music in Canada 1534-1914* (Toronto 1960) 120

20 Ernest MacMillan, 'Heard but Not Created,' *Times* [London], 15 May 1939

21 *Exhibition of Master Watercolours, Drawings and Prints*, The New Brunswick Museum (Saint John 1955) n. pag.

22 Helmut Kallmann et al., eds. *Encyclopedia of Music in Canada* (Toronto 1981) 140; NLC, Ernest MacMillan Papers, 'A Personal Tribute to Vincent Massey' [ca. 15 Jan. 1968] 1

23 Harvey Cowan, 'The Ruins of Winter,' *City and Country Home*, Nov. 1984, 157

24 Robert Harris, 'Art in Quebec and the Maritime Provinces,' in J. Castell Hopkins, ed., *Canada: An Encyclopaedia of the Country* 4 (Toronto 1898) 358

25 CCA, University of Western Ontario Music Program Papers, 'Memo of an Interview among J.M.R., President Fox, Edward Johnson on 19 February 1935,' in 'History of New Movement in Music in Western Ontario,' 1.

Edward Johnson also gave benefit concerts to raise money for charities. See Flora McCrea Eaton, *Memory's Wall* (Toronto 1956) 130-6.

26 Dr James MacCallum quoted in William Colgate, *Canadian Art* (Toronto 1943) 92. See also Douglas Cole, 'Artists, Patrons and Public: An Enquiry into the Success of the Group of Seven,' *Journal of Canadian Studies* 13, no. 2 (Summer 1978) 75.

27 A.Y. Jackson, 'Dr. MacCallum Loyal Friend of Art,' *Saturday Night* 59, no. 14 (11 Dec. 1943) 19

28 NAC, H.O. McCurry Papers, MG 30, D 186, vol. 2, McCurry to Mackenzie King, 17 Jan. 1929

29 PAM, Manitoba Society of Artists Papers, 'Minute Book,' 24 June 1929, n. pag.

30 [Foreword], in *Contemporary Arts Society/Exhibition of Paintings by Members* (Montreal 1939) n. pag. as quoted in Charles C. Hill, *Canadian Painting in the Thirties* (Ottawa 1975) 131

31 Marilyn Baker, *The Winnipeg School of Art* (Winnipeg 1984) 26

32 Ibid.

33 Ernest MacMillan, 'The Organ Was My First Love,' *Canadian Music Journal*, Spring 1959, 10

34 Phyllis R. Blakeley, 'The Theatre and Music in Halifax,' *Dalhousie Review* 29, no. 1 (April 1949) 11

35 Mary Elizabeth Smith, *Too Soon the Curtain Fell: A History of Theatre in Saint John 1789-1900* (Fredericton 1981) 95

36 Kallmann et al., eds., *Encyclopedia of Music in Canada*, 638; PAPEI, Little Theatre Guild Papers, Helen A. Lawson, 'Little Theatre in Charlotte-town' [typescript, 1953] 2

37 NSPA, Halifax Community Concert Association Papers, [flyer] 14 Oct. 1933, 2; William R. Watson, *Retrospective: Recollections of a Montreal Art Dealer* (Toronto 1974) 10

38 Graham C. McInnes, 'The World of Art,' *Saturday Night* 52, no. 1 (7 Nov. 1936) 23

39 Alan Jarvis and Lester B. Pearson quoted respectively in Alan Jarvis, ed., *Douglas Duncan* (Toronto 1974) 11, 5

40 Margery Fee, 'English-Canadian Literary Critics 1890-1950: Defining and Establishing National Literature' (PHD diss., University of Toronto, 1981) 161

41 'A Great Asset to Be Safeguarded,' *Toronto Daily Star*, 28 Oct. 1931

42 NAC, McCurry Papers, vol. 2, McCurry to Eric Brown, 25 Mar. 1924. See also 'Sir Edmund Walker,' *Canadian Bookman* 6, no. 5 (May 1924) 109.

43 TFRBL, Edmund Walker Papers, 'Progress and Canadian Culture' [talk

given at the Savoy Hotel, London, to the Canadian Club, 3 June 1922; inserted in 'Journals, III'] n. pag.

44 Edmund Walker, 'Annual Address' [to Canadian Bank of Commerce] in *Report of the Canadian Bank of Commerce 1920* (Toronto 1921) 18, as quoted in Barbara Ruth Marshall, 'Sir Edmund Walker, Servant of Canada' (MA thesis, University of British Columbia, 1971) 25

45 A.T. Drummond, 'A Course in Music at Queen's,' *Queen's Quarterly* 9, no. 1 (July 1901) 61

46 Louise McDowell, *Past and Present* (Kirkland Lake, Ont. n.d.) 29

47 Dorothy E. Salisbury, 'Music in B.C. outside Vancouver,' *Canadian Music Journal* 2, no. 4 (Summer 1958) 36

48 VCA, Vancouver Women's Musical Club Papers, vol. 1, 'The Vancouver Women's Musical Club' [typescript, n.d.] 2

49 Paul George Fuller, 'Aspects of London's Cultural Development from the Turn of the Century to World War II' (MA thesis, University of Western Ontario, 1966) 81

50 Nora E. Vaughan, 'The Future of Handicrafts in Canada,' *Public Affairs* 7, no. 1 (Aug. 1943) 10

51 'Encouraging Canadian Handicrafts,' *Echoes* no. 129 (Dec. 1932) 25

52 UMA, Men's Musical Club Papers, Box 1, 'A Short History of the Men's Musical Club, Winnipeg' [mimeograph; inscribed 20 Oct. 1955] 11

53 Oswald C.J. Withrow, *The Romance of the Canadian National Exhibition* (Toronto 1936) ix

54 Fred R. Mackelcan, 'Our Musical Future,' *Queen's Quarterly* 44, no. 1 (Spring 1937) 84

55 NLC, George Brewer Papers, B.E. Chadwick [musical director of the Apollo Glee Club of Montreal] to Brewer, 18 May 1923

56 Herbert Davis, 'A Symphony Orchestra,' *Canadian Forum* 6, no. 41 (Feb. 1924) 146

57 Floyd S. Chalmers, *Both Sides of the Street* (Toronto 1983) 117

58 Mabel Crews Ringwood, 'The Work of Canadian Hands,' *Canadian Magazine* 75, no. 5 (May 1931) 11; PANB, Rotary Club Papers, 'Minute Book 1931-32,' 6 Oct. 1931, n. pag.

59 Chester Duncan, *Wanna Fight, Kid?* (Winnipeg 1975) 58, 32

60 Charlie Fowler, 'Membership-Morale,' *K-Ray* 8, no. 4 (7 April 1932) 5

61 J. Castell Hopkins, ed., *The Canadian Annual Review of Public Affairs 1927-1928* (Toronto 1928) 571

62 Grey Owl, 'A Plea for the Canadian Northland,' in *Empire Club of Canada 1936-37* (Toronto 1937) 91-102

63 'Businessman Tells of His Experiences at Parsifal Performance,' *Montreal*

Star, 28 Oct. 1905. See also Stephen Leacock, 'The University and Business,' *University Magazine* 12 (Dec. 1913) 540–9; and A.Y. Jackson, 'Artists in the Mountains,' *Canadian Forum* 5, no. 52 (Jan. 1925) 112

64 J.S. McLean, 'On the Pleasures of Collecting Paintings,' *Canadian Art* 10, no. 1 (Autumn 1952) 6

65 'An Unique Institution,' *Canadian Review of Music and Art* 2, nos. 7–8 (Aug.–Sept. 1943) 34

66 Eaton's Archives, Toronto, Roy Davis, 'Department Store Opera,' *Magazine Digest*, June 1940, 33

67 NAC, Association of Canadian Bookmen, MG 28, I 74, vol. 1, 'Genesis of Revival and Re-organization of the Association of Canadian Bookmen' (1935) 2

68 'The Maid of Tokyo,' *Blue Bell* [Toronto], Mar. 1922, 9

69 Alfred Zealley, *Musical Canada* (March 1929), as quoted in Kallmann et al., eds., *Encyclopedia of Music in Canada*, 21. The Anglo-Canadian Leather Company Band dissolved in 1927.

70 'Gondoliers Great Success,' *Maple Leaflet* 1, no. 8 (9 Jan. 1943) 1

71 *Maple Leaflet*, 1, no. 9 (20 Feb. 1943) 2

72 F.R., 'The Blue Bell Operatic Society,' *Blue Bell* April 1938, 7

73 Canada Packers Archives, Toronto, clipping from *Maple Leaflet* [inscribed 18 Sept. 1942] n. pag.

74 J.A. Fullerton, 'Music on the Payroll – an Aid to Efficiency,' *Industrial Canada* 20, no. 4 (Aug. 1919) 73

75 UBCSC, British Columbia Electric Papers, 'Band Concerts,' W.J. Murrin [president of BC Electric Company] to F. Leighton Thomas, 20 April 1933

76 D.H. Miller-Barstow, *Beatty of the C.P.R.* (Toronto 1951) 6

77 For the CPR festival programs – there were sixteen festivals in all – see CPRCA. Similar festivals were organized from 1928 in the United States; see David E. Whisnant, *All That Is Native and Fine* (Chapel Hill, North Carolina, 1983) 183 ff. Note that the CPR also sponsored an 'Indian Week at Banff' in 1928, at which native Indian groups from reserves in the immediate vicinity and from the Prairie foothills gathered for song and dance and to display their handicrafts.

78 Ernest Gagnon, *Chansons populaire du Canada* (Québec 1865); Lawrence J. Burpee, *Songs of French Canada* (Toronto 1909); George T. Lanigan, *National Ballads of Canada* (Montreal 1865); William McLennan, *Songs of Old Canada* (Montreal 1886); Roy Mackenzie, *The Quest for the Ballad* (Princeton 1919); Archibald MacMechan, *Sagas of the Sea* (London 1923)

79 George Pearson, ' "You See the Song and Dance Begin," ' *Maclean's Magazine* 11, no. 9 (1 May 1927) 72

80 *Melody Mike's Favourite Irish Songs* (Montreal n.d.), published by the CPR; Marius Barbeau, 'Canadian Folksongs as a National Asset,' *Canadian Nation*, Feb. 1928, 20

81 W.H. Drummond, *The Habitant and Other French-Canadians* (London 1897); D.C. Scott, *In the Village of Viger* (Boston 1896); William Parker Greenough, *Canadian Folklife and Folklore* (New York 1897)

82 CPRCA, John Murray Gibbon, 'Scot to Canadian: One of More than a Million' [typescript, n.d.] 57

83 Harold Eustace Key as quoted in C.E. Robertson, 'Artists All,' *Canadian Magazine* 73, no. 1 (Jan. 1930) 6

84 Frederick Philip Grove quoted from a *Maclean's Magazine* article (1928) in Terrance L. Craig, 'Attitudes towards Race in Canadian Prose Fiction in English 1905–1980' (PHD diss., University of Toronto, 1982) 17

85 Gibbon reports in 'Scot to Canadian,' 53–4, that Charles Gordon (pseud. Ralph Connor), after talking to a Polish dance group following their performance at the Winnipeg Festival, told him: 'Do you know, these are some of the finest, most cultured people I have met since I have come to Winnipeg. But I have something on my conscience – I feel that I have done them an injustice.' According to Gibbon, after having said this Gordon attempted to make amends by telephoning all his friends and telling them, 'We have the best show in town.' 'That change of heart did us a world of good,' Gibbon recalls. 'The criticism died down, and at the last concert in the Walker Theatre it was "Standing Room Only." '

86 Lawrence Mason, 'Great-West Folk-Festival,' *Globe* 29 Mar. 1930, 20

87 Gibbon, 'Scot to Canadian,' 52. Among many other books and articles by Gibbon see *Canadian Mosaic: The Making of a Northern Nation* (Toronto 1938); *Canadian Folk Songs, Old and New* (New York 1927); and 'European Seeds in the Canadian Garden,' *Proceedings and Transactions of the Royal Society of Canada* 3rd ser., 17, sect. II (1923) 119–29.

88 Carole Henderson Carpenter, *Many Voices: A Study of Folklore Activities in Canada and Their Role in Canadian Culture* (Ottawa 1979) 336

89 'Developing Canada's Immigrant Culture,' *Edmonton Journal*, 13 Dec. 1928, 2

90 'CPR Fostering Canadian Music,' *Calgary Daily Herald*, 13 July 1939, 4

91 Gibbon to Voaden, 1 Jan. 1931, as quoted in Anton Wagner, 'Herman Voaden's Symphonic Expressionism' (PHD diss., University of Toronto, 1984) 146

92 Claude Bissell, *The Young Vincent Massey* (Toronto 1981) 8

93 Vincent Massey, *What's Past Is Prologue* (Toronto 1963) 55

94 NAC, G.R. Parkin Papers, MG 30, D 77, vol. 10, Vincent Massey File, [no

title, typescript of 4 pages dealing with Vincent Massey, Feb. 1968] 3

95 Bissell, *The Young Vincent Massey*, 81

96 Henry Nevinson [the British newspaper journalist], 'Culture in Western Canada' [a letter to the *Manchester Guardian*], reprinted in *World Wide* 30, no. 6 (8 Feb. 1930) 221

97 For the disbursements of the Massey Foundation see NAC, Massey Foundation Papers, MG 28, I 136, vol. 1, balance sheets for the years up to 1939.

98 Renate Usmiani, 'Roy Mitchell: Prophet in Our Past,' *Theatre History in Canada* 8, no. 2 (Fall 1987) 162

99 Kallmann et al., eds., *Encyclopedia of Music in Canada*, 419

100 See Vincent Massey's 'Daily Journal' for the years under discussion in the library of Massey College, University of Toronto. Among his publications see 'The Prospects of Canadian Drama,' *Queen's Quarterly* 30, no. 2 (Nov.-Dec. 1922) 194-212; *Canadian Plays from Hart House Theatre*, vols. 1-2 (Toronto 1926, 1927); and 'Art and Nationality in Canada,' Appendix B in *Proceedings and Transactions of the Royal Society of Canada*, 3rd ser., 24 (May 1930) 59-71.

101 Massey, *What's Past Is Prologue*, 255

102 NAC, Yvonne McKague Housser Papers, MG 30, D 305, vol. 1, Arthur Lismer to Fred Housser, 15 June 1936. Two months later, the Masseys moved into the larger 12 Hyde Park Gardens residence, which they rented for five years.

103 NAC, Massey Family Papers, MG 32, A 1, vol. 34, David Milne to Mrs Massey, 10 Oct. 1934. After making a selection of Milne's work for their own collection, Alice and Vincent arranged to sell the rest of the work through Toronto's Mellor's Galleries. 'It was decided that whatever profits were to be made would be shared between Milne and the Masseys, with the Masseys' share to be turned back into a fund to purchase Canadian art' (Rosemarie L. Tovell, *Reflections in a Quiet Pool: Prints of David Milne* [Ottawa 1981] 128). This arrangement ended in 1938.

104 Vincent Massey to Walter Sinclair, 15 Mar. 1927, as quoted in Bissell, *The Young Vincent Massey*, 65

105 Harry Adaskin, *A Fiddler's World* (Vancouver 1977) 240

106 MCAUT, Vincent Massey Papers, 'Dairy no. 12,' 21 April [1932]

107 Merrill Denison, 'Hart House Theatre,' *Canadian Bookman* 5, no. 3 (Mar. 1923) 63

108 Roy Mitchell, Hart House Theatre's first director, as quoted in Raymond Massey, *When I Was Young* (Toronto 1976) 256

109 Adaskin, *A Fiddler's World*, 248

110 NAC, W.L. Mackenzie King Papers, MG 26, J, 'Dairies,' 27 Jan. 1932 [Wed-

nesday] 27; 30 Nov. 1934 [Friday] 151; 19 Oct. 1937 [Tuesday] 950
111 NAC, G.R. Parkin Papers, vol. 10, Vincent Massey File [typescript, Feb. 1968] 1
112 CCA, P & P Commonwealth-Canada File, 'Draft' [inscribed: 'written some time ago' and enclosed in G.R. Parkin to Charles Dollard, 31 Jan. 1942] 3-4
113 Howe, 'Wanted - a Gospel,' 88
114 Alan Plaunt, secretary to the Canadian Radio League, who had helped found the Canadian Radio Broadcasting Commission in 1932 and whose 'interest, flair and resources' with respect to other cultural organizations were unique, was with Brook Claxton and E.A. Corbett about to form 'a kind of informal institute' to co-ordinate the country's cultural affairs. But he died suddenly before he could make the necessary financial arrangements to pay for it. See CCA, P & P Commonwealth-Canada File, 'Draft' [enclosed in Parkin to Dollard 31 Jan. 1942] 4; RFA, no. 2126, John Marshall, 'Canada, Diary of Visit 142,' 9a.

CHAPTER 5 Leaning 'on Foreign Walking Sticks'

1 Leo Smith, 'Editorial Comments,' *Conservatory Review*, Aug. 1933, 56; J.M. Gibbon, 'Where Is Canadian Literature?' *Canadian Magazine* 50, no. 4 (Feb. 1918) 333; Mark Hambourg, *From Piano to Forte: A Thousand and One Notes* (London 1931) 268
2 Graham McInnes, *A Short History of Canadian Art* (Toronto 1939) 74; see, for example, the Toronto *Globe* columns of the music and dramatic critic Lawrence Mason from 1924 to 1939.
3 Elspeth Cameron, *Hugh MacLennan: A Writer's Life* (Toronto 1981) 127
4 CCA, P & P Commonwealth-Canada File, 'Draft' [undated, ca. 1938; enclosed in G.R. Parkin to Charles Dollard, 31 Jan. 1942] 2
5 Stephen Leacock, 'The National Literature Problem in Canada,' *Canadian Mercury* 1, no. 1 (Dec. 1928) 9
6 Norman McL. Rogers, 'Canadian Nationality,' *Canadian Forum* 12, no. 140 (May 1932) 294. As Donald Buchanan asked in *Saturday Night* two years later, 'Can there be a purely national art today?' ('An American Art Show,' 50, no. 5 [8 Dec. 1934] 18).
7 For a discussion of Australian and New Zealand cultural identity see J.O.C. Phillips 'Musings in Maoriland - or Was There a *Bulletin* School in New Zealand?' *Historical Studies* 20, no. 81 (Oct. 1983) 520-35.
8 G. Sharp Major, *Crescendo: A Business Man's Romance in Music* (Winnipeg 1935) 22

9 Ernest MacMillan, 'Our Musical Public,' *Canadian Forum* 4, no. 46 (July 1924) 308

10 CCAA, Robert Harris Papers, Robert Harris to Willie [Harris], 18 Jan. 1906

11 British Broadcasting Corporation Archives, Reading, E.A. Weir to J.R.F. Howgill, 12 Feb. 1931

12 Graham Carr, 'English-Canadian Literary Culture in the Modernist Milieu, 1920-1940' (PHD diss., University of Maine, 1983) 85-7

13 'The Canadian Pictures,' in *Canadian National Exhibition Catalogue* (Toronto 1913) 93

14 Gordon Mills, 'Art at the Canadian National Exhibition,' *Canadian Bookman* 7, no. 9 (Sept. 1925) 152

15 Marilyn Baker, *The Winnipeg School of Art* (Winnipeg 1984) 70

16 *Morning Chronicle* [Halifax] [4]; NAC, H.O. McCurry Papers, MG 30, D 186, vol. 2, McCurry to Eric Brown, 28 April 1926. See also NSPA, Nova Scotia College of Art Papers, 'Stewart Dick Lectures on Art' [flyer, 1928] n. pag.

17 Bess Housser, 'In the Realm of Art,' *Canadian Bookman* 7, no. 5 (May 1925) 87

18 The 1937 Hutcheson Report, which 'advocated a smaller faculty, to be hired on a salary basis with a greater commitment to comprehensive programmes for senior students of professional calibre,' was partly implemented following the Second World War when a senior division was established within the conservatory. See Helmut Kallmann et al., eds., *Encyclopedia of Music in Canada* (Toronto 1981) 827; Clifford Ford, *Canada's Music: An Historical Survey* (Agincourt, Ont., 1982) 115.

19 Geoffrey Payzant, 'The Competitive Music Festivals,' *Canadian Music Journal* 6, no. 3 (Spring 1960) 44

20 PAM, Manitoba Drama League Papers, W.G. Wilkes to Ross Cameron, 13 Feb. 1939

21 Michael Orme [Alice Augusta Grein], *J.T. Grein: The Story of a Pioneer 1862-1935* (London 1936) 335

22 'A Canadian National Theatre,' *Curtain Call* 7, no. 9 (June 1936) 1

23 'A Canadian Theatre,' *Saturday Night* 51, no. 27 (9 May 1936) 1. Granville-Barker wanted to see Canadians found a theatre along the lines proposed for Britain in his book *A National Theatre* (London 1930).

24 Betty Lee, *Love and Whiskey: The Story of the Dominion Drama Festival* (Toronto 1973) 79

25 Jean Coulthard, 'Canadian Music in the 1930s and 1940s: A Personal Remembrance' (1986) n. pag. [copy in the author's possession]. This is a

transcript of a talk given at a conference entitled 'Pioneers and Pioneering: Music in Canada in the 1930s and 1940s,' held at Queen's University, Kingston, Ont., 8 November 1986.

26 The Macmillan Company of Canada, *A Canadian Publishing House* (Toronto 1923) 19

27 Malcolm C. Salaman, 'Wood-Engraving for Colour in Great Britain,' *Studio* 58, no. 242 (May 1913) 283–99

28 In 1924 Phillips won the Storrow Prize in the California Print-Makers International Exhibition, Los Angeles; in 1931 he received the gold medal of the Society of Arts in Boston; and, in 1933 he was given an honourable mention in The First International Exhibition of Original Woodblock Prints in Warsaw, Poland.

29 See illustrations on pages 35, 37, 38, 39, 41, and 42 in the *Studio* 77, no. 315 (14 June 1919); Edna Gearhart, 'Walter J. Phillips, Block Printer,' *American Magazine of Art* 15 (24 Jan. 1924) 723–6; William Giles, 'Summer,' *Original Colour Print Magazine* 2 (1925) 47–8.

30 Among Barbara Pentland's compositions premièred in the United States were *Prelude, Chorale and Toccata* (1937) performed at the Juilliard Concert Hall in New York in 1938 and *Five Preludes* (1938) performed at the Carnegie Chamber Music Hall in 1939.

31 John Glassco, *Memoirs of Montparnasse* (Toronto 1970) 88; Ruth H. Kerr, 'The Home Theatre of the Canadian Players,' *Theatre Arts Magazine* 6 (Jan. 1922) 67–72; NAC, The Performing Arts Collection, MG 28, I 139, vol. 29, *The Bill* [Winnipeg] 6, no. 3 (Jan. 1934) 4

32 Maria Tippett, *Emily Carr: A Biography* (Toronto 1979) 92

33 Morley Callaghan, *That Summer in Paris: Memories of Tangled Friendships with Hemingway, Fitzgerald, and Some Others* (Toronto 1963) 22

34 Glassco, *Memoirs of Montparnasse*, 26

35 Dorothy Livesay, *Right Hand Left Hand* (Erin, Ont., 1977) 36

36 *Times* [London], 17 July 1906, 10; 23 June 1906, 14.

37 Francis Pollock, *Jupiter Eight* [Toronto 1936] 33–4; NGCA F.H. Varley Papers, Varley to H.O. McCurry, 23 Feb. 1936

38 Albert and Theresa Moritz, *Leacock: A Biography* (Toronto 1985) 11

39 C.H. Bretherton, 'Is Canada Being Americanized?' *Maclean's Magazine* 39, no. 6 (15 Mar. 1926) 41; Domino [Augustus Bridle], *The Masques of Ottawa* (Toronto 1921) 278; Reginald G. Trotter, 'The Canadian Back Fence in Anglo-American Relations,' *Queen's Quarterly* 40, no. 3 (Aug. 1933) 393

40 Leslie Bishop, *Paper Kingdom* (Toronto 1936) 15

41 Pollock, *Jupiter Eight*, 85

42 Bernard K. Sandwell, 'The Annexation of Our Stage,' *Canadian Magazine* 38, no. 1 (Nov. 1911) 23, 22

43 NLC, George Brewer Papers, Brewer to Mr Bate, 18 April 1923

44 Herbert Hodgins, 'Canadian Composer Has Two Selves – One for Her Music; One for Her Home,' *Maclean's Magazine* 38, no. 10 (1 June 1925) 78

45 David G. Pitt, *E.J. Pratt: The Truant Years 1882-1927* (Toronto 1984) 284, 322

46 NAC, Carl Schaefer Papers, MG 30, D 171, vol. 7, Milne to Schaefer, 30 Dec. 1938

47 NAC, E.A. Weir Papers, MG 30, D 70, vol. 2, Arthur L. Phelps, 'Merrill Denison, the Lost Canadian,' The Canadian Pattern, no. 10, CBC, 15 August [ca. 1943, in 'Scrapbook, 1943-1949'] 1

48 Charles G.D. Roberts, 'The Poet Is Bidden to Manhatten Island,' as quoted in James Doyle, 'The American Critical Reaction to Roberts,' in Carrie MacMillan, ed., *The Proceedings of the Sir Charles G.D. Roberts Symposium* (Halifax 1984) 99

49 TFRBL, W.A. Deacon Papers, Box 160, James Strand, 'Problems of Canadian Authorship' [1921] 2

50 Pollock, *Jupiter Eight*, 33-4

51 'Poet Crowned with Wreath of Laurel,' *Montreal Gazette*, 29 Oct. 1921

52 Poem no. 57 in Wilson MacDonald, *The Song of the Undertow and Other Poems* (Toronto 1935) 143

53 NGCA, A.Y. Jackson Papers, 'The Modern Canadian Artist's Point of View [read before the Empire Club, 1925] 1

54 TFRBL, Edmund Walker Papers, 'Journals II, 10 Mar. 1914, 5. See also Patrick B. O'Neill, 'The British Canadian Theatrical Organization Society and the Trans-Canada Theatre Society,' *Journal of Canadian Studies* 15, no. 1 (Sept. 1980) 56-67; Gertrude Lerner, 'Canada's Theatrical Ambitions,' *Literary Digest* 45 (12 Oct. 1912) 622-3.

55 William McRae Fawcett, 'Canada Looks at the Book Clubs,' *Queen's Quarterly* 37, no. 4 (Autumn 1930) 664

56 Jean L. Howson, 'More on Music in Canada,' *Food for Thought* 10, no. 2 (Nov. 1949) 33

57 NLC, Joy Denton Kennedy Papers, Kennedy to Denton Massey, 2 Feb. 1939; Bernard K. Sandwell, 'Our Adjunct Theatre,' in *Addresses Delivered before the Canadian Club of Montreal 1913-14* (Montreal 1914) 99

58 J.G. Sime, *Our Little Life* (New York 1921) 161

59 Ernest MacMillan, 'Musical Relations between Canada and the United States,' in Karl W. Gehrkens, ed., *Volume of Proceedings of the Music*

Teachers National Association 26th Session Meeting at Detroit, Michigan (Oberlin, Ohio, 1932) 38

60 Douglas MacKay, 'The Americanization of Canada,' *Century Monthly Magazine*, June 1926, 190

61 NAC, G.R. Parkin Papers, MG 30, D 77, vol. 16, 'Rough Draft, 1938' [inscribed: 'never used'] 3

62 R.G. Trotter, 'Informal Session in Connection with a Loan Exhibition of Canadian Paintings,' in *Conference of Canadian-American Affairs* (New York 1937) 134

63 RFA, National Film Society of Canada Papers, Box 27, 'Canadian Films Committee Receives Grant' [single sheet, n.d.]

64 Ellen Condliffe Langemann, *Private Power for the Public Good: A History of the Carnegie Foundation for the Advancement of Teaching* (Middletown, Conn., 1983) 5. See Andrew Carnegie, 'Wealth,' *North American Review* 148 (June 1889) 653-4; and 'The Best Fields for Philanthropy,' *North American Review* 149 (Dec. 1889) 688-9.

65 J.C. Field, 'Rockefeller's Service to Mankind,' *Saturday Night* 44 (2 Nov. 1929) 2

66 Donald Fisher, 'The Role of Philanthropic Foundations in the Reproduction and Productions of Hegemony: Rockefeller Foundation and the Social Sciences,' *Sociology* 17, no. 2 (May 1938) 206. See also the Introduction to F. Emerson Andrews, ed., *Foundations: Twenty Viewpoints* (New York 1965).

67 Quoted from Raymond Fosdick, *The Story of the Rockefeller Foundation* (New York 1952) 27, in Allan Nevins, *Study in Power: John D. Rockefeller* 2 (New York 1953) 394

68 J. Castell Hopkins, ed., *The Canadian Annual Review of Public Affairs* 6 (Toronto 1906) 629

69 UAA, Banff School of Fine Arts Papers, Box 16, Ringwood to Donald Cameron, 20 June [1939]

70 Frederick Keppel quoted by Walter Abell in 'Patron, Incorporated: Dr. Keppel and the Carnegie Corporation's Art Program,' *Magazine of Art* 34, no. 9 (Dec. 1941) 492. See also Richard F. Bach's report for the Carnegie Corporation, *The Place of Arts in American Life* (New York 1924) and Frederick P. Keppel and R.L. Duffus, *The Arts in American Life* (London and New York 1933).

71 Frederick P. Keppel, *Education for Adults* (New York 1926) 53

72 CCA, Travel and Miscellaneous File, Frederick P. Keppel, 'The Purpose of the Carnegie Trusts,' *Outspan* [Bloemfontein, South Africa], 5 July 1935, 11. This coincides with what Homer Saint-Gaudens of the Carnegie

Institute in Pittsburgh told a group of Torontonians in 1926: 'The labouring man as well as the wealthy capitalist can be stimulated to something fine through art' because, he continued, 'both have more leisure than they once had and with leisure comes atrophication, unless the feeling and the imagination are kept alive' (Lawren Harris, 'Review of the Toronto Art Gallery Opening,' *Canadian Bookman* 8, no. 2 [Feb. 1926] 47).

73 MAUA, G.J. Trueman Files, J. Russell [assistant to the president of the Carnegie Corporation] to Trueman, 7 May 1936

74 CCA, University of Alberta File, 'Memo from W.S. Learned to Keppel, 31 May 1933.' The Banff School of Fine Arts opened in August 1933.

75 Peggy Leighton, *Artists, Builders and Dreamers: Fifty Years of the Banff School* (Toronto 1982) 18

76 Consult the CCA for all reports and records concerning grants awarded to and requested by Canadian universities. Files are arranged according to university.

77 QUA, André Biéler Papers, Box 4, Walter Abell, 'Art and Democracy,' in André Biéler and Elizabeth Harrison, eds., *The Kingston Conference Proceedings* (Kingston, Ont., 1941) 30

78 CCA, P & P Commonwealth-Canada File, J.W. Dafoe to Keppel, 3 Oct. 1938, 3

79 Sir Henry Miers and S.F. Markham, *A Directory of Museums and Art Galleries* (New York 1932); CCA, Canadian Museum Programme File, Keppel to McCurry, 20 Dec. 1932

80 CCA, Canadian Museum Programme File, McCurry to Keppel, 23 Dec. 1932

81 Abell, 'Patron Incorporated,' 492

82 CCA, P & P Commonwealth-Canada File, Parkin to Keppel, 9 Nov. 1938

83 CCA, P & P Commonwealth-Canada File, 'Summary of J.M.R.'s [John M. Russell] Canadian Trip November 1939'

84 See Miers and Markham, *A Directory*; CCA, Canadian Museum Programme File, 'Report – Notes on Canadian Trip 4-24 October,' 14 Oct. 1942, by Laurence V. Coleman, Director of the American Association of Museums and member of the Smithsonian Institution.

85 CCA, P & P Commonwealth-Canada File, J.W. Dafoe to Keppel, 3 Oct. 1938, 1

86 NAC, G.R. Parkin Papers, vol. 16, 'Rough Draft' (1938) 1. See also ibid., 'Memorandum of Discussion at the Seigniory Club, Montebello, February 23-24 1938,' 1-6.

87 CCA, Canadian Museum Programme File, S.F. Markham to Keppel, 18

May 1933. The Canadian Committee comprised Frank Kermode from the Provincial Museum in Victoria; Dean R.W. Brock of the University of British Columbia; Robert C. Wallace, president of the University of Alberta; Eric Brown and Harry McCurry of the National Gallery of Canada; and private patrons H.S. Southam from Ottawa and Vincent Massey from Toronto; E.J. Judah of the Pathological Institute Museum of Montreal; and J. Clarence Webster of Dalhousie University in Halifax. There was no representative from French Canada.

88 CCA, Canadian Museum Programme File, 'Minutes of the First Meeting of the Canadian Committee on Museums, Carnegie Corporation,' 4 Sept. 1933, 1-2

89 Ibid., W.G. Constable, 'Carnegie Grants in Canada, 23 November 1933,' 1-4. In his report Constable gives full support to the Canadian Committee's plan to set up a museum-training program, as well as encouraging travelling exhibitions and lecture tours. He dissuades the committee, however, from giving money to museums for the purchase of equipment or buildings. To the delight of National Gallery officials Constable criticizes the gallery's lack of space, poor lighting, and absence of humidity controls and fire precautions.

90 Ibid., 'Memo,' R.M. Lester to Laurence V. Coleman, 4 Oct. 1942; Coleman, 'Report – Notes on Canadian Trip 4-24 October,' 14 Oct. 1942, 1

91 *National Gallery of Canada Annual Report 1935-1936* (Ottawa 1937) 10

92 NAC, H.O. McCurry Papers, vol. 1, anonymous two-page typescript, undated [Lethbridge, Alberta, 20 Dec. 1939] 2

93 Ibid., vol. 2, H.S. Southam to Keppel, 3 Dec. 1934

94 CCA, Canadian Museum Programme File, McCurry to Keppel, 3 Dec. 1934

95 NAC, H.O. McCurry Papers, vol. 2, Lismer to McCurry, 4 Aug. 1935

96 Ibid., vol. 1, Graham McInnes, 'Beauty Made Familiar' [mimeographed typescript, 1938] 1. At the end of its tenure the Canadian Committee had allotted $45,475 to galleries and museums, $23,825 to individuals, and $3,700 to its own operations.

97 Ibid.

98 CCA, National Gallery of Canada – Educational Programme File, G.R. Parkin to Frederick Keppel, 30 Aug. 1938. 'I need not develop that theme further,' Parkin continued, '... except to say that the promotion of art activities throughout the Dominion is, I would think, one way of promoting wider and deeper types of thought which in the long run, must surely make a valuable contribution towards national unity.'

99 NAC, G.R. Parkin Papers, vol. 16, 'Memo of Parkin Talking to Keppel

and Mr. Stackpole in New York, 11 February 1941'
100 Ibid., 'Memorandum of Discussion at the Seigniory Club, Montebello, February 23–24 1938,' 4
101 CCA, Canadian Museum Programme File, Coleman, 'Report – Notes on Canadian Trip 4–24 October, 14 Oct. 1942, 2
102 CCA, National Gallery of Canada – Education Programme File, Arthur Lismer, 'Report of the Maritime Lecture Trip, 26 February to 12 March 1940, 1
103 NAC, G.R. Parkin Papers, vol. 16, Parkin quoting Keppel in 'Memorandum of Discussion at the Seigniory Club,' 5
104 CCA, Canadian Museum Programme File, Coleman, 'Report – Notes on Canadian Trip 4–24 October,' 14 Oct. 1942, 2
105 NAC, G.R. Parkin Papers, vol. 16, Parking to Maude [Mrs W.L. Grant] 20 Jan. 1941
106 CCA, P & P Commonwealth-Canada File, 'Draft' [enclosed in G.R. Parkin to Charles Dollard, 31 Jan. 1942] 3
107 NLC, Ernest MacMillan Papers, Toronto Conservatory of Music File, 'To the Governor of the Toronto Conservatory of Music,' 136, 3. MacMillan was also counting among his 'rivals' the Canadian Bureau for the Advancement of Music, which also received Carnegie Corporation support.
108 'Stage Door Alberta Theatre News,' Community Drama Bulletin [BC Drama Association] 4, nos. 11–12 (Nov.-Dec. 1943) 8
109 RFA, Box 25, John Marshall 'Canadian Drama Survey, 31 March–21 April 1942,' 31
110 Ibid., 37
111 Anton Wagner, 'Elsie Park Gowan: Distinctively Canadian,' Theatre History in Canada 8, no. 1 (Sept. 1987) 72
112 R.M. MacIver, 'Cultural Trends, Canadian Culture and North Americanism,' in Conference of Canadian-American Affairs (New York 1937) 146
113 Varpu Lindström-Best, ' "I Won't Be a Slave" – Finnish Domestics in Canada, 1911–1930,' in Jean Burnet, ed., Looking into My Sister's Eyes: An Exploration in Women's History (Toronto 1986) 41

CHAPTER 6 'The Beginning of a Co-ordinated Artistic Life'

1 R.S. Lambert, 'What about the C.B.C.?' Food for Thought 1, no. 2 (Feb. 1940) 17
2 RFA, University of Alberta Drama File, Box 28, 'Grant-in-Aid,' 19 Feb. 1942

3 NAC, National Defence, RG 24, 2145, vol. 1, Charles F. Comfort, 'War Records Committee Report,' 10 Jan. 1943. It was Charles Comfort who promoted these leisure-time classes for men and women in the services.

4 Walter B. Herbert, 'The Writer and the War,' *Institute Journal* 21, no. 3 (Mar. 1942) 43

5 Department of National Defence, Directorate of History Archives, Arthur Lismer Papers, 'The Artist in Time of War' [handwritten, undated]

6 Bertram Brooker, 'Art and Society,' in *Yearbook of the Arts in Canada 1936* (Toronto 1936) xv

7 Raymond A. Davies, 'Writers and Artists Must Work for Offensive,' *Saturday Night* 58, no. 2 (19 Sept. 1942) 19

8 Donald Cameron, 'Foreword,' *Stage Door* [Edmonton] 1, no. 1 (April 1943) 1

9 PAM, Canadian Authors' Association Papers, Box 1, Correspondence and Papers 1925–49, 'A New Year Message from the National Executive' [mimeograph, 1942]

10 NLC, Ernest MacMillan Papers, MacMillan, 'The Arts in War Time,' *Educational Record of the Province of Quebec* 12, no. 2 (Mar. 1941) 94

11 VCA, Vancouver Folk Festival Papers, 'Festival to Stress Canadian Unity' [clipping, 1940, in 'Scrapbook']

12 R.S. Lambert, 'Art in Wartime,' *Maritime Art* 3, no. 1 (Oct.–Nov. 1942) 10. See also NAC, Lawren Harris Papers, MG 30, D 208, vol. 14, 'Artists' Role in Wartime' [typescript, 1941–2] 4; Charles H. Scott quoted in 'Canada at War: A Symposium on Art in War Time,' *Maritime Art* 2, no. 3 (Feb.–Mar. 1942) 85.

13 'The Fighting Poets,' *Canadian Review of Music and Art* 2, nos. 7–8 (Aug.–Sept. 1943) 28

14 Ernest MacMillan, 'Musical Composition in Canada,' *Culture* [Quebec] 3 (1942) 153

15 Frederick B. Taylor, 'Painting Canada's War Industry,' *Maritime Art* 3, no. 5 (July–Aug. 1943) 143

16 R.S. Lambert, 'Ontario Artists Paint War Effort,' *Saturday Night* 58, no. 28 (20 Mar. 1943) 2

17 Eaton's Archives, Toronto, Mrs K. Kells, 'Employees – Re Theatre' [undated typescript] 9

18 SAB, Saskatoon Art Association Papers, 'Minutes,' 1 Nov. 1943 ('Report of the President of the Saskatoon Art Association for 1943') n. pag.

19 'Seven Arts Club Alive to Relation of Arts to Society,' *Standard* [Montreal], 10 Feb. 1940, 7

20 NGCA, Writers', Broadcasters' and Artists' War Council File, 'The Writers',

Broadcasters' and Artists' War Council: Statement of Principles and Aims,' 1

21 For the details of the grants referred to see NAC, Canada Foundation Papers, MG 28, I 179, vol. 50, 'Annual Report of Rockefeller Foundation for 1944'; and RFA, Nova Scotia Folksongs, 'Grant-in-Aid to Public Archives of Nova Scotia for the Maritime Folksong Collector Helen Creighton.' See also Watson Kirkconnell and A.S.P. Woodhouse, *Humanities Research Council of Canada* (Ottawa 1947), and Donald Creighton, *John A. Macdonald* (Toronto 1952, 1955).

22 'Western Canadian Theatre Conference,' *Stage Door* 4, no. 1 (Oct. 1945) 4

23 Donald Cameron, 'The Western Theatre Conference,' *Food for Thought* 4, no. 1 (Sept. 1943) 13. See also RFA, Box 30, Western Canadian Theatre Conference File, 1943–9.

24 CCA, P & P Commonwealth-Canada File, 'Memo of J.M.R.'s [John M. Russell] Report of Meeting with Raleigh Parkin in Montreal,' 13 Nov. 1939

25 CCA, Queen's University Conference on Canadian Art File, 'Short Conversation between F.P. Keppel, Stephen H. Stackpole and André Biéler,' 1 Nov. 1940

26 André Biéler, 'National Aspects of Contemporary American and Canadian Painting,' in *Conference of Canadian-American Affairs* (New York 1937) 136

27 QUA, André Biéler Papers, Box 4, André Biéler and Elizabeth Harrison, eds., *The Kingston Conference Proceedings* (Kingston, Ont., 1941) 9, 62

28 CCA, Queen's University Conference of Canadian Art File, André Biéler to Florence Anderson, 5 July 1941. Biéler was disappointed, however, that despite his efforts to include a representative number of French Canadians, only Henri Masson and Jean-Paul Lemieux attended the conference.

29 QUA, Frances K. Smith Papers, Box 2, Ernest Lindner to Smith, 3 Feb. 1971

30 Ibid., Lucy Jarvis to Smith, 12 Sept. 1971

31 Ibid., Smith interview with Jack Shadbolt, 7 Mar. 1972 [transcript of tape I] 1. Fritz Brandtner saw the conference as giving artists an opportunity to 'convince the public, that the movement is for the benefit of Canadian art as a whole, and this also would give us a voice, to make the Government see, that it has to fulfil its responsibility toward using the crafts and arts talent of the artists for the benefit of the public and the country' (QUA, André Biéler Papers, Box 3, Brandtner to Biéler, 26 April 1941).

32 QUA, André Biéler Papers, Box 4, Biéler and Harrison, eds., *The Kingston Conference Proceedings*, 4–5

33 Ibid. 111–12
34 Ibid., 'Federation of Canadian Artists' [typescript, ca. Nov. 1941]
35 Ibid., Lawren Harris to Biéler, 14 June 1941
36 NAC, War Information Board, RG 36, 31, vol. 1, 'War Policy Statement' (Frederick B. Taylor to W.L. Mackenzie King, 16 Feb. 1943) 5. Mackenzie King sent the petition to John Grierson of the War Information Board, who then asked Walter Abell to prepare a memorandum on war artists and social concerns. The result, 'Art in Relation to War Effort,' 4 Mar. 1943, was enclosed in Abell to Grierson, 6 Mar. 1943, in ibid., vol. 15.
37 CCA, Canadian Museum Programme File, Laurence V. Coleman, 'Report – Notes on Canadian Trip 4–24 October,' 14 Oct. 1942, 11
38 In the late spring of 1943 fifteen servicemen were attached to the Army, Navy, and Air Force as official war artists; their number increased to twenty-five in February 1944; by the war's end thirty-two men and women artists, largely from English Canada, were on the official war artists list. For more information on the Canadian War Artists Programme see Maria Tippett, *Lest We Forget*, London Regional Art Gallery (London, Ont., 1989).
39 NAC, Canadian Society of Painters in Watercolour Papers, MG 28, I 254, vol. 2, 'Minutes of Annual Meeting,' 1 Dec. 1944, 2
40 Lawren Harris, 'The Federation of Canadian Artists,' *Canadian Review of Music and Art* 3, nos. 5–6 (1944) 16. See also CCA, Federation of Canadian Artists File, H.G. Kettle to Robert M. Lester, 17 Jan. 1945.
41 NAC, G.R. Parkin Papers, MG 30, D 77, vol. 16, Parkin to T.W.L. MacDermot, 19 Feb. 1942
42 NAC, Lawren Harris Papers, vol. 5, 'Artists' File' [untitled typescript, n.d.] 1
43 QUA, André Biéler Papers, Box 4, Walter Abell, 'Art and Democracy' and Frances Loring, 'Comments,' in Biéler and Harrison, eds., *The Kingston Conference Proceedings*, 32, 35
44 PAM, Canadian Authors' Association Papers, Box 1, Correspondence and Papers 1925–49, 'A New Year Message from the National Executive' [mimeograph, 1942] 1
45 'A Canadian Ministry of Cultural Affairs,' *Canadian Review of Music and Art* 1, no. 11 (1943) 24
46 Arthur Lismer, 'Federation Means Service,' *Maritime Art* 3, no. 3 (Feb.–Mar. 1943) 93
47 'Canadian Composers and Their Works,' *Pan Press* [New York] 38, no. 1 (Oct. 1945) 18
48 Bertram Brooker, 'When We Awake!' in Brooker, ed., *Yearbook of the Arts*

in Canada 1927–1928 (Toronto 1928) 17. See also F.B. Housser, *A Canadian Art Movement* (Toronto 1926).

49 QUA, Robert Ayre Papers, Box 2, 'Art Alive' [typescript of radio broadcast] 1

50 *People* 3, no. 26 (1 July 1944) 7

51 The Canadian Theatre Council hoped to found councils in each province and receive financing from provincial and federal governments. It never got beyond meeting at the Arts and Letters Club and preparing a manifesto written by Herman Voaden. See John Coulter, 'Toward a Canadian Theatre,' *Canadian Review of Music and Art* 6, nos. 1–2 (1943) 17; Herman Voaden, 'Theatre Record, 1945,' *Canadian Forum* 25, no. 298 (Nov. 1945) 185–6.

52 Elizabeth Wyn Wood, 'A National Program for the Arts in Canada,' *Canadian Art* 1, no. 3 (Feb.–Mar. 1944) 93

53 See, for example, C.A. Ashley, ed., *Reconstruction in Canada* (Toronto 1943). The closest this official report came to including cultural activity in its plans for post-war reconstruction was to suggest the need for more libraries, museums, and art galleries (ibid. 112). See also *Advisory Committee on Reconstruction V: Post-War Employment Opportunities*, Final Report of Subcommittee (Ottawa 1944) 1–27.

54 Blodwen Davies, 'Artists in Post-War Canada,' *Maritime Art* 3, no. 3 (Feb.–Mar. 1943) 69–70

55 NGCA, Writers', Broadcasters' and Artists' War Council File, Blodwen Davies to McCurry, 23 July 1943 and 2 Aug. 1943

56 QUA, Dorothy Livesay Papers, J.A. Macdonald, Associate Private Secretary, Department of Veterans Affairs, to Livesay, 3 Feb. 1945

57 Heliconian Club Archives, Toronto [this material was placed in the AO after the author consulted it], 'Copy of a Letter Sent to Mackenzie King of Resolution and Given to Members of the Committee 8 February' [1944]. This resolution was read to Ian Mackenzie.

58 Ibid., Jean Atkinson, 'Report to Club,' 6 Mar. 1944. This concerns the Ottawa meeting with Mackenzie.

59 Ibid., Mrs Junor to Miss Helen Wilson, 23 Oct. 44. Undaunted by Mackenzie's unwillingness to consider the matter of establishing a cultural commission, the club wrote to members of the provincial governments, all but three of whom responded positively.

60 Canada, House of Commons, Special Committee on Reconstruction and Re-establishment, *Minutes* orders of reference, 24 Mar. 1942

61 Canada, House of Commons, Special Committee on Reconstruction and Re-establishment, *Minutes of Proceedings and Evidence*, no. 10, 21 June 1944, 330–56. The committee responsible for writing 'The Artists' Brief'

comprised W.L. Somerville, Norman Wilks, Herman Voaden, G.H. Kettle, Elizabeth Wyn Wood, Ernest MacMillan, Forsey Page, John Murray Gibbon, and Frederick Taylor. The sixteen organizations were prompted to submit the 'Brief' to the Turgeon Committee by Labour Progressive member of Parliament for North Battleford, Dorise Nielsen, who was herself a member of the Turgeon Committee.

62 Walter Herbert, 'An Acorn on Parliament Hill,' *Canadian Art* 2, no. 1 (Oct.–Nov. 1944) 18, 15

63 'Art Program for Canada' [editorial], *Food for Thought* 5, no. 6 (Mar. 1945) 23

64 SAB, Ernest Lindner Papers, Box 2, H.G. Kettle to Lawren Harris, 26 June 1944 [copy]

65 Special Committee on Reconstruction and Re-establishment, *Minutes*, 21 June 1944, 356

66 SAB, Ernest Lindner Papers, Box 2, Kettle to Lindner, 26 June 1944

67 Herbert, 'An Acorn on Parliament Hill,' 18

68 The community centre plan was first suggested by the short-lived Allied Arts Council (1938), discussed at the conclusion of chapter 1, and then worked out in greater detail by Lawren Harris. See NAC, Lawren Harris Papers, vol. 5, 'Plan' [typescript, 8 pages, n.d.].

69 Voaden, 'Theatre Record, 1945,' 184

70 Ernest MacMillan, 'The Canadian Music Council,' *Canadian Music Journal* 1, no. 1 (Autumn 1956) 3

71 QUA, Frederick Taylor Papers, Bo 1, Arts Reconstruction Committee, Arts and Letters Club, Toronto, 5 Dec. 1945, 'Agenda,' 1

72 The Canadian Arts Council's goals differed from those put forth in the 'Artists' Brief' in one way. Following the establishment of the British Arts Council in June 1945, the Canadian Arts Council suggested that a National Arts Board with a non-political board, rather than a ministry of cultural affairs, be founded.

73 PAA, 'The Cultural Development Act, 1946,' O/C 989/46, chapter 9 of the *Statutes of Alberta*, 1946, c.9.s.3

74 SAB, Ernest Lindner Papers, Box 2. The Order-in-Council under which the Saskatchewan Arts Board was established was 228/48, Regina, 3 Feb. 1948, W.S. Lloyd, Minister of Education, to Lt. Governor-in-Council.

75 'Governments Accept Responsibility to Promote the Arts,' *C.A.C. News* no. 2 (April 1949) 3

76 'Constitution of UNESCO,' Article 7, 1.2., 2, in *The UNESCO* [Final Act of the London Conference, 16 Nov. 1945]

77 QUA, Frederick Taylor Papers, Box 1, Herman Voaden to Mackenzie King,

17 Oct. 1947. The Canadian Arts Council approached King regarding the establishment of an arts board even before its participation in UNESCO. See ibid., Voaden to Mackenzie King, 16 April 1946 and 30 April 1947; York University Archives, Herman Voaden Papers, Box 2, 'Canadian Arts Council Report,' 17 Dec. 1947; and ibid., C.E. Lewis, 'A Brief to the Standing Committee on External Affairs of the House of Commons,' 18 June 1948.

78 A delegation from the Canadian Arts Council visited the minister of health and welfare, Paul Martin, regarding the founding of community centres. See ibid., 'Canadian Arts Council Report on Conference with the Hon. Paul Martin, Minister of Health and Welfare and Louis St. Laurent, Secretary of State for External Affairs, 17 December 1947.' The Canadian Arts Council also presented a brief to the National Council of Physical Fitness in December 1948 asking that the arts be given adequate representation in the Division of Physical Fitness under the Department of Health and Welfare. See NGCA, Outside Activities/Organization Files, 'Brief from the Canadian Arts Council Submitted to Paul Martin, December 1948.' In 1951 the National Council on Physical Fitness of the Department of Health and Welfare appointed a representative from the Canadian Arts Council to the Physical Fitness Council.

79 York University Archives, Herman Voaden Papers, Box 2, 'Canadian Arts Council Report,' 17 Dec. 1947

80 PRO, EL 2/15, 'Report by Dr. Ilfor Evans on His Lecture Tour in Canada, 1 September to 9 October 1947,' 11 Oct. 1947, 9

81 *The Canada Foundation* [pamphlet] (Ottawa 1945) 5; Walter Herbert, 'A Ministry of Cultural Affairs,' *Canadian Review of Music and Art* 3, nos. 3–4 (1944) 15

82 NAC, Canada Foundation Papers, vol. 26, Herbert to Claude E. Lewis, 26 Mar. 1946

83 Herbert had been thinking about establishing the Canada Foundation as early as 1942. The Canada Foundation grew out of the Canadian Committee, which had been create that year by an anonymous donor – most likely the British Council – and headed by Walter Herbert with trustees Malcolm Robertson of the British Council and Vincent Massey, high commissioner in London, England. Its purpose was to 'stimulate cultural relations between Canada and Great Britain' by supplying books, pamphlets, magazines, reproductions of Canadian paintings, films, and maps to thousands of Royal Air Force and United States Army personnel posted in Canada during the war. The difficulty with accomplishing this task had made the committee's organizers – Justice Joseph T. Thorson, John

Grierson, E.A. Corbett, George de T. Glazebrook, and A.D. Dunton –
realize 'the need for an organization which would serve as a national
Canadian centre for the exchange of information about the life and
thought of our country, and which would be able to stimulate cultural
activity throughout Canada.' And, indeed, these individuals, along with
Mrs G.V. Ferguson, Senator L.M. Gouin, Arthur M. Phelps, Wilfrid
Eggleston, Milton F. Gregg, Lawren Harris, F.R. Scott, Mrs J. George
Garneau, Elizabeth Wyn Wood, and Judge Samuel Factor became trustees
of the Canada Foundation. See NAC, Walter Herbert Papers, MG 30, D 205,
vol. 1, 'Passing Thoughts about the Canadian Committee' [typescript,
n.d.] 1–4.

84 NAC, Canada Foundation Papers, vol. 50, Herbert to John Marshall, 17
 July 1945
85 Ibid., vol. 46, Herbert to Harold Brown, 27 June 1945
86 NAC, Walter Herbert Papers, vol. 1, Herbert to Dr Milton F. Gregg, presi-
 dent of the University of New Brunswick, 2 May 1947
87 PRO, EL 2/15, Herbert to E.W. White, assistant secretary to the Arts Coun-
 cil of Great Britain, 3 Jan. 1947; *The Canada Foundation*, 2
88 There was an unsuccessful attempt, for example, to bring Brooke Clax-
 ton, F.R. Scott, Sydney Smith, G.R. Parkin, and T.W.L. MacDermot
 together to form an 'intellectual Cultural Council' as a means of 'making
 unself-seeking Canadians to pool their knowledge of the people and
 needs of their country, to endeavour to see the country as a whole' (NAC,
 G.R. Parkin Papers, vol. 16, 'I.E.C., 19 March 1941' [copy] 1–4).
89 *The Canada Foundation*, 2
90 QUA, Frederick Taylor Papers, Box 1, Walter Herbert to Taylor, 11 Oct.
 1945; ibid., Taylor to Herbert, 1 Nov. 1945
91 NAC, Canada Foundation Papers, vol. 38, Department of Trade and Com-
 merce, International Office, to Herbert, 5 Feb. 1945. Herbert replied on 18
 Feb. 1945 to a request for advice from N.A. Robertson, under secretary of
 state for external affairs, by stating, 'I find it difficult to express concise
 opinions on the "Canada Council," ' and concluding that it was 'some-
 thing I cannot favour whole-heartedly' (ibid).
92 'The Canada Foundation,' *Canadian Review of Music and Art* 4, nos. 1–2
 (Aug.–Sept. 1945) 14
93 NAC, Walter Herbert Papers, vol. 1, Herbert to 'Tommy,' 3 July 1945; CCA,
 Canada Foundation File, Wilfrid Eggleston to Stephen H. Stackpole, 15
 Sept. 1950. By 1950 the Canada Foundation had earned $112,000. Among
 the Canada Foundation's patrons were members of Parliament; academic
 administrators and university professors; Composers, Authors and Pub-

lishers Association of Canada; Distillers Company Limited of Montreal; Montreal Standard Publishing Company Limited; Bata Shoe Company; and Canada Packers, among others.

94 NAC, Walter Herbert Papers, Herbert to 'Matt,' 29 Oct. 1947

95 QUA, Frederick Taylor Papers, Box 1, Herbert to Taylor, 21 Sept. 1945

96 NAC, Canada Foundation Papers, vol. 38, Herbert to Saul F. Rae, Chief Information Branch, Department of External Affairs, 20 Jan. 1949. Herbert was informed that his request would not be considered because of the impending Royal Commission on National Development in the Arts, Letters, and Sciences (ibid., L.B. Pearson to Herbert, 11 April 1949). See also ibid., vol. 34, John E. Robbins, treasurer of the Canada Foundation, to Stephen H. Stackpole, 14 Sept. 1950; CCA, Canada Foundation File, Wilfrid Eggleston to Stephen H. Stackpole, 11 Jan. 1951.

97 NGCA, Outside Activities/Organization File, Davies to H.O. McCurry, 23 July 1943. This 'scientific approach' was practised by a number of cultural organizations, including the Junior League of Vancouver and later the Vancouver Community Arts Council in preparing reports such as 'The Arts and Our Town' [1946-7] (in VCA, Community Arts Council of Vancouver Papers).

98 NLC, Ernest MacMillan Papers, Box 10, Post-War Reconstruction File, Canadian Council for Reconstruction through UNESCO, 'Minutes of Second Annual Meeting of the Council,' 27 May 1949, Quebec City, 5. Executive committee members came from such organizations as the Canadian Legion, the United Nations Association of Canada, the Canadian Arts Council, and the Federation of Canadian Artists. See also York University Archives, Herman Voaden Papers, Box 3, 'Move to Assist UNESCO Rehabilitation,' United Nations News [clipping, 1947].

99 'The Arts Council of Great Britain,' C.A.C. News no. 2 (April 1949) 2

100 PRO, Ilfor Evans, 'Report,' 11 Oct. 1947, 1

101 Ibid., 9, 12

102 Ibid. 13

103 Those activities included sending Ernest MacMillan to Australia in 1945, Boris Brott, another composer, to western Europe in 1948, and the Exhibition of Canadian Graphic Arts to Rio de Janeiro and Sao Paulo, Brazil, in 1946, to mention only three examples. For some thoughts on Canada's relationship with UNESCO see J.R. Kidd, 'Canada's Stake in UNESCO,' Queen's Quarterly 63, no. 2 (Summer 1956) 248-64.

104 NAC, Louis St Laurent Papers, MG 26, L, vol. 222, Brooke Claxton to St Laurent, 'Memorandum for the Prime Minister, Re: Commission on National Gallery, etc.,' 29 Nov. 1948, 1-5. I am grateful to Jim Whalen,

archivist at the NAC, for bringing this memorandum to my notice.
105 Ibid., L.B. Pearson to Jack Pickersgill, 5 Nov. 1948. See also J.W. Pickers-
gill, *My Years with Louis St. Laurent* (Toronto 1975) 139.
106 MCAUT, Vincent Massey Papers, 'Diary, no.60,' 6 Jan. [1949]
107 'Vincent Massey Heads Royal Commission,' *C.A.C. News* no. 2 (April
1949) 1
108 'Appointment of the Royal Commission Arouses Hope' [editorial],
C.A.C. News no. 2 (April 1949) 1

EPILOGUE

1 See *Report of Royal Commission on National Development in the Arts,
Letters and Sciences 1949-1951* (Ottawa 1951); J.L. Granatstein, 'Culture
and Scholarship: The First Ten Years of the Canada Council,' *Canadian
Historical Review* 65, no. 4 (Dec. 1984) 441-74; and Maria Tippett, 'Gov-
ernment Patronage and the Origins of the Canada Council: "The Most
Generous Sugar Daddy Art Has Ever Known," ' paper given at 'Contem-
porary Anglo-Canadian Culture and the Question of Its Origin,' Confer-
ence of the British and German Associations for Canadian Studies, Kiel,
West Germany, 25 Nov. 1989.

Index